THE BEST OF NEWS DESIGN™

E D I T I O N

The 2011 Creative Competition of the Society for News Design

Lo Mejor del Diseño™ La competencia creativa del 2011 de la Sociedad de Diseño de Noticias

 SND

COVER DESIGN

DOUGLAS OKASAKI
Gulf News Media columnist
Gulf News (Dubai- UAE)

THE MISSION OF THE SOCIETY FOR NEWS DESIGN is to enhance excellence in visual journalism and communications around the world.

To that end, the Society will:

Promote the highest ethical standards in all of our crafts;

Champion visual journalism as an integral discipline;

Educate journalists on a continuing basis;

Celebrate excellence in all aspects of journalism;

Encourage innovation throughout our industry;

Provide a forum for critical review and discussion of issues;

Value our unique and diverse international and multicultural character.

LA MISIÓN DE LA SOCIEDAD DE DISEÑO DE NOTICIAS es realzar la excelencia en el periodismo visual y las comunicaciones alrededor del mundo.

Con ese fin, la Sociedad va a:

Promover los estándares éticos más altos en todo nuestro trabajo;

Abogar por el periodismo visual como una disciplina integral;

Educar a los periodistas de forma continua;

Destacar la excelencia en todos los aspectos del periodismo;

Incentivar la innovación en toda nuestra industria;

Proporcionar un foro para la revisión crítica y la discusión de asuntos;

Valorar nuestro carácter internacional y multicultural único y diverso.

SOCIETY FOR NEWS DESIGN

424 E. Central Blvd., Suite 406
Orlando, FL 32801
(407) 420-7748
snd@snd.org
www.snd.org

Other distribution by Rockport Publishers, Beverly, Mass.
www.rockpub.com.

ISBN: 1-878107-04-6
ISBN-13: 978-1-59253-823-2

Judging takes place at the S.I. Newhouse School of Public Communications, Syracuse University (N.Y.)

La evaluación de los jueces se realiza en la Escuela de Comunicaciones Públicas S.I. Newhouse, de Syracuse University (estado de Nueva York, EE.UU.).

WORLD'S BEST

Bill Gaspard
Scott Goldman
Søren Nyeland
Rhonda Prast
Bob Unger

SMALL PAPER & PHOTO

Mike Albano
Adonis Durado
Steve Layton
Staffan Lowstedt
Roxanne Sorooshian

NEWS

Steve Cavendish
Dave Elsesser
Susan Ferguson
Michael Tribble
Danny Wong

LONG FORM

Tim Ball
Tracy Collins
Chris Courtney
Tiffany Grandstaff
Richard Johnson

FEATURES

Michael Hogue
Mathew Kurian
Sarah Morley
Alejandro Tumas
Daniel Zakroczemski

GENERALIST

Becky Pendergast

Mike Albano is creative director of Long Island Business News, and heads the graphic training program for the paper's corporate parent, The Dolan Company, which operates more than 60 niche publications nationwide. His work has been recognized with repeated SND awards and numerous national, state and local honors.

Mike Albano es director creativo del diario Long Island Business News, y lidera el programa de capacitación de gráficos de la empresa corporativa, The Dolan Company, que opera más de 60 periódicos de nicho en todo Estados Unidos. Su trabajo ha sido premiado varias veces por la SND y otras organizaciones locales, tanto del estado de Nueva York como de Norteamérica.

Tim Ball is art director for sports and news projects at The Washington Post. He has held management positions in the newsrooms of the San Jose Mercury News, Indianapolis Star and the South Florida Sun Sentinel. He briefly served as creative director for a magazine in Bangkok.

Tim Ball es director de arte de deportes y proyectos noticiosos de The Washington Post. Ha tenido varios puestos de mando en las salas de noticias de los diarios San Jose Mercury News, Indianapolis Star y South Florida Sun Sentinel. Por un breve periodo fue director creativo de una revista de Bangkok.

Steve Cavendish is the editor of The City Paper in Nashville. Before that, he was a writer, editor, presentation director and graphics editor at the Chicago Tribune, and held leadership positions at the Washington Post, San Jose Mercury News and St. Petersburg Times.

Steve Cavendish es editor de The City Paper, en Nashville, Tennessee, EE.UU. Anteriormente, fue redactor, editor, director de arte y editor de infografía del diario Chicago Tribune, y desempeñó cargos de liderazgo en los periódicos Washington Post, San Jose Mercury News y St. Petersburg Times.

Tracy Collins is director of Gannett's Phoenix Design Studio. He was senior director of operations (design, graphics and photo) at The Arizona Republic and azcentral.com. He joined The Republic in 2000, after a 10-year stay in Pittsburgh. At the Post-Gazette, he was graphics/design editor and, later, assistant managing editor for news.

Tracy Collins es director del estudio de diseño de Gannett en Phoenix. Fue director de operaciones (diseño, infografía y fotografía) del diario The Arizona Republic y azcentral. com. Comenzó a trabajar en The Republic en el 2000, después de 10 años en el Pittsburgh Post-Gazette, donde se desempeñó primero como editor de gráficos y diseño, y luego como subeditor ejecutivo de noticias.

Chris Courtney is mobile product manager for Tribune Media Group. He's created more than 40 apps for the company. Chris received awards for his work with the Los Angeles Times, was design director of RedEye and served as the creative consultant for Hoy and Mash. He recently has been bridging the world of mobile and print design with The Bulletin, a daily iPad magazine covering the Chicago Bulls..

Chris Courtney es gerente de producto móvil del Tribune Media Group, donde ha creado más de 40 aplicaciones. Ha recibido premios por su trabajo en el diario Los Angeles Times, ha sido director de diseño del periódico para jóvenes RedEye y se ha desempeñado como consultor creativo de los medios Hoy y Mash. Recientemente se ha dedicado a acercar los mundos del diseño móvil e impreso con The Bulletin, una revista diaria para iPad que cubre noticias del equipo de fútbol norteamericano Chicago Bulls.

Adonis Durado is the design director of Times of Oman and Al Shabiba (Arabic). His work has been recognized by SND, Communication Arts Design, Society of Illustrators, CA Typographics, and TABPI's Tabbie and FOLIO's Eddie Awards.

Adonis Durado se director de diseño de los periódicos Times of Oman y Al Shabiba (en inglés y árabe, respectivamente). Su trabajo ha sido galardonado por la SND, Communication Arts Design, Society of Illustrators, CA Typographics, y los premios Tabbie, de TABPI, y Eddie, de FOLIO..

Dave Elsesser is news and presentation editor at the Omaha World-Herald. He has won numerous writing, editing and SND awards as designer, copy editor, sports writer and sports editor. His 22-year career also includes time at The Wichita Eagle, the Springfield (Ill.) State Journal-Register and the LaSalle (Ill.) News-Tribune..

Dave Elsesser es editor de noticias y diseño del diario Omaha World-Herald. Ha ganado muchos premios como redactor, editor y diseñador tanto de noticias deportivas como de otros temas. Sus 22 años de carrera también incluyen trabajos en los periódicos The Wichita Eagle, de Kansas, Springfield State Journal-Register, y LaSalle News-Tribune, los dos últimos del estado de Illinois.

Susan Ferguson has been a design editor at The Montreal Gazette since 1998 and has held other positions at the paper since 1984. On any given day, she might handle Page One, section fronts, inside pages, print and online graphics or illustrations. She teaches newspaper design and InDesign part-time at Concordia University.

Susan Ferguson ha sido editora de diseño de The Montreal Gazette desde 1998, y ha tenido otros cargos en ese diario desde 1984. En su trabajo cotidiano puede ocuparse de la portada (tapa), las primeras páginas de secciones, las páginas interiores, los infográficos del diario u online, o las ilustraciones. Es profesora part time en Concordia University de diseño de noticias y del programa InDesign.

Bill Gaspard is the design director at China Daily, China's main English-language newspaper, published in 51 countries/ regions worldwide. Bill is a past president of SND and, in 2005, winner of the Society's Lifetime Achievement Award. In previous incarnations, he's held design management positions at the Las Vegas Sun, the Los Angeles Times and the San Diego Union-Tribune.

Bill Gaspard es director de diseño del China Daily, el principal diario en inglés de ese país, que se publica en 51 países y regiones de todo el mundo. Bill es uno de los ex presidentes de la SND y, en el 2005, obtuvo el premio SND Lifetime Achievement Award por su carrera en periodismo visual. Anteriormente desempeñó puestos ejecutivos de diseño en los diarios Las Vegas Sun, Los Angeles Times y San Diego Union-Tribune.

Scott Goldman is director of digital and visuals at The Indianapolis Star and IndyStar.com. He supervises a staff that delivers content across five platforms and has won numerous awards for visual presentation. Scott led visuals and content teams at the Charlotte Observer and The Washington Post before joining the Star in 2004. He served as SND president in 2007.

Scott Goldman es director digital y de imágenes de The Indianapolis Star e IndyStar. com. Supervisa un grupo que entrega contenido a través de cinco plataformas, y que ha ganado muchos premios de periodismo visual. Scott estuvo a cargo de los equipos visuales y de contenido de los diarios Charlotte Observer y The Washington Post antes de ir a trabajar al Star en 2004. Fue presidente de la SND en 2007.

Tiffany Grandstaff is the design director for the Bay Area News Group and oversees visuals for the San Jose Mercury News, the Oakland Tribune and the Contra Costa Times. She previously worked at the Charlotte (N.C.) Observer.

Tiffany Grandstaff es directora de diseño del Bay Area News Group y está a cargo de los elementos visuales de los diarios San Jose Mercury News, Oakland Tribune y Contra Costa Times. Anteriormente trabajó en el Charlotte Observer, de Carolina del Norte.

Michael Hogue is an illustrator and graphics editor at The Dallas Morning News. His work has received more than 70 international awards, including honors from SND, The Society of Illustrators, Communication Arts Illustration annual, Print, ADDY and Malofiej.

Michael Hogue es ilustrador y editor gráfico de The Dallas Morning News. Ha recibido más de 70 premios internacionales por su trabajo, incluyendo los de SND, The Society of Illustrators, Communication Arts Illustration annual, Print, ADDY y Malofiej..

Richard Johnson has been a graphics editor, news illustrator and foreign correspondent. He is currently graphics editor of The National Post of Toronto, Canada. His skills include an eye for detail, a love of raw data and a need to do work that actually makes readers care.

Richard Johnson ha sido editor de infografía, ilustrador de noticias y corresponsal extranjero. Actualmente es editor de gráficos de The National Post, de Toronto, Canadá. Entre sus habilidades destaca su atención al detalle, un gusto por los datos no procesados y la necesidad de lograr que los lectores se interesen por el contenido.

Steve Layton has taught design and graphics courses in the Journalism School at Indiana University for the past two years. Before teaching, he worked at several publications, including the Chicago Tribune, where he was graphics editor and, later, senior artist.

Steve Layton ha enseñado diseño e infografía en la escuela de periodismo de Indiana University desde hace dos años. Anteriormente, trabajó en varios medios, como el Chicago Tribune, donde fue editor de infografía y luego artista senior.

Sarah Morley is deputy art director for The Independent on Sunday, an award-winning British national newspaper renowned for its design. Working with the art director, editor and editorial team, she is responsible for creating clear, accessible, innovative news and feature pages on tight deadlines.

Sarah Morley es subdirectora de arte del periódico británico dominical The Independent on Sunday, que ha ganado premios y se ha destacado por su diseño. En conjunto con la dirección de arte, la edición de noticias y el equipo editorial, ella es responsable de crear contra el cierre páginas de noticias y reportajes que sean claras, accesibles e innovadoras.

Becky Pendergast has more than 23 years experience in print and digital design. She has held creative and management roles at corporate and nonprofit organizations. She has also designed, managed and executed numerous newspaper redesigns during her 15 years in the newspaper and magazine industry.

Becky Pendergast tiene más de 23 años de experiencia en diseño de página y digital. Ha desempeñado cargos de creatividad y administración tanto en empresas como en organizaciones sin afán de lucro. También ha diseñado, administrado y llevado a cabo muchos rediseños de periódicos a lo largo de los 15 años en que ha trabajado en diarios y revistas.

Roxanne Soroosian is an assistant group production editor at the Herald & Times. She has been a journalist for 20 years, 17 of them with the Herald group. She joined the Sunday Herald launch team in 1999 and, after 10 years as production editor, was tasked with helping reorganize production across all titles.

Roxanne Soroosian es editora asistente de grupo de producción en el diario Herald & Times. Ha sido periodista durante 20 años, 17 de los cuales los ha pasado en el grupo Herald. Se sumó al grupo de lanzamiento del Sunday Herald en 1999 y, luego de 10 años como editora de producción, fue asignada para ayudar a reorganizar la producción de todos los productos del grupo Herald.

Alejandro Tumas has been the graphic director of Clarín Newspaper since 2001. He was a senior graphic editor of National Geographic and now continues to work for the magazine from Argentina. His work has been recognized with more than 80 awards and distinctions from the SND and Malofiej.

Alejandro Tumas ha sido director de infografía del diario argentino Clarín desde 2001. Fue editor senior de gráficos de National Geographic, y continúa trabajando para la revisa desde Argentina. Su trabajo ha ganado más de 80 premios y distinciones de la SND y Malofiej.

Danny Wong is director of SND Chinese (HK & Macau) and art and production director of Sing Tao News Corporation Ltd., where he is responsible for the art and production work of Sing Tao Daily, Headline Daily and The Standard. His distinctive layout designs integrate the Western and Chinese newspaper styles.

Danny Wong es director de SND Chinese (Hong Kong y Macao) y director de arte y producción de Sing Tao News Corporation Ltd., donde está a cargo de las tareas de arte y producción de los periódicos Sing Tao Daily, Headline Daily y The Standard. Integró los estilos de diario occidental y chino y generó un diseño de diagramación distintivo en Hong Kong.

Mathew Kurian is a designer at The National newspaper in Abu Dhabi, UAE. Before that, he was the chief designer of the Weekend Magazine at Khaleej Times in Dubai, UAE. He has also worked for various newspapers and advertising agencies in India as an artist/illustrator. He has won several SND awards, including Silver Medals.

Mathew Kurian es diseñador del diario The National, de Abu Dhabi, la capital de los Emiratos Árabes Unidos. Anteriormente, fue diseñador jefe de de la revista Weekend del diario Khaleej Times, de Dubai, EAU. También ha trabajado como artista e ilustrador en varios periódicos y agencias de publicidad en India. Ha ganado varios premios de la SND, incluyendo medallas de plata.

Staffan Löwstedt is picture and visual editor for Svenska Dagbladet in Sweden. He has been honored by SND and other professional organizations for visual storytelling, picture editing and photography. He has worked as a photographer for 20 years, both for the newspaper and now as a developer for the iPad magazine SvDInsikt.

Staffan Löwstedt es editor de fotografía e imágenes del diario sueco Svenska Dagbladet. Ha recibido premios de la SND y otras organizaciones profesionales por su trabajo de narración gráfica, edición de imágenes y fotografía. Se ha desempeñado como fotógrafo por 20 años, tanto en el diario mencionado como en el desarrollo de la revista SvD Insikt para iPad.

Søren Nyeland has been design editor of Politiken in Denmark since 1997. The paper has won several awards, including SND's World's Best-Designed Newspaper in 2007 and The European Newspaper of the Year in 2010. Nyeland has served as a jury member at SND, SND/S, SND/Russia and the European News Award competitions.

Søren Nyeland ha sido editor de diseño del diario danés Politiken desde 1997, el cual ha obtenido varios premios, incluyendo el de la SND al periódico mejor diseñado del 2007 y el del diario europeo del año en 2010. Nyeland ha integrado el jurado de competencias de diseño de la SND, SND/S (Escandinavia), SND/Rusia y el Premio europeo a las noticias.

Rhonda Prast is on the magazine faculty at the Missouri School of Journalism, where she teaches web content production, social media strategy and iPad app creation. Her work in visual management roles at the Minneapolis Star Tribune, Seattle Times, Miami Herald and the Providence Journal has been recognized with numerous SND and POY awards and an Emmy, a Pulitzer and EPPY awards.

Rhonda Prast enseña producción de contenido web, estrategia de medios sociales y creación de aplicaciones para iPad como profesora de revista del Missouri School of Journalism. Su trabajo en puestos de administración de imágenes en los diarios Minneapolis Star Tribune, Seattle Times, Miami Herald y Providence Journal ha sido destacado con muchos premios de la SND y Picture of the Year (fotoperiodismo), además de un Emmy, un Pulitzer y un EPPY.

Michael Tribble is assistant managing editor for digital and online for The Plain Dealer in Cleveland, Ohio. Before that, he was design director at The Plain Dealer and the San Jose Mercury News. A visual journalist for 20 years, he currently serves as SND Region 4 director, and is site chair for the 2012 SND Workshop.

Michael Tribble es asistente de edición ejecutiva de contenidos digitales y online de The Plain Dealer, de Cleveland, Ohio, EE.UU. Antes de eso, fue director de diseño de ese diario y también del californiano San Jose Mercury News. Ha sido periodista visual durante 20 años y actualmente es el director de la región 4 de la SND y el organizador del congreso anual de la SND de este año, en Cleveland.

Bob Unger is editor and associate publisher of SouthCoast Media Group, publisher of The Standard-Times in New Bedford, Mass. He has served as editor of the Centre Daily Times in State College, Pa.; the St. Joseph (Mo.) News-Press; the Jacksonville (Ill.) Journal-Courier; and the Transcript-Telegram in Holyoke, Mass. His newspapers have won national and regional awards for public service and investigative reporting.

Bob Unger es editor y director asociado de SouthCoast Media Group, que publica el diario The Standard-Times, de New Bedford, Massachusetts, EE.UU. Se ha desempeñado como editor del Centre Daily Times, de State College, Pennsylvania; St. Joseph News-Press, Missouri; Jacksonville Journal-Courier, de Illinois; y Transcript-Telegram, de Holyoke, Massachusetts. Sus diarios han ganado premios a nivel nacional y regional por servicio público y periodismo de investigación.

Daniel Zakroczemski became a staff artist at The Buffalo News in 1998. He has won many awards, including honors from SND, the NYS Associated Press Association, the Sunday Magazine Awards, the Communication Arts and the Society of Illustrators..

Daniel Zakroczemski ha sido artista de la planta laboral del diario The Buffalo News desde 1998. Ha obtenido muchos premios, incluyendo los de SND, NYS Associated Press Association, Sunday Magazine Awards, Communication Arts y Society of Illustrators.

THIS BOOK SHOWCASES THE TALENTS and hard work of newspaper and magazine staffs from around the world. You will see more than 1,200 images that represent the most inspiring work by designers, photographers, illustrators and editors. These are the winners from the Society for News Design's annual Best of News Design™ Creative Competition for the year 2011. Also included in this book are the Best of Digital Design winners.

It took 26 judges almost two weeks to determine the 717 print winners from the 10,236 entries submitted by newspapers and magazines in 39 countries.

In this, its 33rd annual competition, The Society for News Design awarded a Best in Show prize for the first time in a decade, and named five newspapers World's Best-Designed™.

Judges awarded Svenska Dagbladet — a 190,000 circulation daily newspaper in Stockholm, Sweden — with Best in Show for its breaking news coverage of the 2011 attacks in Norway, in which 77 people were killed in Oslo and on a nearby island. Their 16 pages of coverage "combine stunning photography, engrossing information graphics, sharp typography, brilliant pacing and page architecture in a piece of journalism that answers every question a reader might have," the judges said in their statement.

"It shows what journalists should be doing when news breaks and how design plays a central role," said judging competition coordinator Josh Crutchmer of the Minneapolis Star Tribune.

It is the first Best in Show awarded since SND recognized The New York Times for its information graphics coverage of the Sept. 11, 2001, terrorist attacks.

Five publications were named World's Best-Designed™: Excelsior, of México City, México; Frankfurter Allgemeine Sonntagszeitung, of Frankfurt am Main, Germany; The Grid, of Toronto, Canada; the National Post, of Toronto, Canada; and Politiken, of Copenhagen, Denmark.

This marks the fifth time Frankfurter Allgemeine Sonntagszeitung has won "World's Best" designation, and the fourth time since 2006. It is the third win for the National Post, which was also recognized in 1998 and 2000. It is the second win for Politiken, which was previously recognized in 2006.

The common thread in the "World's Best" winners, according to the judges, is "a certainty about who their audiences are and a bold, sure-footed approach to reaching them. All have a unique voice. All are superb. All share a commitment to print that other newspapers should emulate. They never waste a page; never waste their readers' time. These newspapers look healthy, well staffed and richly resourced — even if they are not. It was inspiring to see journalists who still believe in excellence in print."

In the 19 competition categories, judges awarded six Gold Medals, 39 Silver Medals, seven Judges' Special Recognitions and 668 Awards of Excellence.

The six Gold Medal winners:

• Bloomberg Businessweek, for its coverage of Steve Jobs' death.

• Pablo Bernasconi of La Nacion in Buenos Aires, Argentina, for his illustration portfolio.

• The Times of Oman, for a 28-page tiled poster celebrating Ramadan.

• The Times of Oman, for its design treatment of the story "How secrecy undermines audit reform."

• Svenska Dagbladet's breaking news coverage of the Norway attacks.

• The Washington Post, for its non-narrative treatment of a story on tablet shopping.

The competition, co-sponsored by SND and the S.I. Newhouse School of Public Communications at Syracuse University, recognizes excellence in newspaper design, graphics and photography. Judges from around the globe met in two stages in February at Syracuse University to select the "best of the best."

The one thing that does not change from year to year is what the awards represent. Each year, judges are given the same award definitions before they begin their work in Syracuse. It's up to the judges to decide what entries, if any, are worthy of one of three awards. Judges may also give a JSR to any winner for special recognition.

Award of Excellence — This is granted for truly excellent work, going beyond mere technical or aesthetic competency. It honors outstanding entries for such things as being daring and innovative, even if they are less than 100 percent in every respect. Judges were asked to be tough, but fair.

Silver Medal — This award is given for work that goes beyond excellence. The technical proficiency of the Silver Medal should stretch the limits of the medium. These entries should shine.

Gold Medal — This award is presented for work that defines the state of the art. Such an entry should stretch the limits of creativity. It should be nearly impossible to find anything deficient in a Gold-winning entry. In past years, very few Gold Medals have been awarded.

TWO ADDITIONAL AWARDS

In addition to the Award of Excellence and the two medals, two special honors are possible: the Judges' Special Recognition and the Best in Show. These honors are given only when special circumstances warrant.

Judges' Special Recognition — This honor can be awarded by a team of judges or by all judges for work that is outstanding in a particular respect not necessarily singled out by the Award of Excellence, Silver or Gold awards structures. This recognition has been granted for such things as use of photography, use of informational graphics and use of typography throughout a body of work. This body of work may be a particular publication, a section or sections by an individual or staff. The special recognition does not supplant any Award of Excellence, Silver or Gold, and should be seen as an adjunct.

Best in Show — As the name implies, this is the best of the Gold Medal winners. Any discussion for this award takes place at the conclusion of the judging. Judges have an opportunity to view all Gold Medal winners at the same time. Only one Best in Show award may be presented at this judging. Some years no Best of Show is given. For the award to be given the entry must receive "yes" votes from the majority of the judges. Votes are taken by secret ballots after a discussion by judges, who are encouraged to express support or non-support for the award.

It takes a lot of help to make the judging happen:

33rd Edition Judging Coordinator: Josh Crutchmer, news design director, Minneapolis Star Tribune

33rd Edition Audit Director: Shamus Walker, Syracuse University

TEAM CAPTAINS

Melissa Angle, designer, Atlanta Journal-Constitution
Vince Chiaramonte, deputy design editor, Buffalo News
Mike Rice, design director, Arizona Daily Star
Dennis Varney, lead sports designer, Lexington Herald-Leader

SND 33RD EDITION FACILITATORS

Will Alford, design chief, Atlanta Journal-Constitution
Jonathon Berlin, graphics editor, Chicago Tribune
Bethany Bickley, designer, Huntsville (Ala.) Times
Rich Boudet, lead sports designer, Seattle Times
Audrey Burian, Syracuse University
Chris Carr, presentation director, Minneapolis Star-Tribune
Steve Dorsey, vice president, research and development, Detroit Media Partnership
Mark Friesen, online presentation editor, Portland Oregonian
Gayle Grin, ME design & graphics, National Post
Lance Johnson, editor, The Best of News Design
Stephen Komives, SND executive director
David Kordalski, AME for visuals, The Plain Dealer
Lily Lu, SND China
James Michalowski, freelance visual journalist
Katherine Myrick, designer, The Washington Post
Tim Parks, deputy presentation editor, Omaha World-Herald
Denise Reagan, AME for visuals, The Florida Times-Union
Claire Regan, AME, Staten Island Advance
Darren A. Sanefski, assistant professor, University of Mississippi
Susan Santoro, SND
Rob Schneider, presentation director, The Dallas Morning News
Colin Smith, design leader, Phoenix Design Studio
Emmet Smith, art director, Cleveland Plain Dealer
Lee Steele, design editor, Hearst Connecticut Newspapers
Claudia Strong, Syracuse University
Tippi Thole, art director, The Washington Post
Lila Victoria, designer, Staten Island Advance
Andrea Zagata, sports designer, Detroit News

SYRACUSE UNIVERSITY STUDENTS

Chris Ballard, Chablé Bracken, Camille Bautista, Sarah Jane Capper, Mark Cooper, Danielle Hinckley, Jenna Ketchmark, Hannah Klein, Veronica Magan, Julie McMahon, Briana Murrell, Alex Onushco, Michele Paolella

We invite you to enjoy the best print and digital designs for 2011.

C. Marshall Matlock

C. Marshall Matlock
Director
Best of News Design & Judging
S.I. Newhouse School of Public Communications

Excelsior — Mexico City, Mexico

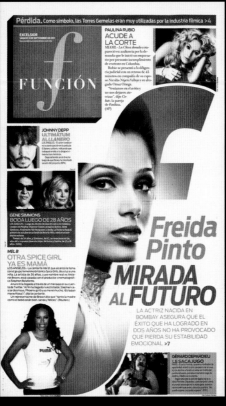

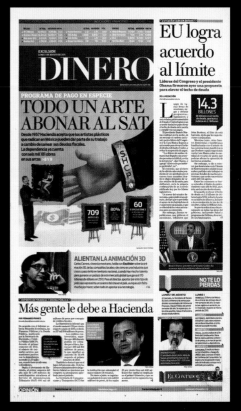

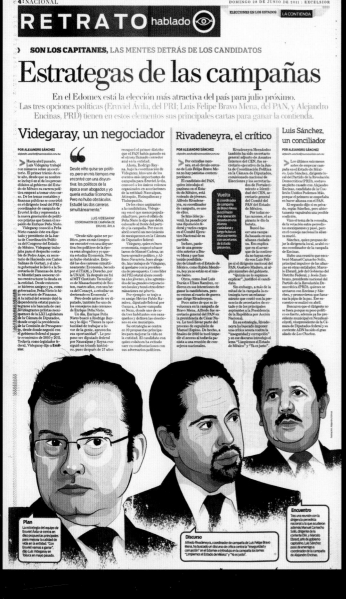

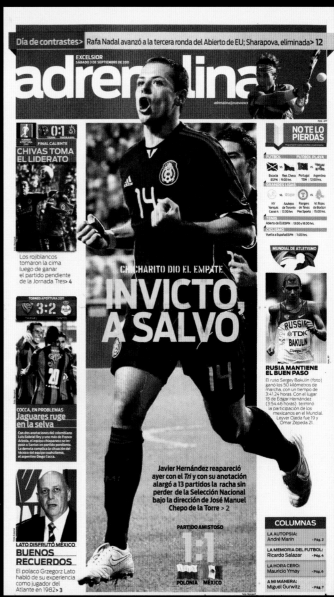

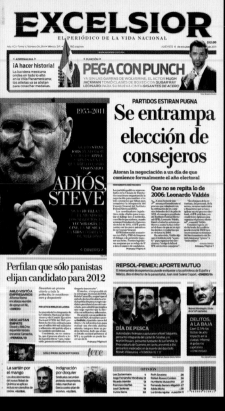

...R
México
5,000 – 174,999

...HIS IS THE FIRST TIME IT HAS WON WORLD'S
... 2007 — when the pages of a redesigned Excelsior
...ved up on the SND judging tables — the previously
...own daily sparked great excitement. It was the talk of
...etition, as much for the scope of its astounding visual
...nation as for the dynamic pages and spreads being

...suing five years, the paper has kept up and refined its
...ated typography, bold color palette and overall visual
...hat energy has once again captivated a World's Best
...eam.

...paper with much going on — lots of stories, sidebars
...kouts, along with an abundance of photographs
...hics. Its ability to bring order to this potential for
...ithout dulling its edge, is a testament to the care
... every page. At the same time, there is a small but
...rsonality shift in each of the sections. There is an
...edgement of the change in content, but done skillfully
...not to make the paper feel disjointed.

...he aptly named sports section — adrenaline — is presented
with all the energy experienced in the stands of a Mexican
soccer game. The features section — heavy on entertainment —
is as colorful and dramatic as its subject matter. The designers
do a terrific job every day, often with little more than the paper's
solid architecture, exquisite typography and some well-chosen
handout photos.

While we saw many papers that do a great job with sports and
features, we saw few that maintain that visual momentum in
the business and local sections. Excelsior does this. Some of the
best covers and inside pages in the paper grace these sections.

Even with its dynamic presentation, Excelsior ably adjusts the
volume as its content demands, from high-amp sports and
feature sections to the relative quiet of its elegant, exceptionally
beautiful editorial pages. It does this through artful — and
sometimes substantial — shifts in the grid, typography, palette
and graphic details.

Excelsior is a paper that directly translates the color, energy and
passion of its region onto its pages. It grabs you and doesn't let
you go — from the first page to the last.

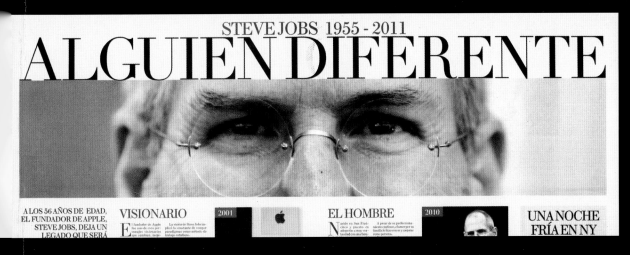

...E ESTA ES LA PRIMERA VEZ QUE GANA EL PREMIO
...OR DEL MUNDO, los jueces de la competencia de la
...minaron en 2007 por primera vez las páginas de un
...do Excelsior. En ese momento, este diario, que hasta
...s era poco conocido, generó un gran interés. Estaba
...de todos, tanto por el alcance de su impresionante
...nación visual como por el dinamismo de sus páginas y
...ginas, que se estaban evaluando.

...guientes cinco años, el periódico ha mantenido y
...su sofisticada tipografía, atrevida paleta de color y
...visual general. Una vez más, esa energía ha cautivado al
...e jueces de Lo Mejor del Mundo.

...cho en este diario; una gran cantidad de artículos,
...s laterales y despieces, junto con una abundancia
...afías e infográficos. Su capacidad para poner orden
...encial caos, aunque sin quitarle brillo a la ventaja
...se destaca, es señal del cuidado que se presta a cada
...Al mismo tiempo, hay un leve pero inteligente cambio
...nalidad en cada una de las secciones. Se nota un
...miento del cambio en el contenido, pero está hecho
...mente que el diario no se siente dislocado.

...n deportiva tiene un nombre apto -adrenalina-, y se

presenta con toda la energía que hay en las graderías de un
partido de fútbol en México. La sección de reportajes –cargada
al ocio o espectáculos–, es tan colorida y dramática como los
temas que cubre. Los diseñadores hacen un gran trabajo cada
día, a menudo con poco más que la sólida arquitectura del
periódico, una tipografía refinada y una buena selección de
algunas fotos conseguidas.

Aunque vimos muchos periódicos que se destacaban en
deportes y reportajes, notamos pocos que mantenían ese
ímpetu en las secciones de negocios y noticias locales. Excelsior,
en cambio, lo logra. Algunas de las mejores portadas o tapas, y
páginas interiores del diario son de esas secciones.

Incluso con su diseño dinámico, Excelsior ajusta el volumen
con habilidad según lo requiera el contenido, desde la alta
amplificación del deportivo y de reportajes, hasta el relativo
silencio de sus elegantes y excepcionalmente hermosas páginas
editoriales. Lo consigue por medio de sus ingeniosos –y
ocasionalmente sustanciales– cambios en la grilla o retícula, la
tipografía, la paleta de color y los detalles gráficos.

Excelsior es un diario que traduce directamente el color, la
energía y la pasión de su región en sus páginas. Atrapa al lector
y no lo suelta, desde la primera página a la última.

WORLD'S BEST-DESIGNED™

lo mejor diseñado del mundo

CONTENTS / CONTENIDOS

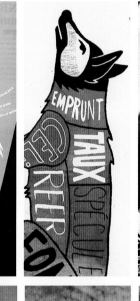

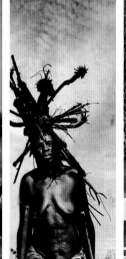

Lo que buscaban los jueces

FOTOGRAFÍA Y DIARIOS DE BAJA TIRADA

En términos de fotografía, buscamos un reportaje que se adentrara en las emociones humanas. Aunque muchos temas eran emotivos en sí, las imágenes debían ir más al fondo que simplemente mirar algo detenidamente desde el lente. Muchos retratos, por ejemplo, estaban bien realizados, pero les faltaba el añadido emocional que lleva las imágenes a otro nivel.

Una magnífica fotografía es la que permite que quien la ve pueda respirar en ella -una imagen limpia y sobria, no sobrecargada ni complicada, pero con niveles de información-. Inevitablemente, las piezas competidoras eran todo un surtido, pero las que funcionaban tenían un rasgo en común: algo de personalidad que saltaba a la vista en la página.

Los mejores diseños de diarios de baja tirada o circulación daban cuenta de simpleza, audacia y seguridad en sí mismos, con elementos elegidos de forma inteligente y editados con rigurosidad, y que resultan bien. A las páginas atiborradas -a las cuales les faltaba disciplina y estructura- no les fue bien, y el mensaje que esperaban transmitir resultaba confuso. Los diarios de baja tirada deberían tratar de divertirse más, y tener un poco más de actitud. De alguna forma, tienen más oportunidades para hacerlo que un diario serio y de gran tirada. Un diario pequeño no cuenta con los recursos de uno grande -a menudo son demasiado esqueléticos como para poder pagar la fotografía de alto nivel-. Por eso, deben usar sus propios recursos, reconocer sus habilidades y trabajar esas fortalezas.

NOTICIAS

Durante tres días enteros, revisamos diarios de todo el mundo. ¿Qué nos gustó? La respuesta se encuentra en las páginas que siguen. Advertimos varias cosas, eso sí:

• Las mejores piezas, incluso en estos tiempos tan preocupados por el espacio, se mantuvieron a flote, al menos en parte, gracias a infográficos sobresalientes. Hay una gran brecha entre quienes relatan historias sofisticadas y los que no lo hacen. Incluso mayor es el abismo entre los periódicos que continúan reduciendo sus secciones de infografía y los que no lo hacen, porque pierden la habilidad para representar visualmente información compleja.

• Las medallas de oro — entregamos solo dos — fueron para las piezas que eran más completas que lo que habíamos visto. Representaban un compromiso total, ya sea con una idea o para explicar un artículo.

• Los rediseños deben ir más allá de una nueva tipografía; deben representar un cambio en la filosofía, y muchos periódicos no estuvieron dispuestos a hacer algo más que una cierta nueva decoración.

• Tal como los infográficos, queda poca edición fotográfica. Las mejores piezas claramente habían pasado por las manos de un editor de imágenes con el fin de conseguir el recorte correcto, quitar una imagen redundante o encontrar aquella foto que otros periódicos habían dejado pasar. Incluso algunos líderes del diseño industrial fueron víctimas de la inconsistente edición fotográfica.

GRAN FORMATO

La edición es un arte, tanto del contenido que se produce como de la forma en que se presenta. Las piezas que realmente saltaron a la vista demostraron una profundidad en el reporteo y una toma de riesgo inteligente, desde el concepto del artículo hasta su diseño. En los casos más completos y atrevidos, el lector fue generosamente recompensado por el tiempo que dedicó al periódico.

La edición requiere coraje -el coraje para eliminar el exceso y tomar decisiones audaces con lo que queda. Las piezas que lo lograron usaron palabras e imágenes con determinación de maneras inteligentes -y frecuentemente sorprendentes-.

Sí, había piezas de diseño fantásticas, pero los esfuerzos para enfrentar los desafíos de las convenciones tradicionales del reporteo y el diseño batallaron continuamente por captar nuestra atención. Algunas piezas nos hicieron sonreír, otras nos hicieron detenernos y las mejores reafirmaron y demostraron el compromiso de un periódico con una historia.

REPORTAJES

Al juzgar las variadas categorías, nuestra prioridad mayor fue simple: Reconocer la excelencia y un alto nivel de habilidad en cada capa y cada faceta que funcionaba bien en una página bien armada.

También buscamos la integración de varios elementos que funcionaran bien como un todo creativo, para que la historia y el mensaje brillaran al máximo.

Un potente mensaje realzado por un diseño contundente es la mayor dupla ganadora, pero la simplicidad y la sutileza también son aspectos importantes para lograr impacto y hacer que un concepto fuerte se destaque.

También premiamos el importante rol de la disciplina y la estructura dentro de una filosofía de diseño. Muchas páginas pueden caerse por un diseño excesivo, incluso por un elemento deshonesto de más que echa a perder el efecto general. Un periódico tanto con parámetros claros como con una estructura y una personalidad distintiva es, a menudo, la mejor plataforma sobre la cual un diseño realmente innovador puede destellar y sorprender.

La consistencia, la continuidad y el ritmo también son componentes vitales que pueden ayudar a los diseñadores con facilidades a expresar su creatividad y a entregar lo que en última instancia estábamos buscando en el proceso de evaluación de las piezas; el factor ¡guau!... un diseño que saltara de la página y mostrara técnicas innovadoras e ideas frescas que puedan expandir las fronteras y abrir camino.

PHOTO AND SMALL PAPERS

In terms of photography, we were looking for reportage that dove down into human emotion. Though many topics were emotional in and of themselves, the photographers needed to go deeper than just peering through the lens. Many portraits, for example, were well executed, but lacked the emotional attachment that takes an image to another level.

An outstanding photograph is one the viewer can breathe in — clean and restrained, not overloaded or complicated, but with layers. Inevitably, the entries were a mixed bag, but the ones that worked shared a common trait: an element of personality that came through on the page.

The best small paper designs represented simplicity, boldness and confidence, combining cleverly chosen and strictly edited elements. Crammed pages — those that lacked discipline and structure — fared poorly, and the message they had hoped to convey was confused. Small papers should strive to have more fun — and maybe even show a bit of attitude as well. In many ways, they have more opportunity to do so than a serious, big paper. Often too skeletal to afford top-level photography, smaller papers must use their own resources, recognize what their skills are and play to those strengths.

NEWS

For three solid days we looked at papers from around the world. What did we like? The answer to that is in the pages that follow. We noticed a lot of things, though:

• The best work, even in these space-conscious times, was buoyed, at least in part, by outstanding graphics. There is a huge gap between those who tell sophisticated stories and those who don't. Bigger yet is the chasm between the publications that continue to hack away at their graphics staffs — thereby losing the ability to visually represent complex information — and those that don't.

• The two Gold Medals we awarded went to entries that were as complete as we've ever seen. They represented total commitment, whether to an idea or to explaining a story.

• Redesigns need to be more than just new type: They must represent a change in philosophy. Many publications were unwilling to do more than some redecoration.

• Like graphics, photo editing is in short supply. The best entries had been noticeably touched by a picture editor to get the right crop, to take out a redundant image or to find that photo other publications missed. Even some design industry leaders were victims of inconsistent photo editing

LONG FORM

Editing is an art — both in the content produced and in the way it is presented. The work that truly shined showed a depth of reporting and intelligent risk-taking, from story concept to presentation. In the most comprehensive and daring cases, the reader was substantially rewarded for spending time with the publication.

Editing takes courage — the courage to eliminate the excess and make bold choices as to what remains. Work that did this used purposeful words and visuals in smart, and often surprising, ways.

Yes, there was fantastic design work, but the efforts brave enough to challenge traditional conventions of reporting and design continually battled for our attention. Some entries made us smile, some made us pause — the best of them made a statement and demonstrated a publication's commitment to a story.

FEATURES

In judging the various categories, our main priority was simple: to recognize excellence and a high level of skill in each layer and facet of a well-constructed page.

We were also looking for the integration of various elements into a creative whole, so that the story and message are displayed to maximum effect.

A powerful message enhanced by forceful design is the ultimate winning partnership, but simplicity and subtlety are also important aspects in making an impact and helping a strong concept shine through.

We also recognize the important role of discipline and structure within a design philosophy. Many pages can fall down through overdesign, with even just one rogue element too many that spoils the overall effect. A publication with clear parameters as well as a distinctive framework and personality is often the best platform from which really innovative design can sparkle and surprise.

Consistency, continuity and pace are also vital components in helping designers with flair express their creativity and deliver what we were ultimately seeking during the judging process: the wow factor ... design that jumps off the page, displaying fresh ideas through innovative techniques that push boundaries and break new ground.

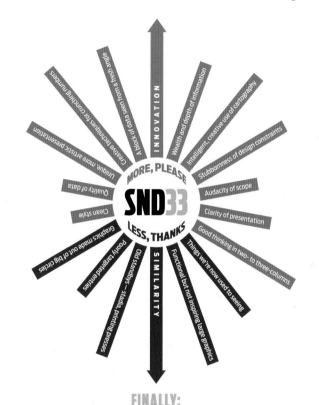

INNOVATION

MORE, PLEASE

SND33

LESS, THANKS

SIMILARITY

A block of data seen from a fresh angle
Wealth and depth of information
Intelligent, creative use of cartography
Stubbornness of design constraints
Audacity of scope
Clarity of presentation
Good thinking in two- to three-columns
Things we're now used to seeing
Functional but not inspiring large graphics
Old standbys - spatia, printing presses
Poorly targeted entries
Graphics made out of big circles
Clean style
Quality of data
Creative techniques for crunching numbers
Unique, more artistic presentation

FINALLY:
We need to be **innovative** to survive. In the near future, anything that can be automated will be.

ESTE LIBRO EXHIBE LOS TALENTOS y el trabajo duro del personal periodístico de periódicos y revistas de todo el mundo. Podrás ver más de 1.200 imágenes que representan la obra de diseñadores, fotógrafos, ilustradores y editores. Estos son los ganadores de la competencia creativa Lo Mejor del Diseño de Noticias™, de la SND, de 2011. En este libro también están los triunfadores de Lo Mejor del Diseño Digital.

Tomó 26 jueces y casi dos semanas determinar los 717 ganadores de impresos de entre las 10.236 piezas enviadas por periódicos y revistas de 39 países.

La SND entregó un premio a Lo Mejor de la Muestra por primera vez en una década, y nombró a cinco como Los Periódicos Mejor Diseñados™ en la 33ª versión de su competencia.

Los jueces reconocieron a Svenska Dagbladet, un diario de Estocolmo, Suecia, con una circulación de 190.000, con el premio Lo Mejor de la Muestra por la cobertura de última hora de los ataques ocurridos en julio de 2011 en Oslo y una isla cercana a la capital noruega, en los cuales murieron 77 personas. Las 16 páginas de noticias "combinan una fotografía sensacional, infográficos apasionantes, una tipografía clara, un ritmo brillante y una arquitectura de página en una pieza de periodismo que responde cada una de las preguntas que un lector se podría hacer", informaron los jueces en su declaración.

"Demuestra lo que los periodistas deberían hacer cuando ocurren noticias, y enseña de qué forma el diseño juega un rol clave", dijo el coordinador de evaluación de la competencia, Josh Crutchmer, del periódico Minneapolis Star Tribune.

Se trata del primer Lo Mejor de la Muestra que se entrega desde que la SND reconoció a The New York Times por su cobertura con infográficos sobre los atentados terroristas del 11 de septiembre de 2001.

Cinco periódicos fueron nombrados Los Periódicos Mejor Diseñados del Mundo™: Excélsior, de Ciudad de México; Frankfurter Allgemeine Sonntagszeitung, de Frankfurt del Meno, Alemania; The Grid, de Toronto, Canadá; el National Post, también de Toronto; y Politiken, de Copenhague, Dinamarca.

Esta premiación marca la quinta vez en que Frankfurter Allgemeine Sonntagszeitung gana Lo Mejor del Mundo, y la cuarta vez desde 2006, la tercera vez para el National Post, el cual fue premiado en 1998 y 2000; y el segundo triunfo para Politiken, dado que había sido reconocido en 2006.

Según los jueces, el hilo común de los ganadores de Lo Mejor del Mundo es "una certeza sobre quiénes son sus lectores y un enfoque audaz y con los pies firmes para llegar a ellos. Cada uno tiene su propia voz, pero todos son excelentes, y comparten un compromiso con lo impreso que otros periódicos deberían imitar. Nunca desperdician una página ni hacen perder el tiempo a sus lectores. Estos periódicos se ven saludables, con una buena planta laboral y con buenos recursos, incluso si no es de verdad así. Fue inspirador ver a periodistas que todavía creen en la excelencia de lo impreso".

En las 19 categorías de la competición, los jueces entregaron seis Medallas de Oro, 39 Medallas de Plata, siete Reconocimientos Especiales de los Jueces (REJ) y 668 Premios de Excelencia.

Los ganadores de las seis Medallas de Oro:

• Bloomberg Businessweek, por su cobertura de la muerte de Steve Jobs.

• Pablo Bernasconi, de La Nación, Buenos Aires, por su portafolio de ilustración.

• The Times of Oman, por un afiche en mosaico compuesto por 28 páginas que celebra Ramadán.

• The Times of Oman, por su tratamiento del diseño en el artículo "De qué forma el secreto socava la reforma de auditoría".

• Svenska Dagbladet, por su cobertura de noticia de última hora de los ataques en Noruega.

• The Washington Post, por su tratamiento no narrativo de un artículo sobre la compra de tabletas.

La competencia, coauspiciada por la SND y la S.I. Newhouse School of Public Communications de Syracuse University, premia la excelencia del diseño de periódicos, las infografías y la fotografía. Los jueces, de todo el mundo, se reunieron en dos etapas en febrero, en Syracuse University, para elegir "lo mejor de lo mejor".

Lo único que no cambia año a año es lo que representan los premios. Cada año, a los jueces se les dan las mismas definiciones de los premios antes de que comiencen la evaluación en Syracuse. Queda a criterio de los jellos decidir cuáles piezas competidoras, si alguna, merece uno de los tres premios. Los jueces también pueden dar un REJ a cualquier ganador para destacarlo en particular.

Premio de Excelencia – Este premio se entrega a trabajos que son realmente excelentes más allá de la destreza técnica o estética. Corresponde que los jueces honren piezas sobresalientes por asuntos tales como tomar riesgos e innovar, aunque no lo logren 100% en todos los aspectos. Se le pide a los jueces que sean exigentes, pero justos.

Medalla de Plata – Este premio se da a trabajos que van más allá de la excelencia. El dominio técnico de la medalla de plata debería expandir los límites del medio. Estas piezas deberían brillar.

Medalla de Oro – Este premio se otorga a trabajos que definen el estado del arte, la vanguardia. Estas piezas deberían expandir los límites de la creatividad y debería ser casi imposible encontrar algo deficiente en ellas. En el pasado se han entregado muy pocas de estas medallas.

DOS PREMIOS ADICIONALES

Dos premios adicionales – Es posible entregar dos honores especiales: el Reconocimiento Especial de los Jueces y Lo Mejor de la Muestra. Estos reconocimientos solo se entregan cuando circunstancias especiales lo ameritan. Reconocimiento Especial de los Jueces Este honor se entrega de parte de un grupo de jueces, o por todos ellos, a piezas sobresalientes en un aspecto en particular que no necesariamente ha sido reconocido por las características del Premio de Excelencia o de las Medallas de Plata o de Oro. Se ha dado este reconocimiento por asuntos tales como el uso de la fotografía, los infográficos o la tipografía a lo largo de una serie de trabajos. Esta serie puede ser un periódico en particular, una sección o más de una, realizado tanto por un individuo como por todo el personal de la redacción.

Lo Mejor de la Muestra – Tal como lo implica su nombre, se trata del mejor de los ganadores de Medallas de Oro. Cualquier intercambio de opiniones sobre este premio ocurre al final de la evaluación de los jueces, quienes tienen la oportunidad de revisar al mismo tiempo todos los ganadores de Oro. Algunos años no se ha entregado, porque para que hacerlo, una pieza debe recibir los votos afirmativos de la mayoría de los jueces.

Toma mucha ayuda lograr que la evaluación de los jueces ocurra:

Coordinador de jueces de la 33ª versión de la competencia: Josh Crutchmer, director de diseño de noticias, Minneapolis Star Tribune

Director auditor de la 33ª versión de la competencia: Shamus Walker, Syracuse University

CAPITANES DE EQUIPO

Melissa Angle, diseñadora, Atlanta Journal-Constitution
Vince Chiaramonte, subeditor de diseño, Buffalo News
Mike Rice, director de diseño, Arizona Daily Star
Dennis Varney, diseñador jefe de deportes, Lexington Herald-Leader

FACILITADORES DE LA 33ª VERSIÓN DE LA COMPETENCIA

Will Alford, jefe de diseño, Atlanta Journal-Constitution
Jonathon Berlin, editor de infografía, Chicago Tribune
Bethany Bickley, diseñadora, Huntsville (Ala.) Times
Rich Boudet, diseñador jefe de deportes, Seattle Times
Audrey Burian, Syracuse University
Chris Carr, director de diseño, Minneapolis Star-Tribune
Steve Dorsey, vicepresidente de investigación y desarrollo, Detroit Media Partnership
Mark Friesen, editor de diseño online, Portland Oregonian
Gayle Grin, ME diseño e infografía, National Post
Lance Johnson, editor, Lo mejor del diseño de noticias, 33ª versión
Stephen Komives, director ejecutivo de la SND
David Kordalski, editor ejecutivo de imágenes, The Plain Dealer
Lily Lu, directora de SND Chinese
James Michalowski, periodista visual freelance
Katherine Myrick, diseñadora, The Washington Post
Tim Parks, subeditor de diseño, Omaha World-Herald
Denise Reagan, editora ejecutiva de imágenes, The Florida Times-Union
Claire Regan, editora ejecutiva, Staten Island Advance
Darren A. Sanefski, profesor asistente, University of Mississippi
Susan Santoro, SND
Rob Schneider, director de diseño, The Dallas Morning News
Colin Smith, líder de diseño, Phoenix Design Studio
Emmet Smith, director de arte, Cleveland Plain Dealer
Lee Steele, editor de diseño, Hearst Connecticut Newspapers
Claudia Strong, Syracuse University
Tippi Thole, directora de arte, The Washington Post
Lila Victoria, diseñadora, Staten Island Advanc
Andrea Zagata, diseñadora de deportes, Detroit News

Lo invitamos a disfrutar de lo mejor del diseño impreso y digital de 2011.

C. Marshall Matlock

C. Marshall Matlock
Director
Lo mejor del Diseño de Noticias y evaluación de los jueces
S.I. Newhouse School of Public Communications

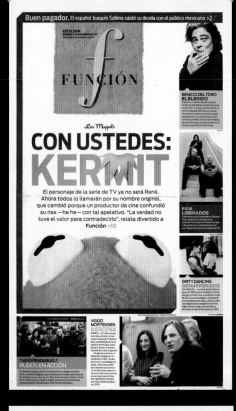
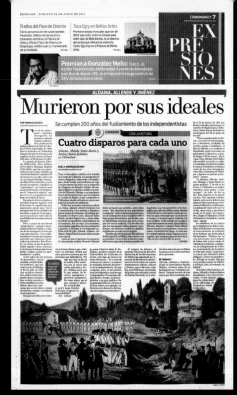
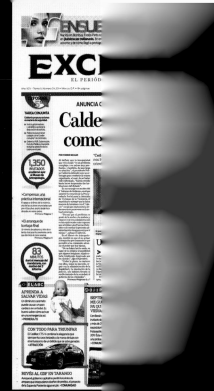

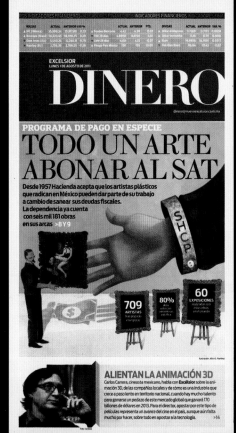

EXCELSIOR
LUNES 1 DE AGOSTO DE 2011

DINERO

dinero@nuevoexcelsior.com.mx

PROGRAMA DE PAGO EN ESPECIE

TODO UN ARTE
ABONAR AL SAT

Desde 1957 Hacienda acepta que los artistas plásticos que radican en México pueden dar parte de su trabajo a cambio de sanear sus deudas fiscales.
La dependencia ya cuenta con seis mil 181 obras en sus arcas >8 Y 9

709 ARTISTAS

80%

60 EXPOSICIONES

ALIENTAN LA ANIMACIÓN 3D

Carlos Carrera, cineasta mexicano, habla con **Excélsior** sobre la animación 3D, de las compañías locales y de cómo es una industria que crece a paso lento en territorio nacional, cuando hay mucho talento para ganarse un pedazo de este mercado global que ganará 170 billones de dólares en 2013. Para el director, apostar por este tipo de películas representa un avance del cine en el país, aunque aún falta mucho por hacer, sobre todo en apostar a la tecnología. >14

Bottom-right page:

POR FABIOLA ÁVILA

The Kennedys

LO QUE
EU NO
QUISO SABER

30 MILLONES de dólares fue el presupuesto de la miniserie que se filmó en Toronto entre junio y septiembre de 2010.

EL PRODUCTOR Y GUIONISTA STEPHEN KRONISH DICE QUE LA UNIÓN AMERICANA NO ESTÁ LISTA PARA VER LA SERIE, PUES NO LE AGRADA DARSE CUENTA QUE, AL FINAL, SUS HÉROES SON DE CARNE Y HUESO

¿DÓNDE VERLA?

EL SEX SYMBOL

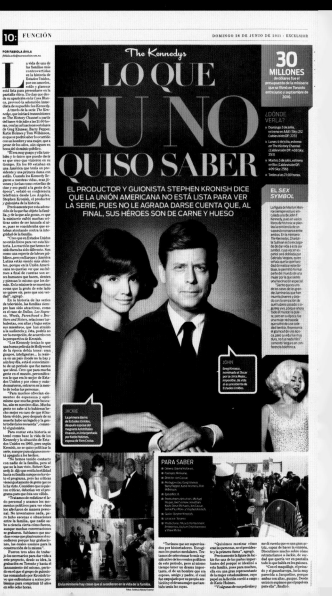

JOHN

JACKIE

PARA SABER

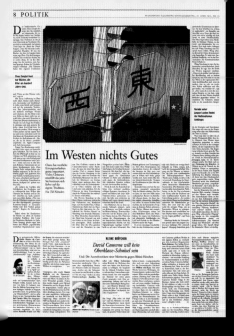

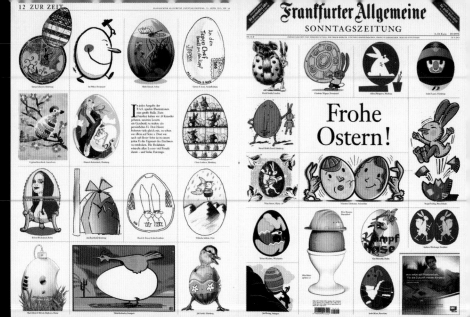

FRANKFURTER ALLGEMEINE SONNTAGSZEITUNG
Frankfurt am Main, Germany
Circulation 300,000

A NATIONAL NEWSPAPER THAT IS INTERNATIONAL IN SCOPE — with readership throughout Germany and around the globe — FAS competes at the highest level. Elegant photography and typography give it an authoritative look that appeals to a discerning readership. Bold photo crops, superb illustrations and near-perfect page production make its inside pages as compelling as its section covers, or even its front page, which is arguably a little busy for a Sunday weekly.

FAS layers its stories, many of them running three or four full columns, with excellent photojournalism, vibrant illustrations and clear, direct information graphics that are laid into the body of the stories, both to provide a visual break and to enhance the elegantly displayed prose. For example, a story about the new gold rush, ushered in by the quadrupling of prices for the precious metal, is told in photos — from panning on the river to the stacking of ingots — along with two simple, effective infographics.

While FAS' classic appearance gives it the look and feel of some of the world's highest-end newspapers, there is nothing stodgy about it. Excellent portrait photography, superb photo editing, brilliantly crafted illustrations, a disciplined use of its signature red and blue color pallet, plus a variety of story forms, command the reader's attention at every page. It also has a sense of humor that engages its audience. An Easter Sunday front page is a composition of submitted Easter drawings, many of them whimsical or irreverent, but all highly entertaining. A full-page series of cartoon sketches depicts the looming bankruptcy of Greece and its cascading impact across Europe (think financial "Armageddon," starring Charlie Chaplin). FAS has been awarded honors regularly from SND, and it shows no signs of slippage.

UN PERIÓDICO NACIONAL DE ALCANCE MUNDIAL, FAS tiene lectores tanto en toda Alemania como a través del mundo, y compite al nivel más alto con una fotografía y una tipografía de elegancia que le da un aspecto de autoridad, lo que atrae a los lectores más exigentes. Recortes de foto audaces, magníficas ilustraciones y una producción de página casi perfecta hacen que las páginas interiores sean tan irresistibles como las portadillas de sección o incluso la primera página -que se podría decir que es algo atiborrada de más para ser de un periódico dominical.

Los artículos de FAS tienen un enfoque estratificado y muchos de ellos están desplegados en tres o cuatro columnas completas. Su fotoperiodismo es excelente, las ilustraciones son vibrantes y los infográficos son claros y directos, y están diagramados dentro del cuerpo de los textos tanto para dar una pausa visual como para hacer resaltar la prosa elegantemente expuesta. Por ejemplo, un artículo sobre una nueva fiebre del oro producto de la cuadruplicación de los precios del metal precioso se relata con fotos que van desde el lavado de oro en un río hasta el apilamiento de lingotes, junto a dos sencillos y claros infográficos.

Aunque la clásica apariencia de FAS le da el look y la sensación de ser uno de los periódicos de lujo del mundo, no lo hace verse nada de pesado o aburrido. Los excelentes retratos, la magnífica edición fotográfica, las geniales ilustraciones, el disciplinado uso de su paleta distintiva roja y azul, sumado a una variedad de formatos de relato, obligan a los visitantes a prestarle atención a cada una de las páginas. También tiene un sentido del humor y un compromiso con los lectores. La portada de Pascua de Resurrección es una composición de dibujos sobre la Pascua enviados por lectores, algunos de ellos juguetones o irreverentes, pero muy divertidos. Una serie de bosquejos de caricaturas en una página completa muestra la quiebra en ciernes de Grecia y su efecto en cascada a través de Europa... un fin del mundo financiero protagonizado por Chaplin. FAS ha sido premiado muchas veces por la SND, pero nunca ha dado

Was brauche ich?

Mehr Reisen, mehr Theater, schöner wohnen – das Leben über das ist nicht billig. Zum Glück fallen nach der Pensionierung auch viele Ausgaben weg: Die Kredite aufs Haus sind abbezahlt, die Kinder stehen auf eigenen Beinen. Und weil es im Alltag jetzt locker zugeht, hält auch der Anzug länger.
Von Dyrk Scherff

Was habe ich?

Nach Jahrzehnten des Sparens steht nun der Kassensturz an: Wie viel Geld steht zur Verfügung? Wie soll es angelegt werden, damit das Vermögen möglichst lange hält? Eines ist klar: Nur von den Zinsen zu leben, schafft kaum einer. Man muss auch an die Substanz gehen.
Von Volker Looman

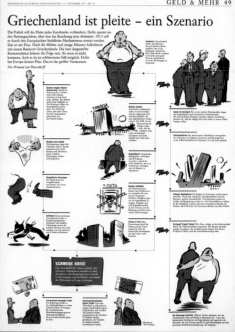

Griechenland ist pleite – ein Szenario

Ein Teilchen für unser Weltbild

Irgendwo zwischen 115 und 145 GeV

Dieser hat viele Väter: Eine kurze Geschichte des Higgs-Bosons

Frankfurter Allgemeine
SONNTAGSZEITUNG

Mieten oder kaufen? Was sich mehr lohnt	Joel und Ethan Coen Western für die Berlinale	Bundesliga	Ronald Reagan Der Retter des Kapitalismus

Kommt Mubarak nach Deutschland?

Spitze der ägyptischen Regierungspartei tritt zurück. Weitere Proteste

Ein Ritual aus alter Zeit

Beschneidung von Jungen weit verbreitet

Merkel: Übergang in Kairo braucht Zeit

Zweifel an Emissionswerten

FDP will mehr Polizisten

Alte Damen

Das Rätsel der großen Klappe

Das Markenzeichen des Tukans ist sein Schnabel. Er kommt damit zurecht. Doch warum hat ihn die Natur überhaupt so verschwenderisch ausgestattet? *Von Georg Rüschemeyer*

Ein goldenes Händchen

John Gould war als Illustrator so genial wie als Geschäftsmann

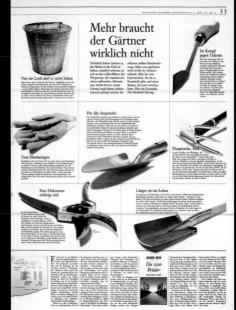

Barbies bestes Stück ist zurück

Von Jörg Thomann

Tanz der Sockenpuppen

Mehr braucht der Gärtner wirklich nicht

Nur ein Loch darf nicht sein

Für alle Ansprüche

Zum Handanlegen

Eine Diskussion erübrigt sich

Länger als ein Leben

Im Kampf gegen Unkraut

Hauptsache, Stiel

Sport

„Wir brauchen mehr Geld"

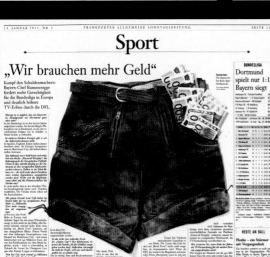

SITZEN

RASEN

SPIELEN

Frankfurter Allgemeine

Surreale Dinge

25 Jahre Schirn Kunsthalle Frankfurt

Gefühle, Träume, Gegenwelten

Die Ausstellung „Surreale Dinge. Skulpturen und Objekte von Dalí bis Man Ray" in der Frankfurter Schirn Kunsthalle versammelt 180 Werke von 51 Künstlern.

Von Michael Hierbolzer

Alexander Calder, Buste with amaret Mölon of green Stiel

Hans Bellmer, La demi-poupée (Die halbe Puppe), 1971

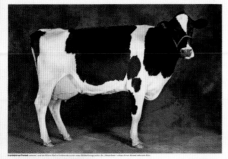

Manche Kühe machen Mühe

Das moderne Rindvieh hat nicht mehr viel mit seinen Vorfahren gemein.
Nur noch eine Handvoll Rassen hat es um 20. Jahrhundert geschafft.
Um den Rest kämpfen Freunde traditioneller Nutztiere. Von *Richard Friebe*

Goldautomat: Kleine Barres gegen Bares — *Standardbarren: Die Bundesbank lagert ihr Gold in London und New York* — *Goldkörner: Auch Uhren und Schmuck werden teurer*

Gold schrumpft Hirn – ein Volk im Rausch

Von
Hendrik Ankenbrand, Dyrk Scherff und Sascha Schimmel

So kommt das Gold aus der Mine zum Kunden

Der Goldpreis

THE GRID

Toronto, Ont., Canada

Circulation **120,000**

"GOOD SHIT IS HAPPENING — lots and lots and lots of it." So say the editors of The Grid in their mission statement about Toronto. And so says the jury about The Grid itself. The more time you spend with this guerrilla guide, the more "good shit" you find. The engaged writing, smart editing and heavy research are done in a young, sophisticated voice, all of it executed with a sense of great fun. The design is minimalist and the fonts — Tiempo for body copy and Fakt for logo face and display fonts — are cool, restrained and exclusive.

The many tiny, informative graphic details throughout the pages make this publication a different visual experience. It must be extremely time-consuming to produce these pages, but the end result pays off for the reader. Specific keywords are highlighted with yellow. Small locator maps show where to find a spot mentioned in the content. On one page, a visual guide on how to dress "Dad-rock" style is supplemented with the ruthless caption, "Facial hair is not necessary, but always appreciated." Hand-drawn portraits accompany bylines. All these details could make the paper a mess, but its overall look is perfectly consistent and clean.

The Grid surprises with sparse but great inside photography on full spreads. Our favorite was the fantastic photo of a line at a hotdog stand. Carried on through four straight pages, the photo is a wonderful surprise for the reader.

This publication really catches you and does not let you go. Any self-respecting big city should get a "good shit" guerrilla guide like this. Right now.

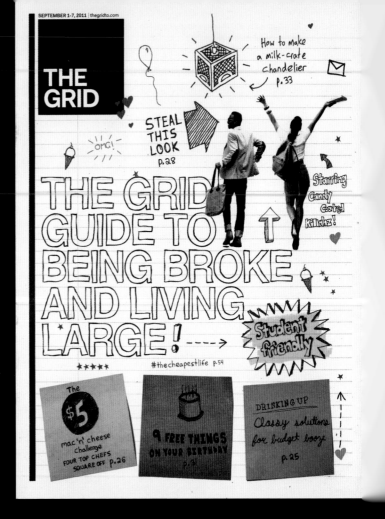

"ALGO MUY BUENO ESTÁ PASANDO – y hay mucho, mucho de eso", dicen los editores de The Grid en la declaración de su misión sobre Toronto. Lo mismo dice el jurado sobre el propio The Grid.

Mientras más rato se pasa con esta guía de guerrilla, más de eso tan bueno aparece. La redacción comprometida, la edición inteligente y la fuerte investigación tienen una voz sofisticada y joven, y todo se lleva a cabo mientras ciertamente se pasa muy bien. El diseño es minimalista y las fuentes tipográficas son exclusivas, sobrias y cool: Tiempo para el texto, y Fakt para el logo y las display.

Los numerosos, pequeños e informativos detalles a lo largo de las páginas hacen que este periódico sea una experiencia visual diferente. Debe tomar mucho tiempo producir estas páginas, pero funcionan bien para el lector. Los términos específicos están marcados con amarillo. Se usan pequeños mapas para localizar lugares mencionados en el contenido. En una página, una guía visual para saber cómo vestirse como "abuelo del rock" está suplementada con una rudo pie (lectura) de fotografía que dice: "No se necesita vello facial, pero siempre viene bien". Retratos dibujados a mano acompañan los nombres de los periodistas. Todos esos detalles podrían hacer que el diario sea un desastre, pero no lo es para nada. La apariencia general es de verdad consistente y limpia.

The Grid sorprende con fotografías escasas pero geniales en las páginas interiores o las páginas dobles. La que más nos gustó fue una fantástica de una fila ante un local de venta de hot dogs: La foto continúa a lo largo de cuatro páginas seguidas. Eso es una sorpresa maravillosa para el lector.

Este periódico realmente atrapa al lector y no permite que uno se aleje. Cualquiera ciudad que se respete a sí misma debería contar con una guía de guerrilla de las rosa

The Grid — Toronto, Ont., Canada

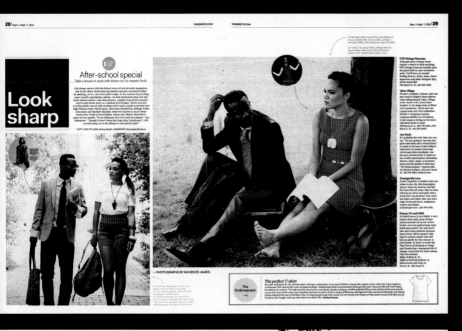

Look sharp

After-school special

Take a lesson in style with these not-so-square finds.

← PHOTOGRAPHS BY McKENZIE JAMES

The perfect T-shirt

Sarah Liss →
Limp tricks: Why is it so hard to write good songs about sex?

Judge this book by its cover

Toronto graphic designer Bill Douglas is responsible for dreaming up over 1,000 eye-catching book covers for iconic Canadian authors like Margaret Atwood and Mark Kingwell. To gain some insight into his craft, we asked Douglas to print out some of the details on one of his favourite covers, One Bird's Choice, which is Iain Reid's memoir about moving back to the farm with his eccentric parents. BY ROD DUFFY

ONE BIRD'S CHOICE

IAIN REID

That's the spirit!

21 WINTER-PROOF COCKTAILS THAT'LL BOOST YOUR GLEE FACTOR THIS HOLIDAY SEASON

Whether you're celebrating the season with friends or trying to forget what happened to the world economy in 2011, the holidays are the perfect time to drink. Here are our most highly recommended cocktail concoctions—ranging from cozy and Christmassy to brazenly boozy—courtesy of the city's top bar-tistes.

BY CHRISTINE SISMONDO

photographs by Helen Yousif

D/ the list

The Grid recommends

FELA! The musical

Fela Kuti was the massively influential Nigerian bandleader who invented Afrobeat and created what many consider the most perfect musical expression of political and social consciousness—mainly due to the fact that it's nearly impossible not to shake your ass off to Fela's grooves. But this will all become perfectly clear to anyone who checks out the Tony Award–winning musical about his life, at the Canon Theatre until Nov. 6.

New on Blu-ray/DVD

On-demand Highlights

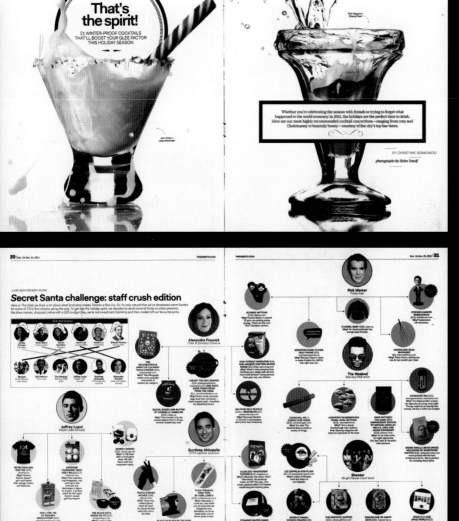

Secret Santa challenge: staff crush edition

Here at The Grid, we think a lot about what (and who) makes Toronto a fine city. So it's only natural that we've developed massive crushes for some of T.O.'s fine citizens along the way. To get into the holiday spirit, we decided to send some of these crushes presents. We drew names, shopped online with a $25 budget (hey, we're not investment bankers) and then mailed off our favourite picks.

Who let the dogs out?

The humble frankfurter has been given a makeover worthy of a chick-flick montage: flatbread buns, pork crackling, wasabi mayo. Welcome to the era of the $13 hot dog. BY KARON LIU

Crumbs

Plating up the week's restaurant news.

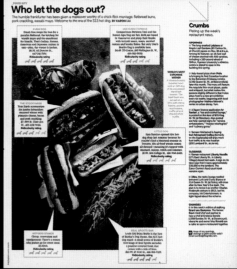

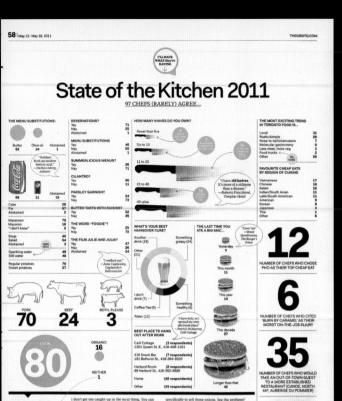

State of the Kitchen 2011

97 CHEFS (RARELY) AGREE...

THE MENU SUBSTITUTIONS:

Butter 62 / Olive oil 34 / Abstained 4

*"Neither! Both are excrete battery acid."
—Norbert Jobrey, Aslanic*

Coca-Cola: 68 / 11 / Abstained 18

Cake / Pie 67 / Abstained 2

Macaroon 79 / Macaron 10 / "I don't know" 2

Soup 40 / Salad 54 / Abstained 1 / *right now!*

Sparkling water 49 / Still water 48

Regular potatoes 70 / Sweet potatoes 27

PORK 70 BEEF 24 BOTH, PLEASE 3

LOCAL **80**

ORGANIC 16

NEITHER 1

RESERVATIONS?
Yay 71 / Nay 25 / Abstained 1

MENU SUBSTITUTIONS:
Yay 46 / Nay 50 / Abstained 1

SUMMERLICIOUS MENUS?
Yay 26 / Nay 71

CILANTRO?
Yay 86 / Nay 11

PARSLEY GARNISH?
Yay 24 / Nay 73

BUTTER TARTS WITH RAISINS?
Yay 52 / Nay 45

THE WORD "FOODIE"?
Yay 19 / Nay 72

THE FILM JULIE AND JULIA?
Yay 47 / Nay 26 / Abstained 24

*"I walked out."
—Zane Caplansky, Caplansky's Delicatessen*

HOW MANY KNIVES DO YOU OWN?
Fewer than five / Six to 10 / 11 to 20 / 21 to 40 / 40-plus

*"I have 155 knives. It's more of a sickness than a disease."
—Roberto Fracchioni, Templar Hotel*

WHAT'S YOUR BEST HANGOVER CURE?
Something greasy (24) / Another drink (19) / Other (21) / I don't drink (7) / Coffee/Tea (6) / Water (12) / Something healthy (8)

*"I have kids, so I opened my own afterwork place"
—Patrick McInerney, Cetli Cottage*

BEST PLACE TO HANG OUT AFTER WORK
Cetli Cottage (3 respondents) 1301 Queen St. E., 416-406-1301
416 Snack Bar (7 respondents) 181 Bathurst St., 416-364-9320
Harbord Room (2 respondents) 89 Harbord St., 416-962-8989
Home (42 respondents)
Other (43 respondents)

THE LAST TIME YOU ATE A BIG MAC.
*"I love 'em"
—David Neinkrasher, The Burger's Priest*
Yesterday 3 / This month 11 / This year 14 / This decade 27 / Longer than that 42

THE MOST EXCITING TREND IN TORONTO FOOD IS...
Local 31 / Rustic/simple 28 / Nose-to-tail/charcuterie 7 / Molecular gastronomy 6 / Less meat, more veg 1 / Food trucks 2 / Other 20

FAVOURITE CHEAP EATS BY REGION OF CUISINE
Vietnamese 17 / Chinese 16 / Italian 12 / Indian/South Asian 11 / Latin/South American 11 / American 3 / Korean 2 / Japanese 1 / Thai 1 / Other 8

12 NUMBER OF CHEFS WHO CHOSE PHO AS THEIR TOP CHEAP EAT

6 NUMBER OF CHEFS WHO CITED 'BURN BY CARAMEL' AS THEIR WORST ON-THE-JOB INJURY

35 NUMBER OF CHEFS WHO WOULD TAKE AN OUT-OF-TOWN GUEST TO A MORE ESTABLISHED RESTAURANT (CANOE, NORTH 44°, AUBERGE DU POMMIER)

32 NUMBER OF CHEFS WHO WOULD TAKE AN OUT-OF-TOWN GUEST TO A NEWISH RESTAURANT (BLACK HOOF, MARBEN, BUCA)

I'll eat what I like, thanks

Secret Pickle Supper Club's Matt Kantor tells us why he rarely worries about local or organic—so long as it's tasty

I don't get too caught up in the local thing. You can buy something that's grown in Ontario, but it might not be grown in good dirt. Or worse, it could be grown in a greenhouse without soil—or much flavour. Same goes for organic. It's hard to tell what you've really getting. Nobody likes eating pesticides, and organic helps with that, but even a crop that's raised locally and organically can get screwed up as soon as it leaves the farm.

Consider this: If you have a small pickup truck filled with a couple baskets of onions versus a plane carrying 80 cases, which one is worse for the environment? Now consider that the plane was probably heading here anyway, but the truck is making the trip into the city specifically to sell those onions. See the problem?

There are occasions when local is better. Corn is a great example because the longer it takes to get somewhere, the more its flavour degrades. The best-tasting corn comes right off the stalk and you get it the same day or the day after. But it's about understanding what the options are and not assuming that because it's local, it's good. The question is, "What's more important to the diner?" Is it a reduction in carbon footprint or getting something that tastes better? Depending on the cost and the time of year, the answer may differ or the difference may be negligible. At the end of the day, I'm going to give my diners the best of what's available.

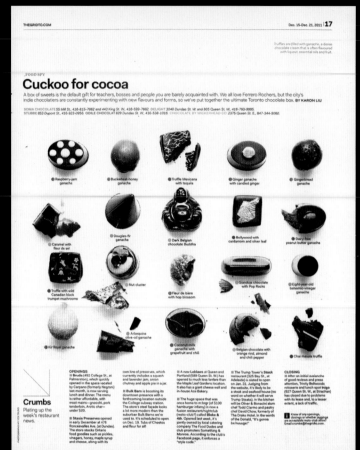

Truffles are filled with ganache, a dense chocolate cream that is often flavoured with liquout, essential oils and fruit.

.FOOD SPY
Cuckoo for cocoa

A box of sweets is the default gift for teachers, bosses and people you are barely acquainted with. We all love Ferrero Rochers, but the city's indie chocolatiers are constantly experimenting with new flavours and forms, so we've put together the ultimate Toronto chocolate box. BY KARON LIU

SOMA CHOCOLATE 55 Mill St., 416-815-7662 and 443 King St. W., 416-599-7662. DELIGHT 3040 Dundas St. W. and 805 Queen St. W., 416-760-9995. STUBBE 653 Dupont St., 416-923-0956. ODILE CHOCOLAT 829 Dundas St. W., 416-538-1016. CHOCOLATE BY WICKERHEAD CO 2375 Queen St. E., 647-344-3080.

Raspberry-jam ganache / Buckwheat-honey ganache / Truffle Mexicana with tequila / Ginger ganache with candied ginger / Gingerbread ganache
Caramel with fleur de sel / Douglas-fir ganache / Dark Belgian chocolate Buddha / Bollywood with cardamom and silver leaf / Dairy-free peanut butter ganache
Truffle with wild Canadian black trumpet mushrooms / Nut cluster / Fleur de bière with hop blossom / Grandeus chocolate ganache with Pop Rocks / Eight-year-old balsamic-vinegar ganache
Kir Royal ganache / Arbequina olive-oil ganache / Coconut-milk ganache with grapefruit and chili / Belgian chocolate with orange rind, almond and chili pepper / Chai masala truffle

OPENINGS
■ Bruda (492 College St., at Palmerston), which quickly opened in the space vacated by Carpano (formerly Negroni) last month, is now serving lunch and dinner. The menu is rather affordable, with most mains—gnocchi, pork tenderloin, Arctic char—under $20.
■ Stasis Preserves opened in early December at 476 Roncesvalles Ave. (at Dundas). The store stocks Ontario food goodies such as pickles, vinegars, honey, maple syrup and cheese, along with its own line of preserves, which currently includes a squash and lavender jam, onion chutney and apple pie in a jar.
■ Bulk Barn is boosting its downtown presence with a forthcoming location outside the College subway station. The store's steel facade looks a lot more modern than the suburban Bulk Barns we're used to. It's scheduled to open on Dec. 19. Tubs of Cheetos and flour for all!
■ A new Loblaws at Queen and Portland (589 Queen St. W.) has opened to much less fanfare than the Maple Leaf Gardens location. It also has a giant cheese wall and in-house Ace Bakery.
■ The huge space that was once home to m:brgr (of $100 hamburger infamy) is now a fusion restaurant/nightclub (resto-club?) called Bloke & 4th. Opened last week, it's owned by local catering company The Food Dudes and club promoters Something & Monroe. According to the club's Facebook page, it enforces a "style code."
■ The Trump Tower's Stock restaurant (325 Bay St., at Adelaide) is slated to open on Jan. 31. Judging from the website, it's likely to be a steak and seafood house (no word on whether it will serve Trump Steaks). In the kitchen will be Oliver & Bonacini alum chef Todd Clarmo and pastry chef David Chow, formerly of The Drake Hotel. In the words of the Donald, "It's gonna be huuuge!"

CLOSING
■ After an initial avalanche of good reviews and press attention, Trinity Bellwoods rotisserie and lunch spot Image (927 Queen St. W., at Strachan) has closed due to problems with its lease and, to a lesser extent, a lack of traffic.

i Know of any openings, closings or whether jeggings are acceptable resto-club attire? Email crumbs@thegrid.com.

Crumbs
Plating up the week's restaurant news.

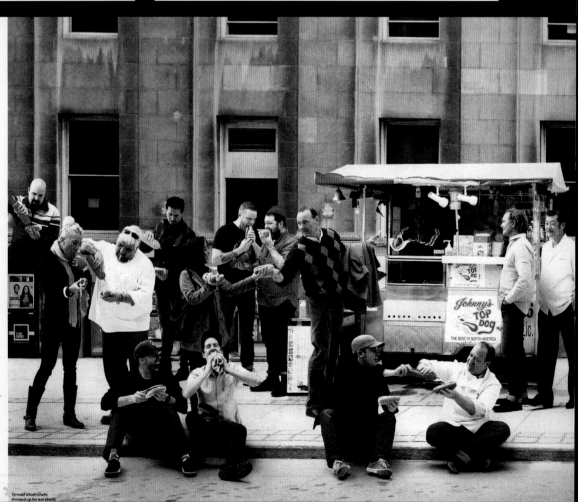

I'LL HAVE WHAT *they're* HAVING

A Chef's Guide to Toronto

We love food. We love chefs. So when we set about planning an eater's guide to the city, we went to the source. Ninety-seven of Toronto's top tastemakers were consulted to create the following nowhere-near-definitive list of the city's greasiest dives, fattiest thrills, enlightened takeout options and most decadent food pleasures. Along the way, the chefs dished on the restaurants they take their friends to, the culinary gods they think are dropping the maddest food science (it's no secret; they're at The Black Hoof), their favourite ingredients and the ones that can go fly a kite. So before you decide what you're going to eat tonight—or any night this year—read on.

By Karon Liu, Jacob Rutka and David Sax

Photograph by Mark Zibert

To read which chefs showed up for our shoot...

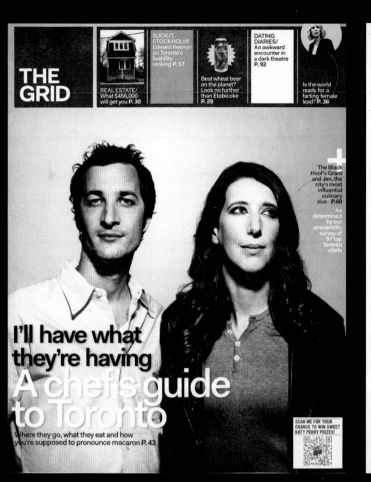

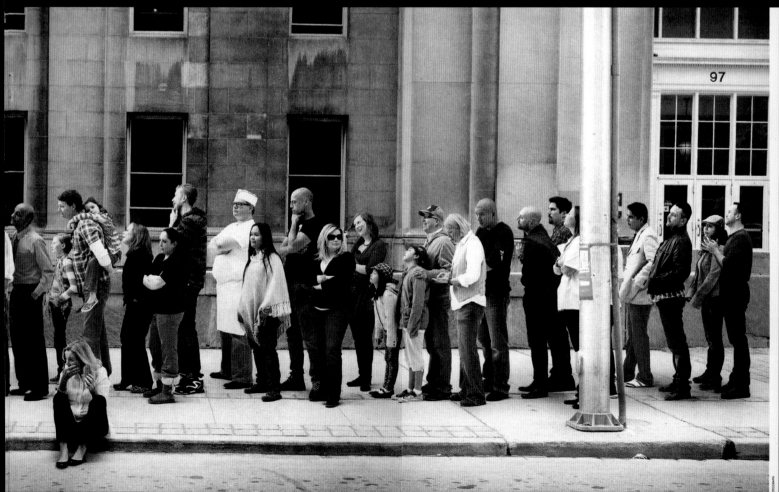

CANADA

NATIONAL POST, SATURDAY, JULY 2, 2011

CANADA

66 The insurgents have very strong intelligence. They know who is working for whom. Believe me, sir, I am scared to come here. Maybe they will come to get me. Everyone knows I am the malik of Salavat. — *Mussa Kalim*, the village's appointed leader

66 The Taliban approached them and threatened to cut off their noses. They are taking their school bags and burning their school books. One of the kids is really scared, but his father says it's OK, he should still come to school. — *Bilal Ahmad*, recruited to teach at school

THE LONG ROAD

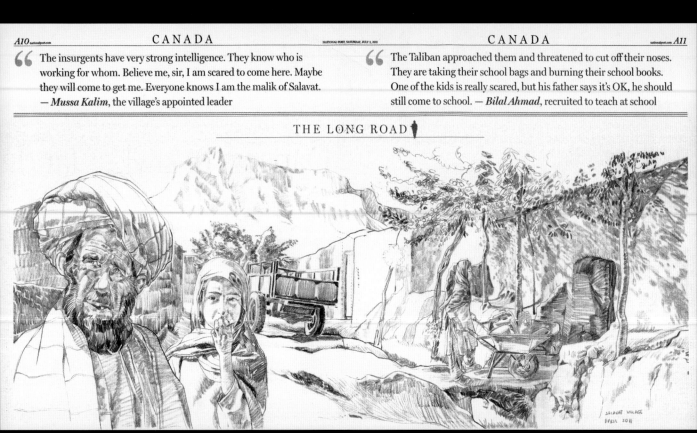

NATIONAL POST
Toronto, Ont., Canada
Circulation 168,000

THE NATIONAL POST LURES ITS READERS WITH A SULTRY BEAUTY, and then captivates them with an authoritative attitude that makes this Canadian daily a must-read. This newspaper — always elegant, always powerful — stands out as a World's Best this year for its excellence in, and devotion to, true visual storytelling. The Post utilizes every visual tool to perfection, from its dramatic use of illustration — even on its front page — to its combinations of photos, graphics and text to explain stories like the tsunami in Japan.

The base structure of the Post is well defined and delivers a stunning, unique look that begins with the vertical nameplate on Page 1 and continues with the horizontal "workspace" at the top of each inside page. This space's diversity — with the bold use of horizontal images, breakout information and strong quotes — adds a dynamic start to every page. The exacting commitment to design is admirable, and the attention to detail throughout the publication is impressive. Even the sports agate is lovingly designed and well executed. No detail is left to chance, and the Post's "voice" is evident on every page. Finally, and most important, the content itself defines this publication. The "How We Die" package, complete with a two-page information graphic, is brilliant. The Financial Post section continues to be outstanding, and the Weekend Post section is packed with elegant visual treats. This is a paper that knows when to whisper and when to shout. It chooses its words, pictures, graphics and illustrations with care. It knows its mission, and delivers it each day ... with style.

THE NATIONAL POST ATRAE A SUS LECTORES CON UNA SENSUAL BELLEZA y luego los cautiva con una actitud de autoridad que hace de este diario canadiense un *must* informativo.

Este periódico, siempre elegante y potente, se destaca este año como uno de los mejor diseñados del mundo por su excelencia y devoción a la real narración visual. Desde su dramático uso de la ilustración –incluso en la primera página– a sus combinaciones de fotos, gráficos y textos para explicar temas como el tsunami en Japón, el Post utiliza a la perfección todas las herramientas visuales.

La estructura de base del diario está bien definida y presenta una apariencia despampanante y única que comienza con la cabecera vertical en la primera página y continúa con el espacio noticioso horizontal en la parte de arriba de cada página interior. La diversidad de este espacio –con el audaz uso de imágenes horizontales, recuadros informativos y citas destacadas–, le da un inicio dinámico a cada página.

El exigente compromiso con el diseño es admirable y el cuidado a los detalles a lo largo del periódico es impresionante. Incluso la tipografía Agate de la sección deportiva está diseñada con cariño y realizada a la perfección. No se descuida ningún detalle, con lo que la "voz" del Post es evidente en cada página.

Finalmente, y lo más importante, este periódico está definido por el contenido. El paquete informativo "Cómo morimos", que incluye una infografía de dos páginas, es fenomenal. La sección financiera sigue siendo excepcional, y la de fin de semana está llena de detalles visuales elegantes.

Este es un diario que sabe cuándo susurrar y cuándo gritar. Elige sus palabras, fotos, gráficos e ilustraciones con esmero. Conoce su misión y la cumple cada día... siempre con estilo.

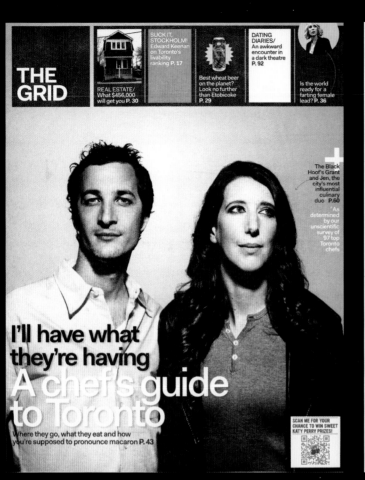

THE GRID

REAL ESTATE/ What $456,000 will get you P. 30

SUCK IT, STOCKHOLM! Edward Keenan on Toronto's livability ranking P. 17

Best wheat beer on the planet? Look no further than Etobicoke P. 29

DATING DIARIES/ An awkward encounter in a dark theatre P. 92

Is the world ready for a farting female lead? P. 36

The Black Hoof's Grant and Jen, the city's most influential culinary duo P.60

As determined by our unscientific survey of 97 top Toronto chefs

I'll have what they're having
A chef's guide to Toronto

Where they go, what they eat and how you're supposed to pronounce macaron P. 43

SCAN ME FOR YOUR CHANCE TO WIN SWEET KATY PERRY PRIZES!

I'LL HAVE WHAT THEY'RE HAVING

27 Perfect Orders

THE GRID ASKED TORONTO CHEFS WHAT THEY EAT WHEN THEY'RE NOT COOKING FOR US. CALL IT A LOW FOOD MANIFESTO: IT'S GOTTA BE TASTY, IT OUGHTA BE CHEAP, AND BEST OF ALL, IT'S PROBABLY AVAILABLE WHENEVER HUNGER STRIKES—ESPECIALLY IF THAT'S AT 1 A.M. AFTER THE DINERS HAVE ALL GONE HOME.

THE PORK AND DILL DUMPLINGS AT MOTHER'S DUMPLINGS
$6.10 for 12 dumplings
421 Spadina Ave., 416-217-2008
"I first went when they were located on Huron Street. The staff recommended the pork and dill dumplings, and they've been my favorite ever since. I once asked the chef how they were made and she took me to the kitchen and let me help. On the way home I stopped at a Chinatown grocery store and picked up the ingredients to make them again for dinner."
—Scott Vivian, Beast

THE PULLED PORK SAMMY AT THE STOCKYARDS
$6, 699 St. Clair St. W.
416-658-9666
—Mark Cutrara, Cowbell

THE NACHOS AT SNEAKY DEE'S
$7.75 (toppings extra).
431 College St., 416-603-3090
"My order is always the same: guacamole, jalapenos and black beans, baked on. It's a classic. I used to come here when I was a cook. Now my staff comes here after service on Saturdays. It's like a passing of generations."
—Ted Corrado, C5

MA-PO TOFU WITH MINCED MEAT, PEPPER AND HOT SAUCE AT YUEH TUNG
$6.99, 126 Elizabeth St.,
416-977-0853
—Markus Bestig, O&B Café Grill

THE KIMCHEE STIRFRY AT OWL OF MINERVA
$9.20, 700 Bloor St. W.
416-538-3030
"Thinly-sliced pork belly sautéed with kimchee'd zucchini and served on a sizzling platter with rice. It's spicy, smoky, a little sweet and fatty. Best of all, you can get it with a combo where, for an extra $6, you get six beers."
—David Haman, Woodlot

DIM SUM AT ROL SAN
323 Spadina Ave., 416-977-1128
—Thomas Davis, The Stockyards

THE KAMIKAZE ROLL AT SUSHI MARCHÉ
$7 for five pieces, 1105 Queen St. E.,
416-463-0114
"It looks like a normal roll, but inside is battered and fried soft-shell crab, and they serve it with this wasabi cream. The texture is just so fresh—every time it's just gorgeous. Since the place is just a few doors away from my restaurant, the owners just tap on the window to see if I want more. I've only been in Leslieville a few years but I would say I've had about 60 orders between my fiancé and me."
—Brad Clark, Fare Bistro

Those tiny donuts at Little Nicky's Coffee
$4 per dozen, 375 Queen St. W.,
416-260-0500
—Aidan Pascoe, Liberty Belle Bistro

"There's a corner booth that I usually sit in that faces the bar where the donut machine is. I'll come here once a week when I have the day off and have a coffee or two and a basket of donuts. They're perfectly sized for dipping with the right amount of doughy-ness to absorb the coffee but still hold their shape."

THE NAAN AT CURRY TWIST
$2.45, 3034 Dundas St. W.
416-769-9460
"The tandoor oven is right there in the open kitchen and they make the naan to order, which is how it should be. You can watch them shape it, press it against the side of the oven and then use a big stick to pull it out. It really is the best. Fluffy, warm and comforting. It's like some sort of magic melting in my mouth."
—Donna Dooher, Mildred's Temple Kitchen

THE SALTED COD AT BAIRRADA CHURRASQUEIRA
$11.50, 1000 College St.,
416-539-8239
—Chris McDonald, Cava

THE TRIPE SOUP AT CAFÉ POLONEZ
$5.75, 195 Roncesvalles Ave.,
416-532-8432
"I'm the son of a butcher. My grandfather was a butcher. I like tripe and all the offal cuts. The tripe soup at this place is earthy and warming. For people that haven't had tripe, I always describe the taste so if you were to lick the forehead of a cow—it's very bovine. You either love it or you don't."
—Andrew Carter, The Queen & Beaver

DISCOUNTED END-OF-DAY HOT COUNTER ITEMS AT T&T GROCERY STORE
222 Cherry St., 416-463-8113
—Ed Ho, Globe Bistro and Globe Earth

10 foods chefs hate...

1. **FIDDLEHEADS**
Kanida Chey, former sous chef at Flow Lounge

2. **EGGPLANT**
Michael Bonacini, O&B

3. **BROCCOLINI**
"It's a retarded vegetable." Jeremy Gash, Bravi Ristorante

4. **QUAIL**
David Lee, Nota Bene

5. **MELONS**
Mark Cutrara, Cowbell

6. **BRAINS**
"The potential for Mad Cow scares me."
Joel McDonald, Fanny Chadwicks

7. **SAGE**
Lorenzo Loseto, George

8. **FENNEL**
Jenna Sweetcakes

9. **TARRAGON**
Jeff Glowacki, Auld Spot Pub

10. **GREEN PEPPERS**
"Green peppers can go fly a kite."
Matty Matheson, Parts & Labour

THE YUMMY PORK BONE AT THUMBS UP KOREAN BBQ
57, 615 Bloor St. W., 416-536-4106
"These guys are known for their pork bone soup and their japchae, but a few years ago they came up with this new thing called 'yummy pork bone.' Basically, they take the pork bones and, instead of braising them in a broth, they do it in a sugary, spicy sauce and serve it with rice. It's sweet and glazed and sticky. I've tried to hook it up in Korean cookbooks but I've never found it."
—Filippo Mascaua, Jump

PHO WITH TRIPE AT MI MI VIETNAMESE
$8.50, 688 Gerrard St. E.,
416-778-5948
"I like to split a bird's eye chili in half, and put one half in the broth and then nibble on the other as I'm eating my noodles. That way, the

The Geddy at Caplansky's Delicatessen
356 College St., 416-500-3852
—Matt Kantor, Secret Pickle supper club

WHAT ZANE CAPLANSKY SAYS:
"It's actually what Geddy Lee orders when he comes into the restaurant. He once told me that his father used to make a variation on another dish we have called the Leo, a classic deli breakfast of lox, eggs and onions. Geddy's father made his with salami. When I redid the menu back in September, under 'The Geddy' I put 'Closer to the Heart'! You Betcha'. Geddy wanted me to put 'Closer to the Heart Attack.' I just wasn't prepared to have that on my menu."

HOW TO EAT A POGO STICK
According to Colborne Lane and Origin's Claudio Aprile, who was introduced to the corn-battered hot dog by his son:
"I like to put them in a pan so they get crispy. I don't do the Dijon thing. I go full-on trailer park with white-trash yellow mustard. Full ghetto."

Amazing threesomes continued

Cucumber + avocado + lime
Tawfik Shehata, The Ballroom

Sun-dried tomato pesto + bucatini + basil
Lora Kirk, Ruby Watchco

Roasted beets + goat cheese + walnuts
Kym Stein, One

Porcini mushrooms + wild asparagus + parmesan
Grant van Gameren, Black Hoof

Halibut + rapini + garlic
Andrea Nicholson, Great Cooks on Eight

Baked sliced fontina + shaved garlic + white wine
Linda Haynes, Ace Bakery

Melon + feta + toasted pumpkin seeds
Scott Vivian, Beast

97

> The insurgents have very strong intelligence. They know who is working for whom. Believe me, sir, I am scared to come here. Maybe they will come to get me. Everyone knows I am the malik of Salavat.
> — *Mussa Kalim*, the village's appointed leader

> The Taliban approached them and threatened to cut off their noses. They are taking their school bags and burning their school books. One of the kids is really scared, but his father says it's OK, he should still come to school. — *Bilal Ahmad*, recruited to teach at school

THE LONG ROAD

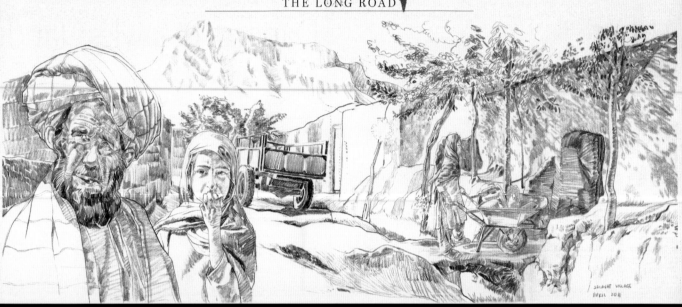

NATIONAL POST
Toronto, Ont., Canada
Circulation 168,000

THE NATIONAL POST LURES ITS READERS WITH A SULTRY BEAUTY, and then captivates them with an authoritative attitude that makes this Canadian daily a must-read. This newspaper — always elegant, always powerful — stands out as a World's Best this year for its excellence in, and devotion to, true visual storytelling. The Post utilizes every visual tool to perfection, from its dramatic use of illustration — even on its front page — to its combinations of photos, graphics and text to explain stories like the tsunami in Japan.

The base structure of the Post is well defined and delivers a stunning, unique look that begins with the vertical nameplate on Page 1 and continues with the horizontal "workspace" at the top of each inside page. This space's diversity — with the bold use of horizontal images, breakout information and strong quotes — adds a dynamic start to every page. The exacting commitment to design is admirable, and the attention to detail throughout the publication is impressive. Even the sports agate is lovingly designed and well executed. No detail is left to chance, and the Post's "voice" is evident on every page. Finally, and most important, the content itself defines this publication. The "How We Die" package, complete with a two-page information graphic, is brilliant. The Financial Post section continues to be outstanding, and the Weekend Post section is packed with elegant visual treats. This is a paper that

THE NATIONAL POST ATRAE A SUS LECTORES CON UNA SENSUAL BELLEZA y luego los cautiva con una actitud de autoridad que hace de este diario canadiense un *must* informativo.

Este periódico, siempre elegante y potente, se destaca este año como uno de los mejor diseñados del mundo por su excelencia y devoción a la real narración visual. Desde su dramático uso de la ilustración -incluso en la primera página- a sus combinaciones de fotos, gráficos y textos para explicar temas como el tsunami en Japón, el Post utiliza a la perfección todas las herramientas visuales.

La estructura de base del diario está bien definida y presenta una apariencia despampanante y única que comienza con la cabecera vertical en la primera página y continúa con el espacio noticioso horizontal en la parte de arriba de cada página interior. La diversidad de este espacio -con el audaz uso de imágenes horizontales, recuadros informativos y citas destacadas-, le da un inicio dinámico a cada página.

El exigente compromiso con el diseño es admirable y el cuidado a los detalles a lo largo del periódico es impresionante. Incluso la tipografía Agate de la sección deportiva está diseñada con cariño y realizada a la perfección. No se descuida ningún detalle, con lo que la "voz" del Post es evidente en cada página.

Finalmente, y lo más importante, este periódico está definido por el contenido. El paquete informativo "Cómo morimos", que incluye una infografía de dos páginas, es fenomenal. La sección financiera sigue siendo excepcional, y la de fin de semana está llena de detalles visuales elegantes.

Este es un diario que sabe cuándo susurrar y cuándo gritar. Elige sus palabras, fotos, gráficos e ilustraciones con esmero. Conoce

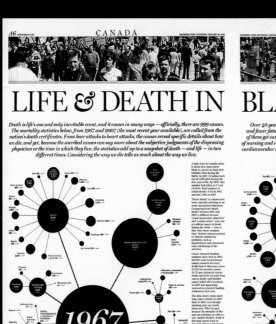
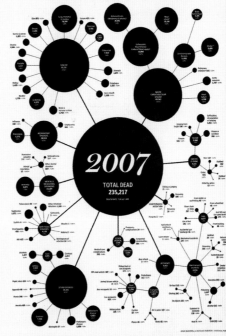

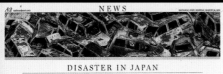
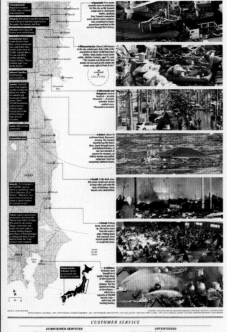
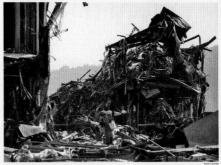

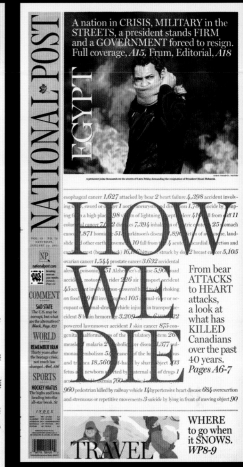

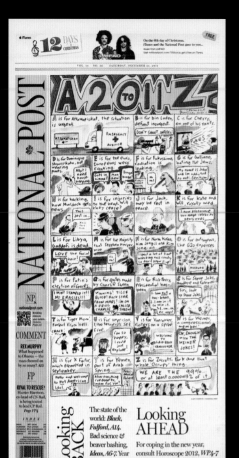

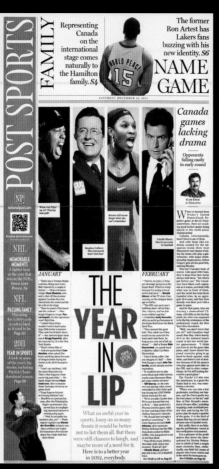

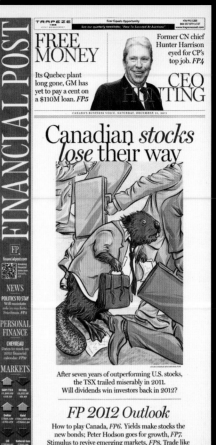

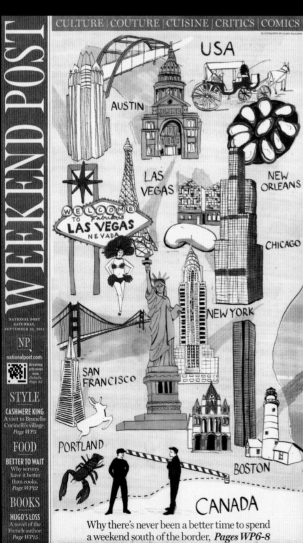

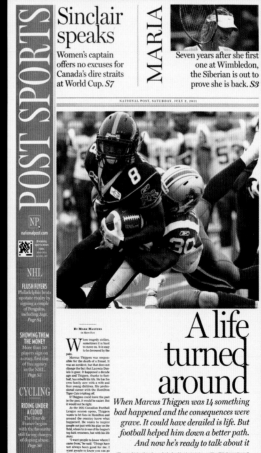

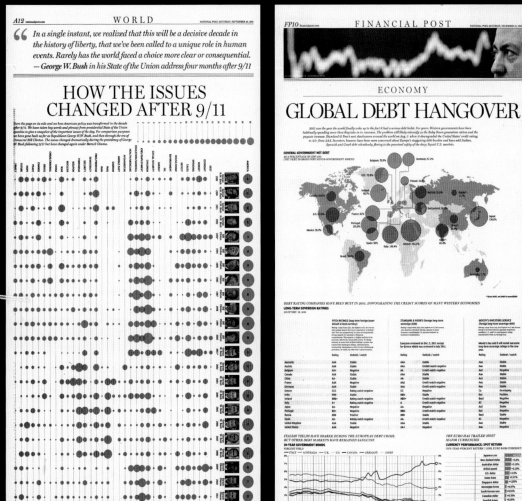

POLITIKEN
Copenhagen, Denmark
Circulation 100,000

POLITIKEN, DENMARK'S SECOND-LARGEST MORNING NEWSPAPER, has a long history of excellence and an intensely loyal readership. Its mission is to engage ordinary people in societal issues.

Published for 127 years, Politiken launched a redesign in December 2011 to appeal to readers in a fresh and modern way, with the goals of improved navigation and usability. It has succeeded.

The fresh approach is evident in the wrap page that appeared the first day of the redesign. Hand-drawn by one of the paper's illustrators to guide readers through the paper's changes, this whimsical page immediately set the tone for the new look: sophisticated, enticing, bold, risky.

Each front page has an atypical visual approach or solution — from documentary photojournalism to caricature. Great attention has been given to type decisions, even down to the smallest detail. A quest for optimum readability — extra white space above and below headlines, and the body text and leading choices — is evidence that the reader comes first. The simplicity of the byline styles and columnist sigs adds to the paper's elegant visage.

Politiken prides itself on the space given to opinion pages as one of the paper's social engagement tools. The pages are full of multiple entry points and provocative illustrative work, and color is used to move readers through stories and columns.

There is thoughtfulness to the cropping and editing of photographs, with designers using the full width of pages for impact. Oftentimes, we turned pages to find an unexpected and delightful grouping of photographs or illustrations, as seen in a story about a young entrepreneur who had to restart a career after an illness.

Politiken is a model for the power of visual consistency throughout a newspaper. A previous winner in this category, Politiken again deservedly joins the ranks of World's Best.

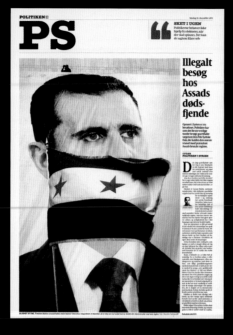

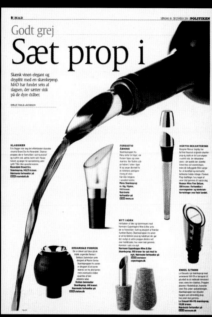

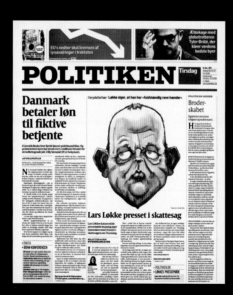

POLITIKEN, EL SEGUNDO PERIÓDICO MATINAL EN CIRCULACIÓN DE DINAMARCA, tiene una larga historia de excelencia y de una lectoría intensamente leal. Su misión es generar compromiso entre la gente común y corriente y los asuntos de la sociedad.

Publicado hace 127 años, este diario lanzó un rediseño en diciembre de 2011 para atraer a lectores de forma fresca y moderna, con los objetivos de una mejorada navegación y una mayor usabilidad. Sí que lo ha logrado.

Esta fresca aproximación es evidente en la página que envolvió el diario el primer día de su rediseño. Dibujada a mano por uno de los ilustradores del periódico para guiar a los lectores sobre los cambios, esa página juguetona inmediatamente fijó el tono del nuevo look; sofisticado, tentador, atrevido y arriesgado. Cada portada o tapa tiene un enfoque o solución visual fuera de lo común, desde el fotoperiodismo documental hasta la caricatura. Se presta atención a las decisiones tipográficas hasta el mínimo detalle. Una búsqueda de lecturabilidad óptima -espacio blanco extra encima y debajo de los títulos, y el texto y las alternativas de artículo principal-, es evidencia de que se privilegia al lector. La simplicidad del estilo para nombrar los autores de los artículos y de las firmas de las columnas de opinión da un toque al elegante rostro del diario.

Politiken se enorgullece del espacio que da a las páginas de opinión como una de sus herramientas de compromiso social. Las páginas tienen muchos puntos de entrada e ilustraciones provocativas. El color se usa para que los lectores puedan navegar por los artículos y las columnas.

El recorte y la edición de las fotografías están hechas con consideración, y los diseñadores usan todo el ancho de la página para dar impacto. A menudo, dimos vuelta la página y nos encontramos con agrupaciones de fotos o ilustraciones inesperadas y encantadoras, tal como se ve en un artículo sobre un joven emprendedor que debió recomenzar su carrera después de una enfermedad.

Politiken es un modelo del poder de la consistencia visual a lo largo de un periódico. Ya había ganado en esta categoría de la competencia y nuevamente merece formar parte de Lo mejor del mundo.

En kugle røg ud af sin bane

For to år siden op mod sin jul afbrød den nu 37-årige kunstner Jeppe Heins krop sin hjerne alt samarbejde med ham og hans daværende liv i den internationale overhalingsbane for kunstnere. Han bliver aldrig sit gamle jeg, mener han nu, og måske er det fantastisk.

INTERVIEW

BLÅ BOG

JEPPE HEIN

Født: 1974. Bor i Berlin med sin kone og to døtre.

Uddannet: tømrer, men blev senere uddannet på Det Kongelige Danske Kunstakademi i København og Städelschule for Bildende Künste i Frankfurt.

ØJEBLIK. Det som øjeblik en stor mand med meget at leve. Det næste øjeblik skulle der ingenting til for at få ham i knæ og så helt ned at ligge. Foto: Lærke Posselt

POLITIKEN

Hysteri og hypnose? Nej. Hun får for lidt!

I den romantiske komedie 'Hysteria' om 1800-tallets hysteri-epidemi og massageapparatets opfindelse spiller Maggie Gyllenhaal den kvindelige hovedrolle. Hun er overrasket over, hvor generte folk stadig bliver i dag over at se en film om kvindelige orgasmer.

INTERVIEW

MANDEKLUB. Professor Charcot kunne fremvise hysteriske patienter på sin klinik i Salpêtrière, hvor han var leder, og hvor også Sigmund Freud modtog lektioner 1885-86. Maleri af André Brouillet/Polfoto

MAGGIE GYLLENHAAL. Amerikansk skuespiller, f. 1977. Debuterede 1992 i 'Waterland', der var instrueret af hendes far, Stephen Gyllenhaal. Spillede derefter i 'Donnie Darko' (2001) over for lillebror Jake Gyllenhaal. Hendes vigtigste film er 'Secretary' (2002), 'Orkideboy' (2002), 'Sherrybaby' (2007), 'The Dark Knight' (2008) og 'Crazy Heart' (2009). Hendes næste film er 'Learning To Fly'.

MISFORSTÅET. Charcot tog selv fotografier af de kvinder, der kom under hans behandling. Foto fra bogen 'Iconographie photographique de la Salpêtrière' (1878) af Charcot.

LIGE DÉR, JA.

ØJNENE, DER SER. Professor Jean-Martin Charcot var leder af sindssygehospitalet La Salpêtrière repræsentant for det mandlige blik, der i 1800-tallets Europa gjorde undertrykte kvinder til patienter i stedet for at give dem det, de havde brug for: sex, opmærksomhed og anerkendelse. Foto: Polfoto

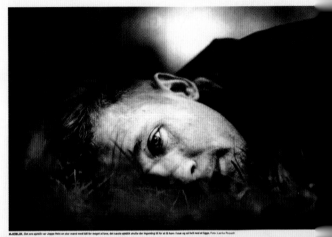

BALANCEAKT. Vær hans værdige og nyt for Berlin. For før er Jeppe Hein nu så mobil som mange af verdens skulpturer. Foto: Lærke Posselt

OVERBLIK

God dansk start på sæsonfinale

BADMINTON. Peter Gade nåede ...

Torres på vej væk fra Chelsea

FORBOLD. ...

18
gange har Hvide IF's volleyball-kvinder været i pokalfinalen, og med en sejr over Holmegaard IF er holdet nu klar til nummer 18 ved Modelmesteren i Finalen 22. januar i Odense ...

Udvalgt sport i tv

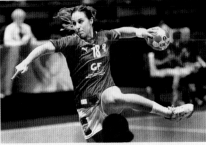

Nu gælder det medaljer

Køligt spil i brandvarm hal endte med 28-23-sejr over Angola. Dermed er Danmark klar til VM-semifinale mod Frankrig.

VM-HÅNDBOLD

KARAKTERBOGEN

DANMARK

1. Sandra Toft
2. Karin Mortensen
3. Christina Pedersen
4. Mette Melgaard
5. Susan Thorsgaard
6. Maria Fisker
7. Christina Krogshede
8. Kristina Bille
9. Pernille Larsen
10. Louise Burgaard
11. Line Jørgensen
12. Kristina Kristiansen
13. Trine Troelsen
14. Ann Grete Nørgaard
15. Louise S. Spellerberg
16. Stine Jørgensen

TRIUMF: Vi turde spille håndbold

Uden tyngende forventninger turde spillerne give los.

Højt niveau blandt kandidater til Årets Fund

Team Danmark og DIF glæder sig over, at positiv talentudvikling kommer til udtryk i nominering.

ÅRETS FUND 2011

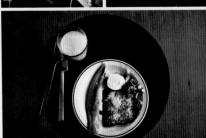

ÅRETS FUND 2011

DE 10 NOMINEREDE

Afgørelsens time for EU

Alene på baggrund af den forhastede mafia-beskyttelses-logik skal Danmark ikke gå med i Stabilitetsunionen.

DANMARK OG EU

Fyrtårn

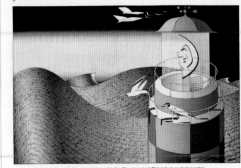

Politikens vendetta mod forfatterne?

SIGNATUR
PER MICHAEL JESPERSEN

En gruppe kendte forfattere vil stoppe en Politiken-undersøgelse, fordi vi stiller de forkerte spørgsmål.

Stå fast på menneskerettighederne

Vi laver rettighedsbaseret udvikling i Tanzania.

UDVIKLINGSBISTAND

Nu var hun død. Og derfor skal man videre

Per Mathiesen på 69 år havde planlagt at tilbringe alderdommen med sin hustru Rie. Sådan skulle det ikke gå. Alligevel er han ikke gået i hundene, sådan som mænd ellers gør flest, når de bliver alene.

TRESSERNE

MÆND, DER BOR ALENE

SERIE

FORSKNING • MØDER, DER SKAL SLÅ BRO

Før gik de i hver sin skole

Blodbad kalder på forsoning

Mareridtet fortsætter i skolen

Hvordan skal børn kunne forstå en krig, hvis de ikke får en nuanceret fremstilling i skolen? Dansk forsker tager undervisningstemperaturen på skolerne i Bosnien-Hercegovina.

FORSKNING

HENRIK LARSEN

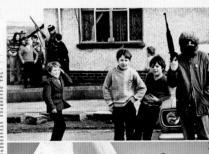

FAKTA

SAMMENSAT LAND

13

KRIG OG FRED

Page 1 (top-left)

OVERBLIK

Skal du have skolepenge tilbage?

Der skal gøres plads til flere

49

Hvad er ICDP?

$$A) 13 - 3 \times 4 + 3 =$$
$$B) - 2 \times (5 \cdot 7) + 3 =$$

Lærere filmer sig til at blive bedre

Mange lærere på skolerne

60

97

60

Efterskoleelever får julegave

Min skoletid: Troels Lunds afløser er sproghandikappet

INTERVIEW

Page 2 (top-right)

Fin norsk debut om sidespring i sneen

16 år. De unge er på vej til at få stemmeret

Danmark betalte for omtale i hipt magasin

POLITIKEN Torsdag

467.449 | Antallet af danske mænd, der bor alene, eksploderer

Folkevalgte vil bremse ny EU-traktat

EUROKRISE

Alenemænd

POLITIKEN MENER

Børn bag tremmer

▶ LÆS MERE

Page 3 (bottom)

2 | KULTUR | OVERBLIK

POLITIKEN | Søndag 18. dec. 2011

GUIDE TIL

100 millioner dollar sagsøges Beyoncé nu for af en videospiludvikler, efter at popdivaen har trukket sig ud af samarbejdet om videospillet 'Starpower: Beyoncé' i utide.

Lisbeth Salander

Født: 30. april 1978
Højde: 150 cm Vægt: 41 kg

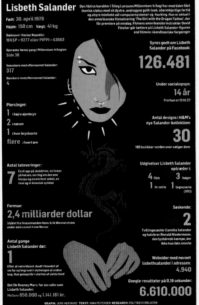

Synes godt om Lisbeth Salander på Facebook
126.481

Under socialopsyn:
14 år

Antal designs i H&M's nye Salander-kollektion
30

Udgivelser Lisbeth Salander optræder i:

Piercinger:
1 i højre øjenbryn
1 i næsen
1 i hver brystvorte
flere i hvert øre

Antal tatoveringer:
7

Formue:
2,4 milliarder dollar

Søskende:
2

Antal gange Lisbeth Salander dør:
1

Websider med navnet lisbethsalander.com i adressen:
4.940

Google-resultater på 0,18 sekunder for Lisbeth Salander:
6.610.000

GRAFIK: JENS HERSLAND TEKST: NINA PEITERSEN RESEARCH: POLITIKENS BIBLIOTEK

Vi lister os af sted på tå

TOPTI HENRIK PALLE

Aarhusianerne rykker frem i bybussen

Lise-Lotte Frederiksen fra Peter og Ping, der arrangerer turistomvisninger i København, har lanceret vandreturen 'In the footsteps of Sarah Lund'.

POLITIKEN.DK I DAG

Debat • **Bøger** • **Bagsiden**

Banksy kommenterer sexmisbrug i den katolske kirke

KUNST.

folketeatret | nørregade

OM BARONESSEN
BLIXENS SIDSTE KÆRLIGHED
15. DECEMBER 2011 – 28. JANUAR 2012
BILLETTER 3312 1845 | WWW.BILLETBILLET.DK

HOTEL.CABINN.COM DEJLIG SØVN

ically and stylistically.

a bold color palette and multiple photographs on
ge, and this gives it vigor and urgency. FAS and
phisticated typography, masterful illustrations
dsheet display for authoritative looks. The
evels in its narrow page, and tells stories visually
ewspaper in the world. The Grid has the feeling
und paper minus the political coverage, but there
ory forms on every page that make its readers
their heads. The Grid knows its audience and
antly.

d the winners, we saw a lot of newspapers
be that are converting from broadsheet to tabloid
many good ones that made it into the final
e that had the consistent excellence to move
. Designers and editors of these tabloids seem to
ntify the right look and feel. We expect they will
the months and years ahead, because many of
ly outstanding.

ce and innovation in pockets around the globe.
ame from South China and the United Arab
nce from Buffalo and Portugal; and consistent
Hamburg and New York.

excellence will always be less about format
y and more about an unreserved commitment
nd interests of readers. What is a perfect look
e in Beijing or Oslo may not fit an audience in
r Charlotte. A newspaper must find the voice that
o its unique audience of readers, and the best
l always do so.

's Best newspapers share a certainty about
nces are, and a bold, sure-footed approach to
All have a unique voice. All are superb. All share
to print that other newspapers should emulate.
te a page, never waste their readers' time. These
k healthy, well staffed and richly resourced,
not. It was inspiring to see international
still believe in excellence in print.

ciety for News Design's World's Best competition
, too, of how much has been lost in so many
ners and journalists have gutted their
ndermined their relationships with readers and
he health and vigor of the world's newspapers
on the preservation and renewal of the bonds
ournalists and readers.

excellence represented by the five winners is
ormula still works.

Excelsior usa una paleta de color atrevida y muchas
fotografías en casi todas las páginas, lo que le da vigor y
sentido de urgencia. FAS y Politiken emplean tipografías
sofisticadas, ilustraciones dominantes y formatos estándares
anchos, con lo que logran inspirar autoridad. El National
Post se revela en su angosta página y relata noticias de forma
visual tan bien como cualquier periódico del mundo. The
Grid da la impresión de ser un diario clandestino sin la
cobertura sobre política, pero tiene formas de relato atractivos
en cada página, que hace que sus lectores se rían o sacudan
la cabeza. The Grid conoce a sus lectores y se comunica con
ellos de forma brillante.

Al mirar más allá de los ganadores, notamos muchos
periódicos de todo el mundo que están pasando del formato
estándar al tabloide, y vimos varios muy buenos que llegaron
a la ronda clasificatoria de la competencia, pero ninguno
que tuviera una excelencia consistente como para alcanzar
el escalón más alto. Da la impresión de que los diseñadores
y editores de estos tabloides estuvieran tratando de hallar
la apariencia y la sensación correctas. Esperamos que
encuentren la respuesta en los meses y años que vienen,
aunque muchos de ellos ya son excepcionales.

Vimos brillantez e innovación en varios puntos alrededor del
mundo: Diseños atrevidos en el sur de China y los Emiratos
Árabes Unidos, elegancia de Buffalo a Portugal, y excelencia
consistente de Hamburgo a Nueva York.

La fórmula de la excelencia siempre tendrá menos que ver
con el formato y la tipografía, y más con un compromiso sin
reservas con la naturaleza y los intereses de los lectores. Una
apariencia perfecta para los lectores de Beijing u Oslo puede
no servir en Buenos Aires o Charlotte. Por eso, un diario
debe encontrar la voz que le habla con claridad a sus propios
lectores, y los mejores periódicos siempre lo logran.

Todos los diarios mejor diseñados del mundo comparten una
certeza sobre quiénes sus lectores, y una propuesta atrevida
y firme para llegar a ellos. Todos tienen una voz única. Todos
son espléndidos. Todos comparten un compromiso con lo
impreso que otros periódicos deberían imitar. Nunca pierden
una sola página ni hacen perder el tiempo de los lectores.
Estos diarios se sienten en buen estado de salud, dotados de
una buena planta laboral y con suficientes recursos, incluso si
no lo están. Fue inspirador ver a periodistas internacionales
que todavía creen en la excelencia de la prensa.

La 33ª Competencia de Lo Mejor del Diseño de la SND fue
un recordatorio, además, de cuánto se ha perdido en tantos
lugares donde tanto los dueños como los periodistas han
destruido sus productos y socavado sus relaciones con
los lectores y las comunidades. La salud y el vigor de los
periódicos del mundo va a depender de la preservación y la
renovación de los lazos entre los periodistas de la prensa y los
lectores.

La excelencia consistente que representan los cinco

AGSZ UM
SIOR VOLKSKRA
GARTER ZEITUNG STA
DESIGN
LL STREET JOURI
MES MEXICO NEW.
SWERVE MAGA
SSWEEK MAGNES-DZIENNIK
SE MERCURY NEWS RED
PAULO CANADA H

E BEST OF NEWS DES

SND
33

RIBUNE THE NATIO
SEATTLE TIMES NA
TARDE OMAHA WORLD-H
LER FINANCIAL TI
EGAS REVIEW-JOURNAL OREG
I DAGENS NYHE
Y LAS VEGAS SUN NOROESTE MA
NUESTRO DIARIO RA
S EXPRESSO METR
LINE

JUDGES' SPECIAL RECOGNITION

reconocimiento especial de los jueces

CATARINA HOSPODÁ
T ZETA WEEKLY STAR TRI
T RCERA SE

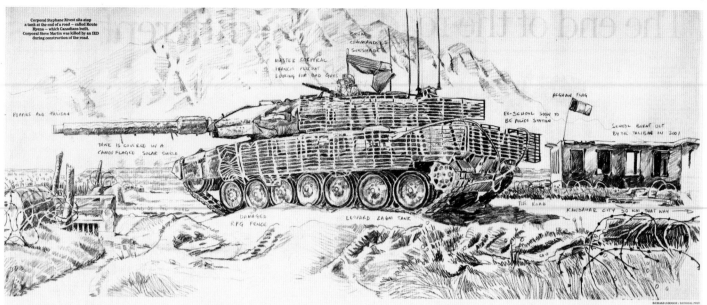

Taking the battle to the Taliban

NATIONAL POST
Toronto, Ont., Canada
Richard Johnson, Illustrator/Graphics Editor; **Laura Morrison**, News Presentation Editor; **Paolo Zinatelli**, Senior Designer; **Jeff Wasserman**, Photo & Multimedia Editor; **Michael Higgins**, Foreign Editor; **Brian Hutchinson**, Writer; **Joe Hood**, Page One Editor; **Anne Marie Owens**, M.E./News; **Stephen Meurice**, Editor-in-Chief; **Gayle Grin**, M.E./Design & Graphics
AWARDS OF EXCELLENCE (3) & JSR (2)
Special News Topics
Commitment to illustration
News Design Page(s)
A-Section/Broadsheet 50,000-174,999
Miscellaneous

JSR FOR COMMITMENT TO DOCUMENTARY ILLUSTRATION

IT'S AMAZING THAT A PUBLICATION would send an illustrator into a war zone to bring back this classic style of visual reportage. The dedication to this art form is incredible. You can see the time that this illustrator spent with his subjects in every line drawn. Each piece tells a story. In a time where budgets are being cut, it's refreshing and exciting to see this level of commitment to excellent illustration, which in this case was done under very difficult and trying circumstances. This publication should be commended for its commitment to telling stories through illustration. You want to spend more time with the artwork because you don't normally see these scenes depicted in this way. By commanding reader attention in a way that photography wouldn't, this work shines a light on the everyday aspects of fighting a war overseas.

EL LARGO CAMINO

ES SORPRENDENTE QUE UN PERIÓDICO haya enviado un ilustrador a una zona de guerra para traer de vuelta este estilo clásico de reportaje visual. La dedicación a esta forma artística es increíble. Se nota el tiempo que pasó este ilustrador con los temas en cada línea dibujada. Cada pieza relata un artículo. En una época en que se recortan los presupuestos, es refrescante y apasionante ver este nivel de compromiso con la excelencia de la ilustración bajo circunstancias muy difíciles y desafiantes.

Se debería elogiar a este periódico por su dedicación al relato de temas a través de la ilustración. Dan ganas de dedicar más tiempo al arte, porque normalmente no se muestran escenas de esta forma. Este trabajo enciende una luz sobre los aspectos cotidianos del combate de una guerra en el extranjero, al guiar la atención del lector de una forma tal que la fotografía no podría lograr.

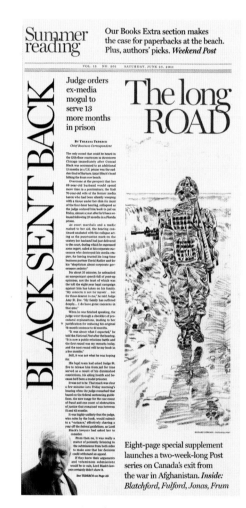

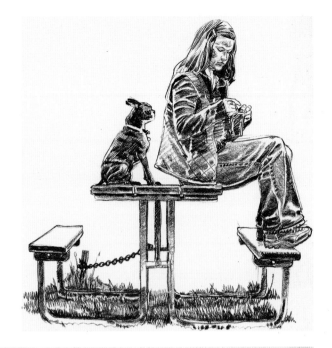

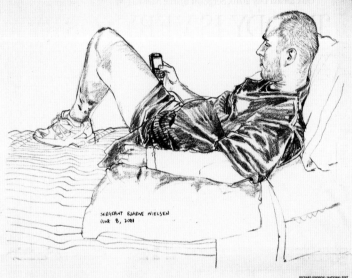

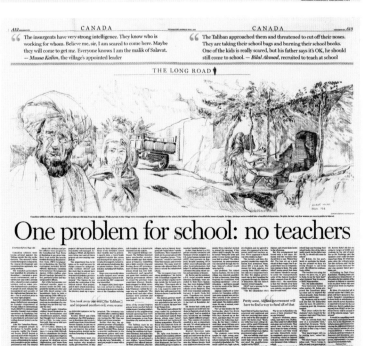

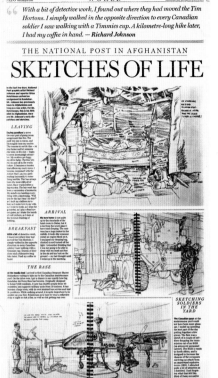

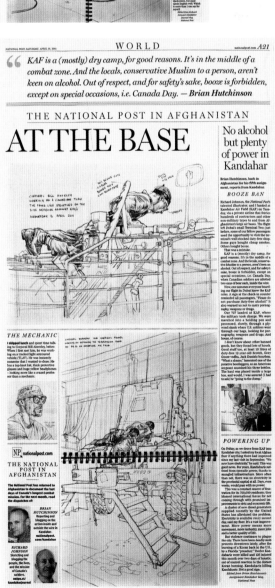

The New York Times

THE NEW YORK TIMES
New York, N.Y.
Sam Manchester, Designer/Illustrator; **Marcus Yam**, Photographer; **Joe Ward**, Graphics Editor; **New York Times Photographers**;
Wayne Kamidoi, Art Director; **Tom Bodkin**, Design Director; **Bruce Kluckkohn**, Photographer/NHL via Getty Images
AWARDS OF EXCELLENCE (2) & JSR
Special News Topics
Editor's Choice: Sports
News Design Page(s)
Sports/Broadsheet 175,000 and Over

JSR FOR DEPTH OF STORYTELLING AND RESTRAINT

THE SUPERIOR PLANNING AND EXECUTION across all three days of this series show a commitment to this unusual and in-depth story. The liberal use of white space on each cover forces readers to focus on small images that might not have worked at a larger size. The restrained and elegant design takes a gory subject and makes it more palatable. The attention to detail, typography and photography is outstanding.

REJ POR PROFUNDIDAD Y COMPOSTURA DE LA NARRACIÓN

EL ALTO NIVEL DE PLANIFICACIÓN Y REALIZACIÓN a lo largo de los tres días de esta serie demuestra dedicación a este inusual tema tratado en profundidad. El generoso uso del espacio en blanco en cada tapa o primera página fuerza a los lectores a enfocarse en imágenes pequeñas que no hubieran funcionado a un mayor tamaño. El compuesto y elegante diseño hacen más aceptable un tema sangriento como este. La atención al detalle, la tipografía y la fotografía es excepcional.

A Boy Learns to Brawl

'He didn't have a Plan B. Plan A was to play hockey. There was no backup plan.'

A Boy Learns To Brawl

By JOHN BRANCH

'I didn't want him to fight. He knew that. He would always be: "Oh, Mom, it's O.K. It's my job now. It's what I'm doing." '
JOANNE BOOGAARD, Derek's mother

A Brain 'Going Bad'

By JOHN BRANCH

'His demeanor, his personality, it just left him. He didn't have a personality anymore. He just was kind of — a blank face.'
JOHN SCOTT, N.H.L. enforcer

THE NEW YORK TIMES, MONDAY, DECEMBER 5, 2011 D3

PUNCHED OUT
THE LIFE AND DEATH OF A HOCKEY ENFORCER

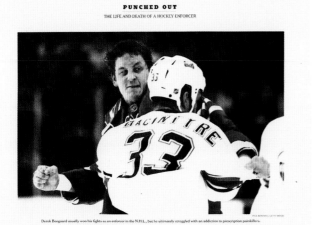

Derek Boogaard usually won his fights as an enforcer in the N.H.L., but he ultimately struggled with an addiction to prescription painkillers.

Blood on the Ice

From First Sports Page

That interpretation of justice, now Rule 48.14, still stands. It has never been much of a deterrent.

The best way to protect top players from violent onslaughts, teams have long believed, is the threat of more violence, like having a missile in a silo. Teams employ on-ice bruisers, the equivalent of playground bodyguards. Hurt one of us, and we will send out someone bigger, tougher to exact revenge.

"Having another player in the bench that is willing to come over and willing to punch you is a good deterrent for other violence on the ice — as crazy as that sounds," said Matt Shaw, an assistant coach for the N.H.L.'s San Jose Sharks.

"Derek would take two or three punches to land one good one. He wasn't a defensive fighter. I remember he said: 'I hate guys that hide. When I fight, I'm going to throw, and I'm going to throw hard. I don't have an off switch.' Anytime a fight didn't go his way — a draw or maybe he thought he lost — that would eat at him."
JOHN SCOTT, N.H.L. enforcer

Todd Fedoruk, another enforcer, had a cheekbone crushed by Boogaard in October 2006, later. Fedoruk later became a teammate whom Boogaard relied on for help.

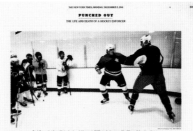

"There's no better feeling when the boys get a rise from you showing up, putting yourself out there. I'm getting chills right now just from talking about it."
TODD FEDORUK, former N.H.L. enforcer

Sports**Monday**

The New York Times

MONDAY, DECEMBER 5, 2011 D1

Derek Boogaard
Age 27

Blood On the Ice

By JOHN BRANCH

"I DIDN'T SEE it coming at all. I was in a bad position and he hit me hard, hardest I've ever been hit. I instantly knew it was broken. I didn't lose consciousness, but I went straight on the ice. And I felt where it was, and my hand didn't rub my face normally. It was a little chunky and sharp in spots and there was a hole there about the size of a fist."
— TODD FEDORUK, former N.H.L. enforcer

The list belonged to Derek Boogaard.

PUNCHED OUT
THE LIFE AND DEATH OF A HOCKEY ENFORCER
PART 2

Continued on Page D3

'Having another player in the bench that is willing to come over and willing to punch you is a good deterrent for other violence on the ice — as crazy as that sounds.'
MATT SHAW, assistant coach in the N.H.L.

THE NEW YORK TIMES, MONDAY, DECEMBER 5, 2011 D4

PUNCHED OUT
THE LIFE AND DEATH OF A HOCKEY ENFORCER

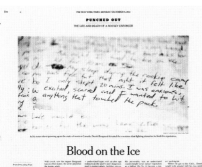

Blood on the Ice

From Preceding Page

'He would fight and his knuckles would be pushed back into the wrist. And then he'd have to have it manipulated and have his knuckles put back in place.'
LEN BOOGAARD, Derek's father

THE NEW YORK TIMES, MONDAY, DECEMBER 5, 2011 D5

PUNCHED OUT
THE LIFE AND DEATH OF A HOCKEY ENFORCER

Derek Boogaard, right, and his brother Aaron fought players ages 12 to 28 how to fight and avoid injuries.

PUNCHED OUT Part 2

'He's such a big guy. The doctor told him it took about twice as much medicine to knock him out as for most people. He'd need 30 pills in a couple of days. He'd need 8 to 10 at a time to feel O.K.'
AARON BOOGAARD, Derek's brother

The New York Times

PUNCHED OUT
THE LIFE AND DEATH OF A HOCKEY ENFORCER

The Signs and Science of C.T.E.

Dr. Ann McKee, a neuropathologist, received Derek Boogaard's brain within days of his death and began testing it for chronic traumatic encephalopathy, more commonly known as C.T.E. McKee found the disease in many parts of his brain. Below is a look at one of the areas she found.

Inside Boogaard's Brain

C.T.E. can occur in different parts of the brain and can therefore result in a variety of symptoms, including dementia and changes in mood and behavior.

Attacking a Cell's Transport System

In healthy brains, nutrients, electrical impulses and other cargo are transported from the cell body to the synapse along the axon. C.T.E. destroys this transport system, eventually killing the cell.

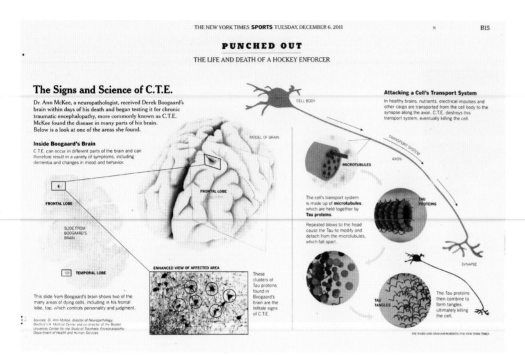

The cell's transport system is made up of **microtubules**, which are held together by **Tau proteins**.

Repeated blows to the head cause the Tau to modify and detach from the microtubules, which fall apart.

The Tau proteins then combine to form tangles, ultimately killing the cell.

This slide from Boogaard's brain shows two of the many areas of dying cells, including in his frontal lobe, top, which controls personality and judgment.

These clusters of Tau proteins found in Boogaard's brain are the telltale signs of C.T.E.

Sources: Dr. Ann McKee, director of Neuropathology, Bedford V.A. Medical Center and co-director of the Boston University Center for the Study of Traumatic Encephalopathy; Department of Health and Human Services

JOE WARD AND GRAHAM ROBERTS/THE NEW YORK TIMES

PUNCHED OUT
THE LIFE AND DEATH OF A HOCKEY ENFORCER

PUNCHED OUT
THE LIFE AND DEATH OF A HOCKEY ENFORCER

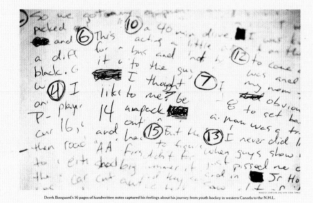

Derek Boogaard's 16 pages of handwritten notes captured his feelings about his journey from youth hockey in western Canada to the N.H.L.

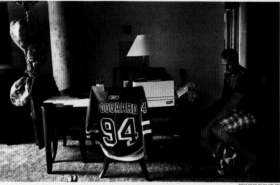

Aaron Boogaard in the apartment he and Derek shared and in which Derek died. Aaron gave his brother a painkiller before he went out that night.

A Brain 'Going Bad'

From Preceding Page

PUNCHED OUT Part 3

Over six months, The New York Times examined the life and death of the professional hockey player Derek Boogaard, who rose to fame as one of the sport's most feared fighters before dying at age 28 on May 13.

This article, the third of a three-part series, chronicles Boogaard's descent, on and off the ice, and the posthumous determination by researchers that he had a degenerative brain condition believed to be caused by repeated blows to the head.

On the Web nytimes.com/boogaard

In addition to this article:

- **VIDEO** Battling injuries and abusing prescription drugs, Boogaard is a shell of the player who won fans' adoration in Minnesota. His final chapter is written by a neuropathologist.
- **EXTENDED INTERVIEWS** Gary Bettman, commissioner of the N.H.L., discusses Boogaard's death, the role of fighting in hockey, the use of prescription drugs among players and the league's substance-abuse program; and Jeremy Clark, Boogaard's close friend and trainer, talks about Boogaard's life off the ice.
- **MOTION GRAPHIC** A look inside Boogaard's brain and the disease that might have contributed to his decline.
- **DOCUMENTS** The police report from Boogaard's death at his apartment, and his brother's statement to the police.
- **PHOTOGRAPHS** The Boogaard family.

Boogaard was thrown to the ice by Matt Carkner, a veteran minor league intimidator, on Dec. 9, 2010. He never played again.

'If you polled our fans, probably more would say they think it's part of the game and should be retained.'

GARY BETTMAN, N.H.L. commissioner, on fighting

The Wild brought in Boogaard's family when it honored him with a tribute before a game last month. A video showed his three N.H.L. goals and not a single punch.

'They are trading money for brain cells.'

CHRIS NOWINSKI, a co-director for the Center for the Study of Traumatic Encephalopathy at Boston University

POLITIKEN
Copenhagen, Denmark
Politiken Staff Photographers
AWARDS OF EXCELLENCE (3) & JSR
Photography/Multiple Photos
Portfolio/Team or Staff
Feature Design Page(s)
Entertainment/Broadsheet 50,000-174,999
Photography/Single Photos
Portrait (Martin Lehmann)

JSR FOR BOLDNESS AND UNDERSTANDING OF THE POWER OF PHOTOGRAPHY

Here we see the use of the canvas to its full potential. Bold, powerful and dynamic, it stops you in your tracks. There is a great use of the broadsheet format, with different perspectives and contrasts, and strong images of different sizes. It's a body of work that feels like a complete set, yet all are different from each other.

REJ POR LA AUDACIA Y LA COMPRENSIÓN DEL PODER DE LA FOTOGRAFÍA

Aquí se nota el uso al máximo del lienzo. Es atrevido, poderoso y dinámico, y lo deja a uno parado en seco. seco. Se ve un gran uso del formato estándar de periódico, ya que se reciben diferentes perspectivas y contrastes, y obras potentes de diferentes tamaños. Es un conjunto de obras que se siente como un set completo, aunque no hay dos piezas iguales.

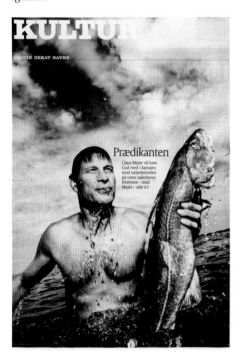

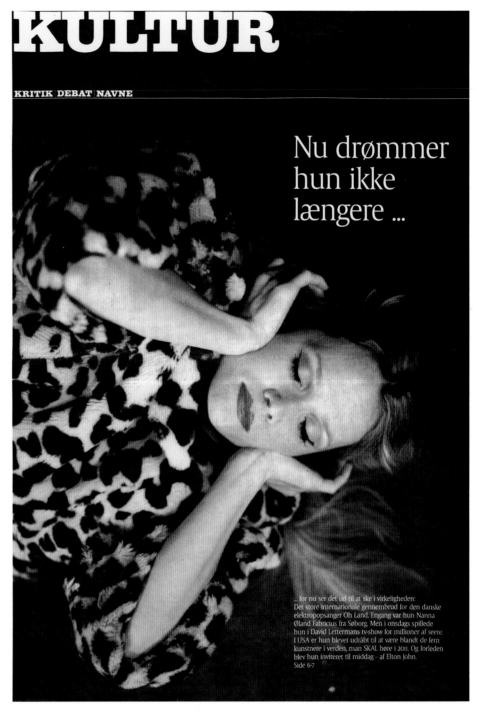

KULTUR

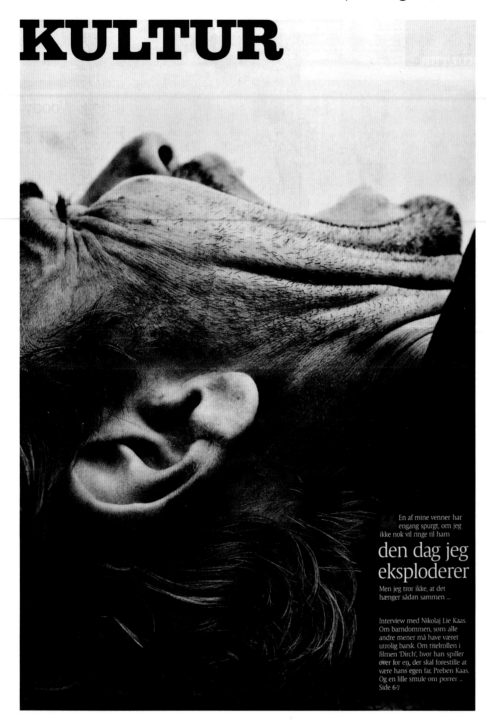

En af mine venner har
engang spurgt, om jeg
ikke nok vil ringe til ham

den dag jeg
eksploderer

Men jeg tror ikke, at det
hænger sådan sammen ...

Interview med Nikolaj Lie Kaas.
Om barndommen, som alle
andre mener må have været
utrolig barsk. Om titelrollen i
filmen 'Dirch', hvor han spiller
over for en, der skal forestille at
være hans egen far, Preben Kaas.
Og en lille smule om porrer ...
Side 6-7

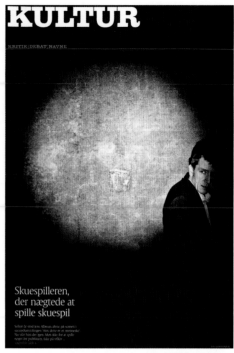

KULTUR
KRITIK|DEBAT|NAVNE

Skuespilleren,
der nægtede at
spille skuespil

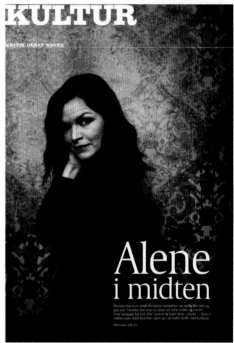

KULTUR
KRITIK DEBAT NAVNE

Alene
i midten

KULTUR

KULTUR

KRITIK DEBAT NAVNE

♥ ♥ ♥ ♥ ♥ ♡

Sonny Rollins. Copenhagen Jazz Festival. Side 5

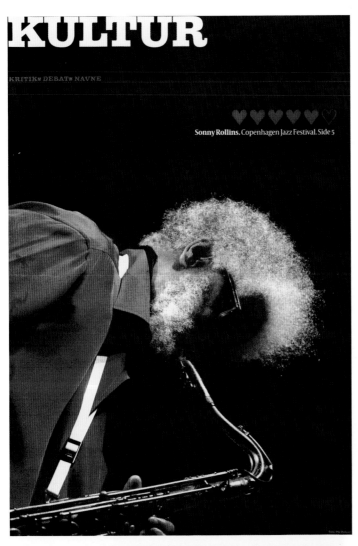

KRITIK DEBAT NAVNE

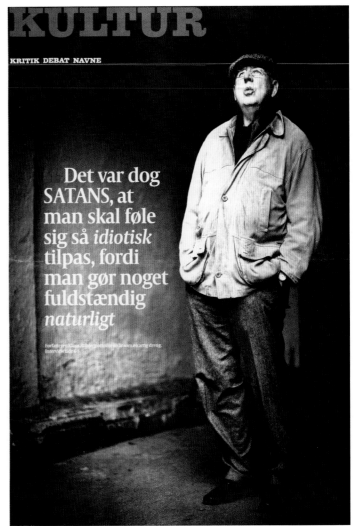

Det var dog
SATANS, at
man skal føle
sig så *idiotisk*
tilpas, fordi
man gør noget
fuldstændig
naturligt

Forfatteren Klaus Rifbjerg om sig selv som en artig dreng.
Interview side 6

KRITIK DEBAT NAVNE

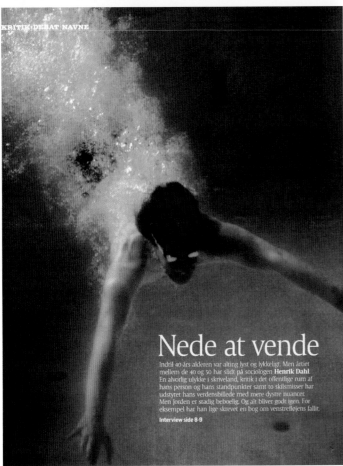

Nede at vende

Indtil 40-års alderen var alting lyst og lykkeligt. Men årtiet mellem de 40 og 50 har slidt på sociologen **Henrik Dahl.** En alvorlig ulykke i skriveland, kritik i det offentlige rum af hans person og hans standpunkter samt to skilsmisser har udstyret hans verdensbillede med mere dystre nuancer. Men jorden er stadig beboelig. Og alt bliver godt igen. For eksempel har han lige skrevet en bog om venstrefløjens fallit.

Interview side 8-9

TIMES OF OMAN
Muscat, Oman
Times of Oman Staff
AWARDS OF EXCELLENCE (3) & JSR (OVERALL)
News Design Page(s)
Business/Broadsheet 49,999 and Under
Illustration
Single lead color
News Design Page(s)
Business/Broadsheet 49,999 and Under

JSR FOR SETTING A CONSISTENT, IMPOSSIBLY HIGH STANDARD FOR QUALITY OF WORK

IT'S HEAD AND SHOULDERS above any of the papers we've seen. It's the approach — their philosophy toward the development of ideas — that's encouraging to all of us. You cannot help but celebrate and appreciate the freedom they have. It's clearly a staff that has the confidence of their management, and you can sense an atmosphere of healthy competition, but also collaboration, among them.

REJ POR FIJAR UN ESTÁNDAR DE CALIDAD DE TRABAJO CONSISTENTE Y ALTÍSIMO

SOBREPASA CUALQUIER PERIÓDICO que hayamos visto. Es el enfoque –su filosofía de desarrollo de ideas–, lo que nos anima a todos. No se puede dejar de celebrar y apreciar la libertad que despliega. Es evidente que el equipo de trabajo tiene la confianza de la gerencia, y se nota que entre ellos hay una atmósfera tanto de sana competencia como de colaboración.

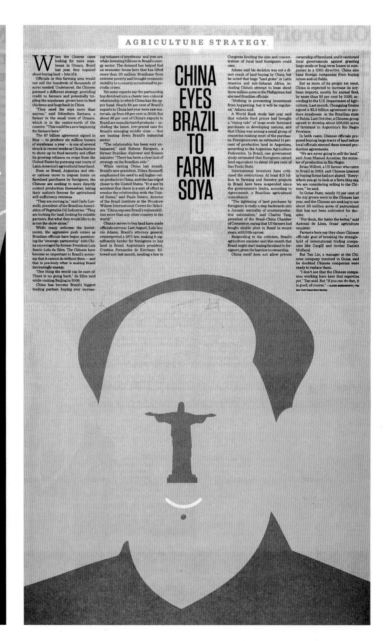

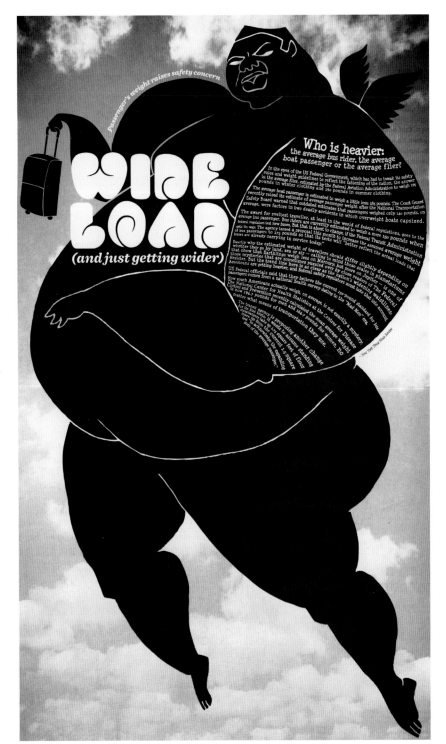

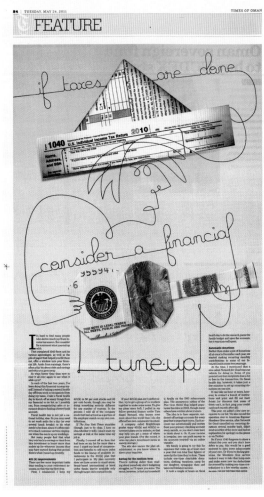

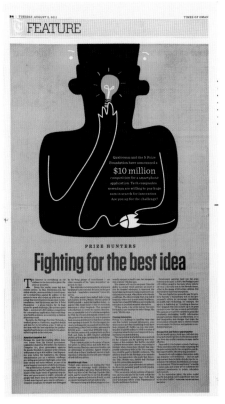

WHEN IT COMES

TO INBOX ADVERTISING,

LESS IS MORE

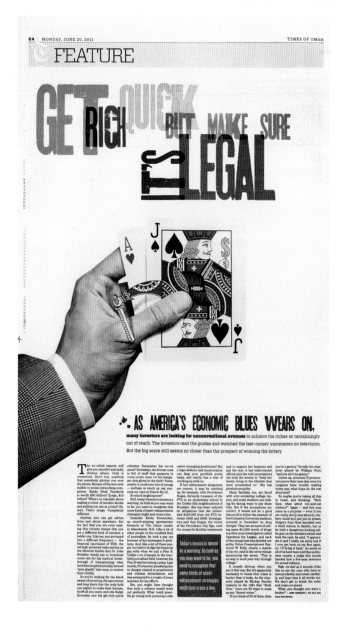

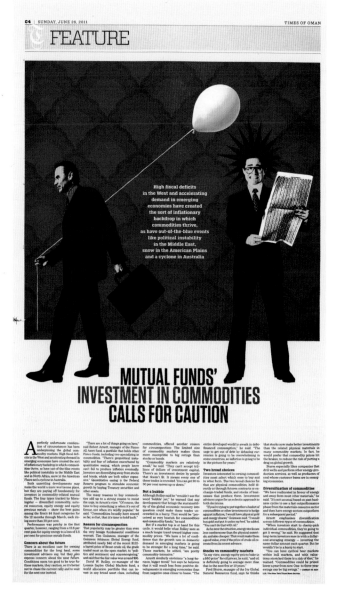

AGSZ ITU U
SIOR VOLKSKR
GARTER ZEITUNG ST
DESIGN
LL STREET JOUR
MES MEXICO NEW
SWERVE MAGA
SSWEEK MAGNES-DZIENNIK
E MERCURY NEWS RED
PAULO CANADA H
E BEST OF NEWS DES
SND
33
RIBUNE THE NATIO
SEATTLE TIMES NA
TARDE OMAHA WORLD-H
LER FINANCIAL TI
EGAS REVIEW-JOURNAL OREG
I DAGENS NYHE
Y LAS VEGAS SUN NOROESTE MA
NUESTRO DIARIO RA
S EXPRESSO METR
LINE
CATARINA HOSPODÁ
ZETA WEEKLY STAR TRI
TERCERA SE

BEST IN SHOW / MEDAL WINNERS

lo mejor de la muestra &
medallas de oro y plata

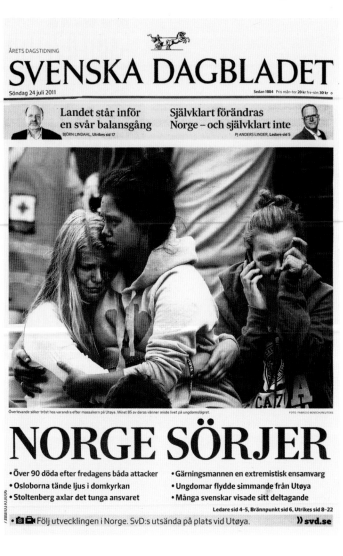

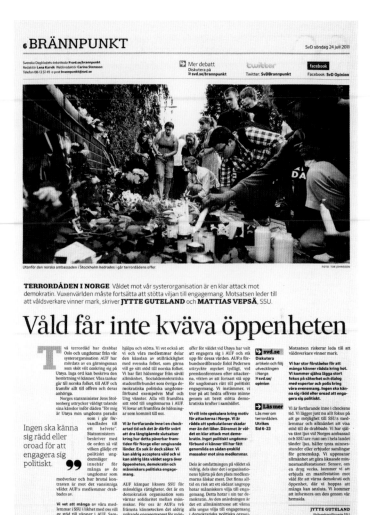

SVENSKA DAGBLADET
Stockholm, Sweden
Anna W. Thurfjell, Head of Design; **Tor Johnson**, Picture Editor; **Jessika Olofsson**, Picture Editor; **Helena Frank**, Page Designer; **Fabrizio Bensch/Reuters**, Photographer
GOLD & BEST IN SHOW
Breaking News Topics
Editor's Choice: International

BEST IN SHOW

THIS IS THE ONE ENTRY IN THE COMPETITION THAT HAD EVERYTHING THE JUDGES WANTED TO SEE AND, on top of it all, it was in the breaking news category. There is pacing hardly seen in breaking news, and impressive storytelling throughout. This entry is about great storytelling, emotional photography, detailed graphics, strong copy editing, precise design — all executed on deadline. They used every tool at their disposal exceptionally well. They covered the hell out of this story. To accomplish something as authoritative as this, they had to have a strong design philosophy already in place that allowed them to present the news in this way. Every question you might have about this event is answered. To accomplish that, the team shared a common understanding of where the coverage was headed. Their tremendous vision is to be rewarded. For Best in Show, the judges wanted to elevate the single entry that said the most about what the craft is. As a journalist, you'd be hard-pressed to find a better example.

LO MEJOR DE LA MUESTRA

ESTA ES LA ÚNICA PIEZA DE LA COMPETENCIA QUE TENÍA TODO LO QUE LOS JUECES QUERÍAN VER Y, más aun, era de la categoría de noticias de última hora. Hay un ritmo rara vez visto en este tipo de noticias y una impresionante narración a lo largo del relato. Esta pieza tiene una gran narración informativa, una fotografía emotiva, infografías detalladas, una fuerte edición del texto y un diseño preciso; todo realizado al filo del plazo. Se usaron excepcionalmente bien todas las herramientas a su disposición y se cubrieron todos los aspectos de este tema a fondo. Para lograr algo con tanta autoridad como esto, debieron tener una filosofía de diseño ya en operación, lo que les permitió presentar las noticias de esta forma. Cualquier pregunta que se pudiera tener sobre este evento está respondida. El equipo debió haberse puesto de acuerdo sobre lo que esta cobertura iba a lograr y su tremenda visión está recompensada. Para Lo mejor de la muestra, los jueces querían realzar la pieza que mejor que ninguna diera cuenta en qué consiste este oficio. Como periodista, habría sido difícil encontrar un mejor ejemplo.

Svenska Dagbladet: Gold & Best in Show

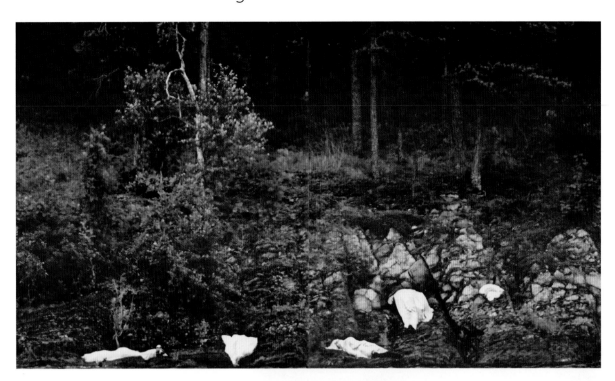

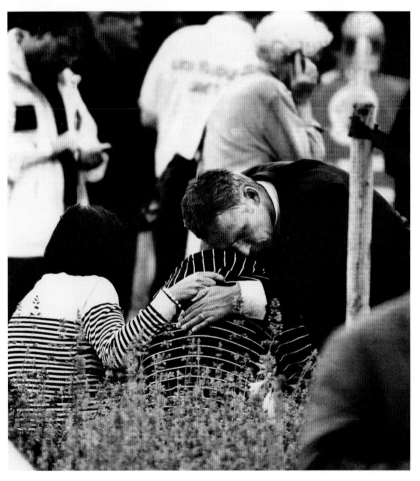

GOLD

THIS IS ONE OF THE BEST PIECES of breaking news coverage we've ever seen. It could be held up as a template for handling a breaking news story. When covering an event of this magnitude, the tendency is to turn on the fire hose. Yet this publication gave the story structure and used several different devices — from straight news to explanatory journalism to pure emotion. There is rhythm throughout the pages, which use both traditional and alternative story forms. The reader is guided easily through each page. The package is comprehensive — even including how other publications covered the story — without feeling heavy. The authoritative coverage shows complete ownership of the story.

ORO

ESTA ES UNA DE LAS MEJORES PIEZAS de cobertura noticiosa de última hora que hemos visto, tanto que podría servir como maqueta para tratar una noticia de última hora. Cuando se cubre un evento de esta magnitud, la tendencia es usar la manguera de bomberos. Sin embargo, este periódico le dio estructura a este tema y usó varios mecanismos, desde noticias directas a periodismo explicativo y emoción pura. Hay ritmo a través de las páginas gracias al uso de formas de relato tradicionales y alternativas. Incluso mostraron la forma en que otros periódicos cubrieron el tema. El paquete tiene autoridad. informativo es exhaustivo sin que se sienta pesado. De hecho, se guía al lector con facilidad a través de cada página. La cobertura noticiosa tiene tanta autoridad que demuestra un completo dominio del tema.

Svenska Dagbladet: Gold & Best in Show

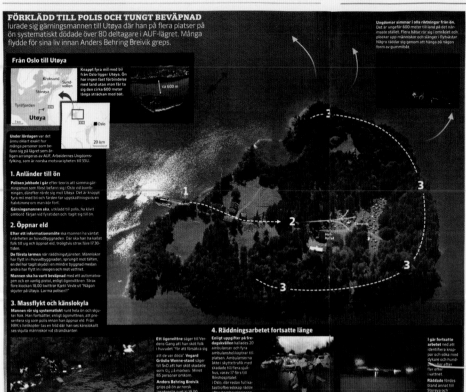

FÖRKLÄDD TILL POLIS OCH TUNGT BEVÄPNAD
lurade sig gärningsmannen till Utøya där han på flera platser på ön systematiskt dödade över 80 deltagare i AUF-lägret. Många flydde för sina liv innan Anders Behring Breivik greps.

Från Oslo till Utøya

1. Anländer till ön

2. Öppnar eld

3. Massflykt och känslokyla

4. Räddningsarbetet fortsatte länge

Ungdomarna flydde i panik

Anders Behring Breivik, 32, misstänks ha dödat ungdomar metodiskt med automatvapen och pistol.

"Jag såg honom gå och skjuta"-

Norge märkt av tragedin

PERSPEKTIV NORSK POLITIK
BJÖRN LINDAHL

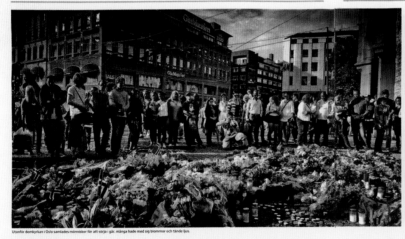

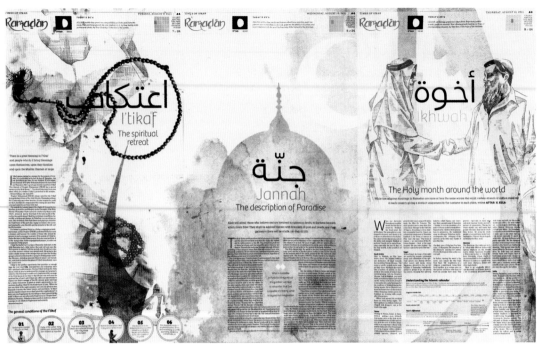

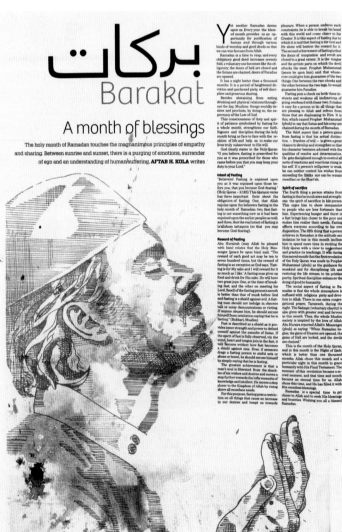

TIMES OF OMAN
Muscat, Oman
Essa Al Zedjali, Chairman; **Ahmed Essa Al Zedjali**, CEO; **Adonis Durado**, Design Director; **Waleed Rabin**, Designer;
K.M. Sahir, Designer; **Gregory Fernandez**, Designer; **Osama Al Jawish**, Calligrapher;
Antonio Farach, Graphics Editor; **Lucille Umali**, Illustrator; **Winie Ariany**, Illustrator
GOLD
Miscellaneous

GOLD

THE IDEA OF A TILED POSTER IS NOT NEW, but it is very difficult to do — and this one is done so well. Each day is an easy read, but it also fits together seamlessly over 24 days of Ramadan. There is layer upon layer of detail, but the subtle blend of color, photography, illustrations and typography keeps the combined work from becoming too overpowering. If you didn't know anything about Ramadan, you could learn everything you need to know from this. They really worked to pull readers in and to give them something special.

ORO

NO SE TRATA DE UNA IDEA NUEVA, pero es muy difícil de llevar a cabo, y está muy bien hecha. Cada día es una lectura fácil, pero también encaja fluidamente a lo largo de 24 días de los 29 ó 30 de Ramadán. Hay una capa de detalle sobre otra, pero la sutil mezcla de color, fotografía, ilustraciones y tipografía logran que el trabajo combinado no sea sofocante. Si no se sabe nada sobre Ramadán es posible aprender en esta pieza todo lo necesario. Se trabajó duro para darle a los lectores algo especial que los atraiga.

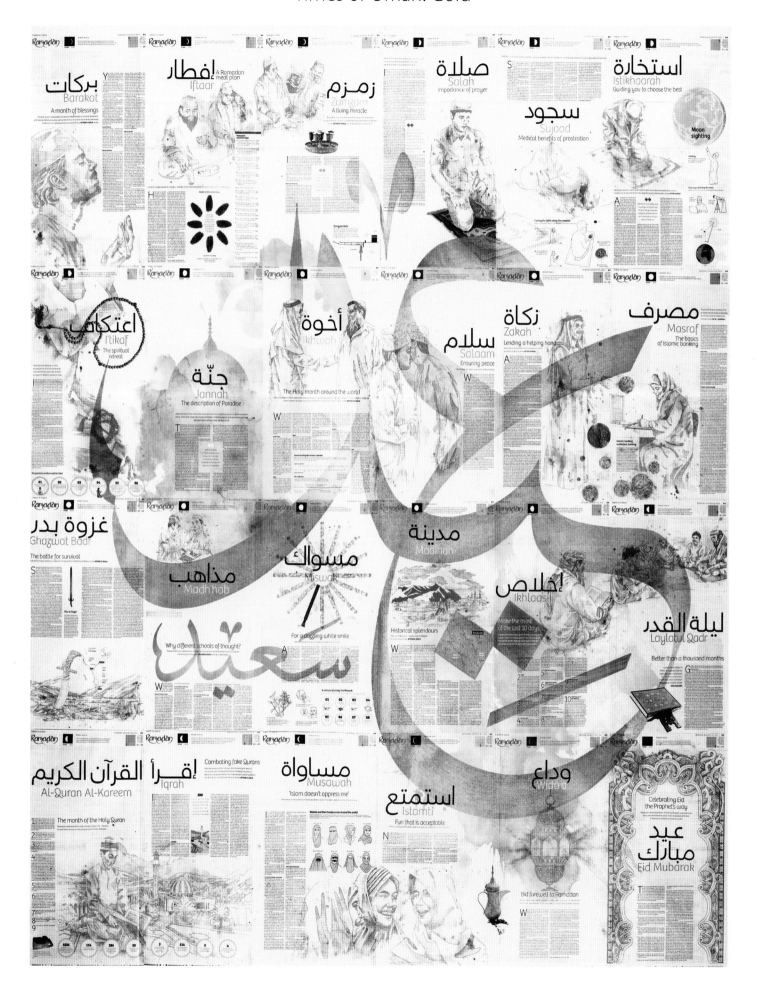

The Washington Post: Gold

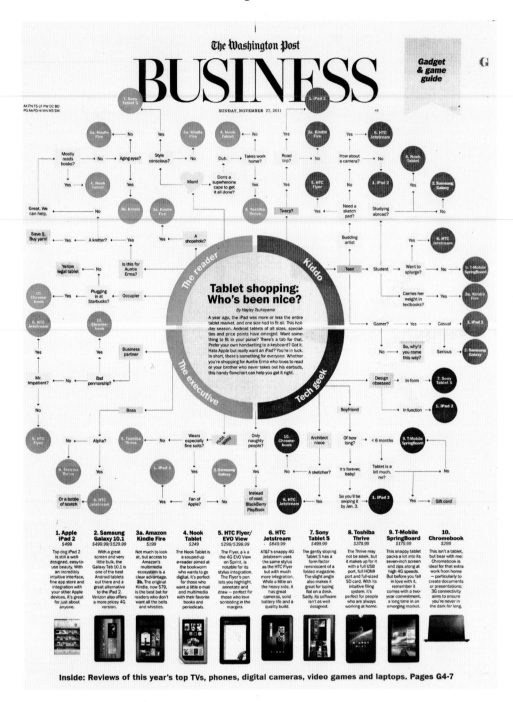

THE WASHINGTON POST
Washington, D.C.
Marianne Seregi, Designer; **Kristin Lenz**, Designer; **Christopher Meighan**, Deputy Design Director/Features; **Greg Manifold**, Deputy Design Director/News; **Kelly Johnson**, Editor; **Hayley Tsukayama**, Writer; **David Griffin**, Visuals Editor; **Janet Michaud**, Design Director
GOLD
News Design Page(s)
Business/Broadsheet 175,000 and Over

GOLD

THEY TOOK ONE OF THE MOST PEDESTRIAN STORY IDEAS we deal with — a shopper's guide — and turned it into a fantastic feat. To take something as static as a news page and to make it this interactive is amazing. There's not a flaw in the storytelling and the writing is spectacular. The graphic is dense but easy to follow. It's fun to trace the flow chart through all the possible paths. It's so helpful that you would want to carry it with you while you're shopping. The translation from the initial idea to the final execution is spectacular.

ORO

TOMARON UNA DE LAS IDEAS DE RELATO MÁS SIMPLES con que uno se puede encontrar –una guía de compras–, y la convirtieron en una proeza fantástica. Es sorprendente transformar algo tan estático como una página de noticias en algo tan interactivo. No hay ninguna falla en la narración visual y la redacción es espectacular. El infográfico es denso pero fácil de seguir. Es divertido trazar el organigrama a través de los caminos posibles. Ayuda tanto que se querría como una verdadera guía de compras. La transformación de la idea inicial a la realización final es espectacular.

Times of Oman: Gold

FEATURE

TIMES OF OMAN
Muscat, Oman
Essa Al Zedjali, Chairman; **Ahmed Essa Al Zedjali**, CEO; **Adonis Durado**, Designer
GOLD
News Design Page(s)
Business/Broadsheet 49,999 and Under

GOLD

IT'S SO DIFFERENT THAT YOU HAVE TO DECODE IT. The page IS the illustration and you MUST appreciate the craftsmanship. It breaks rules of conventional presentation, and it is allowed, because that's how strong the concept is. They took a lot of chances and everything worked. We would love to think that we would have had this idea, but then we could just picture ourselves trying to sell it to our editors. Clearly this visual team has the confidence of those paying to put the paper out, and that in itself is an accomplishment. We've never seen a concept pushed so far, with so little to work with. It's not flashy — the concept is so pure, it's genius.

ORO

ES TAN DIFERENTE QUE ES NECESARIO DECODIFICARLO. La página ES la ilustración y SE DEBE apreciar la maestría de la confección. Rompe las reglas de la presentación convencional, lo que se permite debido a la fuerza del concepto. Tomaron el riesgo y lo lograron. Nos gustaría creer que esta idea fue nuestra, pero basta con imaginar lo difícil que sería proponerla a los editores. Queda claro que el equipo gráfico goza de la confianza de quienes pagan para producir el diario, y eso en sí es todo un logro. Nunca habíamos visto que un concepto llegara tan lejos con tan pocos recursos. No es ostentoso; el concepto es tan puro que es una genialidad.

FOR THE AUDITING INDUSTRY, the financial crisis was really not that bad. While nearly every other group involved in the financial system — banks, mortgage brokers, bond rating agencies, derivatives dealers and regulators — faced severe criticism and new legislation, auditors largely escaped unscathed.

There were, to be sure, a few discordant notes. The Lehman Brothers bankruptcy trustee blasted Ernst & Young for allowing Lehman to use a dubious accounting method to hide its leverage in the months leading to its demise, and the attorney general of New York filed fraud charges against Ernst. Robert Herz, then the chairman of the Financial Accounting Standards Board, complained that auditors had allowed banks to violate the rules on off-balance sheet entities in order to hide assets and liabilities.

But the Dodd-Frank law did nothing to the auditors.

That was in sharp contrast to the previous round of scandals — the Enron and WorldCom accounting frauds that led to the enactment in 2002 of the Sarbanes-Oxley law. That law established the Public Company Accounting Oversight Board (PCAOB) to audit the auditors. With a second set of eyes looking over their shoulders, it was hoped, auditors would do a better job. While auditors may be doing a better job, that does not necessarily mean they are doing a good one.

Recently James R. Doty, the new chairman of the PCAOB, let loose a blast at the job the profession had done — and was doing.

In a speech to the Council of Institutional Investors, Doty said the board had gone back and inspected the audits of many companies that later failed or were bailed out. "In several cases — including audits involving substantial financial institutions — PCAOB inspection teams found audit failures that were of such significance that our inspectors concluded the firm had failed to support its opinion," he said.

That is, it should be noted, not the same as saying the financial statements were wrong. It is possible that the audit firm did not do enough work to know if the statements were accurate but that they would have been acceptable even to a proper audit.

Moreover, as Doty noted, "Auditors were not charged with enforcing good risk management practices at financial institutions." But they were supposed to make sure the statements reflected the conditions at the time. That appears not to have happened at Lehman Brothers, at least when it came to leverage, and it might not have happened at other banks.

What's worse, the problems seem to be continuing.

In the wake of the financial crisis, no accounting issue has been more critical than the valuation of financial assets. In some cases, banks are now required to report the fair value — normally the market value — of securities they own. That is not easy for securities that rarely trade, and it was made all the harder by the complexity of some securities that Wall Street invented during the boom years. Banks claim, with some justification, that markets became unduly fearful at the height of the crisis, and that market values fell too low.

Investors and regulators could, if they chose, make allowances for depressed markets. But they need to be able to compare banks with one another, and to do that they need to have confidence that financial statements are comparable.

But the accounting oversight board does not think that has happened. In the board's report of its 2009 inspection of PricewaterhouseCoopers, which concerns 2008 audits conducted at the height of the financial crisis, the board wrote that "in four audits, due to deficiencies in its testing of fair values of investment securities and/or derivatives, the firm failed to obtain sufficient competent evidential matter to support its audit opinion."

It had similar complaints about each of the other members of the Big Four — KPMG, Ernst & Young and Deloitte & Touche.

Unfortunately for investors, the board has not revealed the names of any clients involved. Nor do the auditors appear to have gotten everything right in later audits, at least in Doty's view.

"Although the 2010 reporting cycle is not yet complete, so far PCAOB inspectors have continued to identify significant issues related to the valuation of complex financial instruments, among other areas," he said, adding that the "inspectors have also identified more issues than in prior years."

In 2002, when the auditing firms had been humiliated by audit failures, their efforts to prevent any regulation failed, but they did win one crucial victory in the details of the Sarbanes-Oxley law. The oversight board must keep secret its most critical assessments of audits unless a firm fails to respond to the criticism. And the board's disciplinary actions remain secret until they are resolved by the board and the Securities and Exchange Commission has ruled on any appeal.

It is as if the fact a man was suspected of robbing a bank had to be kept secret until after he was not only convicted but failed in his appeal. That secrecy was justified as necessary to protect reputations that could be tarnished by charges that might later be disproved. In practice, board officials complain, it has led to stalling tactics by firms that figure they can avoid negative publicity indefinitely. The board has asked Congress to change the law, but that seems unlikely.

In his speech this week, Doty said that several pre-crisis audits were "the subject of pending PCAOB investigations and may lead to disciplinary actions against firms or individuals," but he of course gave no details. As a result, all firms are tarred, not just those the board thinks acted irresponsibly.

To be fair, the accounting rules give the firms a difficult job in evaluating a bank's estimate of fair value of securities that rarely trade. Banks have some flexibility in determining how to make those estimates, and the auditor is supposed to satisfy itself that the methods used are reasonable. The board makes it clear in the publicly released sections of inspection reports that banks use varying methods.

As a result, even if every audit were done properly, there would be no assurance that the results would be comparable.

One reason the board exists is that investors were shocked by disclosures in the Enron scandal that local auditors for Arthur Andersen — the fifth member, now defunct, of what was then the Big Five — had felt free to ignore advice on accounting standards from the firm's technical experts, who worked in what is known in the industry as the national office.

Other firms assured me at the time that nothing comparable could happen in their operations.

But perhaps it can.

In his speech, Doty quoted from two assurances given by auditors to clients, and discovered by board inspectors. He did not name either firm involved.

One firm promised that the auditors on the scene would "support the desired outcome where the audit team may be confronted with an issue that merits consultation with our national office."

At least that firm seemed to leave open the possibility that the national office would prevail. Another pitch for audit work went further. It promised, Doty said, that audit decisions would be "made by the global engagement partner with no second guessing or national office reversals."

Abraham Briloff, a longtime professor of accounting at Baruch College and a critic of misleading accounting practices — and a man whose articles I had the honour of editing many years ago when I worked at Barron's — used to tell a joke about a chief executive interviewing prospective auditors and asking, "What is two plus two?"

The winner, he said, responded, "What number were you looking for?"

Now it is board audit committees, not chief executives, who are supposed to hire auditors. But the fact that accounting firms thought such promises would help — and were willing to put the pitches in writing — is evidence that too little has changed since the accounting oversight board was established.

One can hope most firms would never stoop that low to win business, and that most audit committees would summarily reject any firm that pursued such a course. But because board disciplinary actions can remain secret for years, we have no way of knowing which firm or firms have partners willing to make such offers, or which companies accepted them.

— FLOYD NORRIS / The New York Times News Service

BLOOMBERG BUSINESSWEEK
New York, N.Y.
Richard Turley, Creative Director; **David Carths**, Director of Photography; **Cynthia Hoffman**, Design Director; **Robert Vargas**, Art Director; **Jennifer Daniel**, Graphics Director; **Chandra Illick**, Designer; **Shawn Hasto**, Designer; **Maayan Pearl**, Designer; **Lee Wilson**, Designer; **Evan Applegate**, Graphic Artist
GOLD
Magazines
Features/Cover story design

GOLD

THIS SUCCINCT SUMMATION OF STEVE JOBS' IMPACT on society uses photos and Jobs' quotes to create an unconventional timeline. Getting to the essence of the subject more than words could, it shows how the products Jobs helped create are embedded in everyday life. The fact that the idea generation, photo editing and execution of this piece were on deadline makes it a home run. This kind of storytelling device, which continues from the cover through several inside pages, makes a huge editorial statement. The piece ends on the topic of family, a magical touch and — as we found out in the biography released after his death — so important to Jobs. It embodies every meaning of Gold.

ORO

ESTE ES UN SUCINTO RESUMEN DEL IMPACTO DE STEVE JOBS en el mundo a través del uso de fotos y citas de él para generar una línea de tiempo poco convencional. Se muestra la forma en que están insertos en la vida diaria los productos que Jobs ayudó a crear y así se logra llegar a la esencia del tema de mejor manera que con palabras. Es una verdadera goleada si se tiene en mente que la generación de la idea, la edición fotográfica y la puesta en página se hicieron al cierre. Este tipo de recurso narrativo, que se extiende desde la portada o tapa hasta varias páginas adentro, es una enorme declaración editorial. La pieza termina en el tema de la familia, un toque mágico y muy importante para Jobs según se dio a conocer en su biografía después de su muerte. Esta pieza cumple con la verdadera definición de la medalla de oro.

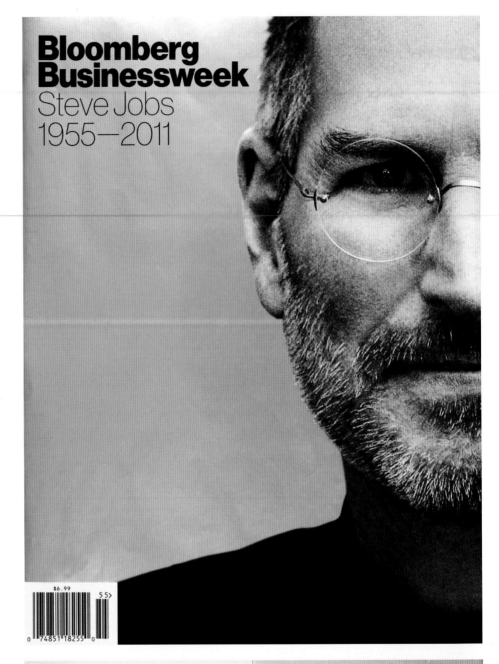

Bloomberg Businessweek
Steve Jobs
1955—2011

$6.99

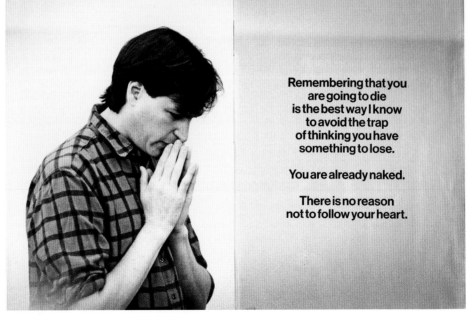

Remembering that you are going to die is the best way I know to avoid the trap of thinking you have something to lose.

You are already naked.

There is no reason not to follow your heart.

A lot of times, people don't know what they want until you show it to them.

Things don't have to change the world to be important.

Creativity is about connecting things.

When you ask a creative person how they did something, they may feel a little guilty because they didn't really do it, they just saw something.

But it's worth it in the end.

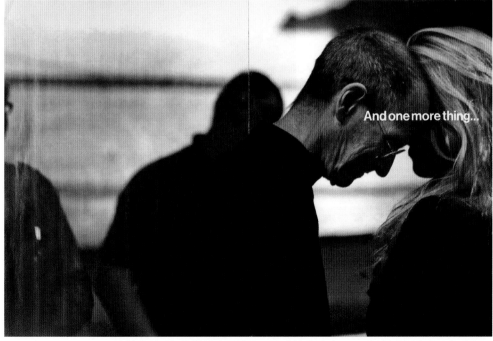

And one more thing...

LA (ARGENTINA) NACIÓN
Buenos Aires, Argentina
Pablo Bernasconi, Illustrator
GOLD
Illustration
Portfolio Individual

GOLD

THERE ARE SO MANY LAYERS TO THESE
ILLUSTRATIONS — the more you look
at them the more engaged you become.
Each detail combines to make a whole that
works. The likenesses are impressive, and
you instantly recognize the person being
portrayed. The use of collage is so innovative
that it feels like a completely new approach.
Each piece contains an Easter egg that
helps tell the story of the person, and each
illustration is a story in itself. The pieces
exude such wit and personality that you
feel engaged with the person who created
the illustrations. A strong voice emerges
throughout this work.

ORO

ESTAS ILUSTRACIONES TIENEN TANTAS
CAPAS QUE MIENTRAS MÁS SE MIRAN,
más detalles saltan a la vista y más se cautiva
la atención. Los detalles se combinan
para formar un total que funciona bien.
Los parecidos son impresionantemente
buenos; de inmediato se reconoce a la
persona retratada. Este uso del collage es
tan innovador que se ve como un enfoque
completamente novedoso. Cada pieza
contiene un huevo de Pascua que ayuda
a contar la historia de la persona, y cada
ilustración es una historia en sí misma. Estas
piezas secretan tanto ingenio y personalidad
que hacen sentirse confraternizado con el
creador de las ilustraciones. De este trabajo
emerge una voz potente.

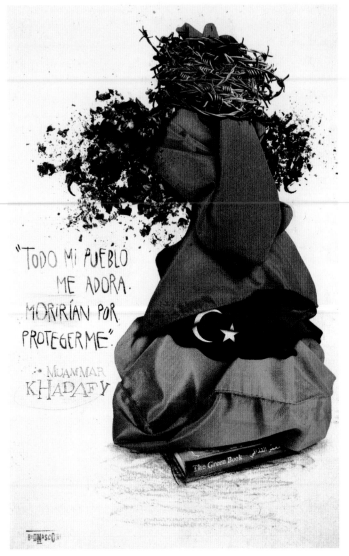

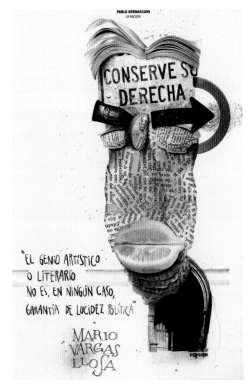

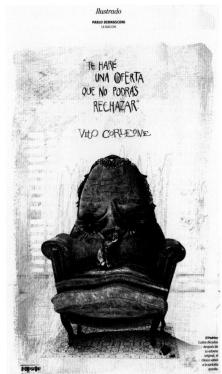

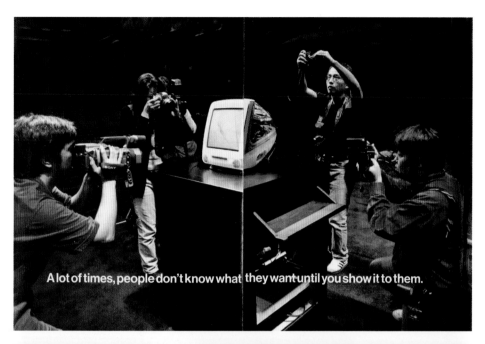

A lot of times, people don't know what they want until you show it to them.

Things don't have to change the world to be important.

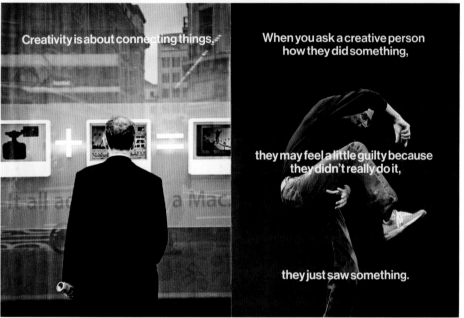

Creativity is about connecting things.

When you ask a creative person how they did something,

they may feel a little guilty because they didn't really do it,

they just saw something.

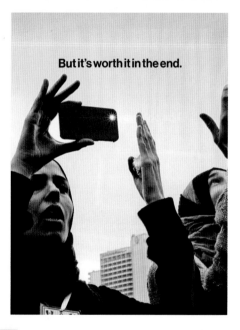

But it's worth it in the end.

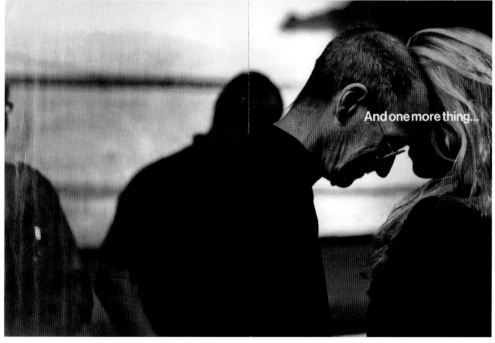

And one more thing...

LA (ARGENTINA) NACIÓN
Buenos Aires, Argentina
Pablo Bernasconi, Illustrator
GOLD
Illustration
Portfolio Individual

GOLD

THERE ARE SO MANY LAYERS TO THESE ILLUSTRATIONS — the more you look at them the more engaged you become. Each detail combines to make a whole that works. The likenesses are impressive, and you instantly recognize the person being portrayed. The use of collage is so innovative that it feels like a completely new approach. Each piece contains an Easter egg that helps tell the story of the person, and each illustration is a story in itself. The pieces exude such wit and personality that you feel engaged with the person who created the illustrations. A strong voice emerges throughout this work.

ORO

ESTAS ILUSTRACIONES TIENEN TANTAS CAPAS QUE MIENTRAS MÁS SE MIRAN, más detalles saltan a la vista y más se cautiva la atención. Los detalles se combinan para formar un total que funciona bien. Los parecidos son impresionantemente buenos; de inmediato se reconoce a la persona retratada. Este uso del collage es tan innovador que se ve como un enfoque completamente novedoso. Cada pieza contiene un huevo de Pascua que ayuda a contar la historia de la persona, y cada ilustración es una historia en sí misma. Estas piezas secretan tanto ingenio y personalidad que hacen sentirse confraternizado con el creador de las ilustraciones. De este trabajo emerge una voz potente.

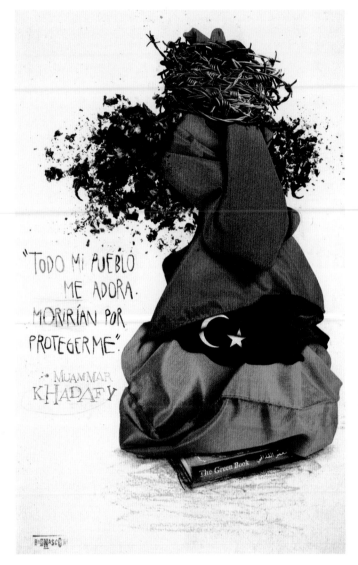

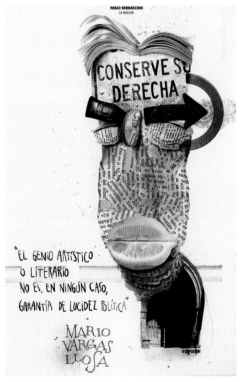

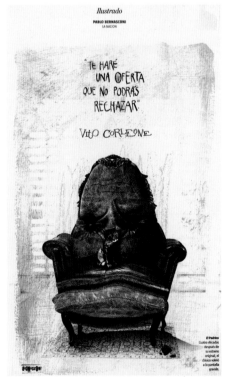

Los Angeles Times: Silver

LOS ANGELES TIMES
Los Angeles, Calif.
Michael Whitley, A.M.E.; **Paul Gonzales**, Deputy Design Director; **Wes Bausmith**, Deputy Design Director; **Kirk Christ**, Designer; **Jan Molen**, Designer; **An Moonen**, Designer; **Joey Santos**, Designer; **Kelli Sullivan**, Deputy Design Director; **Steve Hawkins**, Deputy Design Director; **Calvin Hom**, Deputy Photo Editor
SILVER (2)
News Design Page(s)
Editor's Choice: Local/Regional
Other/Broadsheet 175,000 and Over

SILVER

THEY COVER THE OSCARS EVERY YEAR, and somehow always manage to make it spectacular and bring something new to the presentation. They dig into this event, which nearly everyone watches, and find moments and sew them together into something that makes all the buildup worth it. Both the photo editing and the use of those photos — all done on deadline — are amazing. The pacing is excellent, with a strong beginning and ending.

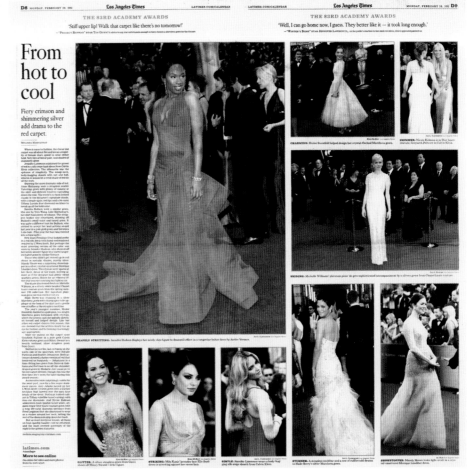

PLATA

ESTE DIARIO CUBRE LOS PREMIOS ÓSCAR CADA AÑO, y de alguna forma siempre logra hacerlo de forma espectacular y de darle algo nuevo a la presentación. Le hincan el diente a este evento, que casi todo el mundo sigue por la TV, logran encontrar los momentos clave y los unen generando algo que hace valer la pena el bombo que tiene. La edición fotográfica y el uso de esas imágenes, todo hecho al cierre, es sorprendente. El ritmo del relato es excelente, con un comienzo y un final igualmente fuertes.

LOS ANGELES TIMES
Los Angeles, Calif.
Kelli Sullivan, Deputy Design Director; **Michael Whitley**, A.M.E.; **Dan Santos**, Designer;
Mark Yemma, Designer; **Gerard Babb**, Designer; **Lorraine Wang**, Designer; **Rick Collins**, Designer;
Steve Stroud, Photo Editor; **Robert St. John**, Photo Editor; **Mary Vignoles**, Photo Editor
SILVER (2)
Special News Topics
Japan Earthquake
Breaking News Topics
Japan Earthquake

SILVER

THIS PIECE SETS THE STANDARD for covering a disaster, and it wasn't in their backyard — it was across the world. The photo editing is impeccable. Whether played large or small, the scale of the photos is perfect. The scale of the headlines is also spot on and remarkably consistent. These pages are designed exactly the way they should be and are made to be read — no gimmicks. They picked the very best photographs, and each one is there for a reason. From urgent to explanatory, the pictures tell the complete story.

This is phenomenal work on deadline. They mined all the photo sources to show a different story at a time when everybody else in the world was racing to do the same thing. They battled over story lengths and photo edits in pursuit of packing in more detail. It's difficult to achieve this level of pacing, structure and flow on deadline.

PLATA

ESTO FIJA EL ESTÁNDAR PARA cubrir un desastre, aunque no haya ocurrido en la zona de cobertura de este diario, sino al otro lado del planeta. La edición fotográfica es impecable y la escala de las fotos –grandes y chicas– es perfecta. La escala de los títulos es precisa y sorprendentemente consistente. Estas páginas han sido diseñadas tal como deberían ser leídas, sin trucos ni montajes. Se seleccionaron las mejores fotos para narrar el tema; cada una está justificada y en conjunto relatan toda la historia, desde lo urgente a lo explicativo.

Esto es un tremendo trabajo al cierre. Se buscó en todas las fuentes fotográficas para mostrar un tema diferente, mientras todo el mundo corría para hacer lo mismo. Se enfrentaron con las extensiones de los temas y las ediciones fotográficas para intentar incluir un mayor detalle. Es difícil lograr al cierre este nivel de ritmo narrativo, estructura y flujo.

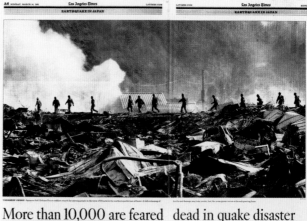

EARTHQUAKE IN JAPAN

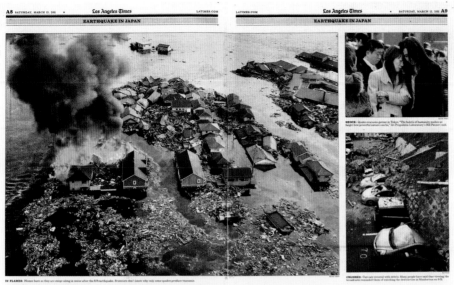

IN FLAMES: Homes burn as they are swept along in water after the 8.9 earthquake.

SHOCK: Quake evacuees gather in Tokyo.

CRUSHED: Cars are covered with debris.

Years of preparing go only so far in 8.9 quake

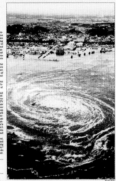

TSUNAMI'S FORCE: A boat spins in a whirlpool off Oarai, Japan.

Spellbound, yet unable to help

How tsunamis form

Los Angeles Times

SHOCK AND FURY

The world can only watch as Japan tragedy unfolds

DEVASTATION: Waves from the 8.9 quake engulf coastal homes.

Years of drills are no match for 8.9

Deadly waves

A wired planet sees the horror as it happens

Refineries' shutdown may boost oil prices

A powerhouse, upside down

Event has reach to the West Coast

EXPANDED COVERAGE IN LATEXTRA

latimes.com The latest news is available online

Another part of old Las Vegas vanishes

Obama vows to squeeze Kadafi out

AA6 — EARTHQUAKE IN JAPAN

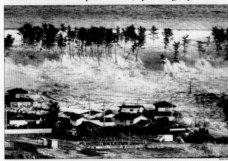

TO SAFETY: A helicopter crew rescues a person from the roof of a school in Sendai.

SHELTER: A woman and child join others taking refuge at the Tokyo Forum theater the day after the massive quake struck Japan.

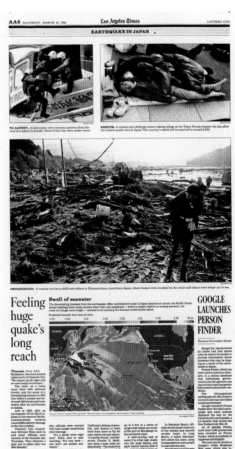

DEVASTATION: A woman carries a child over debris in Rikuzentakata.

Feeling huge quake's long reach

Swell of seawater

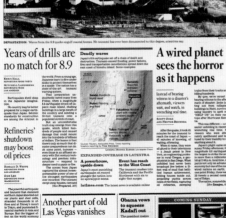

GOOGLE LAUNCHES PERSON FINDER

YOU'VE REACHED THE MOBILE PHONE
VOICE MAIL FOR MARK BINGHAM.
LEAVE A MESSAGE AND I'LL RETURN YOUR CALL.
YOU HAVE 44 UNHEARD MESSAGES. FIRST MESSAGE:

BayAreaNewsGroup SUNDAY, SEPTEMBER 11, 2011

On Sept. 11, 2001, while Mark Bingham and his fellow passengers were overpowering the hijackers of Bay Area-bound United Flight 93, friends and family began frantically calling his cellphone, leaving behind voice mails he would never hear, each more heartbreaking than the last. The worried callers echoed the shock of a nation and provided a chilling record of the fear and, ultimately, the American resolve of that day.

Hey, Mark, Amanda. Where are you? Call me — please.

Hi, Mark, this is Judy. I don't know if you're flying or what because I just heard that all the plane traffic has been grounded today after the

attack

in New York and in Washington. I hope I can reach you, anyway, today. I just would like to know if you are in the air or what's happening, and it's very worrying with these things.

HEY, MARK, IT'S KEN. I AM ABSOLUTELY IN

SHOCK

RIGHT NOW. I CAN'T GET OVER THIS, WHAT'S HAPPENING. I AM IN WALNUT CREEK AT GARY'S HOUSE. WHY DON'T YOU GIVE ME A CALL HERE? MY GOD, THIS IS JUST DEVASTATING. I CAN'T BELIEVE THIS.

Hey, Mark, this is Dad, just calling to see how you're doing. I'm looking at that

big wreck.

Man, I hope you're not too close to that. Give me a call when you can.

MARK, THIS IS YOUR MOM. ... THE NEWS IS THAT IT'S BEEN

HIJACKED BY TERRORISTS.

THEY ARE PLANNING TO PROBABLY USE THE PLANE AS A TARGET TO HIT SOME SITE ON THE GROUND. IF YOU POSSIBLY CAN, TRY TO OVERPOWER THESE GUYS, IF YOU CAN, 'CAUSE THEY'LL PROBABLY USE THE PLANE AS A TARGET. I WOULD SAY GO AHEAD AND DO EVERYTHING YOU CAN TO OVERPOWER THEM, BECAUSE THEY'RE HELLBENT. TRY TO CALL ME BACK IF YOU CAN. YOU KNOW THE NUMBER HERE. OK. I LOVE YOU, SWEETIE, BYE.

Mark, apparently it's terrorists and they're

hellbent

on crashing the aircraft.

So, if you can, try to take over the aircraft. There doesn't seem to be much plan to land normally, so I guess your best bet would be to try to take it over if you can, or tell the other passengers. There's one flight they say is heading to San Francisco. It might be yours. If you can, group some people and perhaps do the best you can to get control of it. I love you, Sweetie. Good luck. Bye.

HEY, MARK, IT'S TODD. CAN YOU GIVE ME A CALL AND LET ME KNOW YOU'RE OK WHEN YOU GET A CHANCE? I'M WATCHING ALL THIS ... ON THE NEWS. OK. BYE.

Mark Bingham, it's Paul Etto. It's 8:45 West Coast time. Just saw all the news, wanted to check how you're doing. Hope you're OK. I'm sure you'll call your mom at Kathy's. Talk to you later. Bye.

Hey, it's Todd. Just give me a call when you get a chance. Sorry to call again, but a little

freaked out

watching all this stuff. And, I know, you know, anyway, just give me a call when you can.

MARK, IT'S JIM. I'M JUST TRYING TO GET A HOLD OF YOU EVERYWHERE. THANKS.

Hi, Mark, this is Judy calling. This is Tuesday, Pacific time, quarter to 10 in the morning, and, um, Peer-Olaf and I are worried about you, so please give one of us a call as soon as you can. There's a lot of

conflicting reports about flying

and things like this and we just want to know where you are, OK? So please give us a call. Thanks.

MARK, IT'S TOM. JUST CALLING TO MAKE SURE THAT YOU AND AMANDA ARE ALL RIGHT. IF YOU GET THE MESSAGE, GIVE ME A CALL AT HOME. I'LL BE HERE UNTIL ABOUT 3. I'LL TALK TO YOU LATER.

Hey, what's up dude? This is Damon. I'm watching the crazy ... on the news. Um, I just want to call and make sure you and Amanda are OK. Anyway, give me a call back later. Talk to you later. Bye.

MARK, IT'S JEFF DAVIS. IT'S TUESDAY. DON'T KNOW IF YOU'RE IN THE CITY.

JUST CHECKING TO SEE IF YOU'RE OK AND HOPEFULLY YOU ARE.

UNBELIEVABLE

TRAGEDY THAT HAPPENED TODAY AND JUST CALLING THE PEOPLE I KNOW IN

NEW YORK TO MAKE SURE EVERYTHING'S OK. I HOPE TO TALK TO YOU SOON. BYE.

Hey, Mark, this is Dave Robertson. We of course have heard the news of what's going on in New York and just wanted to make sure you're OK. So, if you could just give us a quick call back and let us know, either through email or phone call or whatever, that you're OK, would appreciate it. A couple guys are asking about it.

HOPE YOU'RE

OK

AND GOD BLESS

Hey, Mark, it's Bryce. Just calling to check up on you and also let you know a couple of guys on the rugby team have kind of put out feelers on our website. Just wanted to know how you are. So, if you could just shoot a message to the bigger or let me know you're OK and I'll put up a message. That would be great. Talk to you soon. Bye.

Hey, Mark. It's Mark Wain calling. It's about five minutes to 11, my time, and I just wanted to call and make sure everything is OK with you. Give me a call back when you get a chance. Talk to you later. Bye.

BINGHAM, PETROVICH. WHAT'S GOING ON? UM, AH,

THAT DAY, THAT MORNING'

AND I'M WONDERING WHERE THE HELL YOU ARE AND HOPING TO GOD THAT YOU AND AMANDA ARE SAFE AS WELL AS, YOU KNOW, EVERYBODY ELSE THAT WE KNOW AND LOVE. MY MOBILE IS HARD TO GET THROUGH TO ME ON. YOU CAN REACH ME AT EITHER THE OFFICE OR YOU COULD TRY AND REACH ME AT CARL'S. I'M GOING TO HANG WITH HIM, EVEN THOUGH I DON'T LIVE THERE ANYMORE. I'LL BE ONE PLACE OR THE OTHER. JUST LET ME KNOW YOU'RE OK, ALL RIGHT? I'LL SPEAK TO YOU SOON.

MARK, IT'S COREY. I'M JUST CALLING TO SEE IF YOU'RE OK. BYE.

Hey Mark, it's Jason. Just trying to get a hold of you, make sure you and Amanda are OK. Give me a call back. Talk to you later. Bye.

HEY, MARK, THIS IS MARY, DAMON'S MOM. JUST TRYING TO CHECK OUT, MAKE SURE THAT YOU AND AMANDA ARE OK. IF YOU HAVE A CHANCE, TRY TO GIVE DAMON A CALL BECAUSE, UM, HE'S A LITTLE CONCERNED, SO, HOPEFULLY ALL IS WELL WITH YOU AND YOU WERE NOWHERE NEAR THE

TRAGEDY

TODAY. I'LL TALK TO YOU LATER. BYE-BYE, SWEETIE.

Hey, Mark, it's Joe. I just want to make sure you're OK. If you could drop me a line and let me know, I'm just trying to check in on everyone, and make sure they're OK, that I know out there. So if you could give me a call, I'd greatly appreciate it.

Mark, it's Dario. Please send me an email or something. I want to know how are you? I'm too, I'm too, uh, no peace.

MARK, IT'S STEVEN. I WAS JUST CALLING. I DIDN'T KNOW IF YOU WERE IN NEW YORK OR NOT. BUT I WAS JUST CALLING TO MAKE SURE YOU'RE OK. GIVE US A CALL. LEAVE A MESSAGE AT THE HOUSE OR SOMETHING. UM, SPEAK TO YOU SOON. BYE.

HEY, MARK, IT'S JIM. IT'S 3:30 ON TUESDAY AND I'M

REALLY PRAYING

YOU'RE OK, BUDDY.

I'M WORRIED. ANYWAY, UM, CALL ME, YOU KNOW, SOMEWHERE, LEAVE ME A MESSAGE ANYWHERE, ANYTIME. I DON'T CARE. UM, JUST TO LET ME KNOW YOU'RE OK. THANKS. I HOPE YOU'RE OK, BYE.

Hey, Mark. It's Bryce.

Um.

Please give me a call as soon as you get this message. I hope you're OK. Bye.

HEY, MARK. IT'S STEVEN. I JUST WAS HOPING I COULD GET IN TOUCH WITH YOU, BILL AND I ARE A LITTLE

WORRIED

ABOUT YOU. GIVE US A CALL AS SOON AS YOU GET THIS. LET US KNOW YOU'RE OK. WE'LL SPEAK TO YOU SOON. BYE.

Mark, this is Tom Bilbo. I was just giving you a call trying to see if you're OK. I heard your name, or someone with your name, mentioned on the news and just wanted to try to get a hold of you. Anyway, I'll try to reach you later.

HEY, MARK. THIS IS JOHN. JUST CALLING TO SEE WHAT YOU ARE UP TO. YOU CAN REACH ME AT HOME. THANKS. BYE.

Hello? Um. This message is for the family of Mark Bingham. My name is Randa Steble. I'm calling on behalf of the child care centers in Washington, D.C. I run a large child care center in Washington, D.C., next to the White House. There are many other child care centers in that area. I want to commend the heroism of Mark Bingham. Without Mr. Bingham, we might have been targeted. We are right near the White House, right next to the White House. God bless you. Our sympathies and our sadness are there. We are very, very wanting to communicate with the family of Mark Bingham, his mother, his aunt, his nephews, nieces, and we ...

I'm a fr— was a friend

of Mark's and I just saw his picture across the CNN. If this gets to Mark's mother, please accept my condolences. I spent a few days with Mark last week.

Uh, I don't know who will get this message, but this is David Smith.

HEY, MARK. IT'S RICH DALTON. WE MET DOWN IN NEW ORLEANS. I WAS JUST CALLING TO MAKE SURE YOU'RE OK AND HOPE EVERYTHING IS OK.

IN ALL THIS MESS.

HOPE EVERYTHING'S OK.

commend his heroism.

It could have been a direct hit on the White House and also upon the lives of these little children, numbering in the hundreds. I run the Osel School in Washington, D.C., Northwest. And if anyone needs our help for anything, my staff, my parents, myself. My name is Randa Steble. God bless you all. Bye.

BY JULIA PRODIS SULEK

Her voice was shaking, pleading. ... Mark Bingham was still alive and United Flight 93 was still in the air that Sept. 11 morning 10 years ago when his housemate, Amanda Mark, left the message on his cellphone. It was the first of dozens of plaintive messages recorded that day on Bingham's black flip phone — a phone he likely left in his first class seat after terrorists hijacked the plane and herded the passengers to the back. The calls kept coming, each more frantic and heartbreaking than the last, unaware that Bingham and his fellow passengers were taking action that would turn them instantly into American legends. ... The calls came from his childhood buddies in San Jose, a business colleague in Portola Valley, his old fraternity brothers from Cal, rugby teammates from San Francisco. Without realizing it, as the twin towers at the World Trade Center were collapsing and the Pentagon was burning, the callers were leaving behind a chilling historical record of the confusion, fear and American resolve of that day.

After 9-11, Bingham's mother, Alice Hoagland ... searching for a way to stay close to him ... got the code for her son's cellphone and preserved his final messages on an old cassette tape, of top.

SAN JOSE MERCURY NEWS
San Jose, Calif.
Tiffany Grandstaff, Design Director; **Alex K. Fong**, Deputy Design Director; **Jami Smith**, Picture Editor; **Ron Kitagawa**, M.E./Production; **Margaret Bethel**, Copy Chief; **Tim O'Rourke**, Copy Chief; **John Swartley**, Copy Editor
SILVER (2)
Special Coverage/Sections
News/Cover Only
Special News Topics
September 11 Anniversary
AWARD OF EXCELLENCE
News Design Page(s)
Other/Broadsheet 175,000 and Over

SILVER

THIS IS ONE OF THE MOST EMOTIONAL PAGES we saw involving the anniversary of 9/11. It's an unexpected way to remember the day. Every detail is perfect; the type is intricately pieced together. It makes you want to read every word. This is an excellent example of what great visual journalism can do. It lets the voices of people tell the story, which builds throughout the page. You can't help but feel it all over again.

PLATA

ES UNA DE LAS PÁGINAS MÁS EMOTIVAS que vimos sobre el aniversario de los atentados del 11-S. Es una forma inesperada de recordar ese día. Cada uno de los detalles es perfecto y la tipografía está intrincadamente reunida, con lo que dan ganas de leer cada una de las palabras. Este es un excelente ejemplo de lo que puede lograr el periodismo visual, porque permite que las voces de la gente puedan contar la noticia a través de la página. No se puede evitar volver a sentirlo de nuevo.

LOS ANGELES TIMES
Los Angeles, Calif.
Brian Van der Brug, Photographer; **Robert St. John**, Photo Editor; **Kelli Sullivan**, Deputy Design Director; **Michael Whitley**, A.M.E.
SILVER (2)
Photography/Multiple Photos
Series/Project or Story
Portfolio/Page Designer (Kelli Sullivan)
News 175,000 and Over

SILVER

IT'S VERY HARD TO GET THIS LEVEL OF ACCESS TO A SUBJECT; it takes time and effort. The lighting, the details and the different perspectives create a powerful body of work. The photography goes a long way toward portraying someone who would not otherwise be humanized in media coverage, creating a story arc that is really well told.

PLATA

ES MUY DIFÍCIL TENER ESTE NIVEL DE ACCESO A UN SUJETO, porque toma tiempo y esfuerzo. La iluminación, los detalles y las diversas perspectivas generan un potente trabajo. La fotografía llega lejos al retratar a alguien que de otra forma no recibiría un trato humano de parte de los medios. Como arco narrativo, este relato fotográfico está muy bien contado.

CARE AND ATONEMENT

Photographs by BRIAN VAN DER BRUG Los Angeles Times

A PASTORAL CARE WORKER comforts a dying inmate at the California Medical Facility in Vacaville. It was inside these walls that John Paul Madrona forged a bond with Freddy Garcia, who was serving nine years for robbery and who had terminal cancer.

Trying to make things right

Tending to ill and dying inmates in a prison hospice helped John Paul Madrona do penance for a terrible deed in his youth. But perhaps the work was not enough.

Kurt Streeter
FIRST OF TWO PARTS

The two men walked slowly through the steel-framed door, the older one leading the younger. The door slammed shut behind them.

"Don't worry," said the older man, John Paul Madrona. "It's true people die here, but we help them."

"What's it going to be like?" Freddy Garcia asked.

They passed a row of rooms filled with men in their 50s, 60s and 70s. Most had committed horrendous crimes and would spend their final days in this small wing of the California Medical Facility, a high-security prison at the base of rolling hills near Sacramento. The facility housed roughly 3,000 criminals: some in good health, some ill, some dying.

In the hospice, the oldest inside a California prison and one of the nation's first, some of the dying men looked robust, as if defying their illnesses. Some were hunched and gaunt. One stood in a corner, a mound of flesh jutting from his neck. Inscribed on the fingers of his right hand was LOVE, on the other, HATE. He glared as Garcia walked across the worn linoleum.

"This is going to be the best place for you now," said Madrona, a healthy inmate who had worked at the hospice for two years.

"Six months," Garcia replied. That was how much time a doctor had given him. He grimaced. He was now the hospice's youngest patient, only 24 and with colon cancer. [See Hospice, A24]

MADRONA, A CONVICTED killer who is trying to turn his life around, is pensive during eulogies for recently deceased inmates.

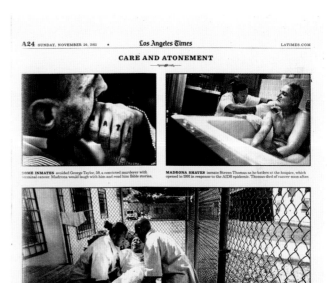

A24 SUNDAY, NOVEMBER 20, 2011 • Los Angeles Times LATIMES.COM

CARE AND ATONEMENT

SOME INMATES avoided George Taylor, a convicted murderer with terminal cancer. Madrona would laugh with him and read him Bible stories.

MADRONA SHAVES inmate Steven Thomas as he bathes at the hospice, which opened in 1991 in response to the AIDS epidemic. Thomas died of cancer soon after.

MADRONA AND Sean Reece lift Richard Curry from a bed on the hospice patio. When an inmate's last days arrive, at least one care worker sits vigil day and night.

His search for redemption

[Hospice, from A1]

The tattoo on his head glistened with sweat, but he pulled out his chest, trying to act tough. To Madrona, 35, he seemed like a mixed-up kid — the kind Madrona had been years before.

"We will take care of you," Madrona said. "No matter what, I will be here for you."

Maybe by helping Garcia, he thought, he could make amends for the terrible thing he had done as a young man. Maybe he could find redemption.

John Paul Aranas Madrona was born in the Philippines in 1975, the third son of a prison guard who prayed that he would grow up to become a priest.

A sweet-natured child, he was raised in large part by his maternal grandmother, Lourdes. Everyone who met him loved her too, and he loved her back. But his mother and father dreamed of America, and as his teens approached he was on a plane to Los Angeles with his parents, sister and older brothers.

The family settled into a cramped apartment in Redondo Beach, and John Paul, dark-skinned and shy, became a target for roving gangs. They would corner him and beat him. One day on the playground, he fought back; before long, he had gained a reputation for his fists. He joined the local Royal Brotherhood, a Filipino gang based in Carson. He convinced himself that if a bullet flew in a gang fight he would take it, just to earn his stripes.

On a November night in 1993, Madrona and another gang member named Jeremiah DeGuzman went to an apartment in Gardena and banged on the door. Tracy Takahashi was inside. A 26-year-old environmental chemist, Takahashi had many friends who sometimes would stop by unannounced. He walked to the door, slid back a lock and opened it.

Without pause, Madrona and DeGuzman raised handguns and fired rapidly. One bullet pierced Takahashi's forehead. When Madrona was caught two weeks later, he realized his mistake. He had gone to shoot a rival gang member. But Takahashi wasn't in a gang, not even close. Madrona and DeGuzman had gone to the wrong door.

A year later, after a jury found the two men guilty of murder, Madrona sat in a Torrance courtroom as the judge read a letter from Takahashi's brother, Dean, then a business reporter at The Times:

I've often wondered what I would say if I had a chance to confront [Tracy's] killers as they pleaded for leniency. They have no reason to fear me ... I don't believe in mercifully retaliation. I would ask them to think about what they've done ... When you pull the trigger, it shatters the bonds that connect the lives of dozens of people together ... You have to realize that you look from this earth sometime who was loved dearly. Think about that for a long time. And turn your life around, whether you're in jail or not. No excuses.

The judge sentenced both men to 39 years to life. Madrona entered prison, a 19-year-old trying to mask insecurity with arrogance. But as he grew older, he began to sit alone in his cell and reconsider his life. He replayed his crime, and over and over the thought of Dean Takahashi's letter and imagined Tracy Takahashi living a good and fruitful life if not for him.

One day in the mid-1990s, he and his grandmother spoke by phone. "When are you coming home?" she asked. He'd never told her he was in prison. Weeks later, Lourdes died. His vow to care for her would never be fulfilled. He knew then that he had to change. But how?

Around that time, an inmate asked him to join in a gang fight. Instead, he headed to the prison chapel and prayed to become a different man.

Eventually, he immersed himself in group counseling and took college correspondence courses. Long animated about faith, he became a devoted Christian, attending every worship service he could. He began walking without his strut, stopped cursing and grew out the hair he'd worn for years in the close-cropped style favored by gangs. Prison guards considered him a model inmate.

"These men are not pleasant to look at," the chaplain explained matter-of-factly. "How could they do what they did?"

"But Jesus was asked: 'How many times should I forgive?' Seventy times seven' is what he said. And when you realize Jesus died alongside criminals, to me it makes sense to be here."

Roughly a dozen inmates worked for Knauf. Most were convicted murderers. The chaplain raided them his Pastoral Care Workers. After a series of interviews and background checks — to screen for troublemakers, drug users or serial predators — he chose them, trained them, mentored them and leaned on them to give the hospice heart.

They massaged aching hands, scrubbed urine-soaked floors, walked sickly men to showers, read to them from magazines and letters, Bibles, Tswalu and Koran. Trust, uncommon among prisoners, was built. Whiter helped blacks. Latinos helped Asians. Bloods gangbangers helped Crips.

When an inmate's last days arrived, at least one care worker sat vigil day and night. No prisoner, they vowed, would die alone.

Madrona hoped to join these men. Becoming a care worker might help him prove to himself that he could treat death with respect, just as he'd promised to do for Lourdes. Maybe it could be his path toward redemption.

When he applied, Knauf told him there would be peaceful, poignant, even spiritual moments. There would also be gruesome nights, nauseating smells and the curdling shrieks of frightened men.

Each month, on average, five inmates died.

The job, Knauf said, would humble him. Could Madrona handle it?

The chaplain looked across his desk and saw a quiet, starkly handsome man. Madrona had thick wrists, dark eyes and long black hair pulled neatly into a ponytail. He looked both physically strong and deeply sad. "No matter what," Madrona told the chaplain, "I will be there for you."

When he arrived in March 1998, and Madrona was glad at his job life. "There's not a guy among our dying prisoners who does not find [See Redemption, A25]

FREDDY GARCIA, suffering from colon cancer, prepares to change his colostomy bag. He'd been a member of the Varrio Keystones, a Carson gang. He and Madrona had a lot in common.

Photographs by BRIAN VAN DER BRUG Los Angeles Times

THE GRID
Toronto, Ont., Canada
Vanessa Wyse, Creative Director; **Shelbie Vermette**, Photo Editor; **Mark Zibert**,
Photographer; **Diana Monge**, Photographer; **Michael Crichton**, Photographer;
Adam Cholewa, Associate Art Director; **Matt Barnes**, Photographer
SILVER (2)
News Design Page(s)
A-Section/Compact 50,000-174,999
News Design Page(s)
A-Section/Compact 50,000-174,999

SILVER

THIS LIVELY PRESENTATION works on
many levels — it's beautiful, informative and
fun. There are many tools used to tell these
stories — from photo to graphic to narrative
driven — and each idea is executed with
precision. The pieces flow together because
of the cohesive colors and tones. They look so
simple, but several of these photo spreads are
extremely difficult to pull off. It's incredible
that a free publication was able to devote this
many open pages to the package.

How many publications would think of this
and then execute the photo shoot this well?
It's funny, clever, daring — one of those
unique ideas that makes you laugh and
smile. But without the perfect planning and
execution, it would have fallen flat on its face.

PLATA

ESTA ANIMADA PRESENTACIÓN funciona
en varios niveles: es hermosa, informativa
y divertida. Se usan muchas herramientas
para contar estos artículos, desde la
fotográfica hasta la infográfica y la narrativa
textual, y cada idea está realizada a la
perfección. Las piezas fluyen en conjunto
gracias a la cohesión de los colores y tonos.
Se ven tan simples, pero es extremadamente
difícil lograr varias de estas doble páginas
de fotografía. Es increíble que un periódico
gratuito haya sido capaz de dedicar tantas
páginas abiertas a este paquete informativo.

¿A cuántos periódicos se les ocurriría esto y
luego realizarían una toma fotográfica así de
bien? Es divertida, astuta y atrevida; una de
esas ideas únicas que hacen reír y sonreír.
Eso sí, habría fracasado sin una planificación
y una ejecución a la perfección.

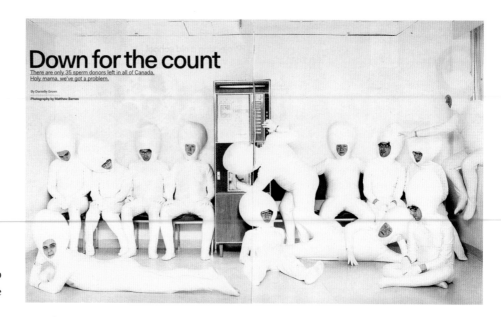

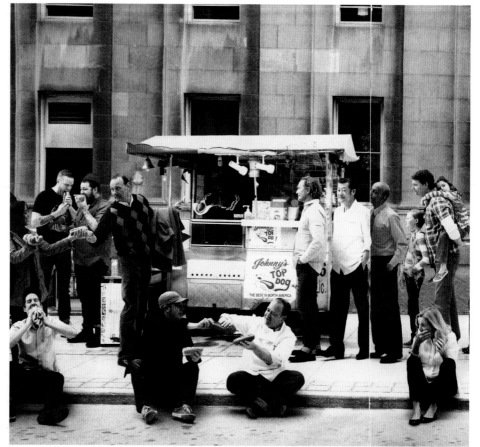

Politiken: Silver

POLITIKEN
Copenhagen, Denmark
Politiken Design Staff
SILVER
News Design/Sections
A-Section 50,000–174,999

SILVER

THESE REMARKABLY CONSISTENT, beautifully constructed sections go above and beyond on every page. They combine a balance of illustration and photography to create surprises throughout. There aren't a lot of big-splash images, but even the secondary images have strong value. The ads don't take over — they're a part of the design and proportionate to the size of the page. In many other papers, the interesting content is only up front, but you'll be entertained all the way through these sections.

PLATA

ESTAS SECCIONES EXCEPCIONALMENTE CONSISTENTES y bellamente construidas fueron más allá de lo esperado en cada página. Combinan un equilibrio entre la ilustración y la fotografía que genera sorpresa en su totalidad. No hay muchas imágenes impresionantes, pero incluso las secundarias son muy valiosas. Los avisos publicitarios no se apoderan de la página, sino que son parte del diseño y están bien proporcionados. En muchos otros diarios, el contenido que interesa solo está adelante, pero en estas secciones uno se entretiene de punta a cabo.

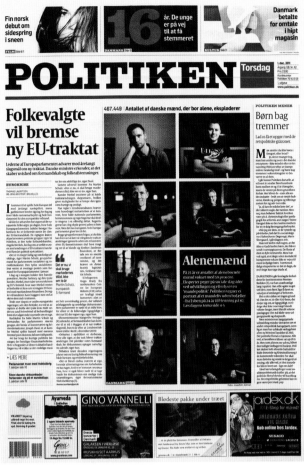

DAGENS NYHETER
Stockholm, Sweden
Nicolaus Daun, Page Designer; **Christian Ferrera**, Page Designer
SILVER
News Design Page(s)
A-Section/Compact 175,000 and Over

SILVER

THIS IS AN IMPORTANT STORY THAT MANY PUBLICATIONS ATTEMPTED TO COVER, but none covered as well. The editing and pacing are impressive in these three very different spreads, which approach the story from multiple angles. There's the emotional pull of the photos, the layering within the graphic, the subtle use of color and the expert use of page size. It's a complete package that makes you want to spend time reading it.

PLATA

ESTE ES UN IMPORTANTE TEMA QUE MUCHOS PERIÓDICOS INTENTARON CUBRIR, pero no tan bien como este. La edición y el ritmo son impresionates en estas tres páginas dobles tan diferentes que enfocan el tema desde varios ángulos. Las fotos tienen fuerza o jalón emocional, el infográfico tiene capas, el uso del color es sutil y el tamaño de la página se emplea a la perfección. Es un paquete informativo completo que invita a pasar tiempo leyéndolo.

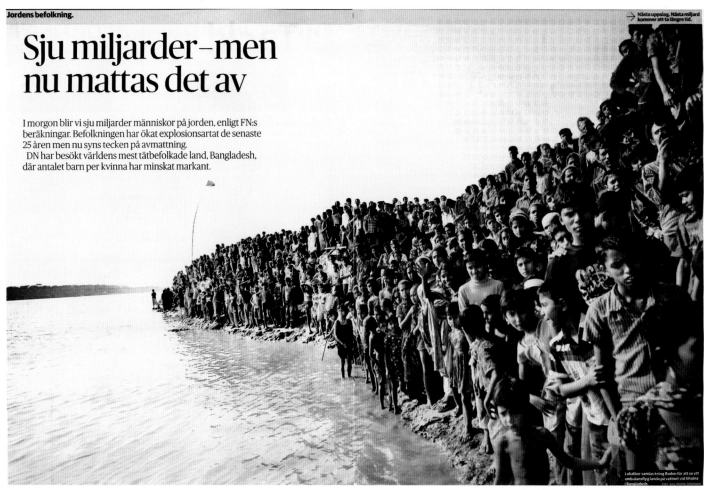

Bergens Tidende: Silver

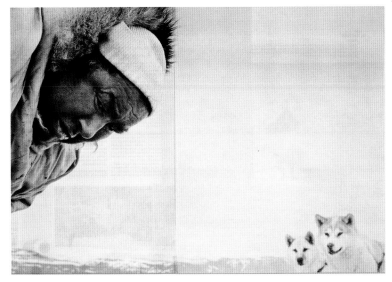

BERGENS TIDENDE
Bergen, Norway
Anneli Solberg, Designer
SILVER
Magazines
Features/Inside Page Design

SILVER

EVERY STUNNING PHOTO REVEALS an incredibly stark scene, and the pages match that tone. Rather than trying to fill every available inch, they let the photos be the size they ought to be. The crops stand out because of that. The choice to run the photos in black and white evokes the environment in which they were taken. There's courage in the precise edit down to five photos to tell the story.

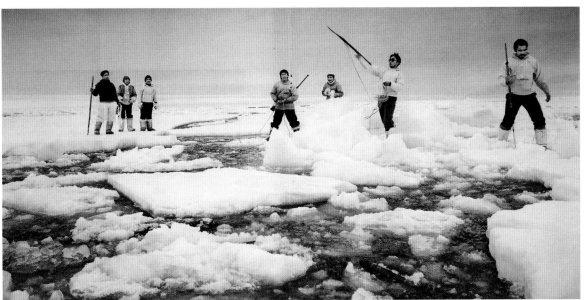

PLATA

CADA GRANDIOSA FOTO REVELA una escena increíblemente cruda, y las página calzan con ese tono. No se intenta llenar cada centímetro cuadrado disponible, sino que se permite que las fotos tengan el tamaño que les corresponde. Debido a eso, se destacan los recortes. La decisión de publicar las fotos en blanco y negro ayuda a hacer sentir el ambiente en el cual fueron tomadas. Hay coraje en la precisa edición de apenas cinco fotos para relatar el artículo.

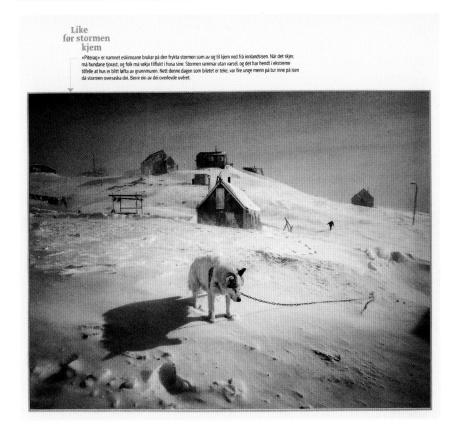

Like
før stormen
kjem

«Piteraq» er namnet eskimoane brukar på den frykta stormen som av og til kjem ned frå innlandsisen. Når det skjer, må hundane tjorast, og folk må søkja tilflukt i husa sine. Stormen rammar utan varsel, og det har hendt i ekstreme tilfelle at hus er blitt løfta av grunnmuren. Nett denne dagen som biletet er teke, var fire unge menn på tur inne på isen då stormen overraska dei. Berre ein av dei overlevde uvêret.

The Huntsville Times: Silver

Times of Oman: Silver

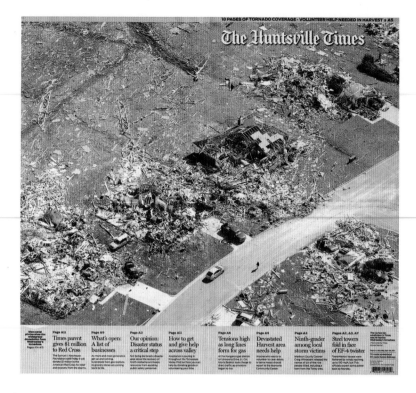

THE HUNTSVILLE TIMES
Huntsville, Ala.
Paul Wallen, Design Director; **Michael Mercier**, Photographer; **Huntsville Times Staff**
SILVER
News Design Page(s)
A-Section/Broadsheet 49,999 and Under

SILVER

THE POWERFUL WAY IN WHICH THIS PIECE CONVEYS THE ENORMITY OF THE TRAGEDY both communicates the devastation and makes a call for help. The paper is in touch with its community, and a page like this demonstrates that level of engagement and understanding. There's no headline and no need for one. The photo alone says, "We all know what happened here."

PLATA

ESTA PIEZA TRANSMITE LA ENORMIDAD DE LA TRAGEDIA: es una forma potente de mostrar la devastación y de hacer un llamado de ayuda. Este diario está en contacto con su comunidad, y una página como esta exhibe ese nivel de compromiso y comprensión. No lleva título, pero no es necesario. La fotografía sola dice: "Todos sabemos lo que pasó aquí".

TIMES OF OMAN
Muscat, Oman
Essa Al Zedjali, Chairman; **Ahmed Essa Al Zedjali**, CEO; **Adonis Durado**, Designer
SILVER
News Design Page(s)
Business/Broadsheet 49,999 and Under

SILVER

THE BEAUTIFUL ILLUSTRATION and textures provide depth and mystery. It's funny, it surprises and it shows masterful use of guiding the eye. The hard lines of type complement the flow of illustration. This is refreshing, since there are so many poor examples of text wraps out there.

SILVER

LA BELLEZA DE LA ILUSTRACIÓN y las texturas entregan profundidad y misterio. Divierte, sorprende y muestra un uso magistral de navegación del ojo. Las líneas duras de tipografía complementan el flujo de la ilustración. Es refrescante, porque en todas partes hay tantos malos ejemplos de textos sinópticos.

The New York Times: Silver

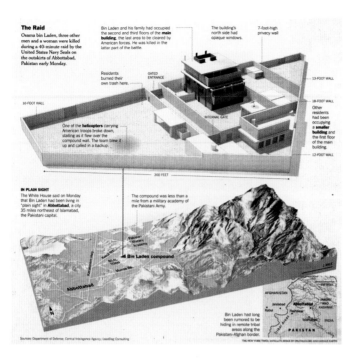

The Raid
Osama bin Laden, three other men and a woman were killed during a 40-minute raid by the United States Navy Seals on the outskirts of Abbottabad, Pakistan early Monday.

IN PLAIN SIGHT
The White House said on Monday that Bin Laden had been living in "plain sight" in **Abbottabad**, a city 35 miles northeast of Islamabad, the Pakistani capital.

THE NEW YORK TIMES
New York, N.Y.
Alan McLean, Graphics Editor; **Archie Tse**, Graphics Editor; **Lisa Waananen**, Graphics Editor; **Timothy Wallace**, Graphics Editor; **Joe Ward**, Graphics Editor; **Bill Marsh**, Graphics Editor; **Ford Fessenden**, Graphics Editor; **Bryan Christie**, Illustrator; **Amanda Cox**, Graphics Editor; **New York Times Graphics Staff**
SILVER
Information Graphics/Portfolios
Combination (Staff) 175,000 and Over

SILVER

IN TELLING THE STORY OF THIS CITY, there is a seamless transition from the breaking news of the Bin Laden raid, to more in-depth coverage of issues such as the turmoil in Egypt, to creative visual representations of the European debt crisis, to the clever presentation of unusual data related to the New York City Marathon. Here you see restraint in design and use of information. The publication is careful to avoid misinformation, and consistently achieves clarity.

PLATA

AL CONTAR LA HISTORIA DE ESTA CIUDAD, hay una transición sin costuras de la noticia de última hora de la redada de Bin Laden a la cobertura más en profundidad de asuntos como la revuelta en Egipto, a las creativas presentaciones visuales de la crisis de deuda europea, y a la inteligente presentación de datos inusuales relacionados con la maratón de Nueva York. Aquí se ve contención en el diseño y el uso de la información. Este periódico tiene cuidado para evitar la desinformación, y consistentemente logra la claridad.

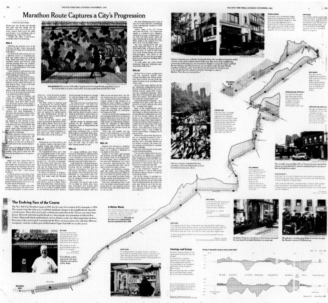

Marathon Route Captures a City's Progression

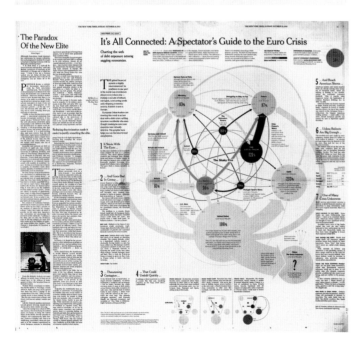

The Paradox Of the New Elite

It's All Connected: A Spectator's Guide to the Euro Crisis

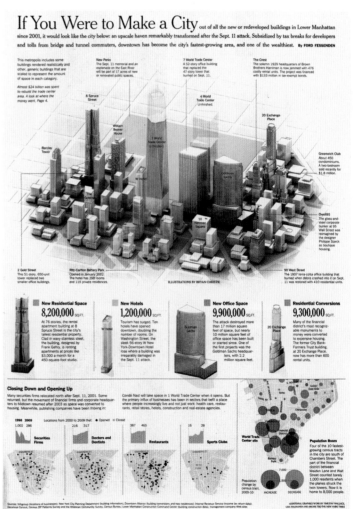

If You Were to Make a City out of all the new or redeveloped buildings in Lower Manhattan since 2001, it would look like the city below: an upscale haven remarkably transformed after the Sept. 11 attack. Subsidized by tax breaks for developers and tolls from bridge and tunnel commuters, downtown has become the city's fastest-growing area, and one of the wealthiest. By FORD FESSENDEN

The New York Times: Silver

THE NEW YORK TIMES
New York, N.Y.
New York Times Photographers; New York Times Illustrators; Elizabeth J. Flynn,
Deputy Photo Editor; **Kelly L. Doe,** Art Director; **Tom Bodkin,** Design Director
SILVER
Special Coverage/Single Section
News/With Ads

SILVER

THE SECTION FEELS LIKE A WELL-EDITED BOOK. The pacing and depth make it outstanding. The spot illustrations feel cohesive, even though they are in very different styles. The headlines and decks are set off consistently. The design doesn't rely on graphic nuances to carry it through. The section is approachable. It projects forward. Rather than leaning on iconic images, they create new ones. It feels sensitive to the citizens of New York City, who don't have to be hit over the head with clichés. It's told as a great local story.

PLATA

SE SIENTE COMO UN LIBRO BIEN EDITADO. El ritmo y la profundidad del relato hacen que la sección sobresalga. Las ilustraciones noticiosas se sienten cohesivas, aunque sus estilos son muy diferentes. Los títulos y las bajadas están separados de forma consistente. El diseño no depende de los matices gráficos para ser llevado a cabo. La sección está al alcance y se proyecta hacia delante. En vez de apoyarse en imágenes icónicas, se crearon unas nuevas. Se percibe sensible hacia los neoyorkinos, a quienes no es necesario golpear en la cabeza con clichés. Esta pieza relata un gran historia local.

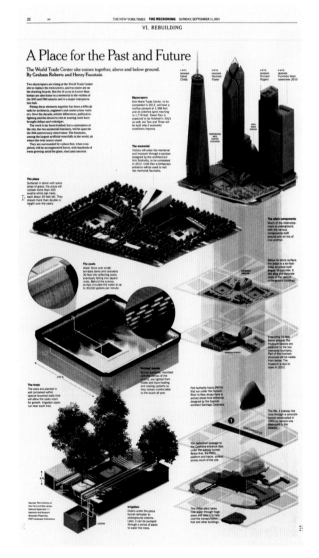

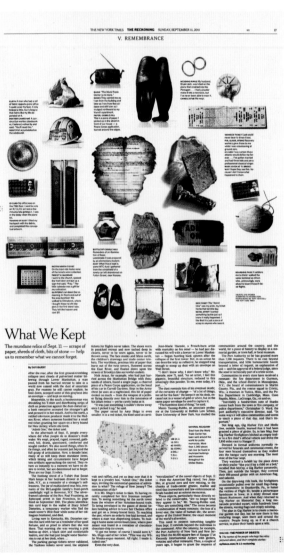

The Plain Dealer: Silver

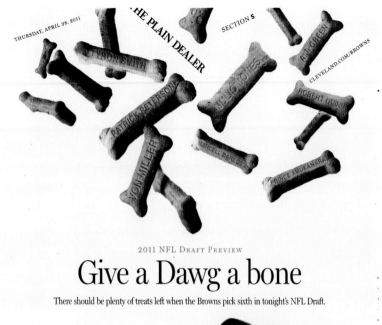

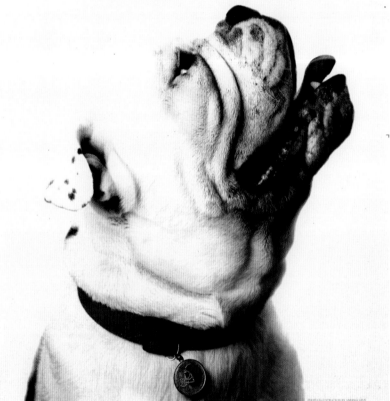

2011 NFL DRAFT PREVIEW

Give a Dawg a bone

There should be plenty of treats left when the Browns pick sixth in tonight's NFL Draft.

THE PLAIN DEALER
Cleveland, Ohio
Emmet Smith, Deputy Design Director/News; **Andrea Levy**, Photographer/Illustrator;
Michael Tribble, Design & Graphics Director; **David Kordalski**, A.M.E./Visuals
SILVER
News Design Page(s)
Sports/Broadsheet 175,000 and Over
AWARDS OF EXCELLENCE
Special Coverage/Section Pages
Sports/Cover Only
Photography/Single Photos
Illustration

SILVER

LOTS OF THESE SORTS OF IDEAS COME OUT OF SPORTS DEPARTMENTS. Many times they sound good, but fall flat. But this is wonderful, bright and inventive. The NFL draft is a big deal, particularly in Cleveland, where fans are known as the Dog Pound. This presentation attracts non-sports fans with little touches, such as the tilting of the type and the helmet on the collar tag. Who wouldn't love this dog?

PLATA

MUCHAS IDAS DE ESTE TIPO PROVIENEN DE LAS SECCIONES DE DEPORTES. Muchas veces suenan bien, pero no resultan. Esta, en cambio, es maravillosa, brillante y genial. El plan de la liga de fútbol norteamericano NFL es un asunto importante, especialmente en la ciudad de Cleveland, donde los hinchas son conocidos como "La perrera". Esta presentación atrae a quienes no son hinchas con pequeños toques, como la inclinación de la tipografía y el casco en la etiqueta de la correa. ¿Acaso a alguien podría no gustarle este perro?

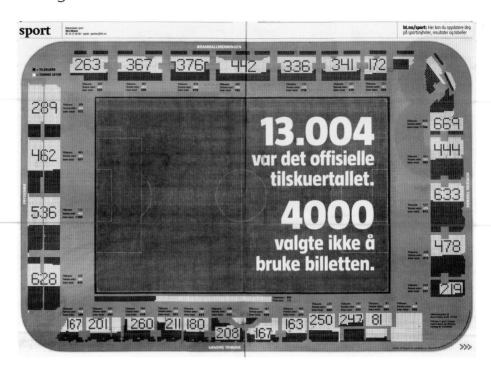

BERGENS TIDENDE
Bergen, Norway
Eir Stegane, Artist; **Endre Lilletvedt**, Designer; **Walter Jensen**, Chief of Presentation;
Tore Nilsen, Sports Editor; **Anders Pamer**, Sports Journalist;
Arne Edvardsen, Editor of Presentation
SILVER
News Design Page(s)
Sports/Compact 50,000–174,999

SILVER

THIS STORY ABOUT THE CONTRAST
between announced and real attendance
is a great piece of watchdog reporting told
visually. You can see all the work they
put into this on the page. The cumulative
effect of the photos holds the idea together,
but the data is the star. The package feels
authoritative.

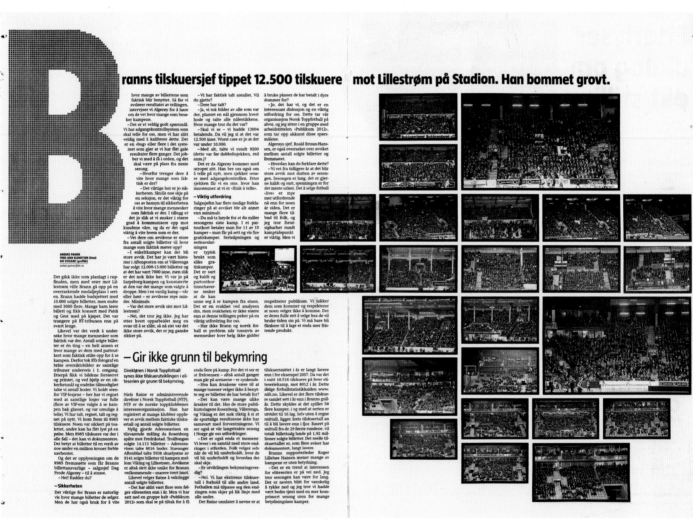

PLATA

ESTE ES UN GRAN REPORTEO VISUAL de un tema sobre el contraste entre la asistencia
anunciada y la que realmente hay. Es una gran pieza de reporteo guardián que se cuenta de
forma visual. Es evidente todo el trabajo puesto en esta página. El efecto acumulativo de las
fotos sostiene la idea, pero los datos son la estrella. El paquete informativo transmite dominio
del tema.

THE NEW REVIEW
London, England
Stephen Petch, Art Director
SILVER
Magazines
Overall Design

SILVER

THIS IS THE BEST OF THE NEWSPRINT MAGAZINES. It doesn't look like a newspaper, as so many do. The chapter leads are really entertaining. Using the form factor to advantage, they take every opportunity to draw in readers. They never take their feet off the gas. The quality runs deep without repetition. It's restrained but still surprising. Readers must be waiting all week to get this magazine.

PLATA

ESTA ES LA MEJOR DE TODAS LAS REVISTAS impresas y no se ve como un periódico, como tantas otras. Contiene introducciones de capítulos realmente interesantes. En ella se usa a su favor el factor de forma y se aprovecha cada oportunidad para atraer a los lectores. Si fuera un vehículo, no se sacaría el pie del acelerador. La calidad es profunda sin repetir. Tiene compostura, pero aun así sorprende. Los lectores deben estar esperando esto toda la semana.

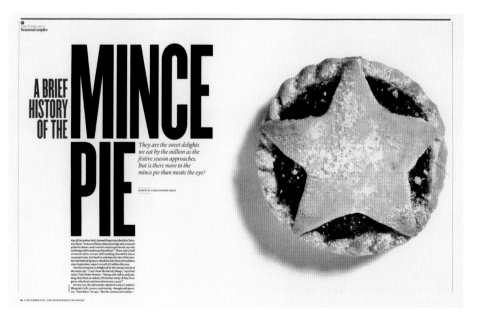

Financial Times: Silver

(LONDON) FINANCIAL TIMES
London, England
Financial Times Staff
SILVER
Magazines
Overall Design

SILVER

THESE MAGAZINES are
a pleasure to flip through.
You want to read every
word of each issue from
cover to cover. They show
a mastery of a multitude
of disciplines. Dictated by
the content rather than
by a formula, each page is
different.

PLATA

ES UN PLACER hojear
estas revistas y dan ganas
de leer cada palabra de
cada número, de punta
a cabo. Demuestran
maestría en un gran
número de disciplinas.
No siguen una fórmula,
sino que cada página es
diferente y dirigida por el
contenido.

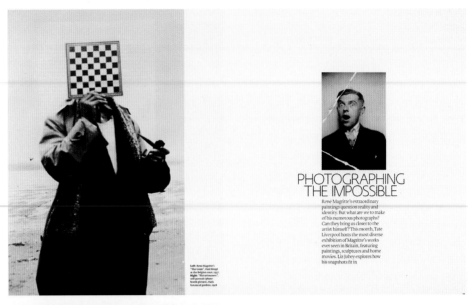

PHOTOGRAPHING THE IMPOSSIBLE

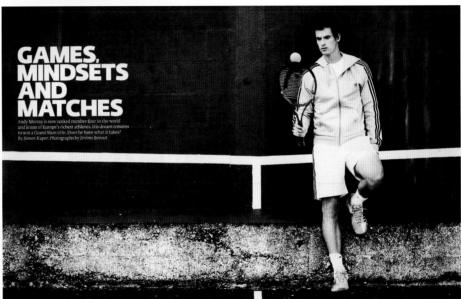

GAMES, MINDSETS AND MATCHES

Andy Murray is now ranked number four in the world and is one of Europe's richest athletes. His dream remains to win a Grand Slam title. Does he have what it takes? By Simon Kuper. Photographs by Jérôme Bonnet

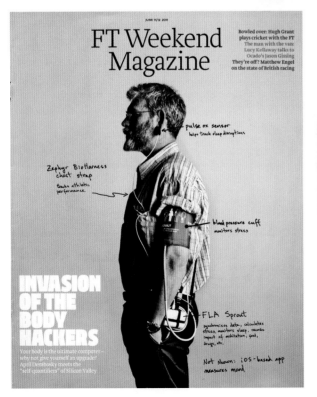

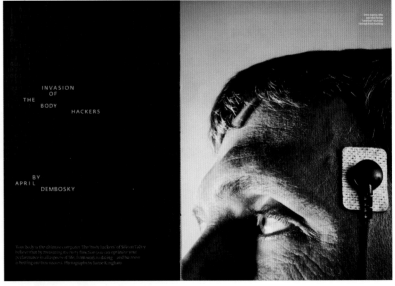

INVASION OF THE BODY HACKERS

BY APRIL DEMBOSKY

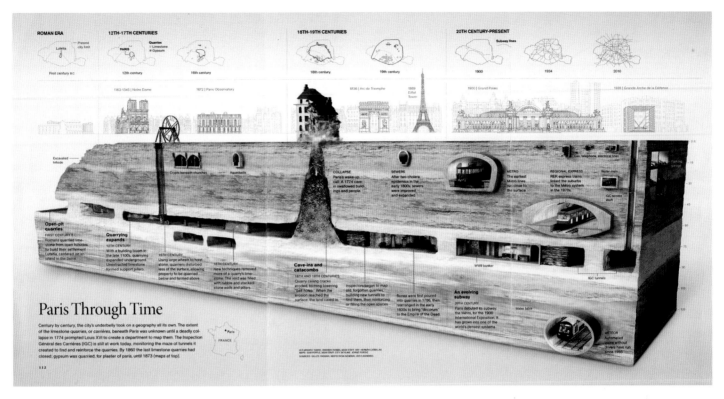

NATIONAL GEOGRAPHIC MAGAZINE
Washington, D.C.
Alejandro Tumas, Graphics Editor; **Amanda Hobbs**, Research Editor; **Hernán Cañellas**, Artist
SILVER
Information Graphics
Features 175,000 and Over

SILVER

YOU CANNOT HELP BUT APPRECIATE the way this graphic sweeps you through the story. In this guided tour of Paris from top and bottom, it's more about what's going on underneath the city, through the ages. It's fascinating and a great topic. You find yourself interested in the individual pieces, but you're looking at a double-axis of information, not just a block cutaway. That changes it dramatically — you're swept into the drama.

PLATA

NO SE PUEDE SINO VALORAR la forma en que este gráfico lo lleva a uno a través del artículo. En este tour guiado de París de arriba abajo, lo importante es lo que ocurre bajo tierra a través de los tiempos. Es fascinante y un gran tema. Uno se siente interesado en las piezas individuales, pero no se mira solamente el corte seccional de un bloque, sino un doble eje de información. Eso lo cambia todo y uno es arrastrado hacia el drama.

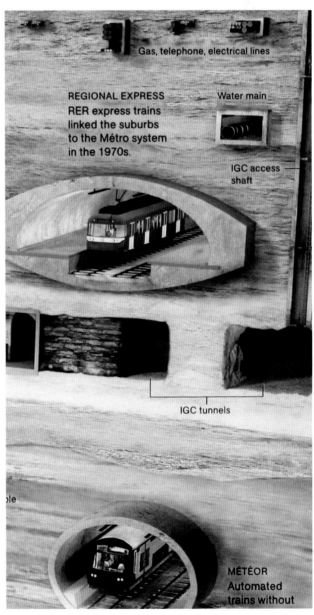

La Presse: Silver

LA PRESSE
Montréal, Qué., Canada
Johan Batier, Designer; **Francis Léveillée**, Illustrator; **France Dupont**, Deputy Art Director;
Hélène de Guise, Deputy Art Director; **Geneviève Dinel**, Art Director
SILVER
Special Coverage/Multiple Sections
Features/With Ads

SILVER

GIVEN THE SUBJECT MATTER, this series of special sections on personal finance is exceptionally fun and refreshing. The content is made accessible and easy to enjoy. Great visual metaphors make dense topics understandable, and the details and concepts are carried through the sections.

PLATA

CON ESTE TEMA, esta serie de secciones especiales sobre finanzas personales es excepcionalmente divertida y refrescante. El contenido está a la mano y es fácil de disfrutar. Las grandes metáforas visuales hacen comprensibles los temas densos, y los detalles y conceptos se llevan a cabo a través de las secciones.

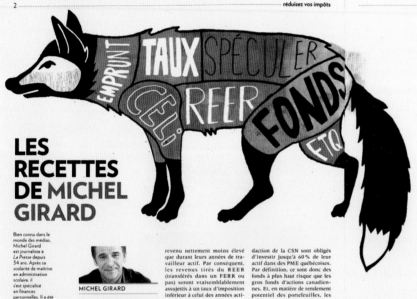

San Francisco Chronicle: Silver

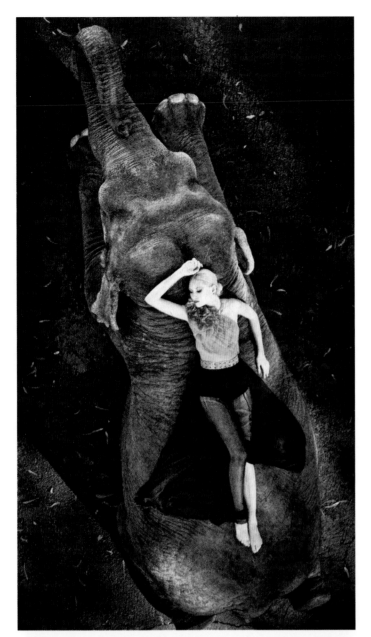

SAN FRANCISCO CHRONICLE
San Francisco, Calif.
Russel Yip, Photo Editor; **Judy Walgren**, Director of Photography; **Elizabeth Burr**, Designer
SILVER
Photography/Multiple Photos
Project Page or Spread

SILVER

EVERYTHING HERE WORKS WELL: the textures, the balance, the lighting and the classic poses. When you involve a creature in a fashion shoot, it can really be a nightmare. We would like to give this silver for the elephant itself — it's the best actor in the shoot.

PLATA

TODO FUNCIONA BIEN AQUÍ: las texturas, el equilibrio, la iluminación y las poses clásicas. Es una verdadera pesadilla cuando se usa un animal en una toma fotográfica de moda. Nos gustaría darle la medalla de plata al propio elefante, porque es el mejor actor de la toma.

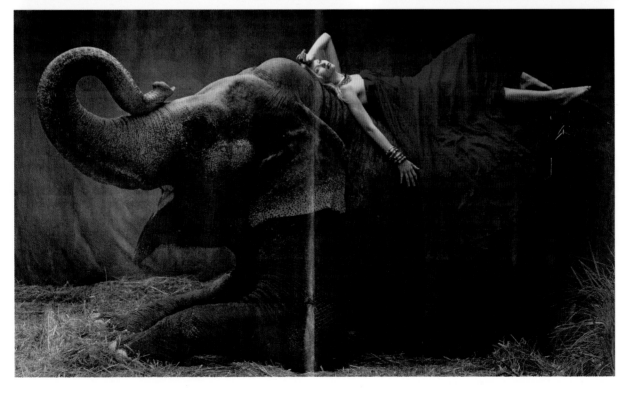

SATURDAY, NOVEMBER 19, 2011

TALES FROM THE HEART
Inside the Cleveland Clinic heart center

Joe Baschnagel's new heart arrives at the Cleveland Clinic. Dr. Suresh Keshavamurthy, the physician who removed the heart from its donor, pulls the cooler holding in into the heart center. CHUCK CROW / THE PLAIN DEALER

'It's a good heart'

AMANDA GARRETT, DIANE SUCHETKA AND BRIE ZELTNER | PLAIN DEALER REPORTERS

At 3:42 p.m., a Cleveland Clinic Police SUV rolls up to the main entrance of the Miller Family Heart & Vascular Institute. ¶ Clinic physician Dr. Suresh Keshavamurthy, who removes organs for transplant, slips out [PART SEVEN OF EIGHT] the passenger-side door, walks to the back of the SUV and lifts out an ordinary Rubbermaid cooler with wheels. ¶ "Donated human organ/tissue for transplant," a red sticker on top reads. "Keep Upright." ¶ The cooler arrived at Burke Lakefront Airport 17 minutes ago. ¶ Keshavamurthy, in scrubs and tennis shoes, rolls the cooler through the lobby, turns left and rides the elevator to the fourth floor. He heads past shelves stacked with boxes of surgical masks and shoe covers and stops at the Control Desk outside the heart center's operating rooms. ¶ Down the hall, Gonzo, Dr. Gonzalo Gonzalez-Stawinski, waits in Operating Room 64. ¶ Joe Baschnagel's new heart has arrived.

CONTINUED ON THE FOLLOWING PAGE

THE PLAIN DEALER
Cleveland, Ohio
Emmet Smith, Deputy Design Director/News; **Plain Dealer Photography Staff; Bill Gugliotta**, Director of Photography; **Dale Omori**, Deputy Director of Photography; **Wendy McManamon**, Copy Editor; **Ellen Stein Burbach**, Series Editor; **Michael Tribble**, Design & Graphics Director; **David Kordalski**, A.M.E./Visuals; **Thom Fladung**, M.E.; **Debra Adams Simmons**, Editor
SILVER
Special News Topics
Editor's Choice: Local/Regional

MONDAY, NOVEMBER 14, 2011

TALES FROM THE HEART
Inside the Cleveland Clinic heart center

Dr. Sochin Shah guides one of the plastic-encased surgical robotic arms into 42-year-old Jeffrey Scott's chest during surgery at the Cleveland Clinic Miller Family Heart & Vascular Institute. Once the arms are in place, Dr. Marc Gillinov will control their movements from a console across the room to repair Scott's mitral valve. JOHN KUNTZ; THE PLAIN DEALER

A matter of minutes

DIANE SUCHETKA, BRIE ZELTNER AND AMANDA GARRETT | PLAIN DEALER REPORTERS

A group of people, some in scrubs, hurries toward the operating rooms of the Cleveland Clinic Miller Family Heart & Vascular Institute. One of them, Dr. Suresh Keshavamurthy, is pulling a large, Rubbermaid [PART TWO OF EIGHT] cooler on wheels. ¶ Inside the cooler is a heart and an adrenal gland from a heart transplant donor. ¶ "You with pathology?" Keshavamurthy asks a young man in a white lab coat waiting in the hallway. ¶ "Yes," says Dr. Trent Marburger, the pathology resident on call. ¶ Marburger was home asleep at 6:30 a.m. when his pager went off. In one fluid movement, he rolled over, scooped his cellphone off the nightstand and slipped downstairs, hoping his wife could fall back asleep. ¶ The caller told him there was a mass on an adrenal gland, or maybe the kidney, of a heart transplant donor. He needed to get to the Clinic fast to test it. If there's cancer in a donor's body, it can spread to the recipient, and the transplant would be off. ¶ Marburger pulled on his scrubs and tennis shoes and drove the nearly empty Shoreway to the Clinic.

CONTINUED ON THE FOLLOWING PAGE

THE PLAIN DEALER

SILVER

THE PHOTOGRAPHY AND PACING ARE DONE SO WELL, taking a story that everyone should have a better understanding of and drawing the reader through it. There must be a serious commitment at the top to devote the space, time and resources to such a story. You can't capture these emotional moments without spending time with the subjects. This is journalism that aids understanding and provides a window into the lives of people we know little about. The photos range from technical moments to real emotion. There are great editing choices. Photos that you might instinctually run small are run large. It's noteworthy that while multiple photographers worked on this project, there is great consistency.

PLATA

LA FOTOGRAFÍA Y EL RITMO DEL RELATO ESTÁN TAN BIEN hechos que llevan al lector a través de un tema que debería comprender mejor. Debe haber una seria dedicación de parte de la dirección del diario para poder destinar el espacio, el tiempo y los recursos a un tema como este. No es posible captar estos emotivos momentos sin pasar un buen tiempo con esas personas. Esto es el tipo de periodismo que ayuda a entender y que abre una ventana a las vidas de personas poco conocidas. Las fotos van desde momentos técnicos hasta emoción real. Hay destacadas decisiones de edición. Las fotos que instintivamente se mostrarían pequeñas se presentan a gran tamaño. Cabe destacar que a pesar de que muchos fotógrafos trabajaron en este proyecto, se nota una gran consistencia.

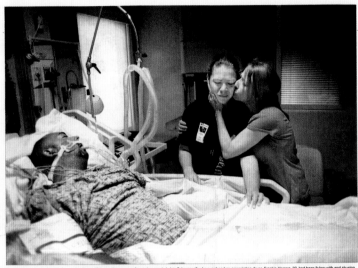

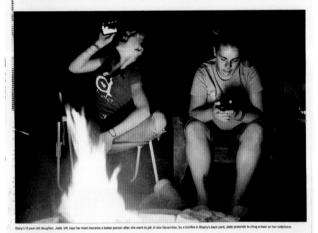

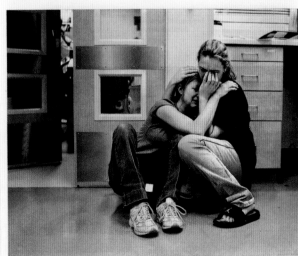

TAMPA BAY TIMES
St. Petersburg, Fla.
John Pendygraft, Photographer; **Bruce Moyer**, Photo Editor; **Terry Chapman**, Designer
SILVER
Photography/Multiple Photos
Project Page or Spread

SILVER

THIS PIECE BRINGS YOU VERY CLOSE to the subjects of the story. The photographer followed the family for a long time, both in happiness and deep despair. It is not easy to create this kind of access — you can see the rapport between photographer and subject.

PLATA

ESTA PIEZA ACERCA MUCHO A LOS TEMAS del artículo. El fotógrafo siguió a la familia durante mucho tiempo, tanto en tiempos felices como en los de gran deseperación. No es fácil lograr este tipo de acceso, pero es posible darse cuenta del nivel de comunicación entre el fotógrafo y el sujeto.

MAGNES — DZIENNIK POLSKI
Krakow, Poland
Tomasz Bocheński, Art Director
SILVER
Portfolio/Page Designer
Magazine 49,999 and Under

SILVER

SIMPLICITY IS WHAT MAKES THIS PORTFOLIO EXCELLENT. It shows variety and makes nice use of handmade work. A lot of design about the arts is so self-reverential, but we like that they're having fun with the coverage! Their willingness to go all the way with the concept and their attention to detail are impressive.

PLATA

ESTE PORTAFOLIO ES EXCELENTE GRACIAS A SU SIMPLICIDAD. Muestra variedad y hace un buen uso del trabajo hecho a mano. ¡Nos agrada que se hayan divertido con la cobertura! Buena parte del diseño sobre las artes es muy autorreferente, pero este diario se divierte. Su buena voluntad para llevar el concepto hasta el final y de cuidar los detalles es admirable.

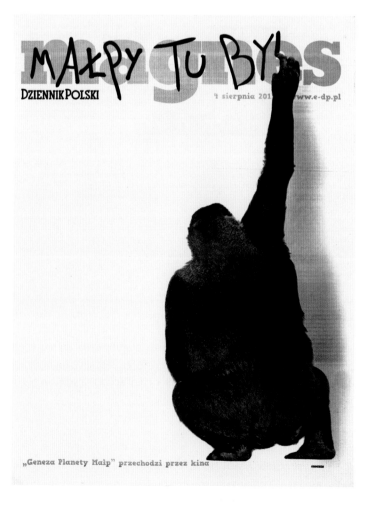

LOS ANGELES TIMES
Los Angeles, Calif.
Kelli Sullivan, Deputy Design Director; **Rick Loomis**, Photographer;
Michael Robinson Chavez, Photographer; **Carolyn Cole**,
Photographer; **Brian Van der Brug**, Photographer; **Mark Boster**,
Photographer; **Francine Orr**, Photographer; **Katie Falkenberg**,
Photographer; **Barbara Davidson**, Photographer; **Jay Clendenin**,
Photographer; **Kirk McKoy**, Photographer; **Colin Crawford**, D.M.E.;
Mary Cooney, Deputy Photo Editor; **Kelli Sullivan**,
Deputy Design Director; **Michael Whitley**, A.M.E.; **Dan Santos**,
Designer; **Gerard Babb**, Designer; **Lorraine Wang**, Designer;
Rick Collins, Designer

SILVER
Portfolio/Page Designer
News 175,000 and Over (Kelli Sullivan)

AWARDS OF EXCELLENCE
Photography/Multiple Photos
Portfolio/Team or Staff
News Design Page(s)
Inside Page/Broadsheet 175,000 and Over
Photography/Multiple Photos
Project Page or Spread
Portfolio/Staff
News 175,000 and Over
Special News Topics
Editor's Choice: International

SILVER

SOME OF THE BEST WORK IN BREAKING NEWS, photo editing, pacing and flow is incorporated all in this one portfolio. And it's not just cover work. There's a variety of breaking news and project coverage. It's impressive that one person has this much impact on a newspaper's content. This is a designer who recognizes excellent content and highlights it appropriately, all the while being careful to stay in the background. The work shows an authoritative voice in visual journalism.

PLATA

ESTA PIEZA INCLUYE PARTE DE LOS MEJORES TRABAJOS DE NOTICIAS DE ÚLTIMA HORA, EDICIÓN FOTOGRÁFICA, ritmo y flujo, y todo en un solo portafolio. No se queda en el trabajo de tapa o portada, sino que hay una variedad de cobertura de última hora y proyectos planificados. Es impresionante que una persona tenga tanto impacto en el contenido de un diario. Aquí hay un diseñador que reconoce la excelencia en el contenido y lo destaca apropiadamente, al tiempo que se cuida de no llamar la atención. La obra muestra una voz con don de mando en periodismo visual.

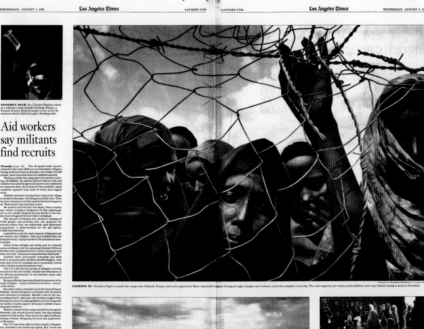

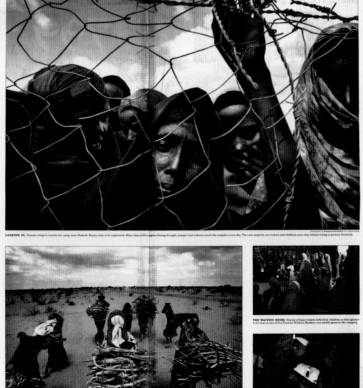

THE BOSTON GLOBE
Boston, Mass.
Luke Knox, Sports Designer; **Dan Zedek**, A.M.E./Design
SILVER
News Design Page(s)
Sports/Broadsheet 175,000 and Over

SILVER

EVERYONE HAS TO SHOWCASE TEAM OVERVIEWS AT THE BEGINNING OF A SPORTS SEASON, but they're difficult because you usually don't have live images at the start of season. The page's tremendous blend of tone, image and typography is understated. It stops you and makes you ask, "What's this about?" Information is layered at every level to reward readers who spend more time with it.

PLATA

TODO EL MUNDO TIENE QUE MOSTRAR VISIONES GENERALES DE EQUIPOS AL COMIENZO DE UNA TEMPORADA DEPORTIVA, pero son difíciles porque corrientemente no se cuenta con imágenes vivas del deporte, ya que la competencia recién ha comenzado. Esta fantástica mezcla de tono, imagen y tipografía está subestimada. Esta página hace detenerse y preguntarse: "¿De qué se trata esto?" La información está compuesta en capas en cada nivel para premiar a los lectores que le dedican más tiempo.

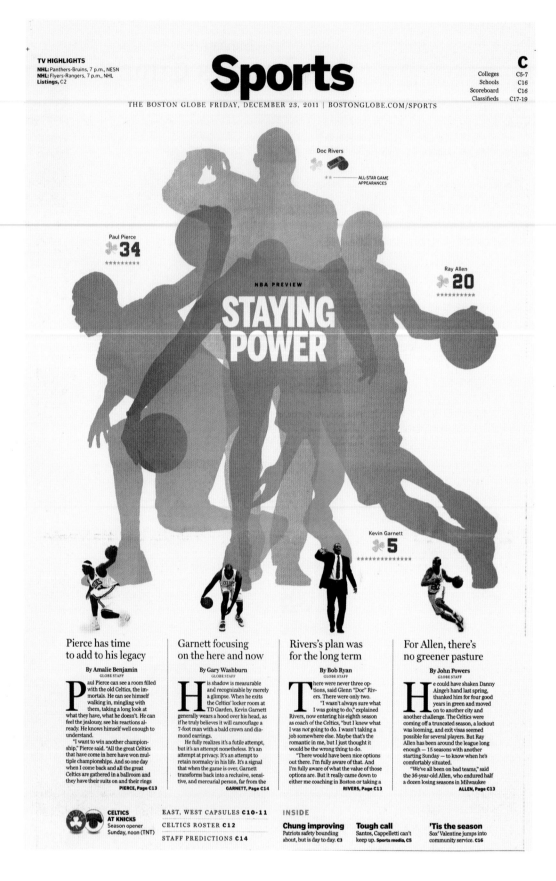

THE STATE
Columbia, S.C.
Gerry Melendez, Photographer
SILVER
Photography/Single Photos
Portrait

SILVER

SOUTH CAROLINA FRESHMAN guard Bruce Ellington is driven by the memory of his cousin Niya Williams, who taught him how to play basketball. He has her jersey number 31 tattooed on his left arm and taps it for inspiration. Ellington was in the eighth grade when Williams died at age 17. This portrait is not only technically good, but it also uses different angles. It's a brave thing for the photographer to move away from the in-your-face, pitch-perfect, conventional way of doing a sports portrait. The contrast between black and white and the delicate silvery texture give this image depth. The photo tells this man's story. It's very successful in conveying emotion through his gesture of stretching his fingers to his arm. In combination with the headline, it is excellent.

PLATA

EL BASQUETBOLISTA DE CAROLINA del Sur Bruce Ellington se deja llevar por el recuerdo de su prima, Niya Williams, quien le enseñó a jugar ese deporte. Tiene el número de su camiseta, el 31, en un tatuaje en su brazo izquierdo y lo toca para inspirarse. Ellington estaba en octavo de preparatoria cuando Williams murió a los 17 años. Este retrato no es bueno solo en lo técnico, sino que emplea diferentes ángulos. Es atrevido que un fotógrafo se aleje de la forma convencional de retratar en el deporte; de cerca y a la perfección. El contraste entre negro y blanco, y la delicada textura plateada le dan profundidad a esta imagen, la cual cuenta la historia de Ellington. Funciona la expresión de su emoción a través del gesto, la forma en que sus dedos están extendidos en su brazo. Es excelente junto con el título.

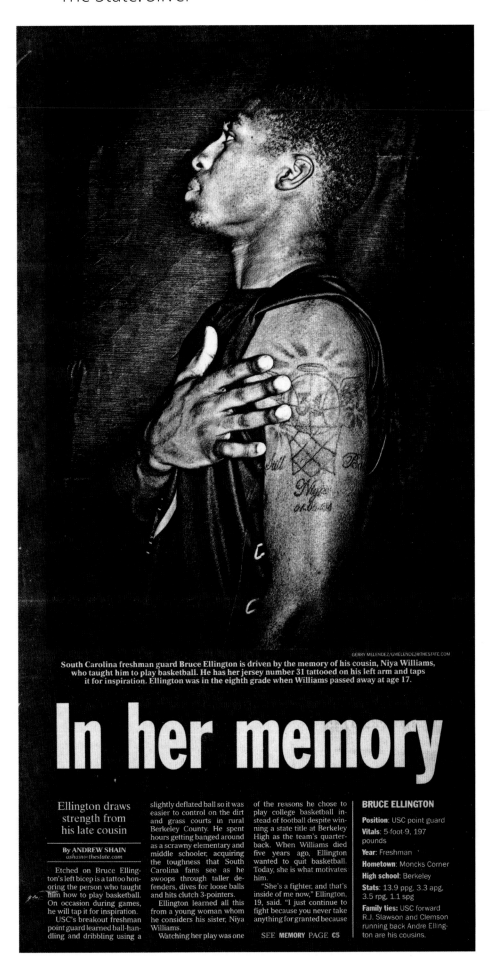

GERRY MELENDEZ/GMELENDEZ@THESTATE.COM

South Carolina freshman guard Bruce Ellington is driven by the memory of his cousin, Niya Williams, who taught him to play basketball. He has her jersey number 31 tattooed on his left arm and taps it for inspiration. Ellington was in the eighth grade when Williams passed away at age 17.

In her memory

Ellington draws strength from his late cousin

By ANDREW SHAIN
ashain@thestate.com

Etched on Bruce Ellington's left bicep is a tattoo honoring the person who taught him how to play basketball. On occasion during games, he will tap it for inspiration. USC's breakout freshman point guard learned ball-handling and dribbling using a slightly deflated ball so it was easier to control on the dirt and grass courts in rural Berkeley County. He spent hours getting banged around as a scrawny elementary and middle schooler, acquiring the toughness that South Carolina fans see as he swoops through taller defenders, dives for loose balls and hits clutch 3-pointers.

Ellington learned all this from a young woman whom he considers his sister, Niya Williams.

Watching her play was one of the reasons he chose to play college basketball instead of football despite winning a state title at Berkeley High as the team's quarterback. When Williams died five years ago, Ellington wanted to quit basketball. Today, she is what motivates him.

"She's a fighter, and that's inside of me now," Ellington, 19, said. "I just continue to fight because you never take anything for granted because

SEE **MEMORY** PAGE **C5**

BRUCE ELLINGTON

Position: USC point guard
Vitals: 5-foot-9, 197 pounds
Year: Freshman
Hometown: Moncks Corner
High school: Berkeley
Stats: 13.9 ppg, 3.3 apg, 3.5 rpg, 1.1 spg
Family ties: USC forward R.J. Slawson and Clemson running back Andre Ellington are his cousins.

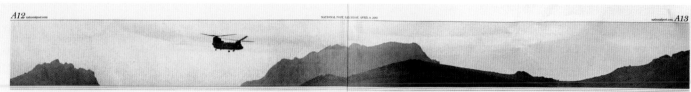

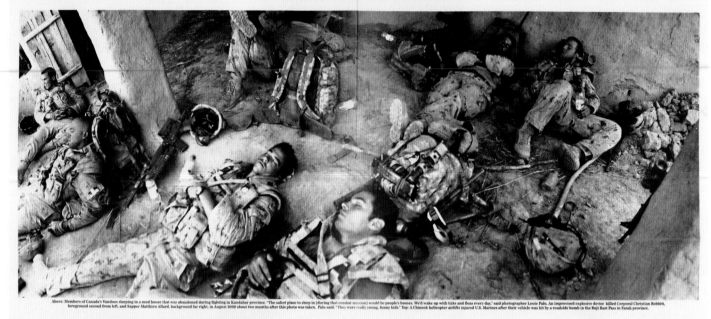

Above: Members of Canada's Vandoos sleeping in a mud house that was abandoned during fighting in Kandahar province. "The safest place to sleep in [during that combat mission] would be people's houses. We'd wake up with ticks and fleas every day," said photographer Louie Palu. An improvised explosive device killed Corporal Christian Bobbitt, foreground second from left, and Sapper Matthieu Allard, background far right. In August 2009 about two months after this photo was taken, Palu said. "They were really young, funny kids." Top: A Chinook helicopter airlifts injured U.S. Marines after their vehicle was hit by a roadside bomb in the Buji East Pass in Farah province.

As Canada's longest-ever combat mission comes to an end, photojournalist *Louie Palu* offers a retrospective of the war

During his long stint in Afghanistan, Louie Palu grew a grey beard to blend in among the locals and gain their respect. He dressed like a crazy old man carrying plastic bags, through which he'd snap some of his stunning panoramic shots of daily life in Kandahar City, where Canadian troops have operated since 2006. The Toronto-born, award-winning photojournalist has been there almost as long, capturing gritty visuals of a country at war. On the eve of Canada's scheduled departure from Afghanistan in July, Mr. Palu has created an in-depth retrospective of the conflict, *The Fighting Season*, which opens at Toronto's Kinsman Robinson Galleries May 7. "For this specific series, I spent about 10 months ... in the field, on the line, out in the districts, with troops and unembedded." While journalists rarely have time to remain in Afghanistan for the long haul, Mr. Palu spent months shooting photographs in myriad different ways, eventually offering a compelling picture of a harsh landscape, its war-weary people and the troops. Photo gallery at nationalpost.com/multimedia

The *National Post* returns to Kandahar next week, as two journalists who have spent considerable time on the ground in Afghanistan begin a month-long stint documenting the last days of Canada's longest-ever combat mission. For Brian Hutchinson, the Post's Vancouver-based columnist, this will be his fifth assignment in Kandahar since 2006. Richard Johnson, the Post's graphics editor, has been to Afghanistan and Iraq as a war artist. His work this time is being sponsored in part by the Smithsonian Museum of American History. Beginning next week, both Richard and Brian will be blogging from Kandahar Air Field and from outside the wire, capturing the work of Canadian Forces soldiers and assessing what the mission has accomplished. Follow their work at www.nationalpost.com/afghanistan

Top: Canadian soldiers on patrol outside Kandahar City. Above: A suspected Afghan insurgent in the village of Salavat, Panjwaii district.

Top: Canadian tanks on patrol before the Afghan elections in 2009. Above: The body of an Afghan man killed in a battle with Taliban insurgents.

NATIONAL POST
Toronto, Ont., Canada
Laura Morrison, News Presentation Editor; **Paolo Zinatelli**, Senior Designer; **Richard Johnson**, Graphics Editor; **Jeff Wasserman**, Photo & Multimedia Editor; **Anne Marie Owens**, M.E./News; **Stephen Meurice**, Editor-in-Chief; **Gayle Grin**, M.E./Design & Graphics
SILVER
News Design Page(s)
Inside Page/Broadsheet 50,000-174,999

SILVER

YOU CAN SEE A DESIGNER'S HAND in the extreme horizontal presentation of this page, but the artistic photo edit and cropping create a clear narrative. The dominant photo has so much detail that the designer wisely balanced it with simpler photos that don't overpower it. The use of white space helps bring out the emotion in the photos.

PLATA

SE NOTA LA MANO DE UN DISEÑADOR en la presentación extremadamente horizontal de esta página, pero el sentido artístico de la edición fotográfica y el recorte crean una narrativa clara. La foto dominante tiene tanto detalle que el diseñador la equilibró sabiamente con fotos más sencillas que no la abruman. El uso del espacio en blanco ayuda a resaltar la emoción de las fotos.

AFTER **BEFORE** **AFTER**

SAN FRANCISCO CHRONICLE
San Francisco, Calif.
Frank Mina, A.M.E./Presentation; **Matt Petty**, Art Director; **Elizabeth Burr**, Designer
SILVER
Redesigns
Section

SILVER

THIS REDESIGN DEMONSTRATES a complete change of philosophy and a commitment to space. The before examples look like news pages. It's a completely transformed section — clean and sophisticated, right down to the paper it's printed on. They're pushing the boundaries of how they tell stories, incorporating a level of surprise that was definitely missing from the before examples. There's no way you would expect to see this. It's big, bold and powerful. They didn't just get rid of everything; they took pieces that were significant to their readers and made them better.

PLATA

ESTE REDISEÑO MUESTRA un cambio radical de filosofía y dedicación al espacio. Los ejemplos de antes se ven como páginas de diarios, pero ahora se trata de una sección completamente nueva y se nota que se busca contar las noticias de una nueva forma. Es muy limpia y sofisticada, tal como el papel en la que se imprime. Incluye ese nivel de sorpresa que evidentemente faltaba en los ejemplos del antes del rediseño. De ninguna forma se esperaría ver algo como esto, porque es grande, atrevido y poderoso. No eliminaron todo simplemente; tomaron las piezas valiosas para los lectores y las hicieron aun mejor.

The New York Times: Silver

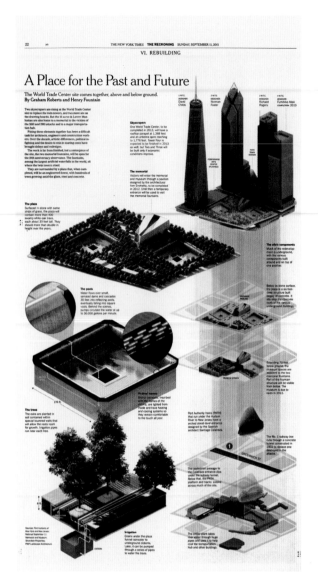

THE NEW YORK TIMES
New York, N.Y.
Tom Bodkin, Design Director; **Kelly L. Doe**, Art Director; **Elizabeth J. Flynn**, Deputy Photo Editor;
Sandra Stevenson, Deputy Photo Editor; **New York Times Photographers**
SILVER
Special News Topics
September 11 Anniversary

SILVER

OF ALL THE COVERAGE OF THE ANNIVERSARY OF 9/11, this stretched beyond the norm. They took a massive amount of information and presented it in an unexpected way, when many of us failed to do it any kind of justice. They collected voices from the day and created a good timeline, but they also looked ahead. It's a highly readable package that readers can dig into. They resisted the draw to be ornate or over the top. Without being cliché, it has the somber tone you want for an anniversary. Every page feels personal.

PLATA

DE TODA LA COBERTURA DEL ANIVERSARIO DE LOS ATENTADOS DEL 11 DE SEPTIEMBRE, esta fue más allá de la norma. Se tomó una gran cantidad de información y se presentó de forma inesperada, mientras que muchos de nosotros no logramos hacerlo con justicia. Se reunieron voces de ese día y se generó una buena línea de tiempo, pero también se miró hacia delante. Se trata de un paquete informativo muy interesante para que los lectores lo exploren. Se resistió la tentación de ser ornamental o desmesurado. Sin llegar a ser cliché, tiene el tono sombrío que se busca para un aniversario. Cada página se siente íntima.

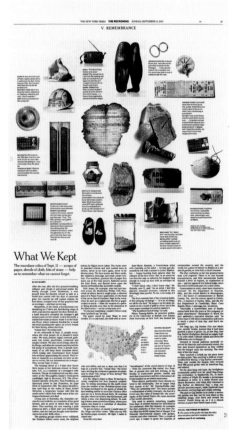

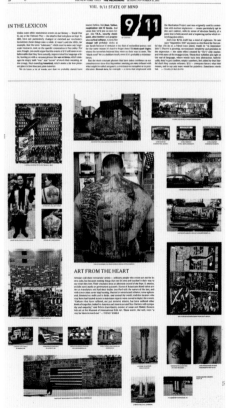

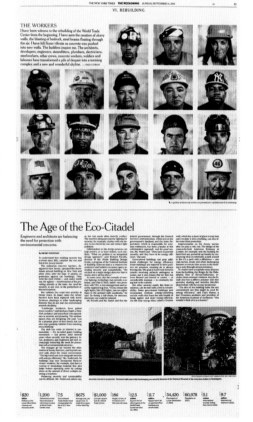

THE GRID
Toronto, Ont., Canada
Adam Cholewa, Associate Art Director; **Vanessa Wyse**,
Creative Director; **Caley Tessier**, Designer
SILVER
Redesigns
Overall Newspaper

SILVER

THIS TRANSFORMATION SHOWS a commitment to a completely different way of doing things. You can't even compare the before and after examples. The architecture is a thousand times better, and the base design is beautiful. Yes, the cover and logo have changed, but the quality has too. You'd almost have to replace the entire staff to get this level of improvement. The extra thought put into spreads gives the publication that magazine feel. It went from an average free publication to something people might pay for.

PLATA

ESTO MUESTRA DEDICACIÓN a una forma completamente diferente de hacer las cosas. Ni siquiera se pueden comparar los ejemplos del antes y el después, porque la arquitectura es mil veces mejor y el diseño de base es hermoso. Sí, la tapa o portada y el logo han cambiado, pero la calidad también. Casi sería neceario cambiar la mitad de la planta laboral para conseguir este nivel de mejoría. Se nota cuánto cerebro más se dedica a las páginas dobles para darle a este periódico un toque de revista. De hecho, pasó de ser un periódico gratuito común y corriente a algo por lo cual se pagaría.

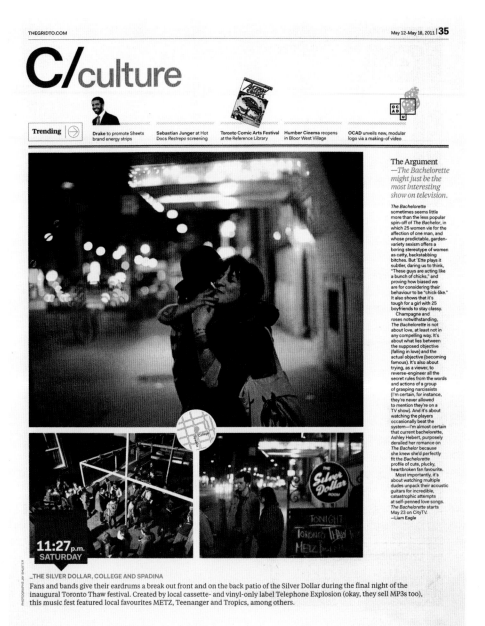

AFTER

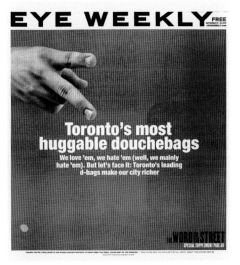

BEFORE

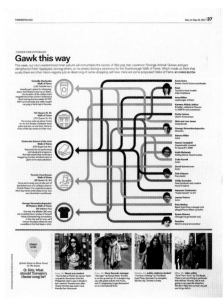

AFTER

Politiken: Silver

POLITIKEN
Copenhagen, Denmark
Søren Nyeland, Design Editor; **Kasper Steenbach**, Deputy Editor; **Philip Ytournel**, Artist; **Per Bergsbo**, Page Designer; **Søren Hansen**, Copy Editor
SILVER
Feature Design Page(s)
Entertainment/Broadsheet 50,000-174,999
AWARD OF EXCELLENCE
Illustration
Single lead color (Philip Ytournel)

SILVER

This page celebrates Bob Dylan's 70th birthday, showing the multiple sides of his personality through the use of many varieties of illustrations. He looks so different in each one, yet the same. It would have been easy (and wrong) to organize the illustrations on a grid, but instead the piece is organic. The use of red punctuates the page, although someone was clever enough to realize the illustrations didn't need color because the line work was so strong.

PLATA

Esta página celebra el 70° cumpleaños de Bob Dylan al mostrar varios aspectos de su personalidad con múltiples ilustraciones. Se ve tan diferente en cada una, pero sigue siendo el mismo. Esta página es orgánica: habría sido fácil –aunque erróneo– organizar las ilustraciones como una grilla o retícula. El uso del rojo puntúa la página, aunque alguien fue suficientemente astuto como para darse cuenta de que las ilustraciones no necesitan color, porque el trazado de líneas es muy potente.

BOB DYLAN 70 ÅR. LÆS OM BOB OG REPRODUKTIONEN, SIDE 4

The Oriental Morning Post: Silver

ORIENTAL MORNING POST
Shanghai, China
Jiafeng Zhao, Art Director; **Yuan Li**, Designer
SILVER
Feature Design Page(s)
Opinion/Compact 175,000 and Over

SILVER

THIS TELLS MANY STORIES WITHOUT WORDS AT ALL, leading you through the entire piece consistently, from decade to decade. You can spend hours enjoying the details. The stylistic drawing creates the effect of a mural with a good balance between old and new styles.

Época Negocios Magazine: Silver

ÉPOCA NEGOCIOS MAGAZINE
São Paulo, Brazil
Rodrigo Buldrini, Art Director; **Samir Hassan Ayoub**, Art Editor; **Idamázio Pereira Machado**, Producer Art; **Flávio Pessoa**, Designer; **Vitor Milito**, Designer; **Gabriel Gianordoli**, Infographic Artist; **Andrea Petkevicius**, Designer; **Lucimara Paiva**, Producer; **Vitor Affaro**, Photographer
SILVER
Magazines
Features/Cover story design

SILVER

THIS PUBLICATION TOOK POTENTIALLY DENSE SUBJECT MATTER and found a fun, smart way to relate it to readers. There's a ton of information, but it's easy to navigate. The pigs metaphor never feels forced, and it makes the content approachable. The pacing and attention to detail draw you through. You can see the entire thought process conceived and executed from beginning to end.

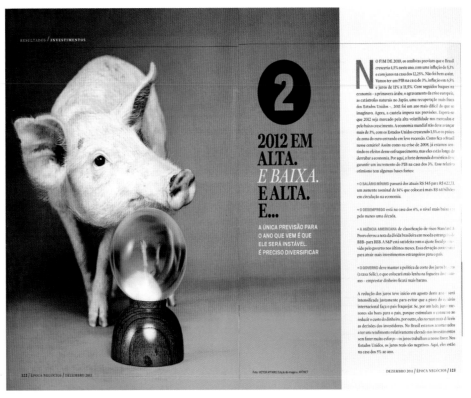

PLATA

ESTE PERIÓDICO TOMÓ UN TEMA POTENCIALMENTE DENSO y encontró una forma divertida e inteligente para contarlo a sus lectores. Hay una tonelada de información, pero es fácil navegar por ella. La metáfora de los cerdos nunca se siente forzada y hace que el contenido sea abordable. El ritmo narrativo y la atención al detalle conducen a lo largo del artículo. Es posible apreciar el proceso completo, desde la idea hasta la publicación.

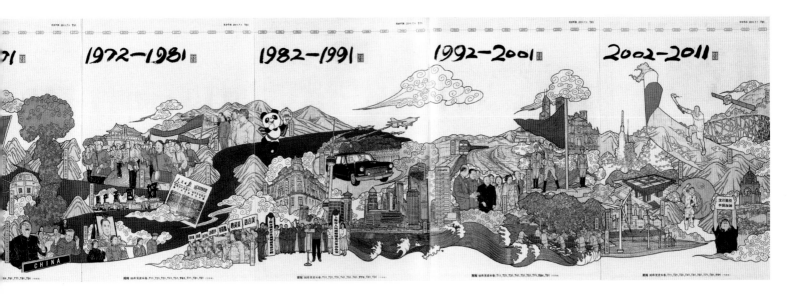

PLATA

ESTA PIEZA RELATA VARIOS TEMAS SIN NINGUNA PALABRA, y guía a través de ella entera de forma consistente, década tras década. Se puede pasar horas disfrutando los detalles. El estilístico dibujo crea el efecto de un mural con un buen equilibrio entre estilos antiguos y nuevos.

The Plain Dealer: Silver

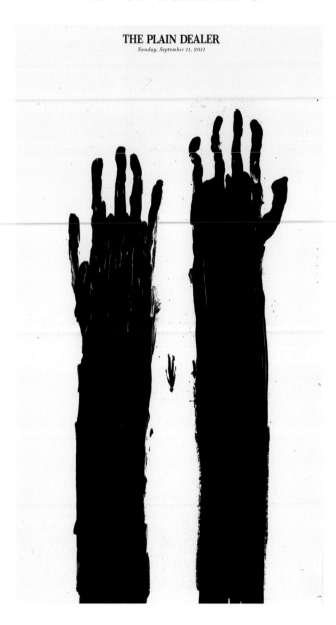

Times of Oman: Silver

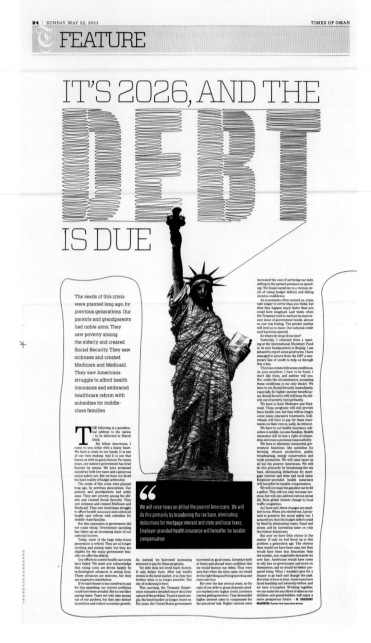

THE PLAIN DEALER
Cleveland, Ohio
Andrea Levy, Illustrator; **Emmet Smith**, Deputy Design Director/News;
Michael Tribble, Design & Graphics Director; **David Kordalski**, A.M.E./Visuals
SILVER
Special Coverage/Sections
News/Cover Only
AWARDS OF EXCELLENCE
Illustration
Single Lead Black-and-White (Andrea Levy)
Portfolio/Page Designer
News 175,000 and Over (Emmet Smith)

TIMES OF OMAN
Muscat, Oman
Essa Al Zedjali, Chairman; **Ahmed Essa Al Zedjali**, CEO; **Adonis Durado**, Design
Director; **KM Sahir**, Designer
SILVER
News Design Page(s)
Business/Broadsheet 49,999 and Under

SILVER

THERE WEREN'T MANY SURPRISES in coverage of the 9/11
anniversary, but this stands out. Taking one of the most poignant
images from that day — the bodies falling from the towers — this
illustration turns it into something that every individual can interpret
for himself.

PLATA

NO HUBO MUCHAS SORPRESAS en la cobertura del aniversario del
11-S, pero esta se destacó. La ilustración toma uno de las imágenes
más dolorosas de ese día –los cuerpos que caen de las torres– y las
convierte en algo que cualquiera puede interpretar por su cuenta.

SILVER

IT'S SO ELEGANT AND CLEAN, and not overdone. Subtle and
thoughtful, it tells the story and makes you interact with it in a
number of ways. As you spend more time with the page, you're drawn
in further and further each time you look at it.

PLATA

ESTA PIEZA ES MUY ELEGANTE Y LIMPIA, y nada de exagerada.
Al contario; es sutil y considerada, relata el tema y hace que el lector
interactúe con ella de varias maneras. Mientras más se mira esta
página y más tiempo se le dedica, más atrae.

THE PLAIN DEALER
Cleveland, Ohio
Emmet Smith, Deputy Design Director/News; **Andrea Levy,** Photographer/Illustrator;
Michael Tribble, Design & Graphics Director; **David Kordalski,** A.M.E./Visuals
AWARDS OF EXCELLENCE
Photography/Single Photos
Illustration (Andrea Levy)
Photography/Multiple Photos
Portfolio/Individual (Andrea Levy)
Special Coverage/Section Pages
Sports/Cover Only

MINNEAPOLIS STAR TRIBUNE
Minneapolis, Minn.
Chris Carr, Presentation Director; **Jim Freitag,** Illustrator
AWARDS OF EXCELLENCE
News Design Page(s)
Sports/Broadsheet 175,000 and Over
Special Coverage/Section Pages
Sports/Cover Only
Portfolio/Page Designer
Combination 175,000 and Over (Chris Carr)

TAMPA BAY TIMES
St. Petersburg, Fla.
Kathleen Flynn, Photographer; **Bruce Moyer,** Photo Editor; **Suzette Moyer,** Designer
AWARDS OF EXCELLENCE
Photography/Multiple Photos
Project Page or Spread
Special Coverage/Single Section
Features/No Ads

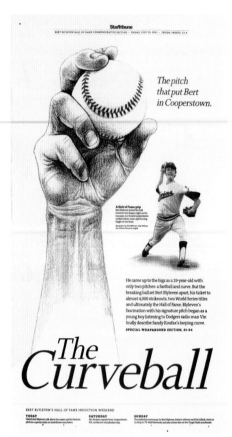

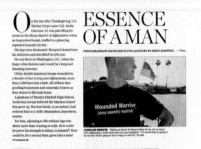

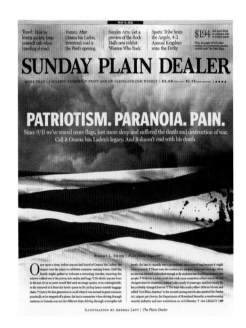

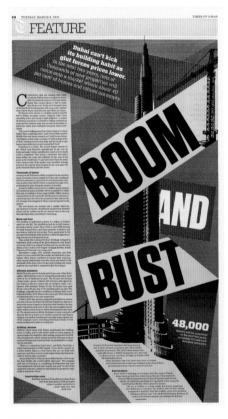

THE PLAIN DEALER
Cleveland, Ohio
Emmet Smith, Deputy Design Director/News; **Andrea Levy,**
Illustrator; **Michael Tribble,** Design & Graphics Director;
David Kordalski, A.M.E./Visuals; **Plain Dealer Design Staff**
AWARDS OF EXCELLENCE
News Design Page(s)
A-Section/Broadsheet 175,000 and Over
Portfolio/Staff
Combination 175,000 and Over

THE BUFFALO NEWS
Buffalo, N.Y.
Vincent Chiaramonte, Design Director; **Greg Connors,** Copy Editor;
Lisa Wilson, Executive Sports Editor
AWARDS OF EXCELLENCE
News Design Page(s)
Inside Page/Broadsheet 175,000 and Over
News Design Page(s)
Sports/Broadsheet 175,000 and Over

TIMES OF OMAN
Muscat, Oman
Essa Mohammed Al Zedjali, Chairman; **Ahmed Essa Al Zedjali,** CEO;
Adonis Durado, Designer
AWARDS OF EXCELLENCE
News Design Page(s)
Business/Broadsheet 49,999 and Under
Illustration
Portfolio/Art Direction/Staff

ORLANDO SENTINEL
Orlando, Fla.
Bonita Burton, Visuals Editor; **Todd Stewart,** Design & Graphics Editor; **Wes Meltzer,** Information Design Editor; **Tom Burton,** Photo Editor; **Red Huber,** Photographer; **Karen Bellville Beaman,** Graphic Artist; **Ebony Stith,** Designer; **Dana Summers,** Cartoonist; **Shiniko R. Floyd,** Senior Artist
AWARDS OF EXCELLENCE
Special News Topics
Editor's Choice: Local/Regional
Special Coverage/Single Section
News/With Ads

LOS ANGELES TIMES
Los Angeles, Calif.
Kelli Sullivan, Deputy Design Director; **Michael Whitley,** A.M.E.; **Dan Santos,** Designer; **Mike Kirkendall,** Designer; **Steve Stroud,** Photo Editor
AWARDS OF EXCELLENCE
News Design Page(s)
Inside Page/Broadsheet 175,000 and Over
Breaking News Topics
Royal Wedding

LOS ANGELES TIMES
Los Angeles, Calif.
Derek Simmons, Deputy Design Director
AWARDS OF EXCELLENCE
News Design Page(s)
Sports/Broadsheet 175,000 and Over
News Design Page(s)
Inside Page/Broadsheet 175,000 and Over

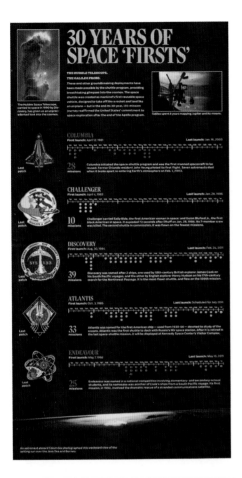

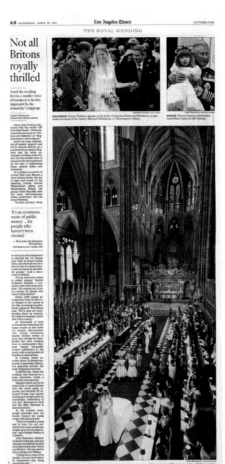

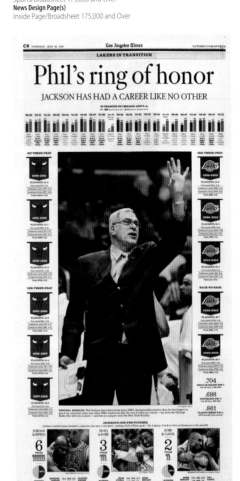

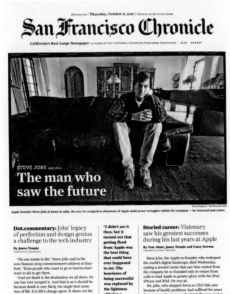

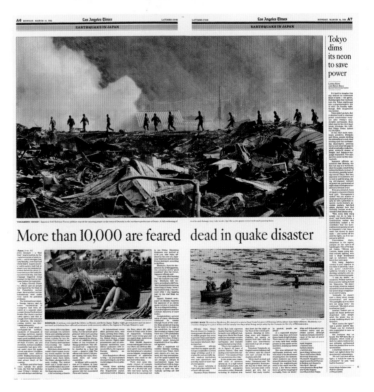

SAN FRANCISCO CHRONICLE
San Francisco, Calif.
Frank Mina, A.M.E./Presentation; **Judy Walgren,** Director of Photography; **Steve Proctor,** M.E.
AWARDS OF EXCELLENCE
Breaking News Topics
Editor's Choice: Local/Regional
News Design Page(s)
A-Section/Broadsheet 175,000 and Over

LOS ANGELES TIMES
Los Angeles, Calif.
Michael Whitley, A.M.E.; **Kelli Sullivan,** Deputy Design Director; **Rick Collins,** Design Editor; **Mike McKay,** Design Editor; **Jeremiah Bogart,** Photo Editor; **Calvin Hom,** Deputy Photo Editor
AWARDS OF EXCELLENCE
News Design Page(s)
A-Section/Broadsheet 175,000 and Over
News Design Page(s)
Inside Page/Broadsheet 175,000 and Over

THE WASHINGTON POST

Washington, D.C.

Tippi Thole, Art Director/Illustrator; **Christopher Meighan**, Deputy Design Director/Features; **Janet Michaud**, Design Director; **Washington Post Staff**

AWARDS OF EXCELLENCE

News Design Page(s)
Local Section/Compact 175,000 and Over
Portfolio/Staff
News 175,000 and Over

LOS ANGELES TIMES

Los Angeles, Calif.

Kelli Sullivan, Deputy Design Director; **Michael Whitley**, A.M.E.; **Robert St. John**, Photo Editor; **Brian Van der Brug**, Photographer

AWARDS OF EXCELLENCE

Special News Topics
Editor's Choice: Local/Regional
News Design Page(s)
Inside Page/Broadsheet 175,000 and Over
News Design Page(s)
A-Section/Broadsheet 175,000 and Over

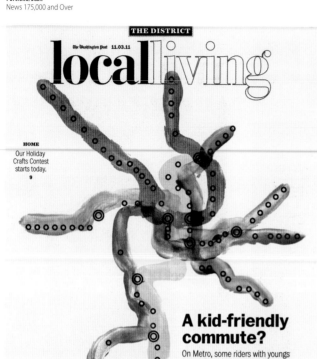

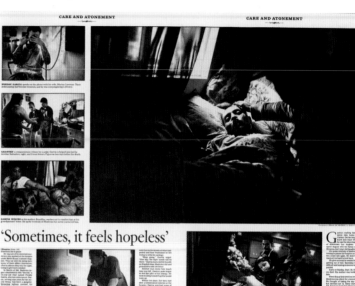

NATIONAL GEOGRAPHIC MAGAZINE

Washington, D.C.

Fernando G. Baptista, Senior Graphics Editor; **National Geographic Magazine Graphics Staff**

AWARDS OF EXCELLENCE

Information Graphics
Features 175,000 and Over
Information Graphics/Portfolios
Non-Breaking or Feature (Staff) 175,000 and Over

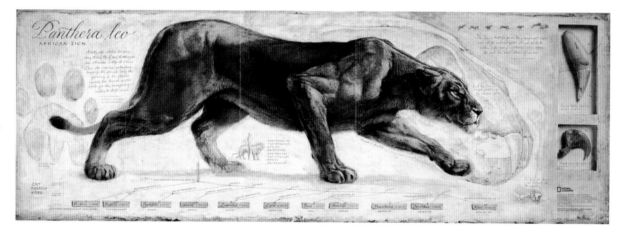

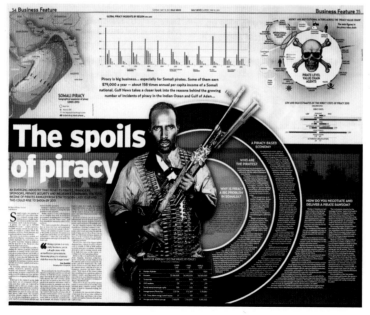

GULF NEWS

Dubai, United Arab Emirates

Douglas Okasaki, Senior Designer; **Paul A. Stober**, Business Editor; **Denna Kamel Yousef**, Staff Reporter; **Robin Trazo**, Senior Infographist; **Ramachandra Babu**, Senior Illustrator; **Syed Muhammad Arshad**, Art Editor; **Miguel Angel Gomez**, Design Director; **Mohammed Al Mezel**, M.E.; **Abdul Hamid Ahmad**, Editor-in-Chief

AWARDS OF EXCELLENCE

News Design Page(s)
Inside Page/Broadsheet 50,000-174,999
News Design Page(s)
Business/Broadsheet 50,000-174,999

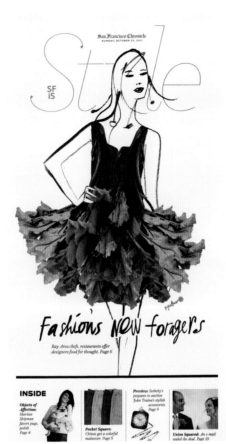

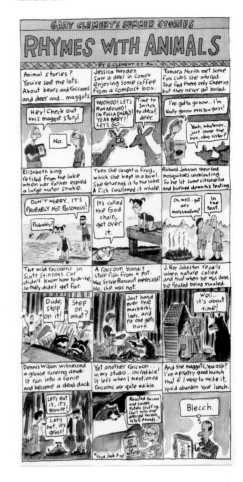

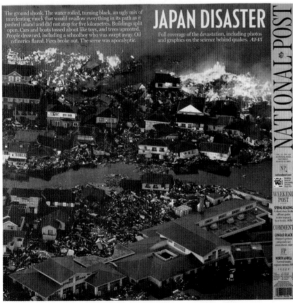

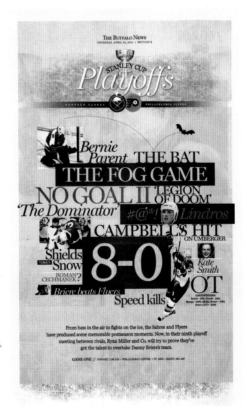

LOS ANGELES TIMES
Los Angeles, Calif.
Michael Whitley, A.M.E.; **Kelli Sullivan**, Deputy Design Director; **Mark Yemma**, Design Editor; **Gerard Babb**, Design Editor; **Mary Vignoles**, Photo Editor; **Lorraine Wang**, Designer; **Rick Collins**, Designer; **Dan Santos**, Designer
AWARDS OF EXCELLENCE
Breaking News Topics
Japan Earthquake
Portfolio/Staff
News 175,000 and Over
News Design Page(s)
Inside Page/Broadsheet 175,000 and Over
News Design Page(s)
A-Section/Broadsheet 175,000 and Over

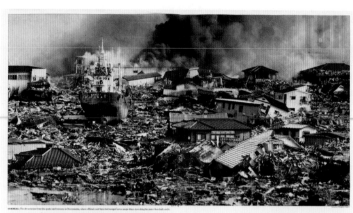

ORIENTAL MORNING POST
Shanghai, China
Jiafeng Zhao, Art Director; **Yuan Li**, Designer
AWARDS OF EXCELLENCE
Special News Topics
Editor's Choice: National
Illustration
Single Lead Color

Impeccable manners quite intact

Japan seeks to calm nuclear fears

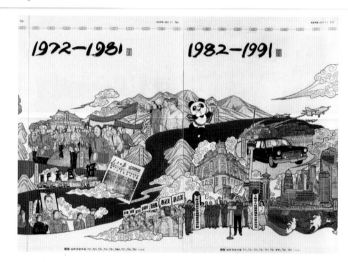

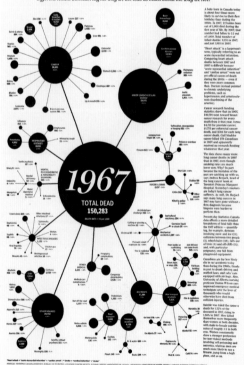

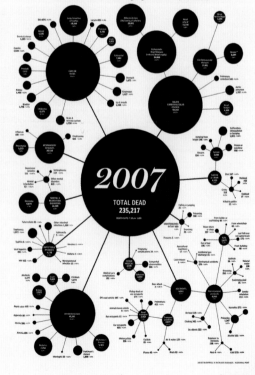

LIFE & DEATH IN BLACK & WHITE

Death is life's one and only inevitable event, and it comes in many ways — officially, there are 999 causes. The mortality statistics below, from 1967 and 2007 (the most recent year available), are culled from the nation's death certificates. From bear attacks to heart attacks, the causes reveal specific details about how we die, and yet, because the ascribed causes can say more about the subjective judgments of the dispensing physician or the time in which they live, the statistics add up to a snapshot of death — and life — in two different times. Considering the way we die tells us much about the way we live.

Over 40 years, improved cardiovascular health — thanks to lifestyle changes and treatment — and fewer fatal accidents have contributed to longer lives. As Canadians live longer, however, more of them get cancer. What about the next 40 years? Donna Wilson, a University of Alberta professor of nursing and co-author of Dying and Death in Canada, cautions that rising obesity rates could cause cardiovascular deaths to climb once again. Doctors are not allowed to list old age on a death certificate, but Dr. Wilson and others have argued for it to be the "1,000th cause."

NATIONAL POST
Toronto, Ont., Canada
Laura Morrison, News Presentation Editor; **Paolo Zinatelli**, Senior Designer; **Richard Johnson**, Illustrator; **Michael Higgins**, Foreign Editor; **Adam McDowell**, Features Editor; **Stephen Meurice**, Editor-in-Chief; **Gayle Grin**, M.E./Design & Graphics; **Anne Marie Owens**, M.E./News
AWARDS OF EXCELLENCE
Information Graphics
News/Non-Deadline 50,000-174,999
News Design Page(s)
A-Section/Broadsheet 50,000-174,999
News Design Page(s)
Inside Page/Broadsheet 50,000-174,999

NATIONAL POST
Toronto, Ont. , Canada
Laura Morrison, News Presentation Editor; **Dean Tweed**, Graphics; **Jonathon Rivait**, Graphics; **Mike Faille**, Graphics; **Andrew Barr**, Graphics; **Gary Clement**, Illustrator; **Jeff Wasserman**, Photo & Multimedia Editor; **Rob Roberts**, National Editor; **Stephen Meurice**, Editor-in-Chief; **Gayle Grin**, M.E./Design & Graphics
AWARDS OF EXCELLENCE
Special News Topics
Editor's Choice: National
Breaking News Topics
Editor's Choice: National

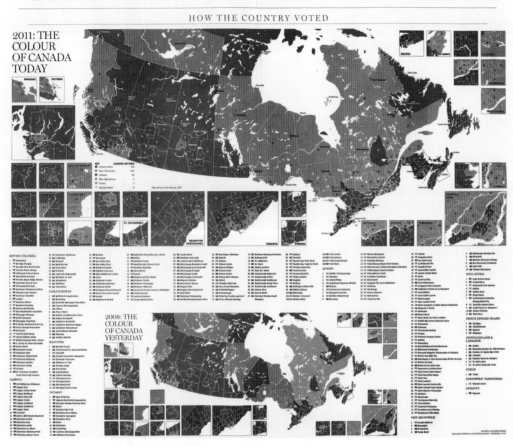

THE BOSTON GLOBE
Boston, Mass.
Ryan Huddle, Editorial Designer;
Dan Zedek, A.M.E./Design
AWARDS OF EXCELLENCE
Feature Design Page(s)
Entertainment/Broadsheet
175,000 and Over
Photography/Single Photos
Illustration

Each of the dots creating the image above represents one of the 107,161 Canadians killed in both World Wars, the Korean War, peacekeeping operations and the conflict in Afghanistan

NATIONAL POST
Toronto, Ont. , Canada
Richard Johnson, Graphics Editor and Illustrator; **Becky Guthrie**, Associate Features Design Editor; **Kevin Libin**, M.E./News; **Barry Hertz**, Arts & Life Editor; **Stephen Meurice**, Editor-in-Chief; **Gayle Grin**, M.E./Design & Graphics
AWARDS OF EXCELLENCE
Information Graphics
News/Non-Deadline 50,000-174,999
Miscellaneous

POLITIKEN
Copenhagen, Denmark
Søren Nyeland, Design Editor; **Kasper Steenbach**, Editor; **Linda Frøkjær**, Page Designer; **Philip Ytournel**, Artist
AWARDS OF EXCELLENCE
Feature Design Page(s)
Lifestyle/Broadsheet 50,000-174,999
Illustration
Single Lead Color

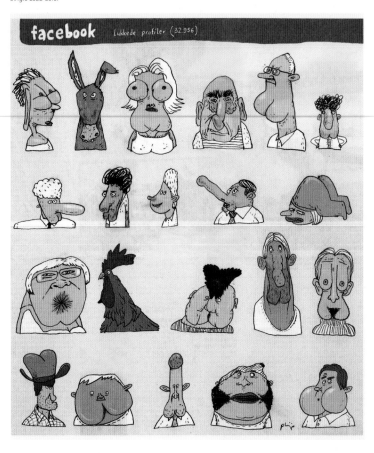

POLITIKEN
Copenhagen, Denmark
Søren Nyeland, Design Editor; **Anne Mette Svane**, Editor-in-Chief; **Philip Ytournel**, Artist
AWARDS OF EXCELLENCE
News Design Page(s)
A-Section/Broadsheet 50,000-174,999
Illustration
Single Lead Color

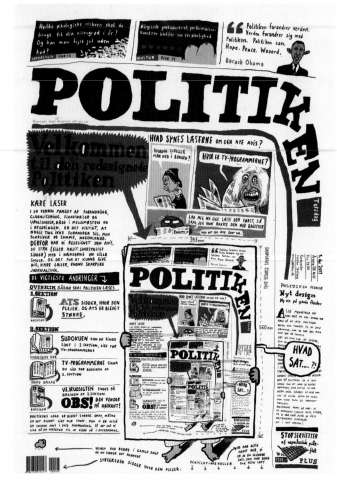

THE WASHINGTON POST
Washington, D.C.
Marianne Seregi, Designer; **Alex Trochut**, Illustrator; **Kristin Lenz**, Designer;
Christopher Meighan, Deputy Design Director/Features; **Greg Manifold**,
Deputy Design Director/News; **Janet Michaud**, Design Director;
Kelly Johnson, Editor
AWARDS OF EXCELLENCE
Special Coverage/Sections
News/Cover Only
Special News Topics
Editor's Choice: National

SOUTH CHINA MORNING POST
Hong Kong, China
Simon Scarr, Infographics Director
AWARDS OF EXCELLENCE
Feature Design Page(s)
Other/Broadsheet 50,000-174,999
Information Graphics
News/Non-Deadline 50,000-174,999

LOS ANGELES TIMES
Los Angeles, Calif.
Paul Gonzales, Deputy Design Director; **Michael Whitley**, A.M.E.; **Owen Smith**, Illustrator
AWARDS OF EXCELLENCE
Special Coverage/Section Pages
Features/Cover Only
Miscellaneous

NATIONAL POST
Toronto, Ont. , Canada
Laura Morrison, News Presentation Editor; **Paolo Zinatelli**, Senior Designer; **Jeff Wasserman**, Photo & Multimedia Editor; **Dean Tweed**, Graphics; **Anne Marie Owens**, M.E./News; **Michael Higgins**, Foreign Editor; **Kagan McLeod**, Illustration; **Stephen Meurice**, Editor-in-Chief; **Gayle Grin**, M.E./Design & Graphics; **Jeff Wasserman**, Photo & Multimedia Editor
AWARDS OF EXCELLENCE
Special News Topics
Royal Wedding
News Design Page(s)
Inside Page/Broadsheet 50,000-174,999
News Design Page(s)
A-Section/Broadsheet 50,000-174,999

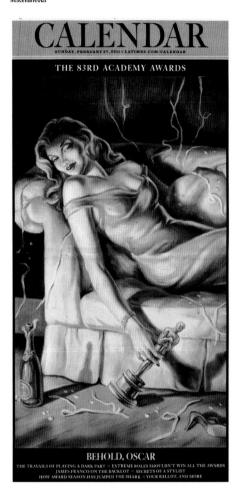

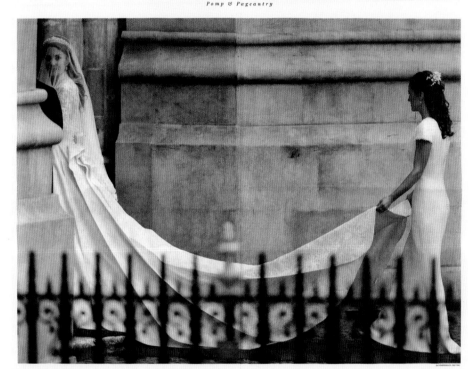

MINNEAPOLIS STAR TRIBUNE
Minneapolis, Minn.
Josh Crutchmer, Designer; **Bob Timmons**, Designer; **Janet Reeves**, Director of Photography; **Chris Carr**, Presentation Director; **Carlos Gonzalez**, Photographer; **Phil Spiker**, Designer
AWARDS OF EXCELLENCE
Special News Topics
Editor's Choice: Sports
News Design Page(s)
Sports/Broadsheet 175,000 and Over
News Design Page(s)
Inside Page/Broadsheet 175,000 and Over

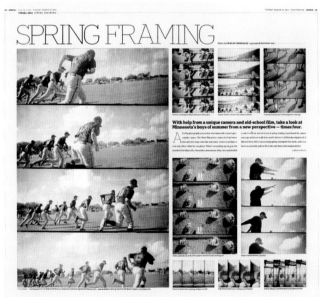

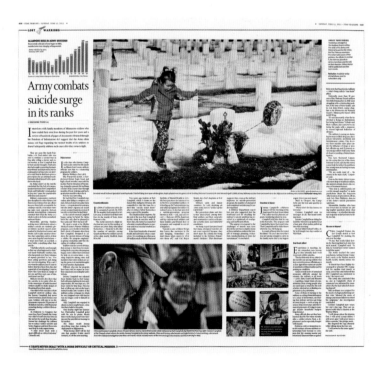

MINNEAPOLIS STAR TRIBUNE
Minneapolis, Minn.
Josh Crutchmer, Designer; **Chris Carr**, Presentation Director; **Janet Reeves**, Director of Photography; **Jim Gehrz**, Photographer; **Rene Sanchez**, M.E.; **Nancy Barnes**, Editor
AWARDS OF EXCELLENCE
Special News Topics
Editor's Choice: Local/Regional
News Design Page(s)
Inside Page/Broadsheet 175,000 and Over

TIMES OF OMAN
Muscat, Oman
Essa Mohammed Al Zedjali, Chairman;
Ahmed Essa Al Zedjali, CEO; **Adonis Durado**, Designer
AWARDS OF EXCELLENCE
News Design Page(s)
Business/Broadsheet 49,999 and Under
Photography/Single Photos
Illustration

NATIONAL POST
Toronto, Ont. , Canada
Becky Guthrie, Associate Features Design Editor; **Benjamin Errett**, M.E./Features;
Barry Hertz, Arts & Life Desk; **Stephen Meurice**, Editor-in-Chief;
Gayle Grin, M.E./Design & Graphics
AWARDS OF EXCELLENCE
News Design Page(s)
Inside Page/Broadsheet 50,000-174,999
News Design Page(s)
Local Section/Broadsheet 50,000-174,999

THE PLAIN DEALER
Cleveland, Ohio
Chris Morris, Art Director/Illustrator; **Emmet Smith**, Deputy Design Director/News;
Michael Tribble, Design & Graphics Director; **David Kordalski**, A.M.E./Visuals
AWARDS OF EXCELLENCE
Special Coverage/Section Pages
Sports/Cover Only
News Design Page(s)
Sports/Broadsheet 175,000 and Over

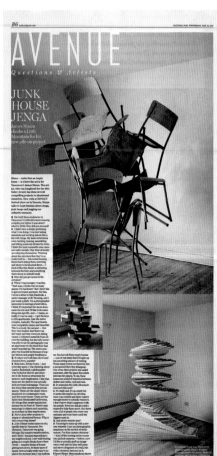

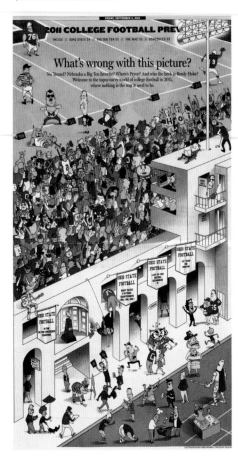

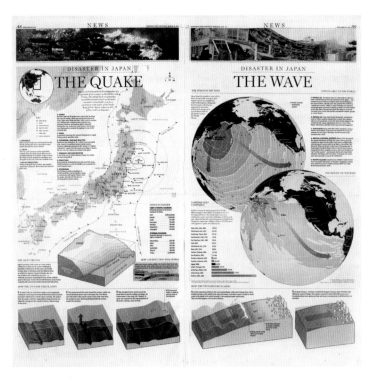

NATIONAL POST
Toronto, Ont., Canada
Steve Murray, Illustrator; **Geneviève Biloski**, Features Design Editor; **Becky Guthrie**,
Associate Features Design Editor; **Benjamin Errett**, M.E./Features; **Barry Hertz**,
Arts & Life Editor; **Stephen Meurice**, Editor-in-Chief; **Gayle Grin**, M.E./Design & Graphics
AWARDS OF EXCELLENCE
Miscellaneous
Feature Design Page(s)
Entertainment/Broadsheet 50,000-174,999

NATIONAL POST
Toronto, Ont. , Canada
Paolo Zinatelli, Senior Designer; **Phill Snel**, Deputy Photo Editor; **Richard Johnson**, Graphics Editor; **Jeff Wasserman**, Photo & Multimedia Editor; **Dan Tsukada**,
Page One Editor; **Anne Marie Owens**, M.E./News; **Michael Higgins**, Foreign Editor; **Stephen Meurice**, Editor-in-Chief; **Gayle Grin**, M.E./Design & Graphics; **Andrew Barr**,
Graphic Artist; **Kagan McLeod**, Graphic Artist; **Mike Faille**, Graphic Artist; **Jonathon Rivait**, Graphic Artist
AWARDS OF EXCELLENCE
Breaking News Topics
Japan Earthquake
Information Graphics/Portfolios
Breaking news/Extended Coverage (Staff) 50,000-174,999

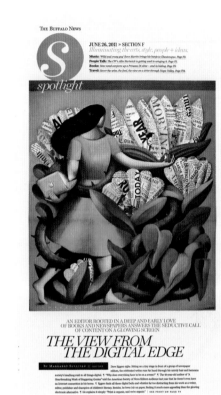

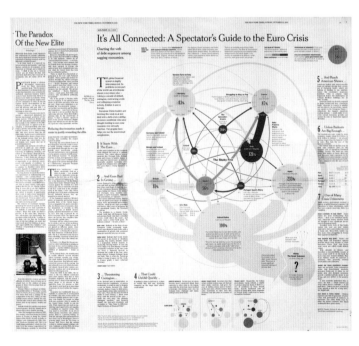

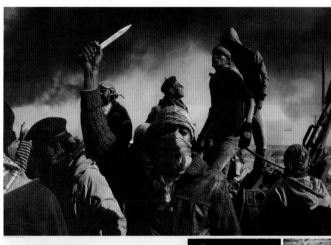

NATIONAL POST
Toronto, Ont. , Canada
Richard Johnson, Graphics Editor; **Andrew Barr**, Graphic Artist;
Jonathon Rivait, Graphic Artist; **Anne Marie Owens**, M.E./News;
Michael Higgins, Foreign Editor; **Stephen Meurice**, Editor-in-Chief;
Gayle Grin, M.E./Design & Graphics
AWARDS OF EXCELLENCE
Information Graphics
News/On Deadline 50,000-174,999
News Design Page(s)
Inside Page/Broadsheet 50,000-174,999

THE WASHINGTON POST
Washington, D.C.
Marianne Seregi, Designer; **Alex Trochut**, Illustrator;
Kristin Lenz, Designer; **Christopher Meighan**, Deputy Design Director/Features;
Greg Manifold, Deputy Design Director/News; **Janet Michaud**, Design Director
AWARDS OF EXCELLENCE
Special Coverage/Sections
News/Cover Only
News Design Page(s)
Business/Broadsheet 175,000 and Over

DAGENS NYHETER
Stockholm, Sweden
Rickard Frank, Head of Design; **Lotta Ek**, Art Director; **Dagens Nyheter Staff; Claes
Sjödin**, Page Designer; **Johan Andersson**, Infographic Artist; **Eric Ljunggren**, Editor;
Anders Sundström, Reporter
AWARDS OF EXCELLENCE
News Design/Sections
Local 175,000 and Over
News Design Page(s)
Local Section/Compact 175,000 and Over

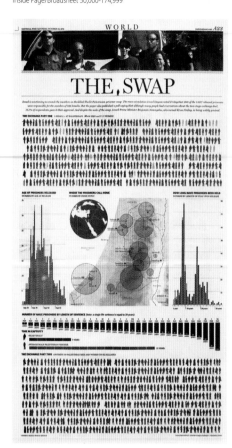

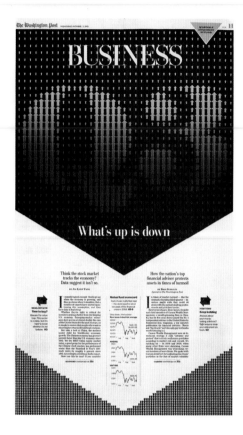

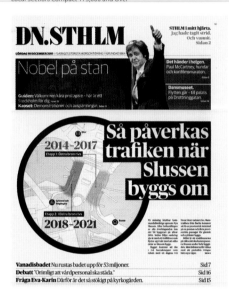

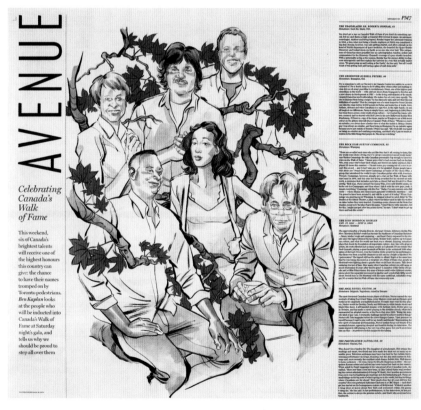

NATIONAL POST
Toronto, Ont. , Canada
Kagan Mcleod, Illustrator; **Geneviève Biloski**, Features Design Editor; **Benjamin Errett**, M.E./Features;
Barry Hertz, Arts & Life Editor; **Stephen Meurice**, Editor-in-Chief; **Gayle Grin**, M.E./Design & Graphics
AWARDS OF EXCELLENCE
News Design Page(s)
Local Section/Broadsheet 50,000-174,999
News Design Page(s)
Inside Page/Broadsheet 50,000-174,999

TORONTO STAR
Toronto, Ont. , Canada
Nuri Ducassi, A.M.E./Presentation; **Tim Fryer**, Designer; **Lynn McAuley**, Associate Editor;
Glenn Colbourn, Team Editor; **Catherine Farley**, Graphic Artist; **Brian Hughes**, Graphic Artist
AWARD OF EXCELLENCE
News Design/Sections
Other 175,000 and Over

SÍNTESIS
Puebla, Mexico
Ismael Espinoza, Diseñador; **Augusto Reynoso**, Editor; **Jesús Peña**, Gerente de Edición;
Omar Sánchez, Director de Arte; **Erick Becerra**, Director Editorial; **Oscar Tendero**,
Director General; **Armando Prida Noriega**, Vice Presidente; **Armando Prida Huerta**,
Presidente; **Diana Sánchez**, Diseñador; **Nayeli Barros**, Editor
AWARD OF EXCELLENCE
News Design/Sections
Other 49,999 and Under

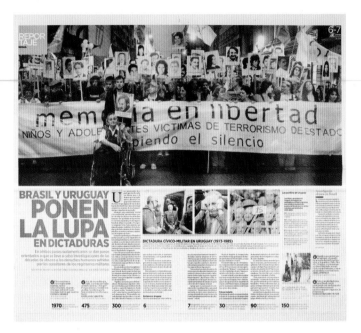

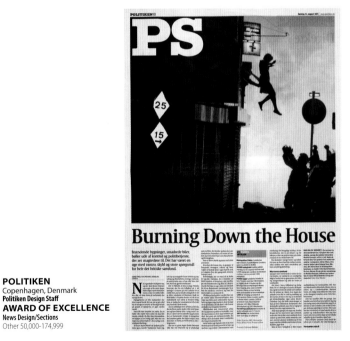

POLITIKEN
Copenhagen, Denmark
Politiken Design Staff
AWARD OF EXCELLENCE
News Design/Sections
Other 50,000-174,999

THE NATIONAL
Abu Dhabi, United Arab Emirates
April Robinson, Designer; **Laura Koot**, Art Director; **Brian Kerrigan**, Photo Editor;
Sara Baumberger, Designer; **Mathew Kurian**, Designer
AWARD OF EXCELLENCE
Special News Topics
Royal Wedding

MINNEAPOLIS STAR TRIBUNE
Minneapolis, Minn.
Chris Carr, Presentation Director
AWARD OF EXCELLENCE
News Design Page(s)
A-Section/Broadsheet 175,000 and Over

THE VIRGINIAN-PILOT
Norfolk, Va.
Sam Hundley, Designer/Illustrator
AWARD OF EXCELLENCE
News Design Page(s)
A-Section/Broadsheet 175,000 and Over

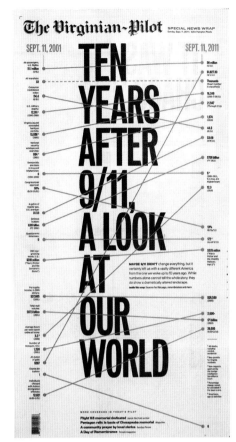

FRANKFURTER ALLGEMEINE
SONNTAGSZEITUNG
Frankfurt am Main, Germany
Peter Breul, Art Director; **Andreas Kuther**, Picture Editor; **Volker Zastrow**, Editor
AWARD OF EXCELLENCE
News Design Page(s)
A-Section/Broadsheet 175,000 and Over

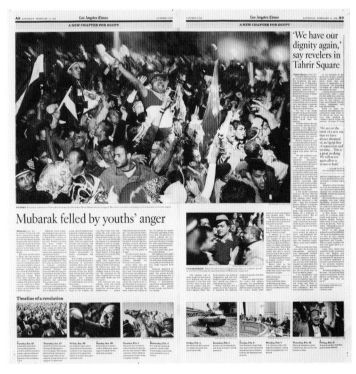

LOS ANGELES TIMES
Los Angeles, Calif.
Michael Whitley, A.M.E.; **Kelli Sullivan**, Deputy Design Director; **Dan Santos**, Designer;
Gerard Babb, Designer; **Steve Stroud**, Deputy Photo Editor
AWARD OF EXCELLENCE
News Design Page(s)
A-Section/Broadsheet 175,000 and Over

THE GLOBE AND MAIL
Toronto, Ont. , Canada
Adrian Norris, M.E./Design; **Jill Borra**, M.E./Features; **Devin Slater**, Assistant Art Director;
Matthew French, Design Editor; **Dennis Owen**, Photo Editor; **Roger Hallett**, Assistant Photo Editor
AWARD OF EXCELLENCE
News Design Page(s)
A-Section/Broadsheet 175,000 and Over

DIE ZEIT

Hamburg, Germany

Haika Hinze, Art Director; **Ellen Dietrich**, Director/Photography; **Klaus-D. Sieling**, Deputy Art Director; **Sina Giesecke**, Layout Editor; **Katrin Guddat**, Layout Editor; **Philipp Schultz**, Layout Editor; **Smetek Wieslaw**, Illustrator

AWARD OF EXCELLENCE

News Design Page(s)
A-Section/Broadsheet 175,000 and Over

DIE ZEIT

Hamburg, Germany

Haika Hinze, Art Director; **Ellen Dietrich**, Director/Photography; **Klaus-D. Sieling**, Deputy Art Director; **Mirko Bosse**, Layout Editor; **Martin Burgdorff**, Layout Editor/Illustrator; **Mechthild Fortmann**, Layout Editor; **Mark Chew**, Photographer

AWARD OF EXCELLENCE

News Design Page(s)
A-Section/Broadsheet 175,000 and Over

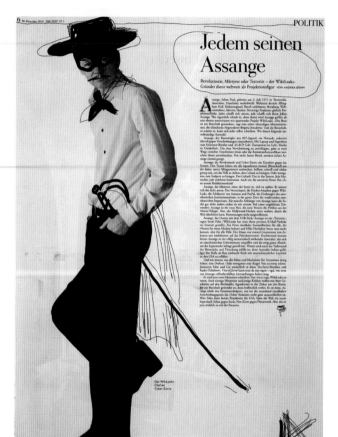

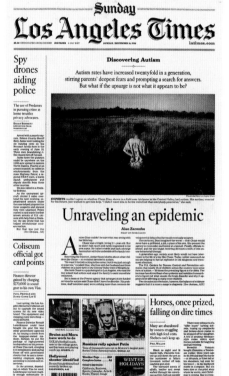

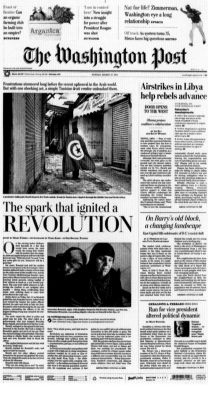

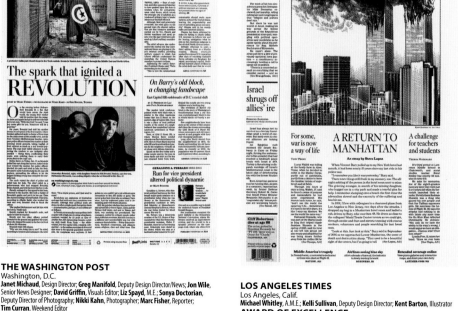

LOS ANGELES TIMES

Los Angeles, Calif.

Kelli Sullivan, Deputy Design Director; **Michael Whitley**, A.M.E.; **Mary Vignoles**, Photo Editor; **Francine Orr**, Photographer

AWARD OF EXCELLENCE

News Design Page(s)
A-Section/Broadsheet 175,000 and Over

THE WASHINGTON POST

Washington, D.C.

Janet Michaud, Design Director; **Greg Manifold**, Deputy Design Director/News; **Jon Wile**, Senior News Designer; **David Griffin**, Visuals Editor; **Liz Spayd**, M.E.; **Sonya Doctorian**, Deputy Director of Photography; **Nikki Kahn**, Photographer; **Marc Fisher**, Reporter; **Tim Curran**, Weekend Editor

AWARD OF EXCELLENCE

News Design Page(s)
A-Section/Broadsheet 175,000 and Over

LOS ANGELES TIMES

Los Angeles, Calif.

Michael Whitley, A.M.E.; **Kelli Sullivan**, Deputy Design Director; **Kent Barton**, Illustrator

AWARD OF EXCELLENCE

News Design Page(s)
A-Section/Broadsheet 175,000 and Over

MINNEAPOLIS STAR TRIBUNE
Minneapolis, Minn.
Chris Carr, Presentation Director
AWARD OF EXCELLENCE
News Design Page(s)
A-Section/Broadsheet 175,000 and Over

THE VIRGINIAN-PILOT
Norfolk, Va.
Sam Hundley, Designer/Illustrator
AWARD OF EXCELLENCE
News Design Page(s)
A-Section/Broadsheet 175,000 and Over

FRANKFURTER ALLGEMEINE SONNTAGSZEITUNG
Frankfurt am Main, Germany
Peter Breul, Art Director; **Andreas Kuther**, Picture Editor; **Volker Zastrow**, Editor
AWARD OF EXCELLENCE
News Design Page(s)
A-Section/Broadsheet 175,000 and Over

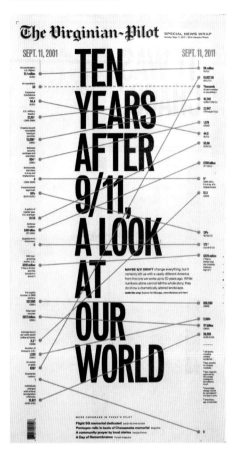

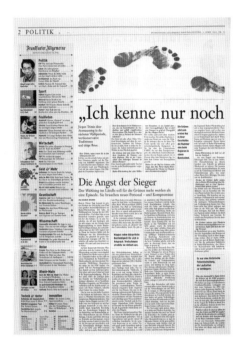

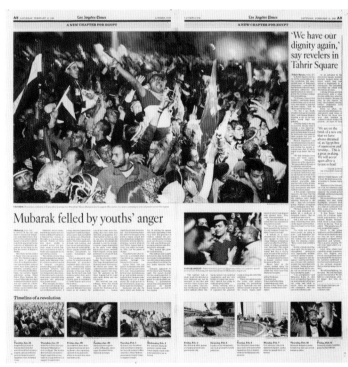

LOS ANGELES TIMES
Los Angeles, Calif.
Michael Whitley, A.M.E.; **Kelli Sullivan**, Deputy Design Director; **Dan Santos**, Designer;
Gerard Babb, Designer; **Steve Stroud**, Deputy Photo Editor
AWARD OF EXCELLENCE
News Design Page(s)
A-Section/Broadsheet 175,000 and Over

THE GLOBE AND MAIL
Toronto, Ont. , Canada
Adrian Norris, M.E./Design; **Jill Borra**, M.E./Features; **Devin Slater**, Assistant Art Director;
Matthew French, Design Editor; **Dennis Owen**, Photo Editor; **Roger Hallett**, Assistant Photo Editor
AWARD OF EXCELLENCE
News Design Page(s)
A-Section/Broadsheet 175,000 and Over

DIE ZEIT
Hamburg, Germany
Haika Hinze, Art Director; **Ellen Dietrich**, Director/Photography; **Klaus-D. Sieling**,
Deputy Art Director; **Sina Giesecke**, Layout Editor; **Katrin Guddat**, Layout Editor;
Philipp Schultz, Layout Editor; **Smetek Wieslaw**, Illustrator
AWARD OF EXCELLENCE
News Design Page(s)
A-Section/Broadsheet 175,000 and Over

DIE ZEIT
Hamburg, Germany
Haika Hinze, Art Director; **Ellen Dietrich**, Director/Photography; **Klaus-D. Sieling**,
Deputy Art Director; **Mirko Bosse**, Layout Editor; **Martin Burgdorff**, Layout Editor/Illustrator;
Mechthild Fortmann, Layout Editor; **Mark Chew**, Photographer
AWARD OF EXCELLENCE
News Design Page(s)
A-Section/Broadsheet 175,000 and Over

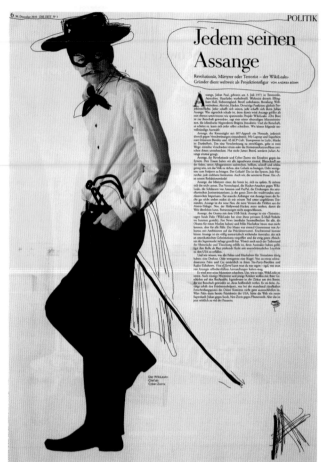

LOS ANGELES TIMES
Los Angeles, Calif.
Kelli Sullivan, Deputy Design Director; **Michael Whitley**, A.M.E.;
Mary Vignoles, Photo Editor; **Francine Orr**, Photographer
AWARD OF EXCELLENCE
News Design Page(s)
A-Section/Broadsheet 175,000 and Over

THE WASHINGTON POST
Washington, D.C.
Janet Michaud, Design Director; **Greg Manifold**, Deputy Design Director/News; **Jon Wile**,
Senior News Designer; **David Griffin**, Visuals Editor; **Liz Spayd**, M.E.; **Sonya Doctorian**,
Deputy Director of Photography; **Nikki Kahn**, Photographer; **Marc Fisher**, Reporter;
Tim Curran, Weekend Editor
AWARD OF EXCELLENCE
News Design Page(s)
A-Section/Broadsheet 175,000 and Over

LOS ANGELES TIMES
Los Angeles, Calif.
Michael Whitley, A.M.E.; **Kelli Sullivan**, Deputy Design Director; **Kent Barton**, Illustrator
AWARD OF EXCELLENCE
News Design Page(s)
A-Section/Broadsheet 175,000 and Over

THE GLOBE AND MAIL
Toronto, Ont. , Canada
Adrian Norris, M.E./Design; **Devin Slater**, Assistant Art Director; **Gregory Boyd**, News Editor; **Matthew French**, Design Editor; **Dennis Owen**, Photo Editor; **Roger Hallett**, Assistant Photo Editor; **Aron Yeomanson**, A1 Editor; **Nicole MacAdam**, Presentation Editor

AWARD OF EXCELLENCE
News Design Page(s)
A-Section/Broadsheet 175,000 and Over

THE PLAIN DEALER
Cleveland, Ohio
Emmet Smith, Deputy Design Director/News; **Michael Tribble**, Design & Graphics Editor; **David Kordalski**, A.M.E./Visuals; **Daryl Kannberg**, D.M.E.; **Thom Fladung**, M.E.

AWARD OF EXCELLENCE
News Design Page(s)
A-Section/Broadsheet 175,000 and Over

CHINA DAILY
Beijing, China
Chi Tian, Designer; **Guillermo Munro**, Illustrator

AWARD OF EXCELLENCE
News Design Page(s)
A-Section/Broadsheet 175,000 and Over

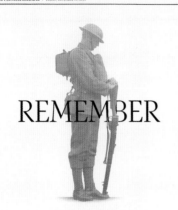

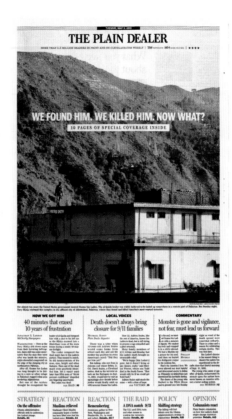

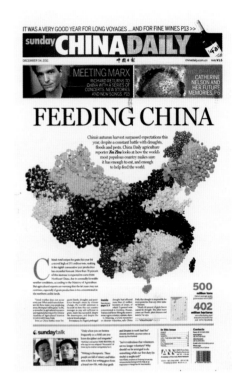

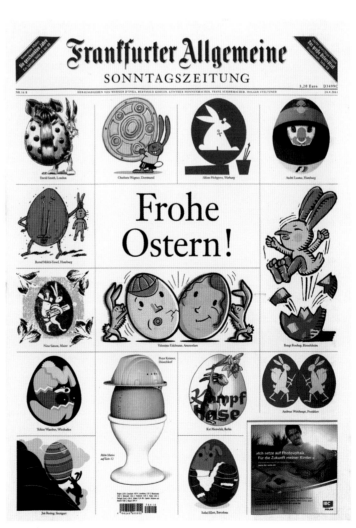

LOS ANGELES TIMES
Los Angeles, Calif.
Kelli Sullivan, Deputy Design Director; **Michael Whitley**, A.M.E.; **Mary Vignoles**, Photo Editor; **Francine Orr**, Photographer

AWARD OF EXCELLENCE
News Design Page(s)
A-Section/Broadsheet 175,000 and Over

FRANKFURTER ALLGEMEINE SONNTAGSZEITUNG
Frankfurt am Main, Germany
Peter Breul, Art Director; **Andreas Kuther**, Picture Editor; **Volker Zastrow**, Editor

AWARD OF EXCELLENCE
News Design Page(s)
A-Section/Broadsheet 175,000 and Over

LOS ANGELES TIMES
Los Angeles, Calif.
Kelli Sullivan, Deputy Design Director; **Mary Cooney**, Deputy Photo Editor;
Colin Crawford, D.M.E.; **Barbara Davidson**, Photographer
AWARD OF EXCELLENCE
News Design Page(s)
A-Section/Broadsheet 175,000 and Over

**FRANKFURTER ALLGEMEINE
SONNTAGSZEITUNG**
Frankfurt am Main, Germany
Peter Breul, Art Director; **Andreas Kuther**, Picture Editor;
Volker Zastrow, Editor; **Lucas Wahl**, Photographer
AWARD OF EXCELLENCE
News Design Page(s)
A-Section/Broadsheet 175,000 and Over

DER TAGESSPIEGEL
Berlin, Germany
Bettina Seuffert, Art Director/Designer; **Lutz Haverkamp**, Editor;
Juliane Schäuble, Editor
AWARD OF EXCELLENCE
News Design Page(s)
A-Section/Broadsheet 50,000-174,999

Blutiger Schnitt

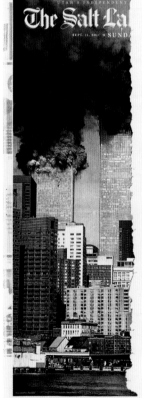

Still rising from the fall

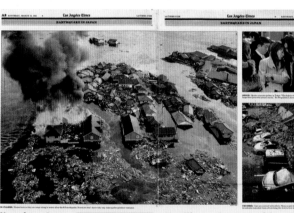

LOS ANGELES TIMES
Los Angeles, Calif.
Michael Whitley, A.M.E.; **Kelli Sullivan**, Deputy Design Director; **Dan Santos**, Design Editor; **Gerard Babb**, Design Editor;
Mark Yemma, Design Editor; **Steve Stroud**, Deputy Photo Editor; **Robert St. John**, Photo Editor
AWARD OF EXCELLENCE
News Design Page(s)
A-Section/Broadsheet 175,000 and Over

THE SALT LAKE TRIBUNE
Salt Lake City, Utah
Colin Smith, Assistant News Editor/Design
AWARD OF EXCELLENCE
News Design Page(s)
A-Section/Broadsheet 50,000-174,999

NATIONAL POST
Toronto, Ont., Canada
Richard Johnson, Illustrator/Graphics Editor; **Laura Morrison**, News Presentation Editor;
Paolo Zinatelli, Senior Designer; **Jeff Wasserman**, Photo & Multimedia Editor;
Anne Marie Owens, M.E./News; **Stephen Meurice**, Editor-in-Chief;
Gayle Grin, M.E./Design & Graphics
AWARD OF EXCELLENCE
News Design Page(s)
A-Section/Broadsheet 50,000–174,999

POLITIKEN
Copenhagen, Denmark
Søren Nyeland, Design Editor; **Anne Mette Svane**, Editor-in-Chief;
Anne-Marie Steen Petersen, Artist
AWARD OF EXCELLENCE
News Design Page(s)
A-Section/Broadsheet 50,000–174,999

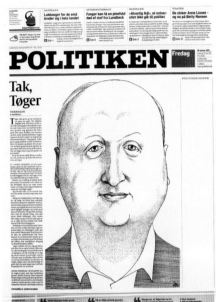

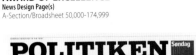
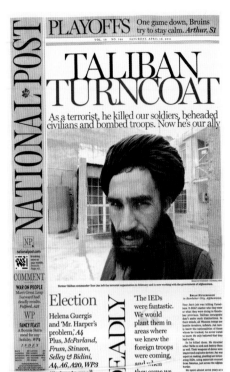

POLITIKEN
Copenhagen, Denmark
Søren Nyeland, Design Editor; **Anne Mette Svane**, Editor-in-Chief;
Tomas Østergren, Page Designer; **Christian Ilsøe**, News Editor
AWARD OF EXCELLENCE
News Design Page(s)
A-Section/Broadsheet 50,000–174,999

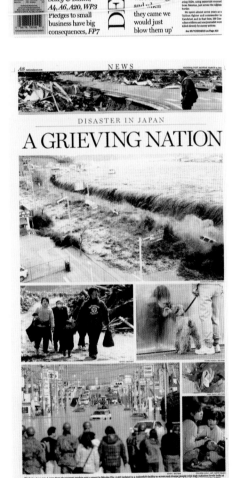

NATIONAL POST
Toronto, Ont., Canada
Mike Faille, Illustrator; **Laura Morrison**, News Presentation Editor;
Paolo Zinatelli, Senior Designer; **Richard Johnson**, Graphics Editor; **Anne Marie Owens**,
M.E./News; **Andrew Barr**, Illustrator; **Stephen Meurice**, Editor-in-Chief;
Gayle Grin, M.E./Design & Graphics
AWARD OF EXCELLENCE
News Design Page(s)
A-Section/Broadsheet 50,000–174,999

NATIONAL POST
Toronto, Ont. , Canada
Jaqueline Nunes, Page One Editor; **Diane Doiron**, Photo Editor; **Richard Johnson**,
Graphics Editor; **Jonathon Rivait**, Graphics; **Joe Hood**, Page One Editor;
Anne Marie Owens, M.E./News; **Michael Higgins**, Foreign Editor;
Stephen Meurice, Editor-in-Chief; **Gayle Grin**, M.E./Design & Graphics
AWARD OF EXCELLENCE
News Design Page(s)
A-Section/Broadsheet 50,000–174,999

A TARDE
Salvador, Brazil
Pierre Themotheo, Art Editor-in-Chief; **Iansã Negrão**, Art Editor;
Raul Spinassé, Photographer; **Axel Augusto**, Designer
AWARD OF EXCELLENCE
News Design Page(s)
A-Section/Broadsheet 49,999 and Under

A.M. DE QUERÉTARO
Querétaro, Mexico
Pedro Pablo Tejada, General Director; **Arturo Hernández**, Graphic Editor;
Claudia Hernández, Editor; **Daniel Martínez**, Reporter; **Javier Kanchi**, Illustrator
AWARD OF EXCELLENCE
News Design Page(s)
A-Section/Broadsheet 49,999 and Under

DER FREITAG
Berlin, Germany
Janine Sack, Art Director; **Andine Müller**, Advising Art Director;
Jana Schnell, Vice Art Director; **Max Sauerbier**, Graphic Designer; **Felix Felasco**,
Graphic Designer; **Corinna Koch**, Picture Editor; **Niklas Rock**, Picture Editor;
Antje Berghäuser, Picture Editor
AWARD OF EXCELLENCE
News Design Page(s)
A-Section/Broadsheet 49,999 and Under

DAGENS NYHETER
Stockholm, Sweden
Dagens Nyheter Staff
AWARD OF EXCELLENCE
News Design Page(s)
A-Section/Compact 175,000 and Over

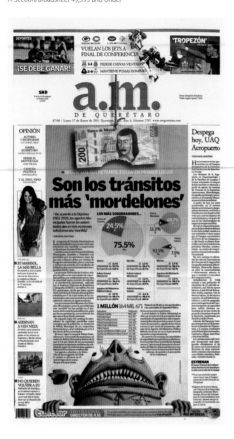

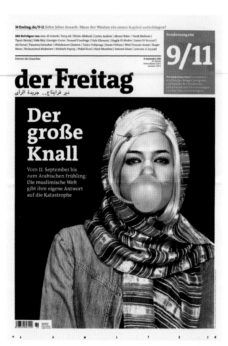

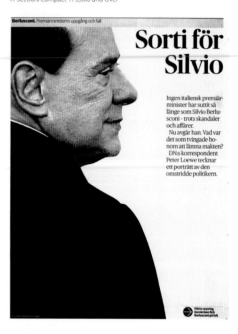

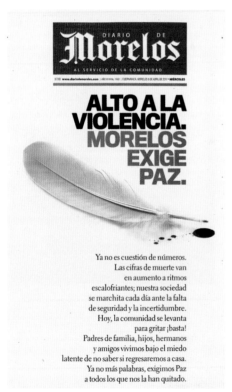

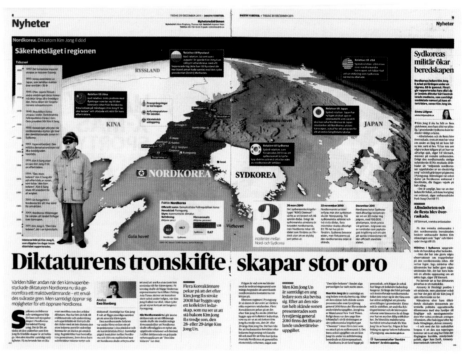

DIARIO DE MORELOS
Cuernavaca, Mexico
Daniel Esqueda, Design Consultant/Designer; **Victorino Zurita**, Design Coordinator;
Ángel Vega, Editorial Director; **Miguel Ángel Bracamontes**, CEO
AWARD OF EXCELLENCE
News Design Page(s)
A-Section/Broadsheet 49,999 and Under

DAGENS NYHETER
Stockholm, Sweden
Nicolaus Daun, Page Designer; **Ingemar Holst**, Page Designer;
Stefan Rothmaier, Infographic Artist
AWARD OF EXCELLENCE
News Design Page(s)
A-Section/Compact 175,000 and Over

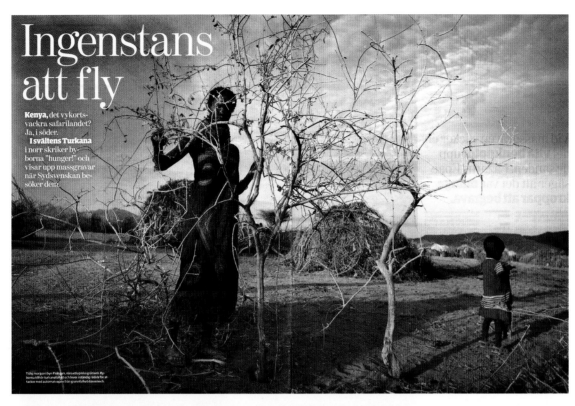

Ingenstans att fly

Kenya, det vykorts-vackra safarilandet? Ja, i söder. **I svältens Turkana** i norr skriker by-borna "hunger!" och visar upp massgravar när Sydsvenskan be-söker dem.

SYDSVENSKAN
Malmö, Sweden
Åsa Sjöström, Photographer; **Karin Sandqvist**, Page Editor
AWARD OF EXCELLENCE
News Design Page(s)
A-Section/Compact 50,000-174,999

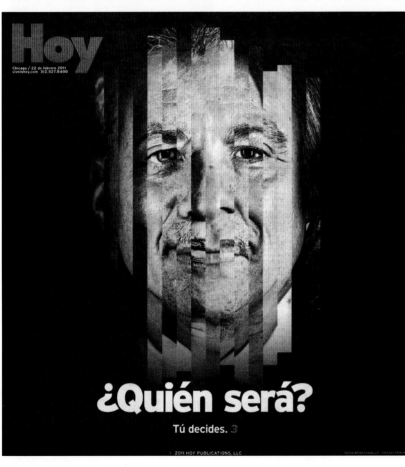

(CHICAGO) HOY
Chicago, Ill.
Lorena González, Designer; **Jacqueline Marrero,** Designer; **Rodolfo Jiménez,** Art Director; **Octavio López,** Editor; **Fernando Díaz,** M.E.; **John Trainor,** General Manager
AWARD OF EXCELLENCE
News Design Page(s)
A-Section/Compact 50,000-174,999

(SONORA) EXPRESO
Hermosillo, Mexico
Giovanna Espriella, Designer/Illustrator; **Patricia Moraga,** Editor; **Eduardo Sánchez,** Editorial Director; **Luis Felipe Romandía,** Director
AWARD OF EXCELLENCE
News Design Page(s)
A-Section/Broadsheet 49,999 and Under

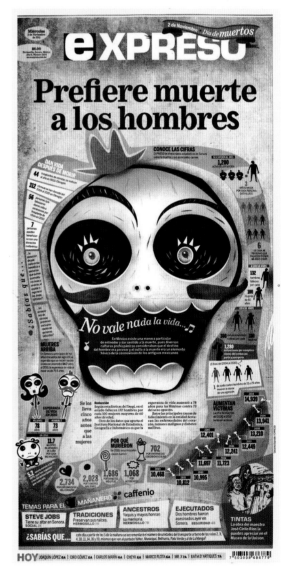

LOS ANGELES TIMES
Los Angeles, Calif.
Michael Whitley, A.M.E.; **Kelli Sullivan**, Deputy Design Director; **Derek Simmons**, Deputy Design Director; **Mark Yemma**, Designer; **Robert St. John**, Photo Editor; **Calvin Hom**, Deputy Photo Editor
AWARD OF EXCELLENCE
News Design Page(s)
Local Section/Broadsheet 175,000 and Over

NATIONAL POST
Toronto, Ont., Canada
Geneviève Biloski, Features Design Editor; **Becky Guthrie**, Associate Features Design Editor; **Benjamin Errett**, M.E./Features; **Barry Hertz**, Arts & Life Editor; **Harry Joy**, Photographer; **Stephen Meurice**, Editor-in-Chief; **Gayle Grin**, M.E./Design & Graphics
AWARD OF EXCELLENCE
News Design Page(s)
Local Section/Broadsheet 50,000-174,999

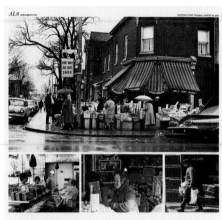

JORNAL DE SANTA CATARINA
Blumenau, Sta. Catarina, Brazil
Aline Fialho, Assistant Design Editor; **Marcelo Camacho**, Illustrator; **Fabiana Roza**, Editor; **Edgar Gonçalves Jr.**, Editor-in-Chief
AWARD OF EXCELLENCE
News Design Page(s)
A-Section/Compact 49,999 and Under

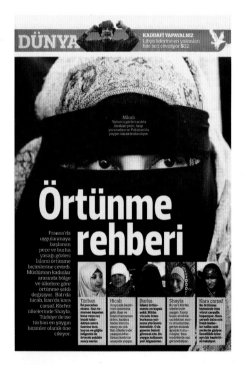

RADIKAL
Günesli, Istanbul, Turkey
Eyüp Can, Editor-in-Chief; **Bülent Mumay**, Editorial Coordinator; **Sefer Levent**, Economy Coordinator; **Cem Erciyes**, Supplement Editor; **Gökçe Aytulu**, News Editor; **Sertaç Bala**, Art Director; **Ersel Yildiz**, Deputy Art Director; **Fehim Taştekin**, Editor; **Çağil Kasapoğlu**, Editor
AWARD OF EXCELLENCE
News Design Page(s)
A-Section/Compact 49,999 and Under

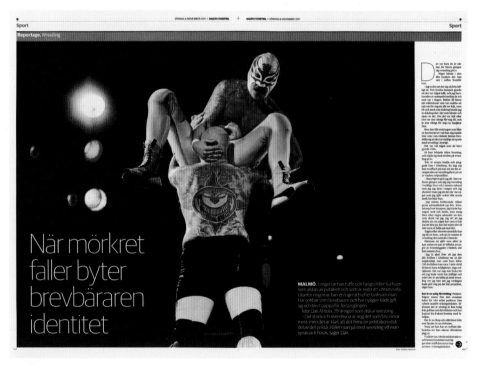

DAGENS NYHETER
Stockholm, Sweden
Claes Sjödin, Page Designer; **Anders Hansson**, Photographer
AWARD OF EXCELLENCE
News Design Page(s)
Sports/Compact 175,000 and Over

NATIONAL POST
Toronto, Ont. , Canada
Becky Guthrie, Associate Features Design Editor; **Benjamin Errett**, M.E./Features;
Maryam Siddiqi, D.M.E./Features; **Stephen Meurice**, Editor-in-Chief;
Gayle Grin, M.E./Design & Graphics
AWARD OF EXCELLENCE
News Design Page(s)
Local Section/Broadsheet 50,000-174,999

(SONORA) EXPRESO
Hermosillo, Mexico
Giovanna Espriella, Designer/Illustrator; **Cecilia Toscano**, Editor;
Eduardo Sánchez, Editorial Director; **Luis Felipe Romandía**, Director
AWARD OF EXCELLENCE
News Design Page(s)
Local Section/Broadsheet 49,999 and Under

TORONTO STAR
Toronto, Ont. , Canada
Kathleen Doody, Designer; **Jayme Poisson**, Writer; **Richard Lautens**, Photographer;
Catherine Farley, Graphic Artist; **Rita Daly**, Copy Editor;
Nuri Ducassi, A.M.E./Presentation; **Graham Parley**, City Editor;
Hélène de Guise, Deputy Art Director; **Geneviève Dinel**, Art Director
AWARD OF EXCELLENCE
News Design Page(s)
Local Section/Broadsheet 175,000 and Over

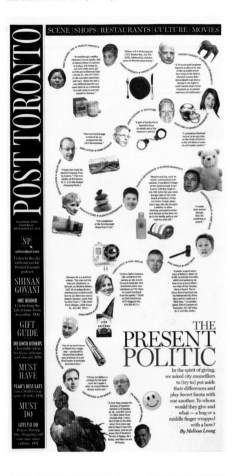

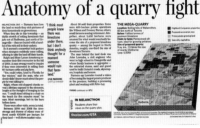

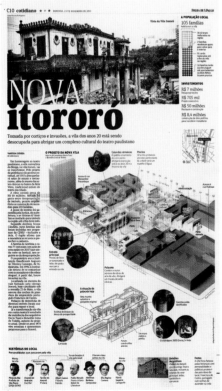

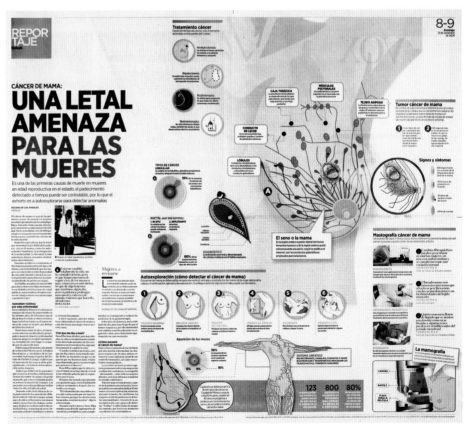

FOLHA DE SÃO PAULO
São Paulo, Brazil
Fabio Marra, Art Editor; **Mario Kanno**, Deputy Art Editor;
Marcelo Pliger, Infographic Designer
AWARD OF EXCELLENCE
News Design Page(s)
Local Section/Broadsheet 175,000 and Over

SÍNTESIS
Puebla, Mexico
Felipe Lamas, Diseñador; **Fabián Sánchez**, Editor; **Celso Juárez**, Illustrator; **Alfredo Guevara**, Gerente de Edición Local; **Omar Sánchez**, Director de Arte;
Erick Becerra, Director Editorial; **Oscar Tendero**, Director General; **Armando Prida Noriega**, Vice President; **Armando Prida Huerta**, President
AWARD OF EXCELLENCE
News Design Page(s)
Local Section/Broadsheet 49,999 and Under

A.M. DE QUERÉTARO
Querétaro, Mexico
Pedro Pablo Tejada, General Director; **Arturo Hernández**, Graphic Editor/Designer/Illustrator; **Ángeles Ocampo**, Editor; **Cupertino Ramírez**, Reporter
AWARD OF EXCELLENCE
News Design Page(s)
Local Section/Broadsheet 49,999 and Under

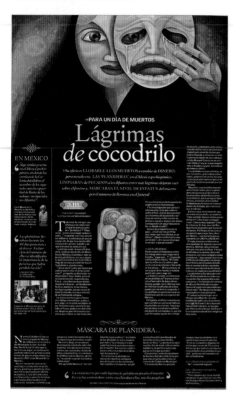

THE BUFFALO NEWS
Buffalo, N.Y.
Vincent Chiaramonte, Design Director; **Lisa Wilson**, Executive Sports Editor
AWARD OF EXCELLENCE
News Design Page(s)
Sports/Broadsheet 175,000 and Over

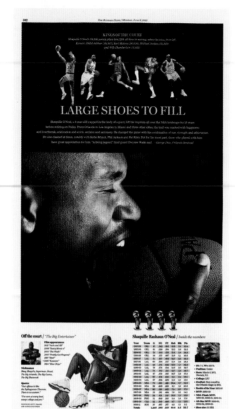

THE WASHINGTON POST
Washington, D.C.
Tippi Thole, Art Director; **Christopher Meighan**, Deputy Design Director/Features; **Janet Michaud**, Design Director
AWARD OF EXCELLENCE
News Design Page(s)
Local Section/Compact 175,000 and Over

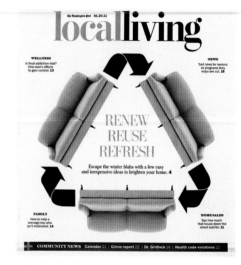

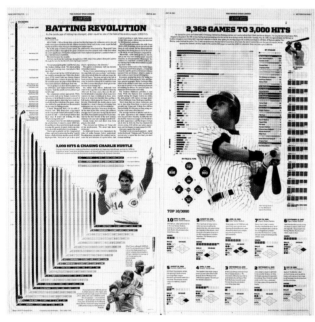

THE STAR-LEDGER
Newark, N.J.
Dan Worthington, Designer
AWARD OF EXCELLENCE
News Design Page(s)
Sports/Broadsheet 175,000 and Over

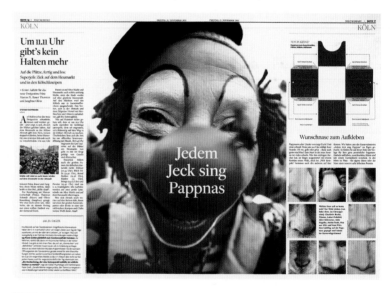

WELT GRUPPE
Berlin, Germany
Katja Fischer, Page Designer; **Stefan Kaufmann**, Editor; **Rainer Morgenroth**, Editor
AWARD OF EXCELLENCE
News Design Page(s)
Local Section/Compact 175,000 and Over

DAGENS NYHETER
Stockholm, Sweden
Claes Sjödin, Page Designer; **Stefan Rothmaier**, Photo Artist; **Eric Ljunggren**, Editor;
Marijana Dragic, Reporter; **Kristoffer Örstadius**, Reporter
AWARD OF EXCELLENCE
News Design Page(s)
Local Section/Compact 175,000 and Over

THE DALLAS MORNING NEWS
Dallas, Texas
Michael Hogue, Graphic Artist
AWARD OF EXCELLENCE
News Design Page(s)
Sports/Broadsheet 175,000 and Over

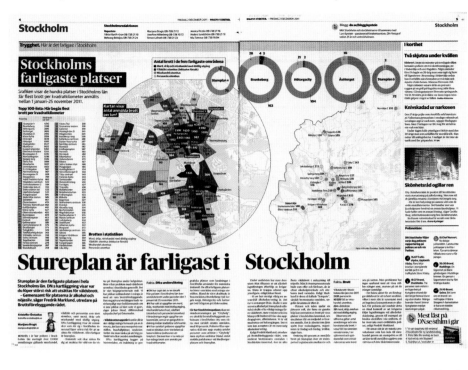

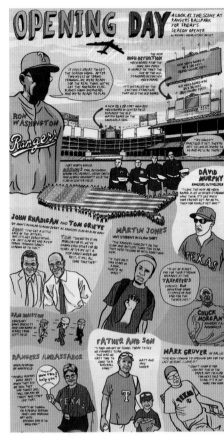

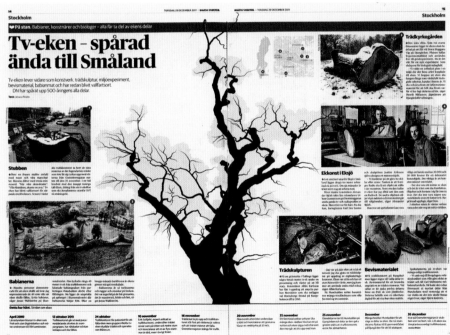

DAGENS NYHETER
Stockholm, Sweden
Claes Sjödin, Page Designer; **Jessica Ritzen**, Reporter; **Eric Ljunggren**, Editor
AWARD OF EXCELLENCE
News Design Page(s)
Local Section/Compact 175,000 and Over

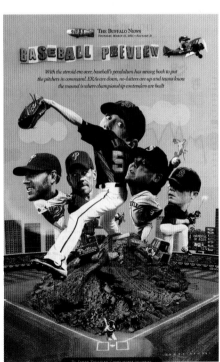

THE BUFFALO NEWS
Buffalo, N.Y.
Vincent Chiaramonte, Design Director; **Daniel Zakroczemski**, Illustrator;
Lisa Wilson, Executive Sports Editor; **Greg Connors**, Copy Editor
AWARD OF EXCELLENCE
News Design Page(s)
Sports/Broadsheet 175,000 and Over

THE DALLAS MORNING NEWS
Dallas, Texas
John Hancock, Designer; **Michael Hogue**, Graphic Artist;
Rob Schneider, Presentation Director
AWARD OF EXCELLENCE
News Design Page(s)
Sports/Broadsheet 175,000 and Over

THE SEATTLE TIMES
Seattle, Wash.
Gabriel Campanario, Illustrator; **Rick Lund**, Designer;
Whitney Strensrud, Editor; **Denise Clifton**, Art Director
AWARD OF EXCELLENCE
News Design Page(s)
Inside Page/Broadsheet 175,000 and Over

THE (NEW YORK) WALL STREET JOURNAL
New York, N.Y.
Tomaso Capuano, Creative Director; **Rebecca R. Markovitz**,
Assistant Art Director; **Dustin Drankoski**, Photo Editor
AWARD OF EXCELLENCE
News Design Page(s)
Sports/Broadsheet 175,000 and Over

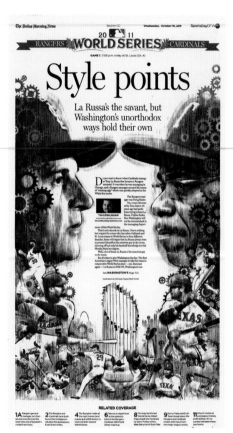

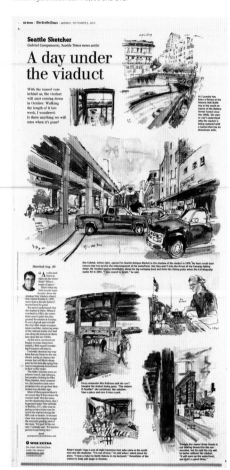

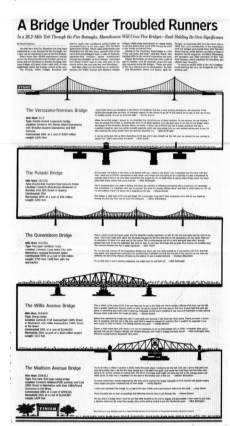

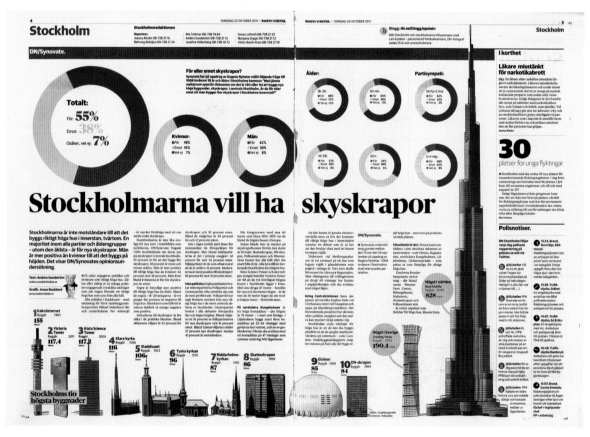

DAGENS NYHETER
Stockholm, Sweden
Claes Sjödin, Page Designer; **Jonas Backlund**, Infographics Artist; **Eric Ljunggren**, Editor
AWARD OF EXCELLENCE
News Design Page(s)
Local Section/Compact 175,000 and Over

THE WASHINGTON POST
Washington, D.C.
Brian Gross, Senior Art Director/Sports; **Christopher Meighan**, Deputy Design Director/
Features; **Greg Manifold**, Deputy Design Director/News; **Janet Michaud**, Design Director
AWARD OF EXCELLENCE
News Design Page(s)
Sports/Broadsheet 175,000 and Over

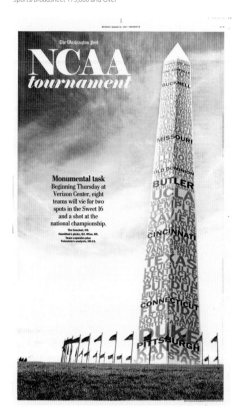

THE BOSTON GLOBE
Boston, Mass.
Luke Knox, Sports Designer; **Dan Zedek**, A.M.E./Design
AWARD OF EXCELLENCE
News Design Page(s)
Sports/Broadsheet 175,000 and Over

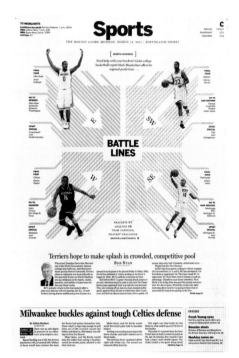

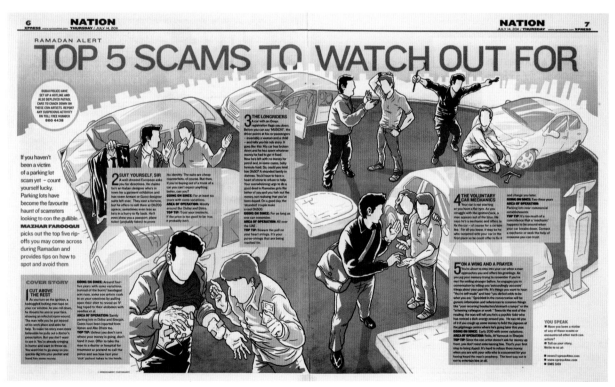

XPRESS
Dubai, United Arab Emirates
Ador Bustamante, Designer; **Miguel Angel Gomez**, Design Director; **Bobby Naqvi**, Editor; **Abdul Hamid Ahmad**, Editor-in-Chief; **Mazhar Farooqui**, Deputy Editor
AWARD OF EXCELLENCE
News Design Page(s)
Local Seciton/Compact 50,000-174,999

THE NEW YORK TIMES
New York, N.Y.
Sam Manchester, Illustrator; **Wayne Kamidoi**, Art Director;
Tom Bodkin, Design Director
AWARD OF EXCELLENCE
News Design Page(s)
Sports/Broadsheet 175,000 and Over

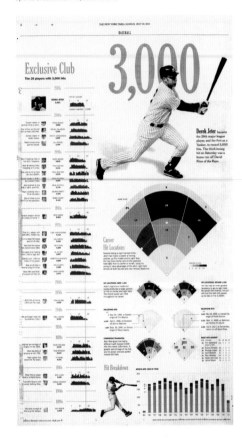

AL BAYAN
Dubai, United Arab Emirates
Luis Chumpitaz, Information Graphic Director; **Liz Ramos Prado**, Information Graphic Editor;
German Fernandez, Information Graphic Editor; **Karina Aricoche**, Information Graphic Researcher; **Asma Ali**, Translator
AWARD OF EXCELLENCE
News Design Page(s)
Sports/Broadsheet 50,000-174,999

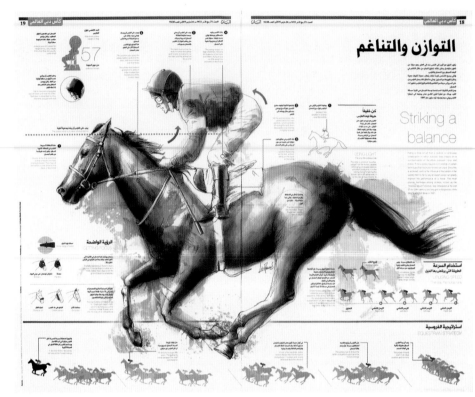

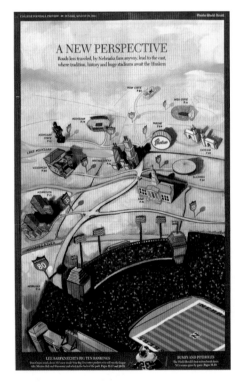

OMAHA WORLD-HERALD
Omaha, Neb.
Tim Parks, Deputy News & Presentation Editor; **Thad Livingston**, Sports Editor;
Matt Haney, Artist; **Dave Elsesser**, News & Presentation Editor
AWARD OF EXCELLENCE
News Design Page(s)
Sports/Broadsheet 50,000-174,999

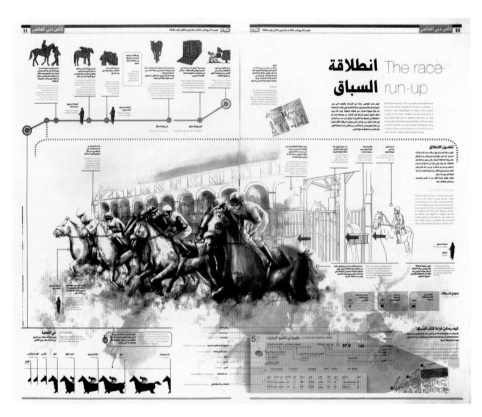

AL BAYAN
Dubai, United Arab Emirates
Luis Chumpitaz, Information Graphic Director; **Liz Ramos Prado**, Information Graphic Editor;
German Fernandez, Information Graphic Editor; **Karina Aricoche**, Information Graphic Researcher; **Asma Ali**, Translator
AWARD OF EXCELLENCE
News Design Page(s)
Sports/Broadsheet 50,000-174,999

GULF NEWS
Dubai, United Arab Emirates
Douglas Okasaki, Senior Designer; **Ramachandra Babu**, Senior Illustrator; **Dwyn Ronald Trazo**, Senior Infographist
Luis Vasquez, Senior Infographist; **Alaric Gomes**, Reporter; **Miguel Angel Gomez**, Design Director;
Mohammed Al Mezel, M.E.; **Abdul Hamid Ahmad**, Editor-in-Chief
AWARD OF EXCELLENCE
News Design Page(s)
Sports/Broadsheet 50,000-174,999

AL BAYAN
Dubai, United Arab Emirates
Luis Chumpitaz, Information Graphic Director; **Liz Ramos Prado**, Information Graphic Editor;
German Fernandez, Information Graphic Editor; **Karina Aricoche**, Information Graphic Researcher; **Asma Ali**, Translator
AWARD OF EXCELLENCE
News Design Page(s)
Sports/Broadsheet 50,000-174,999

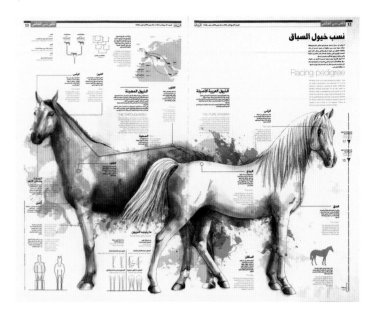

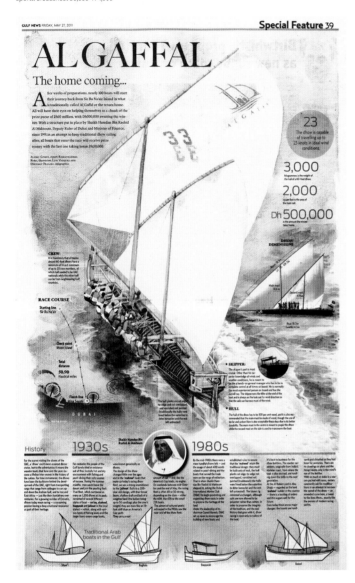

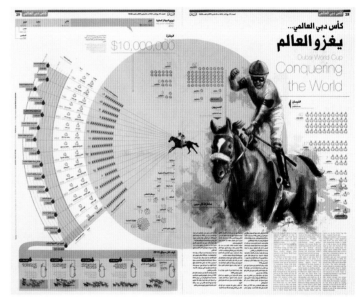

AL BAYAN
Dubai, United Arab Emirates
Luis Chumpitaz, Information Graphic Director;
Liz Ramos Prado, Information Graphic Editor;
German Fernandez, Information Graphic Editor;
Karina Aricoche, Information Graphic Researcher;
Asma Ali, Translator
AWARD OF EXCELLENCE
News Design Page(s)
Sports/Broadsheet 50,000-174,999

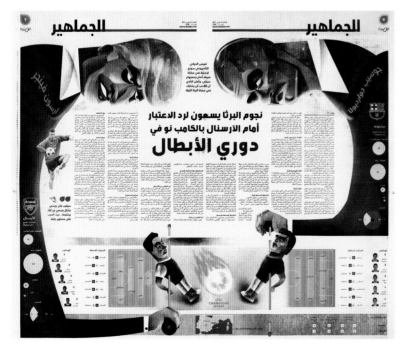

AL SHABIBA
Muscat, Oman
Essa Mohammed Al Zedjali, Chairman; **Ahmed Essa Al Zedjali**, Editor-in-Chief; **Adonis Durado**,
Design Director; **Antonio Farach**, Graphic Editor; **Marcelo Duhalde**, Infographic Designer;
Lucille Umali, Illustrator; **Majid Al-Wahebi**, Designer
AWARD OF EXCELLENCE
News Design Page(s)
Sports/Broadsheet 49,999 and Under

TIMES OF OMAN
Muscat, Oman
Essa Mohammed Al Zedjali, Chairman; **Ahmed Essa Al Zedjali**, Editor-in-Chief;
Adonis Durado, Design Director; **Osama Aljawish**, Designer
AWARD OF EXCELLENCE
News Design Page(s)
Business/Broadsheet 49,999 and Under

DAGENS NYHETER
Stockholm, Sweden
Claes Sjödin, Page Designer; **Stefan Rothmaier**, Infographic Artist; **Göran Löfgren**, Sports Editor; **Anders Lundqvist**, Reporter
AWARD OF EXCELLENCE
News Design Page(s)
Sports/Compact 175,000 and Over

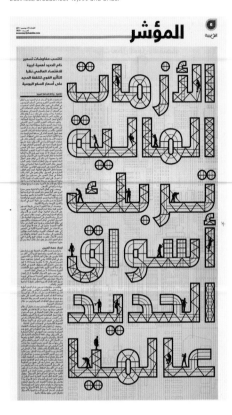

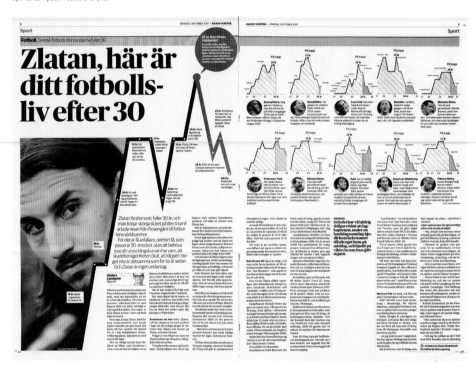

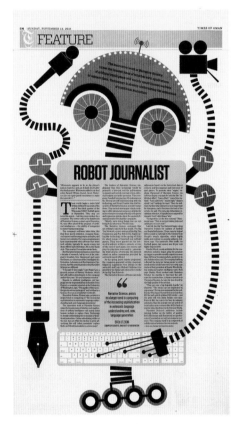

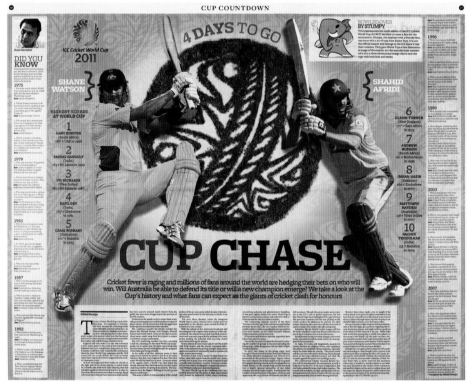

TIMES OF OMAN
Muscat, Oman
Essa Mohammed Al Zedjali, Chairman; **Ahmed Essa Al Zedjali**, CEO;
Adonis Durado, Design Director; **Gregory Fernandez**, Designer
AWARD OF EXCELLENCE
News Design Page(s)
Business/Broadsheet 49,999 and Under

KHALEEJ TIMES
Dubai, United Arab Emirates
Roberto Canseco, Designer/Illustrator/Art Director; **Patrick Michael**, Executive Editor
AWARD OF EXCELLENCE
News Design Page(s)
Sports/Broadsheet 49,999 and Under

HI WEEKLY
Muscat, Oman
Essa Al Zedjali, Chairman; **Ahmed Essa Al Zedjali**, CEO; **Adonis Durado**, Design Director; **Isidore Vic Carloman III**, Illustrator
AWARD OF EXCELLENCE
News Design Page(s)
Sports/Compact 49,999 and Under

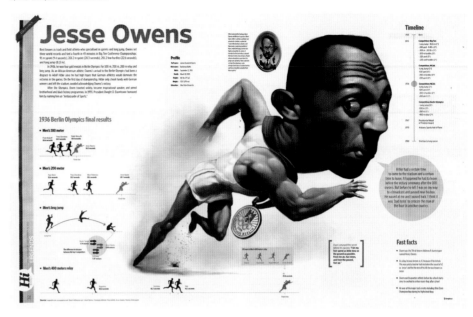

TIMES OF OMAN
Muscat, Oman
Essa Mohammed Al Zedjali, Chairman; **Ahmed Essa Al Zedjali**, CEO;
Adonis Durado, Designer
AWARD OF EXCELLENCE
News Design Page(s)
Business/Broadsheet 49,999 and Under

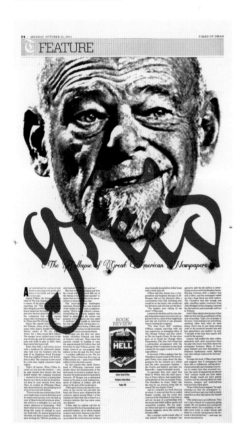

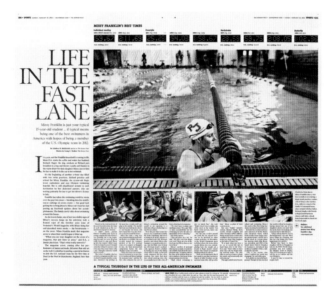

THE DENVER POST
Denver, Colo.
Matt Swaney, Lead Designer
AWARD OF EXCELLENCE
News Design Page(s)
Inside Page/Broadsheet 175,000
and Over

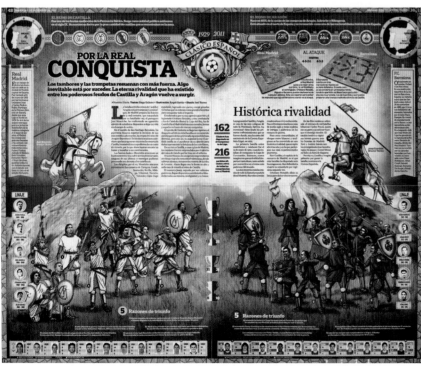

NUESTRO DIARIO
Guatemala City, Guatemala
Joel Torres, Designer; **Angel Garcia**, Graphics Artist; **Diego Galiano**, Researcher;
Fernando Contreras, Editor; **Rodrigo Castillo del Carmen**, M.E.
AWARD OF EXCELLENCE
News Design Page(s)
Sports/Compact 175,000 and Over

THE WASHINGTON POST
Washington, D.C.
Marianne Seregi, Designer; **Andrew Holder**, Illustrator; **Kristin Lenz**, Designer;
Christopher Meighan, Deputy Design Director/Features; **Greg Manifold**,
Deputy Design Director/Features; **Janet Michaud**, Design Director
AWARD OF EXCELLENCE
News Design Page(s)
Business/Broadsheet 175,000 and Over

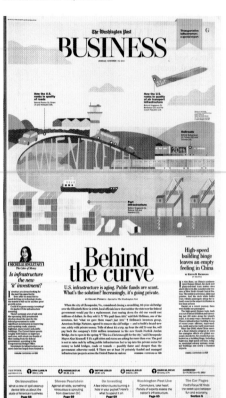

BEIJING NEWS AGENCY
Beijing, China
Yu Fengjun, Designer; **Ni Ping**, Designer; **Pei Xuan**, Designer
AWARD OF EXCELLENCE
Breaking News Topics
Japan Earthquake

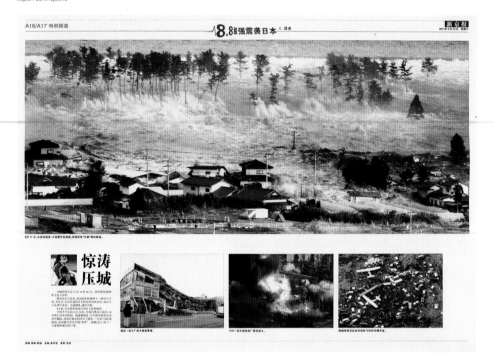

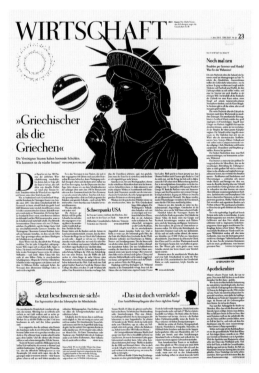

EL GRÁFICO
Antiquo Cuscatlán, El Salvador
Daniel Herrera, Jefe de Redacción; **Agustín Palacios**, Editor de Diseño;
Alexander Rivera, Coordinador de Diseño; **Juan López**, Illustrador;
Francisco Ayala, Illustrador; **Humberto Rodríguez**, Diseñador; **Gabriel Orellana**, Diseñador;
Ernesto Quan, Diseñador; **Rosemberg Girón**, Diseñador
AWARD OF EXCELLENCE
News Design Page(s)
Sports/Compact 49,999 and Under

DIE ZEIT
Hamburg, Germany
Haika Hinze, Art Director; **Ellen Dietrich**, Director/Photography; **Klaus-D. Sieling**,
Deputy Art Director; **Sina Giesecke**, Layout Editor; **Katrin Guddat**, Layout Editor;
Philipp Schultz, Layout Editor; **Delia Wilms**, Layout Editor; **Daniel Stolle**, Illustrator
AWARD OF EXCELLENCE
News Design Page(s)
Business/Broadsheet 175,000 and Over

THE GLOBE AND MAIL
Toronto, Ont. , Canada
Adrian Norris, M.E./Design; **Jason Chiu**, Design Editor; **John Sopinski**, Graphic Artist;
Dennis Owen, Photo Editor; **Roger Hallett**, Assistant Photo Editor;
Michael Bird, Presentation Editor
AWARD OF EXCELLENCE
News Design Page(s)
Business/Broadsheet 175,000 and Over

NATIONAL POST
Toronto, Ont. , Canada
Gigi Suhanic, FP Design Editor; **Grant Ellis**, M.E./FP; **Jacqueline Thorpe**, Deputy M.E./FP;
Stephen Meurice, Editor-in-Chief; **Gayle Grin**, M.E./Design & Graphics
AWARD OF EXCELLENCE
News Design Page(s)
Business/Broadsheet 50,000-174,999

TIMES OF OMAN
Muscat, Oman
Essa Al Zedjali, Chairman; **Ahmed Essa Al Zedjali**, CEO;
Adonis Durado, Design Director; **Waleed Rabin**, Designer
AWARD OF EXCELLENCE
News Design Page(s)
Business/Broadsheet 49,999 and Under

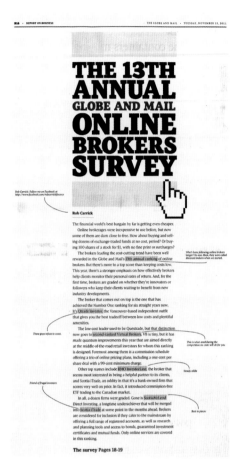

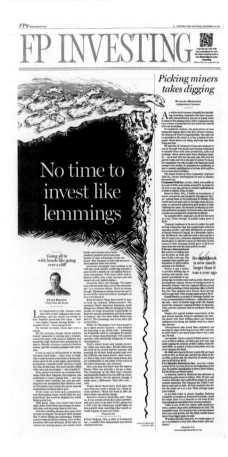

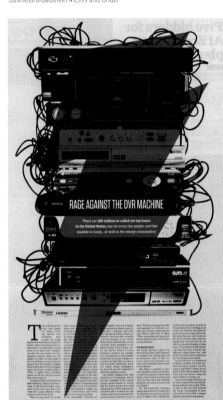

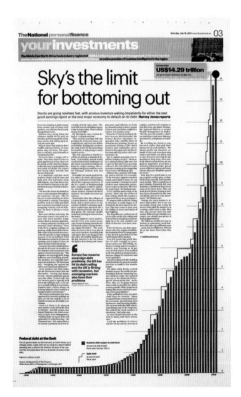

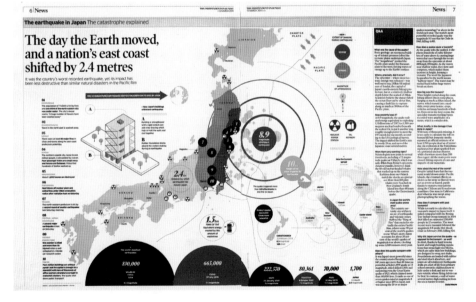

THE INDEPENDENT ON SUNDAY
London, England
Colin Wilson, Art Director; **Sarah Morley**, Deputy Art Director
AWARD OF EXCELLENCE
Breaking News Topics
Japan Earthquake

THE NATIONAL
Abu Dhabi, United Arab Emirates
Lee McGorie, Assistant Art Director
AWARD OF EXCELLENCE
News Design Page(s)
Business/Broadsheet 50,000-174,999

TIMES OF OMAN
Muscat, Oman
Essa Al Zedjali, Chairman; **Ahmed Essa Al Zedjali**, CEO;
Adonis Durado, Design Director; **Waleed Rabin**, Designer
AWARD OF EXCELLENCE
News Design Page(s)
Business/Broadsheet 49,999 and Under

TIMES OF OMAN
Muscat, Oman
Essa Mohammed Al Zedjali, Chairman;
Ahmed Essa Al Zedjali, CEO; **Adonis Durado**, Designer
AWARD OF EXCELLENCE
News Design Page(s)
Business/Broadsheet 49,999 and Under

TIMES OF OMAN
Muscat, Oman
Essa Mohammed Al Zedjali, Chairman;
Ahmed Essa Al Zedjali, CEO; **Adonis Durado**, Designer
AWARD OF EXCELLENCE
News Design Page(s)
Business/Broadsheet 49,999 and Under

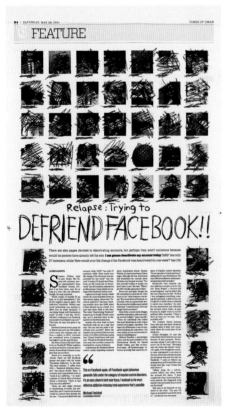

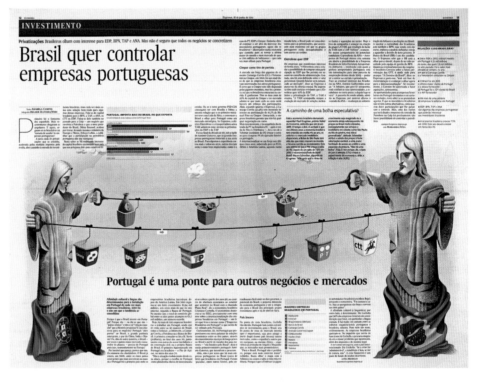

TIMES OF OMAN
Muscat, Oman
Essa Al Zedjali, Chairman; **Ahmed Essa Al Zedjali**, CEO;
Adonis Durado, Design Director; **Winie Ariany**, Designer
AWARD OF EXCELLENCE
News Design Page(s)
Business/Broadsheet 49,999 and Under

(LISBON) EXPRESSO
Paço de Arcos, Lisbon, Portugal
João Galacho, Designer; **Helder Oliveira**, Illustrator; **Marco Grieco**, Art Director
AWARD OF EXCELLENCE
News Design Page(s)
Business/Compact 50,000-174,999

TIMES OF OMAN
Muscat, Oman
Essa Mohammed Al Zedjali, Chairman; **Ahmed Essa Al Zedjali**, CEO;
Adonis Durado, Designer
AWARD OF EXCELLENCE
News Design Page(s)
Business/Broadsheet 49,999 and Under

(LISBON) EXPRESSO
Paço de Arcos, Lisbon, Portugal
João Galacho, Designer; **Olavo Cruz**, Graphic Designer;
Marco Grieco, Art Director; **Alcides Pinto**, Designer
AWARD OF EXCELLENCE
News Design Page(s)
Business/Compact 50,000-174,999

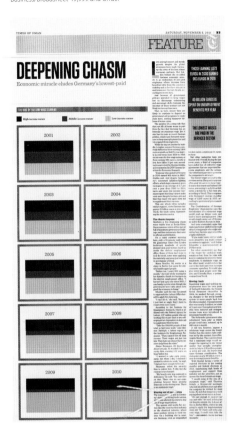

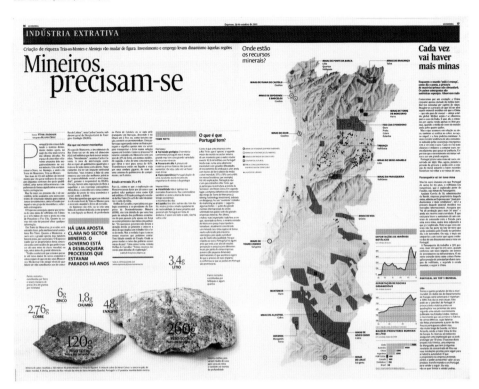

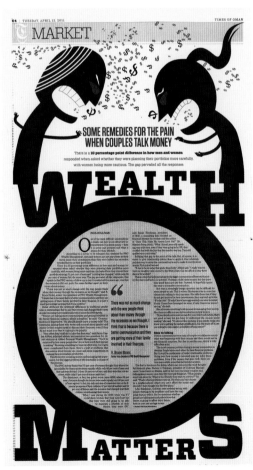

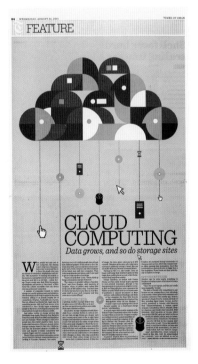

TIMES OF OMAN
Muscat, Oman
Essa Mohammed Al Zedjali, Chairman;
Ahmed Essa Al Zedjali, CEO; **Adonis Durado**,
Design Director; **Srinivasa Rao Redravuthu**, Designer
AWARD OF EXCELLENCE
News Design Page(s)
Business/Broadsheet 49,999 and Under

LONG ISLAND BUSINESS NEWS
Ronkonkoma, N.Y.
Mike Albano, Creative Director; **John Kominicki**, Publisher
AWARD OF EXCELLENCE
News Design Page(s)
Business/Compact 49,999 and Under

TIMES OF OMAN
Muscat, Oman
Essa Mohammed Al Zedjali, Chairman; **Ahmed Essa Al Zedjali**, CEO;
Adonis Durado, Design Director; **Gregory Fernandez**, Designer
AWARD OF EXCELLENCE
News Design Page(s)
Business/Broadsheet 49,999 and Under

TIMES OF OMAN
Muscat, Oman
Essa Mohammed Al Zedjali, Chairman; **Ahmed Essa Al Zedjali**, CEO;
Adonis Durado, Design Director; **KM Sahir**, Designer
AWARD OF EXCELLENCE
News Design Page(s)
Business/Broadsheet 49,999 and Under

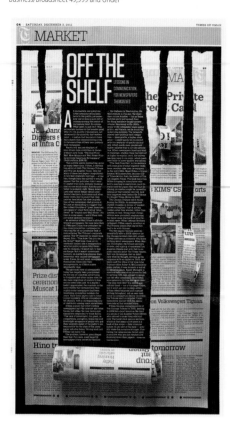

RADIKAL
Günesli, Istanbul, Turkey
Eyüp Can, Editor-in-Chief; **Bülent Mumay**, Editorial Coordinator; **Sefer Levent**, Economy Coordinator;
Cem Erciyes, Supplement Editor; **Gökçe Aytulu**, News Editor; **Sertaç Bala**, Art Director;
Ersel Yildiz, Deputy Art Director; **Bahadir Özgür**, Editor; **Sebnem Turhan**, Editor
AWARD OF EXCELLENCE
News Design Page(s)
Business/Compact 49,999 and Under

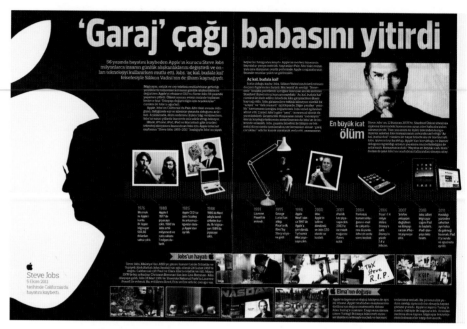

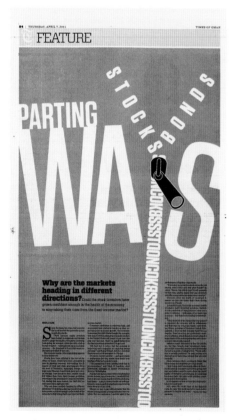

TIMES OF OMAN
Muscat, Oman
Essa Mohammed Al Zedjali, Chairman; **Ahmed Essa Al Zedjali**, CEO;
Adonis Durado, Designer
AWARD OF EXCELLENCE
News Design Page(s)
Business/Broadsheet 49,999 and Under

TIMES OF OMAN
Muscat, Oman
Essa Mohammed Al Zedjali, Chairman; **Ahmed Essa Al Zedjali**, CEO;
Adonis Durado, Design Director; **KM Sahir**, Designer
AWARD OF EXCELLENCE
News Design Page(s)
Business/Broadsheet 49,999 and Under

THE NEW YORK TIMES
New York, N.Y.
Troy Griggs, Art Director; **David Furst**, Photo Editor; **Andrea Bruce**, Photographer;
Tom Bodkin, Design Director
AWARD OF EXCELLENCE
News Design Page(s)
Inside Page/Broadsheet 175,000 and Over

THE WASHINGTON POST
Washington, D.C.
Tim Ball, Designer/Photo Editor; **Brian Gross**, Senior Art Director/Sports;
Greg Manifold, Deputy Design Director/News; **Janet Michaud**, Design Director
AWARD OF EXCELLENCE
News Design Page(s)
Inside Page/Broadsheet 175,000 and Over

MINNEAPOLIS STAR TRIBUNE
Minneapolis, Minn.
Josh Crutchmer, Designer; **Chris Carr**, Presentation Director;
Janet Reeves, Director of Photography; **Brett Deering**, Photographer
AWARD OF EXCELLENCE
News Design Page(s)
Inside Page/Broadsheet 175,000 and Over

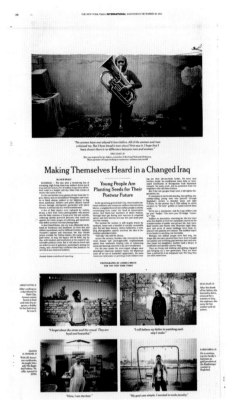
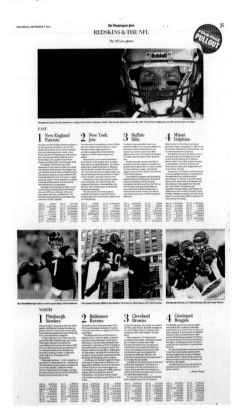
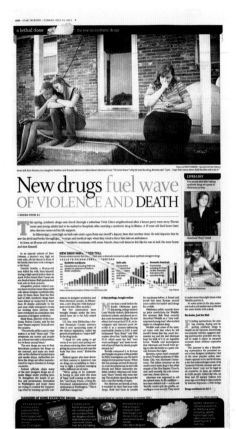
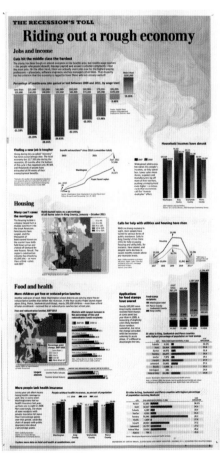
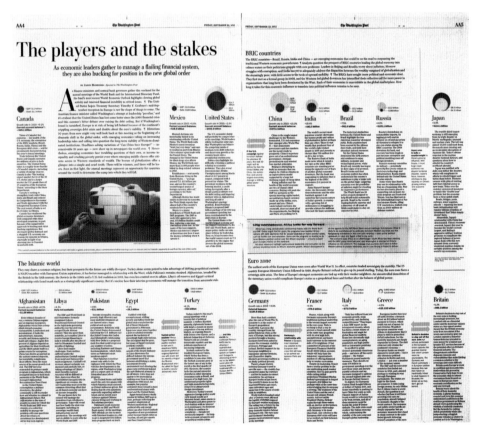

THE SEATTLE TIMES
Seattle, Wash.
Amanda Raymond, Graphic Artist; **Whitney Stensrud**, Graphics Director;
Denise Clifton, Art Director
AWARD OF EXCELLENCE
News Design Page(s)
Inside Page/Broadsheet 175,000 and Over

THE WASHINGTON POST
Washington, D.C.
Marianne Seregi, Designer; **Hannah Fairfield**, Graphics Editor;
Christopher Meighan, Deputy Design Director/Features;
Greg Manifold, Deputy Design Director/News; **Janet Michaud**, Design Director
AWARD OF EXCELLENCE
News Design Page(s)
Inside Page/Broadsheet 175,000 and Over

MINNEAPOLIS STAR TRIBUNE
Minneapolis, Minn.
Josh Crutchmer, Designer; **Chris Carr**, Presentation Director;
Janet Reeves, Director of Photography; **Jeff Wheeler**, Photographer;
AWARD OF EXCELLENCE
News Design Page(s)
Inside Page/Broadsheet 175,000 and Over

FOLHA DE SÃO PAULO
São Paulo, Brazil
Fabio Marra, Art Editor; **Mario Kanna**, Deputy Art Editor/Infographic Designer; **Ana Estela**, Text Editor
AWARD OF EXCELLENCE
News Design Page(s)
Inside Page/Broadsheet 175,000 and Over

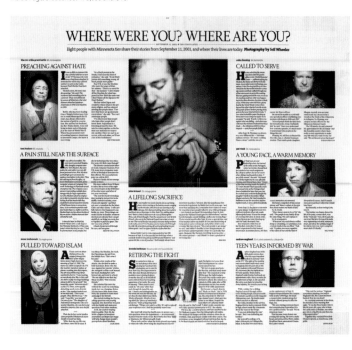

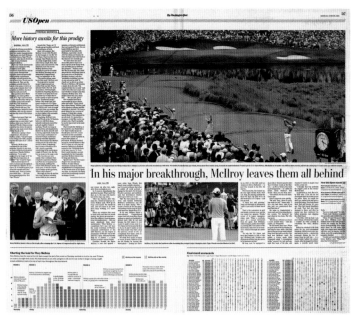

THE WASHINGTON POST
Washington, D.C.
Tim Ball, Designer; **Brian Gross**, Sports Designer; **Greg Manifold**, Deputy Design Director;
Matt McClain, Photographer; **Ray Saunders**, Photo Editor; **Janet Michaud**, Design Director
AWARD OF EXCELLENCE
News Design Page(s)
Inside Page/Broadsheet 175,000 and Over

CHINA DAILY
Beijing, China
Chi Tian, Designer
AWARD OF EXCELLENCE
News Design Page(s)
Inside Page/Broadsheet 175,000 and Over

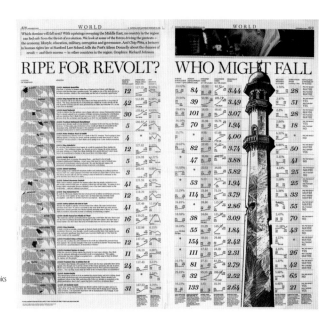

NATIONAL POST
Toronto, Ont. , Canada
Laura Morrison, News Presentation Editor;
Paolo Zinatelli, Senior Designer; **Richard Johnson**,
Graphics Editor; **Jeff Wasserman**, Photo & Multimedia Editor;
Joe Hood, Page One Editor; **Michael Higgins**, Foreign Editor;
Stephen Meurice, Editor-in-Chief; **Gayle Grin**, M.E./Design & Graphics
AWARD OF EXCELLENCE
News Design Page(s)
Inside Page/Broadsheet 50,000-174,999

THE DALLAS MORNING NEWS
Dallas, Texas
Michael Hogue, Graphic Artist; **Rob Schneider**, Presentation Director
AWARD OF EXCELLENCE
News Design Page(s)
Inside Page/Broadsheet 175,000 and Over

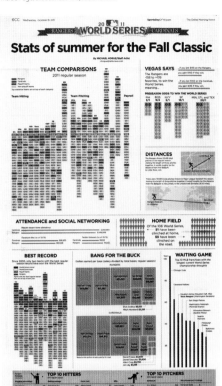

2011 WORLD SERIES RANGERS CARDINALS

Stats of summer for the Fall Classic

LOS ANGELES TIMES
Los Angeles, Calif.
Josh Penrod, Designer; **Alex Nabaum**, Illustrator; **Derek Simmons**, Deputy Design Director
AWARD OF EXCELLENCE
News Design Page(s)
Inside Page/Broadsheet 175,000 and Over

Los Angeles Times

LABOR BATTLES

NFL · SAM FARMER

Reslicing the pie

OWNERS, PLAYERS EACH WANT MORE. AN 18-GAME SEASON IS POSSIBLE. SO IS A LOCKOUT.

A cautionary note on talks

BASEBALL · BILL SHAIKIN

Peace still at hand

THE ERA OF ACCORD COULD EXTEND THROUGH 20 YEARS

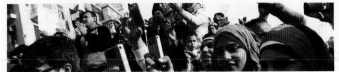

#egypt #jan25 #tahrir #mubarak #feb11 #ghonim #kefaya #noscaf
#arabspring #revolution #tunisia #oct23 #sidibouzid #bahrain #feb14
#libya #feb17 #benghazi #tripoli #gadhafi #yemen #yf #sanaa #syria
#assadcrimes #bashar #martyrs

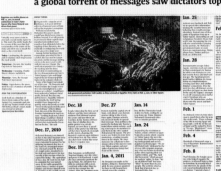

After a Tunisian youth died protesting corruption, a global torrent of messages saw dictators topple

THE GLOBE AND MAIL
Toronto, Ont. , Canada
Adrian Norris, M.E./Design;
David Pratt, Design Editor/Folio;
Andrew Gorham, Folio Editor;
Roger Hallett, Photo Editor
AWARD OF EXCELLENCE
News Design Page(s)
Inside Page/Broadsheet
175,000 and Over

Sixty-one years ago this summer, the United Nations agreed on the Fourth Nuremberg Principle: Nobody can escape war-crimes charges by claiming that they were just following orders from superiors.
For most of the postwar era, that principle was ignored. While most of the top political figures who were in charge of the Third Reich faced trials immediately after the war, those who carried out their orders tended to melt into the German bureaucracy or disappear into exile.

On Thursday, this principle faced its sharpest test: Should a man who really was just following orders, and nothing else, be convicted and sentenced for the greatest single crime in human history?
In the end, the German court in Munich answered yes: John Demjanjuk, a 91-year-old Ukrainian-born former Ohio auto worker, was found guilty of having contributed to the mechanized murder of 27,900 Jews in the Sobibor concentration camp in Poland in 1943.

THE GLOBE AND MAIL
Toronto, Ont. , Canada
Adrian Norris, M.E./Design;
David Pratt, Design Editor/Folio;
Craig Offman, Folio Editor
AWARD OF EXCELLENCE
News Design Page(s)
Inside Page/Broadsheet
175,000 and Over

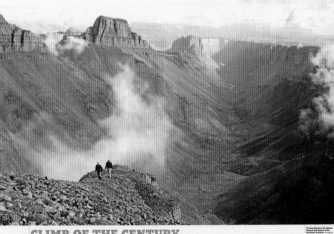

CLIMB OF THE CENTURY

THE GLOBE AND MAIL
Toronto, Ont. , Canada
Adrian Norris, M.E./Design;
David Pratt, Design Editor/Folio;
Craig Offman, Folio Editor;
Roger Hallett, Photo Editor
AWARD OF EXCELLENCE
News Design Page(s)
Inside Page/Broadsheet
175,000 and Over

THE DALLAS MORNING NEWS
Dallas, Texas
Michael Hogue, Graphic Artist
AWARD OF EXCELLENCE
News Design Page(s)
Inside Page/Broadsheet 175,000 and Over

(LISBON) EXPRESSO
Paço de Arcos, Lisbon, Portugal
Marco Grieco, Art Director; **Alcides Pinto**, Designer; **Helder Oliveira**, Illustrator
AWARD OF EXCELLENCE
News Design Page(s)
Inside Page/Compact 50,000-174,999

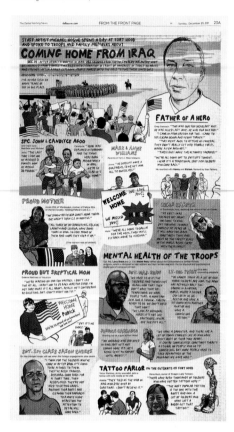

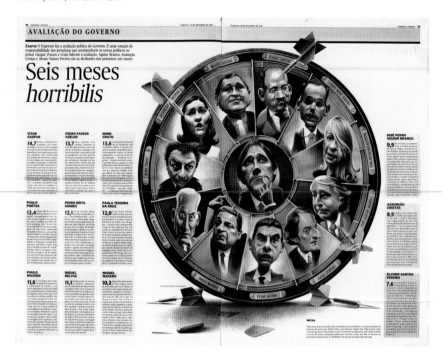

THE GLOBE AND MAIL
Toronto, Ont. , Canada
Adrian Norris, M.E./Design;
David Pratt, Design Editor/Folio; **Craig Offman**,
Foreign Editor; **Roger Hallett**, Photo Editor
AWARD OF EXCELLENCE
News Design Page(s)
Inside Page/Broadsheet 175,000 and Over

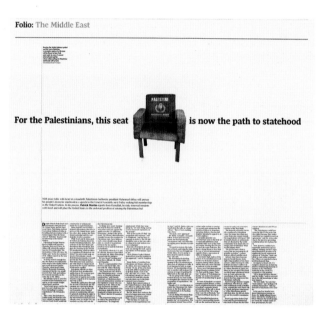

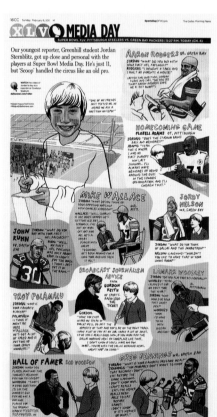

THE DALLAS MORNING NEWS
Dallas, Texas
Michael Hogue, Graphic Artist; **Jordan Sternblitz**, Reporter
AWARD OF EXCELLENCE
News Design Page(s)
Inside Page/Broadsheet 175,000 and Over

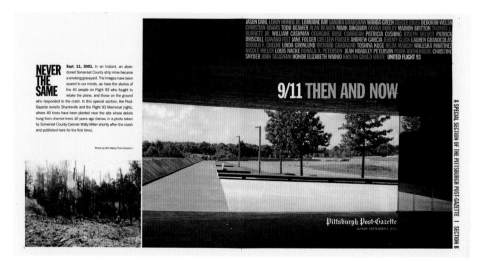

PITTSBURGH POST-GAZETTE
Pittsburgh, Pa.
Diane Juravich, Designer; **Bill Wade**, Photographer
AWARD OF EXCELLENCE
News Design Page(s)
Other/Broadsheet 175,000 and Over

THE WASHINGTON POST
Washington, D.C.
Janet Michaud, Design Director; **Greg Manifold**, Deputy Design Director/News; **Jon Wile**, Senior News Designer; **David Griffin**, Visuals Editor; **Liz Spayd**, M.E.; **Sonya Doctorian**, Deputy Director of Photography; **Nikki Kahn**, Photographer; **Marc Fisher**, Reporter
AWARD OF EXCELLENCE
News Design Page(s)
Inside Page/Broadsheet 175,000 and Over

BERGENS TIDENDE
Bergen, Norway
Walter Jensen, Chief of Presentation; **Bente Ljones**, Chief of Graphics; **Christina Pletten**
AWARD OF EXCELLENCE
News Design Page(s)
Inside Page/Compact 50,000-174,999

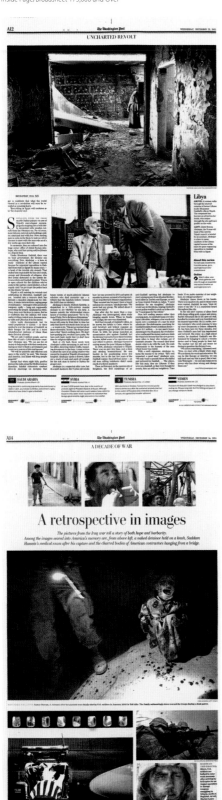

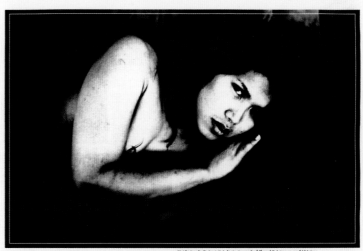

THE WASHINGTON POST
Washington, D.C.
Jon Wile, Senior News Designer; **Janet Michaud**, Design Director; **Greg Manifold**, Deputy Design Director; **Robert Miller**, Photo Editor; **Michel du Cille**, Director of Photography; **David Griffin**, Visuals Editor; **Sonya Doctorian**, Deputy Director of Photography
AWARD OF EXCELLENCE
News Design Page(s)
Inside Page/Broadsheet 175,000 and Over

BERGENS TIDENDE
Bergen, Norway
Walter Jensen, Chief of Presentation; **Bente Ljones**, Chief of Graphics; **Paul Sigve Amundsen**, Photographer; **Anneli Solberg**, Designer
AWARD OF EXCELLENCE
News Design Page(s)
Inside Page/Compact 50,000-174,999

EL HERALDO
Barranquilla, Colombia
Fabián Cárdenas, Director de Arte;
Ronny Pérez, Diseñador; **Carolina Pardo**, Periodista
AWARD OF EXCELLENCE
News Design Page(s)
Other/Broadsheet 49,999 and Under

THE SALT LAKE TRIBUNE
Salt Lake City, Utah
Colin Smith, Assistant News Editor/Design; **Jeremy Harmon**,
Photo Editor; **Todd Adams**, Assistant News Editor/Graphics;
Brandon Loomis, Reporter
AWARD OF EXCELLENCE
Special Coverage/Single Section
News/No Ads

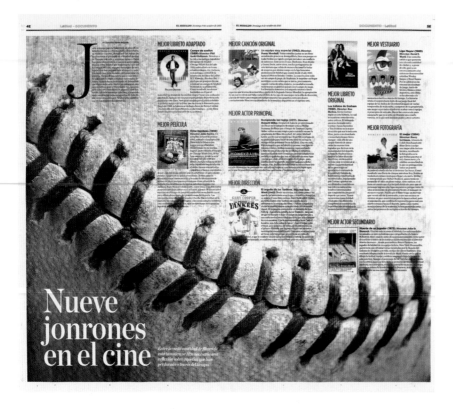

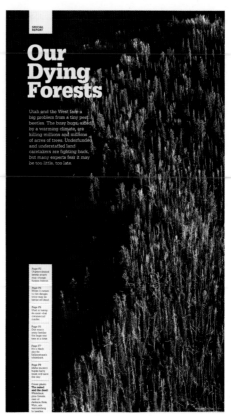

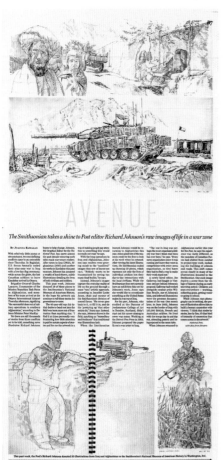

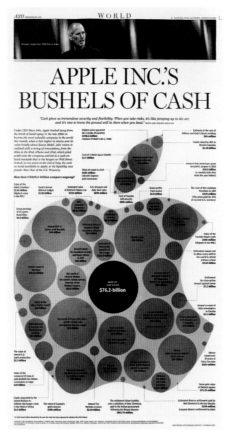

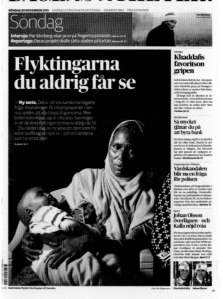

DAGENS NYHETER
Stockholm, Sweden
Dagens Nyheter Staff; Anders Oxelström, Editor; **Nicolaus Daun**, Page Designer;
Johan Andersson, Infographic Artist
AWARD OF EXCELLENCE
Special News Topics
Editor's Choice: National

NATIONAL POST
Toronto, Ont. , Canada
Laura Morrison, News Presentation Editor; **Richard Johnson**, Graphics Editor;
Anne Marie Owens, M.E./News; **Stephen Meurice**, Editor-in-Chief;
Gayle Grin, M.E./Design & Graphics
AWARD OF EXCELLENCE
News Design Page(s)
Inside Page/Broadsheet 50,000-174,999

NATIONAL POST
Toronto, Ont. , Canada
Geneviève Biloski, Features Design Editor; **Becky Guthrie**, Associate Features Design Editor;
Benjamin Errett, M.E./Features; **Richard Johnson**, Illustrator; **Barry Hertz**,
Arts & Life Editor; **Stephen Meurice**, Editor-in-Chief; **Gayle Grin**, M.E./Design & Graphics
AWARD OF EXCELLENCE
News Design Page(s)
Inside Page/Broadsheet 50,000-174,999

THE BOSTON GLOBE
Boston, Mass.
Luke Knox, Sports Designer; **Dan Zedek**, A.M.E./Design
AWARD OF EXCELLENCE
News Design Page(s)
Inside Page/Broadsheet 175,000 and Over

NATIONAL POST
Toronto, Ont. , Canada
Richard Johnson, Graphics Editor/Illustrator; **Laura Morrison**, News Presentation Editor; **Paolo Zinatelli**, Senior Designer; **Michael Higgins**, Foreign Editor; **Anne Marie Owens**, M.E./News; **Stephen Meurice**, Editor-in-Chief; **Gayle Grin**, M.E./Design & Graphics
AWARD OF EXCELLENCE
News Design Page(s)
Inside Page/Broadsheet 50,000–174,999

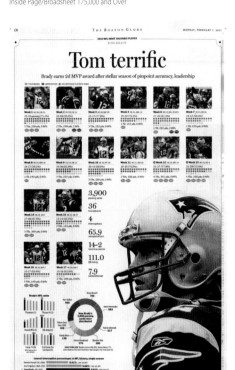

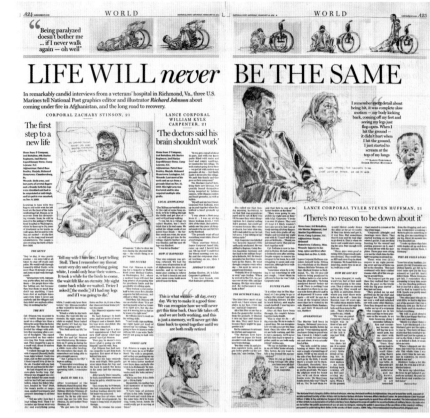

Tom terrific

Brady earns 2d MVP award after stellar season of pinpoint accuracy, leadership

LIFE WILL *never* BE THE SAME

In remarkably candid interviews from a veterans' hospital in Richmond, Va., three U.S. Marines tell National Post graphics editor and illustrator *Richard Johnson* about coming under fire in Afghanistan, and the long road to recovery.

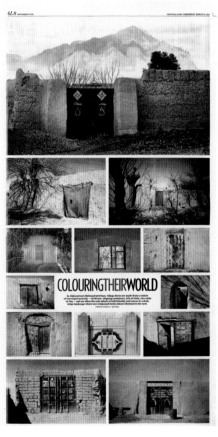

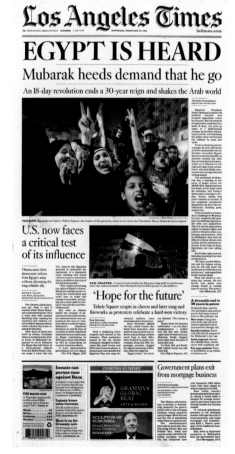

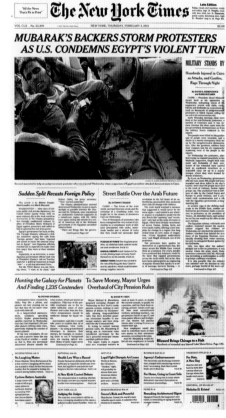

EGYPT IS HEARD

Mubarak heeds demand that he go

An 18-day revolution ends a 30-year reign and shakes the Arab world

U.S. now faces a critical test of its influence

'Hope for the future'

MUBARAK'S BACKERS STORM PROTESTERS AS U.S. CONDEMNS EGYPT'S VIOLENT TURN

COLOURING THEIR WORLD

NATIONAL POST
Toronto, Ont. , Canada
Daniel De Souza, Associate Features Design Editor; **Becky Guthrie**, Associate Features Design Editor; **Benjamin Errett**, M.E./Features; **Maryam Siddiqi**, D.M.E./Features; **Barry Hertz**, Arts & Life Editor; **Finbarr O'Reilly**, Photographer; **Stephen Meurice**, Editor-in-Chief; **Gayle Grin**, M.E./Design & Graphics
AWARD OF EXCELLENCE
News Design Page(s)
Inside Page/Broadsheet 50,000–174,999

LOS ANGELES TIMES
Los Angeles, Calif.
Michael Whitley, A.M.E.; **Kelli Sullivan**, Deputy Design Director; **Dan Santos**, Designer; **Gerard Babb**, Designer; **Steve Stroud**, Deputy Photo Editor
AWARD OF EXCELLENCE
Breaking News Topics
Arab Spring

THE NEW YORK TIMES
New York, N.Y.
New York Times Photographers; **Judd Sparling**, Art Director; **Troy Driggs**, Art Director; **Cynthia Curry**, Art Director; **John Macleod**, Art Director; **Tom Bodkin**, Design Director
AWARD OF EXCELLENCE
Breaking News Topics
Arab Spring

NATIONAL POST
Toronto, Ont. , Canada
Laura Morrison, News Presentation Editor; **Paolo Zinatelli**, Senior Designer;
Jeff Wasserman, Photo & Multimedia Editor; **Joe Hood**, Page One Editor;
Anne Marie Owens, M.E./News; **Michael Higgins**, Foreign Editor;
Stephen Meurice, Editor-in-Chief; **Gayle Grin**, M.E./Design & Graphics
AWARD OF EXCELLENCE
Breaking News Topics
Royal Wedding

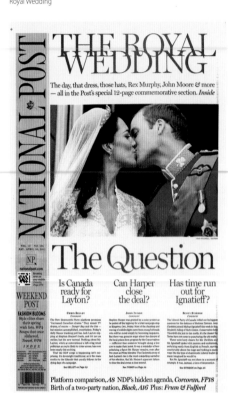

THE INDEPENDENT ON SUNDAY
London, England
Colin Wilson, Art Director; **Sarah Morley**, Deputy Art Director
AWARD OF EXCELLENCE
Breaking News Topics
Editor's Choice: International

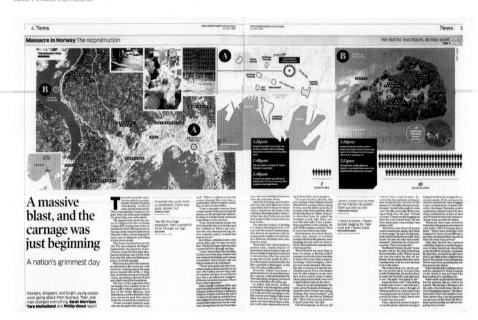

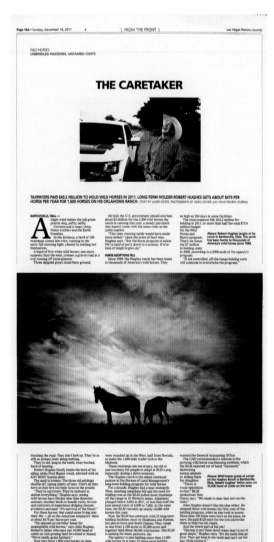

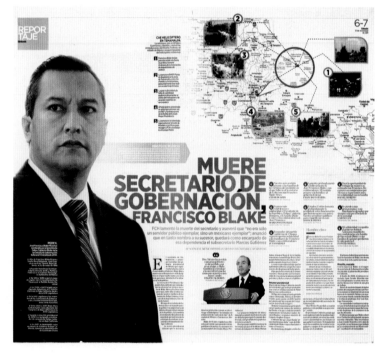

SÍNTESIS
Puebla, Mexico
Ismael Espinoza, Diseñador; **Luis Estrada**, Editor; **Jesús Peña**, Gerente de Edición;
Omar Sánchez, Director de Arte; **Erick Becerra**, Director Editorial; **Oscar Tendero**, Director General;
Armando Prida Noriega, Vice Presidente; **Armando Prida Huerta**, Presidente
AWARD OF EXCELLENCE
Breaking News Topics
Editor's Choice: National

LAS VEGAS REVIEW-JOURNAL
Las Vegas, Nev.
Ched Whitney, Art Director; **John Locher**, Photographer; **Mark Damon**, Director of Photography
AWARD OF EXCELLENCE
Special News Topics
Editor's Choice: Local/Regional

O ESTADO DE S. PAULO
São Paulo, Brazil
Fabio Sales, Art Director; **Regina Silva**, Infographics Director; **Eduardo Asta**, Infographic Assistant Editor; **Marcos Muller**, Infographic Designer; **Rodrigo Brancatelli**, Reporter
AWARD OF EXCELLENCE
Special News Topics
Editor's Choice: Local/Regional

LOS ANGELES TIMES
Los Angeles, Calif.
Kelli Sullivan, Deputy Design Director; **Michael Whitley**, A.M.E.; **Colin Crawford**, D.M.E.
AWARD OF EXCELLENCE
News Design Page(s)
Other/Compact175,000 and Over

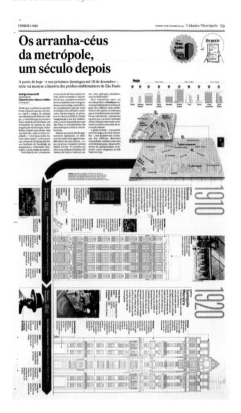

Os arranha-céus da metrópole, um século depois

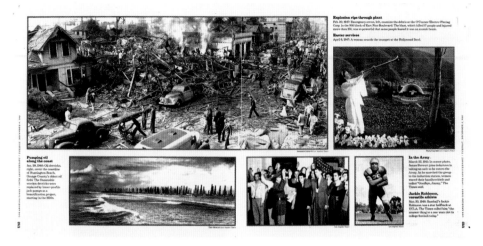

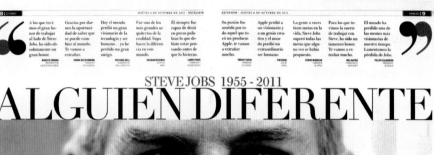

STEVE JOBS 1955 - 2011
ALGUIEN DIFERENTE

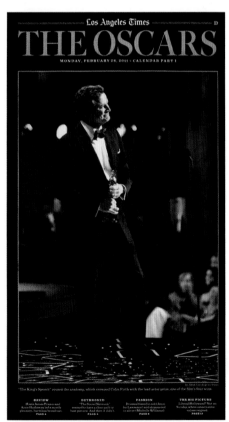

THE OSCARS
MONDAY, FEBRUARY 28, 2011 · CALENDAR PART 1

EXCELSIOR
Mexico City, Mexico
Elizabeth Medina, Visual Co-Editor; **Damián Martínez**, Visual Editor; **Paul Lara**, Editor; **Ricardo Peña**, Design Coordinator; **Ernesto Alcantara**, Creative Coordinator; **Marco Román**, M.E./Art; **Alexandro Medrano**, Art Director; **Pascal Beltrán del Río**, Editorial Director; **Ernesto Rivera**, CEO
AWARD OF EXCELLENCE
Breaking News Topics
Obituaries

LOS ANGELES TIMES
Los Angeles, Calif.
Michael Whitley, A.M.E.; **Paul Gonzales**, Deputy Design Director; **Wes Bausmith**, Deputy Design Director; **Kirk Christ**, Designer; **Jan Molen**, Designer; **An Moonen**, Designer; **Joey Santos**, Designer; **Kelli Sullivan**, Deputy Design Director; **Steve Hawkins**, Deputy Design Director
AWARD OF EXCELLENCE
Special News Topics
Features Content

THE HUNTSVILLE TIMES
Huntsville, Ala.
Paul Wallen, Design Director; **Bethany Bickley**, Designer;
Elizabeth Hoekenga, Features Editor; **Andy Rossback**, Designer
AWARD OF EXCELLENCE
Special News Topics
Editor's Choice: National

NATIONAL POST
Toronto, Ont. , Canada
Geneviève Biloski, Features Design Editor; **Becky Guthrie**, Associate Features
Design Editor; **Benjamin Errett**, M.E./Features; **Barry Hertz**, Arts & Life Editor;
Daniel De Souza, Acting Features Design Editor; **Stephen Meurice**, Editor-in-Chief;
Gayle Grin, M.E./Design & Graphics
AWARD OF EXCELLENCE
Special News Topics
Features Content

THE NEW YORK TIMES
New York, N.Y.
New York Times Photographers; **Cynthia Curry**, Art Director;
Tom Bodkin, Design Director
AWARD OF EXCELLENCE
Special News Topics
Japan Earthquake

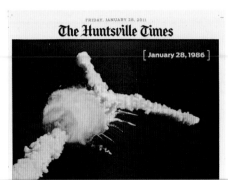

FRIDAY, JANUARY 28, 2011
The Huntsville Times
[January 28, 1986]

Where were you?
We remember Challenger explosion 25 years later

ARTS & LIFE
NATIONAL POST
THURSDAY, DECEMBER 2, 2010

NP
nationalpost.com

CULTURE CLUB

BAD ADVICE
WHAT WOULD MARTHA DO?

THEATRE

THE MONTH AHEAD

The New York Times

U.S. SEES 'EXTREMELY HIGH' RADIATION LEVEL AT PLANT, FOCUSING ON SPENT FUEL'S IMPACT

More Dire Appraisal of Crisis Creates Split With Japan

In Tokyo, a Dearth of Candor

No Red Carpet For Bus Drivers On Casino Runs

C.I.A. Security Officer Is Freed In Pakistan as Redress Is Paid

Atlantic Yards Plans to Build Tallest Prefab

Deadly Rout of Protesters in Bahrain

CAMPAIGN ☆ 2012

The disrupter
Newt Gingrich is a big thinker who is known for throwing bombs. And he's comfortable amid the chaos.

WHERE HE STANDS ON . . .
Education | Tax code | Social Security | Immigration | Afghanistan

THE WASHINGTON POST
Washington, D.C.
Janet Michaud, Design Director; **Greg Manifold**, Deputy Design Director/News; **Jon Wile**,
Senior News, Designer; **David Griffin**, Visuals Editor; **Tim Ball**, News Designer;
Michel du Cille, Director of Photography; **Robert T. Miller**, Photo Editor; **Laura Stanton**,
Graphic Artist; **Steve Ginsberg**, Political Editor
AWARD OF EXCELLENCE
Special News Topics
Editor's Choice: National

A12/A13 目击

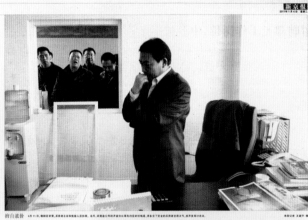

辣
4

BEIJING NEWS AGENCY
Beijing, China
Yu Fengjun, Designer; **Pei Xuan**, Designer
AWARD OF EXCELLENCE
Special News Topics
Editor's Choice: National

LOS ANGELES TIMES
Los Angeles, Calif.
Kelli Sullivan, Deputy Design Director; **Michael Whitley**, A.M.E.; **Mary Vignoles**, Photo Editor; **Francine Orr**, Photographer; **Doug Stevens**, Graphic Artist; **Thomas Suh Lauder**, Graphic Artist
AWARD OF EXCELLENCE
Special News Topics
Editor's Choice: National

BERGENS TIDENDE
Bergen, Norway
Bergens Tidende Staff
AWARD OF EXCELLENCE
Special News Topics
Editor's Choice: National

Discovering Autism

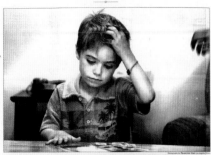

DECLAN BYRNE, 6, tries to focus in a therapy session at Autism Partnership in Seal Beach. He has been getting applied behavior analysis for about a year and a half.

Therapy mixes warm praise, firm guidance

ABA may look like typical parent-child exchanges, but every aspect has purpose

ALAN ZAREMBO

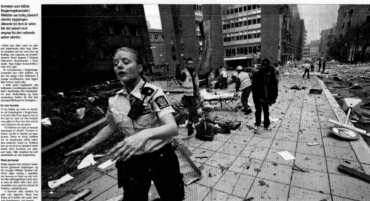

Gigantbomben politiet har fryktet

Pålagt å stenge gaten

SPECIAL REPORT: RADIOACTIVITY ON THE RESERVATION

Members of the **Spokane Tribe** worked gladly in the **uranium mines** on their land. Now they fear **radiation** from the mines is **killing them.**

'I watch them die, young and old'

By Becky Kramer

A PLAIN DEALER SPECIAL REPORT

UNFINISHED BUSINESS

DECADES AFTER VIETNAM, AN INVISIBLE ENEMY STILL HAUNTS US

Vietnam and the United States have a common enemy. ¶ Its name is Agent Orange. ¶ From 1962 to 1971, the U.S. military sprayed millions of gallons of the herbicide, which contained the toxic chemical dioxin, to defoliate the jungles and forests that gave cover to Ho Chi Minh's northern forces in what was then South Vietnam. ¶ At least 4.5 million Vietnamese, and the 2.5 million Americans who served there, may have been exposed to Agent Orange. These numbers do not reflect the possible impact on future generations. ¶ The U.S. Veterans Administration now recognizes 15 illnesses linked to wartime exposure. The Vietnam Red Cross estimates that roughly 3 million adults and children continue to suffer illnesses and birth deformities because of these contaminated sites. ¶ This is a fixable problem. ¶ To the majority of Americans, it is also an invisible one.

McPARLAND The Lives of Conn Smythe. Excerpt, B9

The last hours of a TYRANT

Muammar Gaddafi's 42-year reign of terror comes to an end in the hands of countrymen he oppressed

COMMENT
Girls betrayed religion: father

Afghan custom behind canal killings: Crown

The eccentric, bloody reign of Muammar Gaddafi. *A4* Updating the Arab Spring. *A6* Tyrant's gone, but can Libya avoid tyranny? *A6* NATO and the future of intervention. *A8* Clement's cartoon & Jonathan Kay. *A14*

THE SPOKESMAN-REVIEW
Spokane, Wash.
Geoff Pinnock, Senior Editor/Visuals & Production; **Jed Conklin**, Photographer; **Liz Kishimoto**, Photo Editor; **Molly Quinn**, Graphic Artist
AWARD OF EXCELLENCE
Special News Topics
Editor's Choice: Local/Regional

THE PLAIN DEALER
Cleveland, Ohio
Emmet Smith, Deputy Design Director/News; **Lisa DeJong**, Photographer; **William Neff**, Graphics Reporter; **Bill Gugliotta**, Director of Photography; **Michael Tribble**, Design & Graphics Director; **David Kordalski**, A.M.E./Visuals; **Nick Ut**, Freelance Photographer; **Scott Sheldon**, Graphics Editor
AWARD OF EXCELLENCE
Special News Topics
Editor's Choice: International

NATIONAL POST
Toronto, Ont. , Canada
Paolo Zinatelli, Senior Designer; **Laura Morrison**, News Presentation Editor; **Richard Johnson**, Graphics Editor; **Jeff Wasserman**, Photo & Multimedia Editor; **Don Tsukada**, Page One Editor; **Anne Marie Owens**, M.E./News; **Rob Roberts**, National Editor; **Michael Higgins**, Foreign Editor; **Stephen Meurice**, Editor-in-Chief; **Gayle Grin**, M.E./Design & Graphics
AWARD OF EXCELLENCE
News Design/Sections
A-Section 50,000-174,999

THE VIRGINIAN-PILOT
Norfolk, Va.

Josh Bohling, Designer; **Diana D'Abruzzo**, Designer; **Lisa Merklin**, Designer; **Colleen Kirsten**, Designer; **Paul Nelson**, Director of Presentation; **Robert Suhay**, Assistant Director of Presentation; **Martin Smith-Rodden**, Photo Editor; **Bob Voros**, Graphic Artist

AWARD OF EXCELLENCE
Special News Topics
Natural Disasters

TORONTO STAR
Toronto, Ont. , Canada

Bob Bishop, Designer; **Tim Fryer**, Insight Editor; **Leslie Scrivener**, Writer/Editor; **Kathryn Laskaris**, Copy Editor; **Patricia Hluchy**, Copy Editor; **Charles Kopun**, A.M.E./Presentation; **Alison Uncles**, A.M.E./Features

AWARD OF EXCELLENCE
Special News Topics
Arab Spring

OMAHA WORLD-HERALD
Omaha, Neb.

Jay St. Pierre, Lead Sports Designer; **Tim Parks**, Deputy News & Presentation Editor; **Thad Livingston**, Sports Editor; **Dave Elsesser**, News & Presentation Editor

AWARD OF EXCELLENCE
Special News Topics
Editor's Choice: Sports

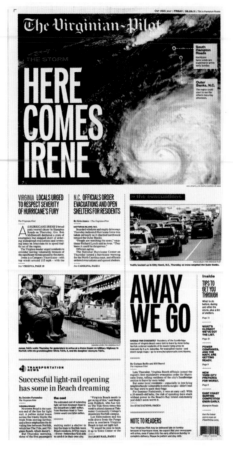

DIE ZEIT
Hamburg, Germany

Haika Hinze, Art Director; **Ellen Dietrich**, Director/Photography; **Klaus-D. Sieling**, Deputy Art Director; **Mirko Bosse**, Layout Editor; **Martin Burgdorff**, Layout Editor; **Mechthild Fortmann**, Layout Editor; **Vera Tammen**, Photographer

AWARD OF EXCELLENCE
News Design Page(s)
A-Section/Broadsheet 175,000 and Over

THE BOSTON GLOBE
Boston, Mass.

Greg Klee, Art Director; **Yoon S. Byun**, Photographer; **Suzanne Kreiter**, Photographer; **Shawn Baldwin**, Photographer; **Robert E. Klein**, Photographer; **James Abundis**, Graphic Artist; **David Butler**, Graphic Artist; **Dan Zedek**, A.M.E./Design

AWARD OF EXCELLENCE
Special News Topics
September 11 Anniversary

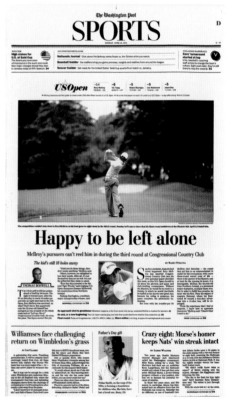

THE WASHINGTON POST
Washington, D.C.

Brian Gross, Senior Art Director/Sports; **Tim Ball**, Designer; **Chris Rukan**, Designer; **Desmond Bieler**, Designer; **Greg Manifold**, Deputy Design Director/News; **Lindsay Applebaum**, Golf Editor; **Ray Saunders**, Photo Editor; **Janet Michaud**, Design Director

AWARD OF EXCELLENCE
Special News Topics
Editor's Choice: Sports

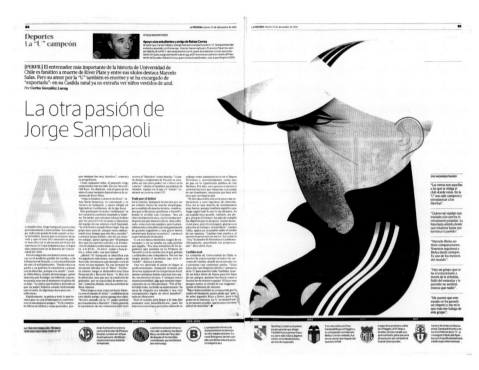

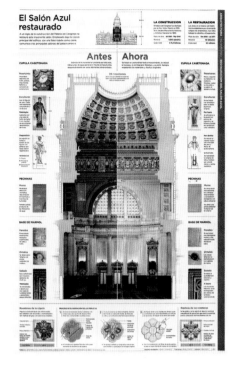

LA TERCERA
Santiago, Chile
Sandro Baeza, Design Editor; **Miguel Vargas**, Sports Designer; **Alexis Galdames**, Designer; **Cristian Navarro**, Designer;
David Hernández, Assistant Design Editor
AWARD OF EXCELLENCE
Special News Topics
Editor's Choice: Sports

CLARÍN
Buenos Aires, Argentina
Pablo Loscri, Graphic Editor; **Alejandro Tumas**, Graphic Editor;
Florencia Caramignoli, Artist; **Jorge Portaz**, Illustrator; **Veronica Spinato**, Illustrator
AWARD OF EXCELLENCE
Information Graphics
News/Non-Deadline 175,000 and Over

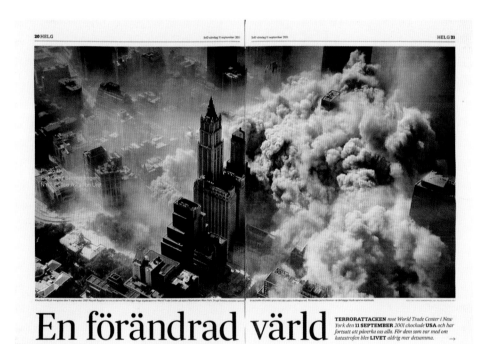

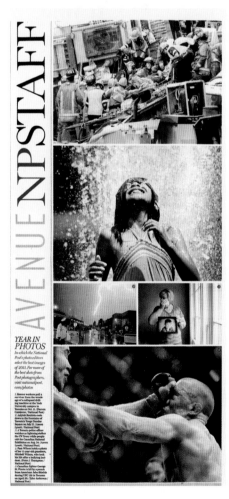

SVENSKA DAGBLADET
Stockholm, Sweden
Anna W. Thurfjell, Head of Design; **Kristofer Gustafson**, Editor; **Sara L. Bränström**, Editor; **Joakim Ståhl**, Editor; **Mats Petersson**, Page Designer; **Mikael Larrson**, A1 Artist;
Nina Kylén, Page Editor; **Stefan Gustavsson**, Picture Editor; **Elisabeth Mård**, Page Designer; **Magnus Gylje**, Editor
AWARD OF EXCELLENCE
Special News Topics
September 11 Anniversary

THE NATIONAL POST
Toronto, Ont. , Canada
Geneviève Biloski, Features Design Editor; **Benjamin Errett**, M.E./Features;
Jeff Wasserman, Photo and Multimedia Editor; **Darren Calabrese**, Photographer;
Aaron Lynet, Photographer; **Peter J. Thompson**, Photographer; **Tyler Anderson**,
Photographer; **Barry Hertz**, Arts & Life Editor; **Stephen Meurice**, Editor-in-Chief;
Gayle Grin, M.E./Design & Graphics
AWARD OF EXCELLENCE
Special News Topics
Editor's Choice: International

NATIONAL POST
Toronto, Ont. , Canada
Dean Tweed, Graphic Artist; **Michael Higgins**, Foreign Editor; **Anne Marie Owens**, M.E.;
Stephen Meurice, Editor-in-Chief; **Gayle Grin**, M.E./Design & Graphics
AWARD OF EXCELLENCE
News Design Page(s)
Inside Page/Broadsheet 50,000-174,999

CLARÍN
Buenos Aires, Argentina
Gustavo Lo Valvo, Design Director; **Pablo Loscri**,
Graphics Editor; **Alejandro Tumas**, Graphics Editor;
Hugo Scapparone, Design Editor
AWARD OF EXCELLENCE
Special News Topics
Japan Earthquake

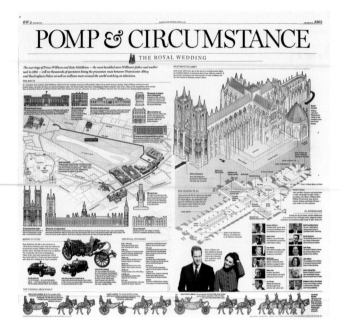

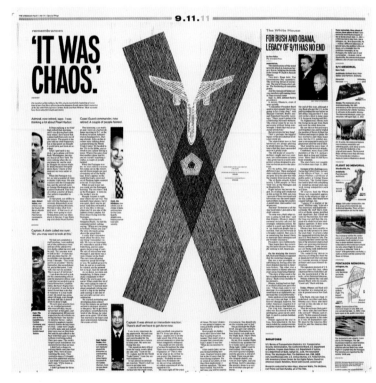

**THE
VIRGINIAN-PILOT**
Norfolk, Va.
Virginian-Pilot Staff
**AWARD OF
EXCELLENCE**
Special News Topics
September 11 Anniversary

TIMES OF OMAN
Muscat, Oman
Essa Mohammed Al Zedjali, Chairman; **Ahmed Essa Al Zedjali**, CEO;
Adonis Durado, Design Director; **KM Sahir**, Designer
AWARD OF EXCELLENCE
News Design Page(s)
Business/Broadsheet 49,999 and Under

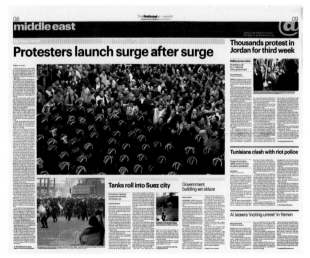

THE NATIONAL
Abu Dhabi, United Arab Emirates
Laura Koot, Art Director; **Marin Devine**, Deputy Art Director;
April Robinson, Designer; **Brian Kerrigan**, Photo Editor
AWARD OF EXCELLENCE
Special News Topics
Arab Spring

THE PLAIN DEALER
Cleveland, Ohio
Emmet Smith, Deputy Design Director/News; **Andrea Levy**, Photographer/Illustrator;
William Neff, Assistant Graphics Editor; **Scott Sheldon**, Graphics Editor; **Bill Gugliotta**,
Director of Photography; **Michael Tribble**, Design & Graphics Director; **David Kordalski**,
A.M.E./Visuals; **Daryl Kannberg**, D.M.E; **Thom Fladung**, M.E.;
Debra Adams Simmons, Editor
AWARD OF EXCELLENCE
Special News Topics
Death of Osama Bin Laden

TIMES OF OMAN
Muscat, Oman
Essa Mohammed Al Zedjali, Chairman; **Ahmed Essa Al Zedjali**, CEO;
Adonis Durado, Designer
AWARD OF EXCELLENCE
News Design Page(s)
Business/Broadsheet 49,999 and Under

THE BUFFALO NEWS
Buffalo, N.Y.
Vincent Chiaramonte, Design Director; **Daniel Zakroczemski**, Illustrator;
Lisa Wilson, Executive Sports Editor
AWARD OF EXCELLENCE
News Design Page(s)
Sports/Broadsheet 175,000 and Over

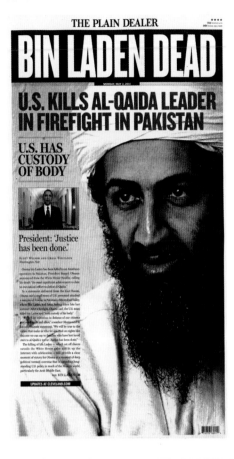

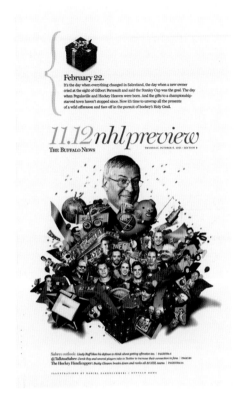

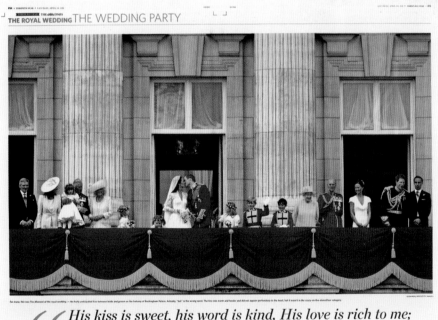

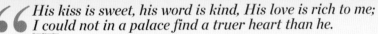

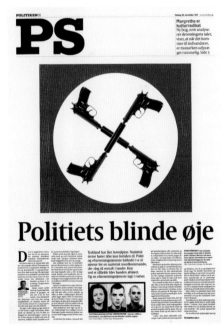

POLITIKEN
Copenhagen, Denmark
Søren Nyeland, Design Editor; **Anne Mette Svane**, Editor-in-Chief;
Per Bergsbo, Page Designer; **Christian Ilsøe**, PS Editor
AWARD OF EXCELLENCE
News Design Page(s)
Other/Broadsheet 50,000-174,999

TORONTO STAR
Toronto, Ont. , Canada
Sharis Shahmiryan, Designer; **Tim Fryer**, Team Editor; **Taras Slywach**, Photo Editor; **Alison Uncles**, A.M.E./Features
AWARD OF EXCELLENCE
Breaking News Topics
Royal Wedding

OMAHA WORLD-HERALD
Omaha, Neb.

Tim Parks, Deputy News & Presentation Editor; **Thad Livingston**, Sports Editor; **Dave Elsesser**, News & Presentation Editor; **Matt Miller**, Photographer; **Bob Saenz**, Sports Designer

AWARD OF EXCELLENCE
News Design Page(s)
Inside Page/Broadsheet 50,000–174,999

KHALEEJ TIMES
Dubai, United Arab Emirates
Santhosh Kumar, Illustrator/, Designer;
Patrick Michael, Executive Editor; **Roberto Canseco**, Art Director

AWARD OF EXCELLENCE
News Design Page(s)
A-Section/Broadsheet 49,999 and Under

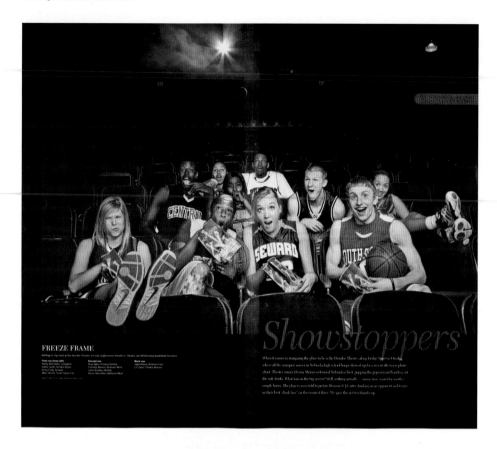

FREEZE FRAME

Showstoppers

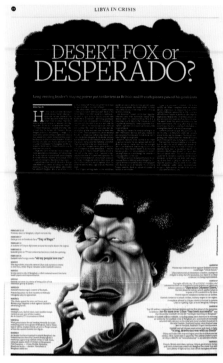

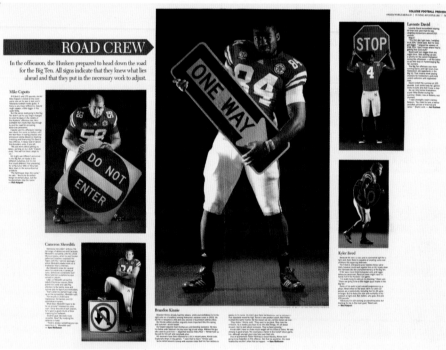

ROAD CREW

In the offseason, the Huskers prepared to head down the road for the Big Ten. All signs indicate that they knew what lies ahead and that they put in the necessary work to adjust.

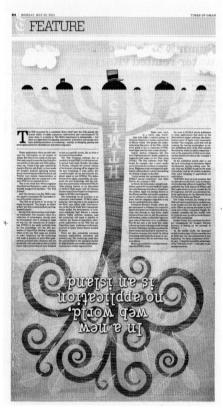

FEATURE

OMAHA WORLD-HERALD
Omaha, Neb.

Tim Parks, Deputy News & Presentation Editor;
Thad Livingston, Sports Editor; **Dave Elsesser**,
News & Presentation Editor; **Jay St. Pierre**,
Lead Sports Designer; **Kent Sievers**, Photographer;
Matt Haney, Artist; **Dave Croy**, Artist; **Ben Vankat**, Designer

AWARD OF EXCELLENCE
Special News Topics
Editor's Choice: Sports

TIMES OF OMAN
Muscat, Oman
Essa Mohammed Al Zedjali, Chairman; **Ahmed Essa Al Zedjali**,
CEO; **Adonis Durado**, Designer

AWARD OF EXCELLENCE
News Design Page(s)
Business/Broadsheet 49,999 and Under

FEATURES & MAGAZINES

Reportajes y revistas

DER FREITAG
Berlin, Germany
Janine Sack, Art Director; **Andine Müller**, Advising Art Director; **Jana Schnell**, Vice Art Director; **Max Sauerbier**, Graphic Designer; **Corinna Koch**, Picture Editor; **Niklas Rock**, Picture Editor
AWARD OF EXCELLENCE
Feature Design Sections
Other 49,999 and Under

CHICAGO TRIBUNE
Chicago, Ill.
Mike Miner, Designer
AWARD OF EXCELLENCE
Feature Design Page(s)
Opinion/Broadsheet 175,000 and Over

LOS ANGELES TIMES
Los Angeles, Calif.
Steve Brodner, Illustrator; **Micheal Whitley**, A.M.E.; **Wes Bausmith**, Deputy Design Director; **Susan Brenneman**, Deputy Op-Ed Editor
AWARD OF EXCELLENCE
Feature Design Page(s)
Opinion/Broadsheet 175,000 and Over

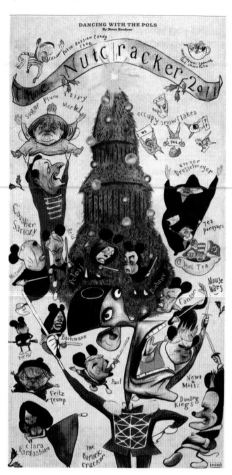

LOS ANGELES TIMES
Los Angeles, Calif.
Susan Tibbles, Illustrator; **Micheal Whitley**, A.M.E.; **Wes Bausmith**, Deputy Design Director
AWARD OF EXCELLENCE
Feature Design Page(s)
Opinion/Broadsheet 175,000 and Over

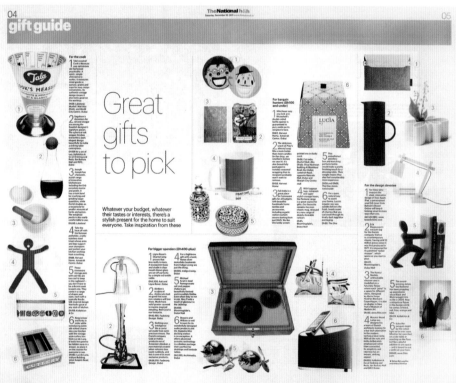

THE NATIONAL
Abu Dhabi, United Arab Emirates
Laura Koot, Art Director; **Marin Devine**, Deputy Art Director; **Nathan Estep**, Deputy Art Director; **Heather Adams**, Production Journalist; **Helen McLaughlin**, House & Home Editor
AWARD OF EXCELLENCE
Feature Design Sections
Home/Real Estate 50,000-174,999

LOS ANGELES TIMES
Los Angeles, Calif.
Steve Brodner, Illustrator; **Micheal Whitley**, A.M.E.;
Wes Bausmith, Deputy Design Director; **Susan Brenneman**, Deputy Op-Ed Editor
AWARD OF EXCELLENCE
Feature Design Page(s)
Opinion/Broadsheet 175,000 and Over

THE BOSTON GLOBE
Boston, Mass.
Greg Klee, Art Director/Illustrator; **Dan Zedek**, A.M.E./Design
AWARD OF EXCELLENCE
Feature Design Page(s)
Opinion/Broadsheet 175,000 and Over

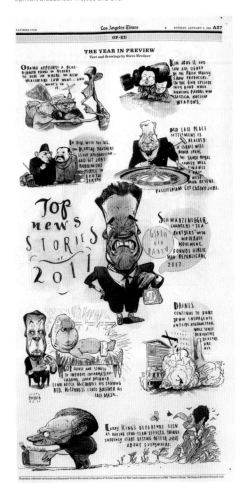

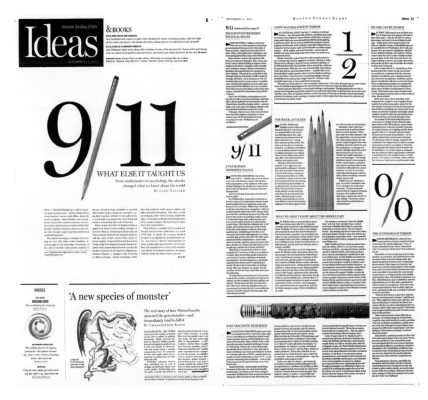

LA PRESSE
Montréal, Qué., Canada
Francis Léveillé, Designer; **Alain Roberge**, Photographer;
Evgen Bavcar, Photographer; **Hélène de Guise**, Deputy Art Director;
Geneviève Dinel, A.M.E./Art Director
AWARD OF EXCELLENCE
Feature Design Page(s)
Opinion/Broadsheet 175,000 and Over

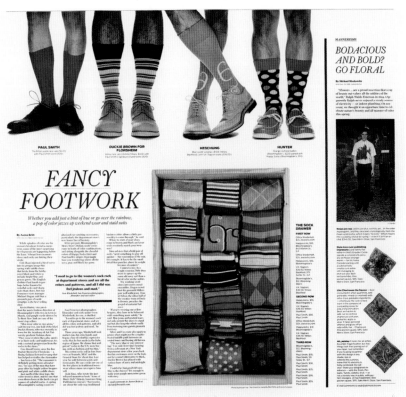

SAN FRANCISCO CHRONICLE
San Francisco, Calif.
Frank Mina, A.M.E./Presentation; **Matt Petty**, Art Director; **Elizabeth Burr**, Designer; **Judy Walgren**,
Director of Photography; **Russell Yip**, Photo Editor/Features; **Wayne Walters**, Imaging & Coloring Manager;
Anastasia Hendrix, Senior Features Editor; **Laura Compton**, Style Editor
AWARD OF EXCELLENCE
Feature Design Sections
Fashion 175,000 and Over

THE NEW YORK TIMES
New York, N.Y.
**New York Times Photographers; New York Times Illustrators;
Kelly L. Doe**, Art Director; **Tom Bodkin**, Design Director
AWARD OF EXCELLENCE
Feature Design Page(s)
Opinion/Broadsheet 175,000 and Over

LA PRESSE
Montréal, Qué., Canada
France Dupont, Designer; **Hélène de Guise**, Deputy Art Director;
Geneviève Dinel, A.M.E./Art Director
AWARD OF EXCELLENCE
Feature Design Page(s)
Lifestyle/Broadsheet 175,000 and Over

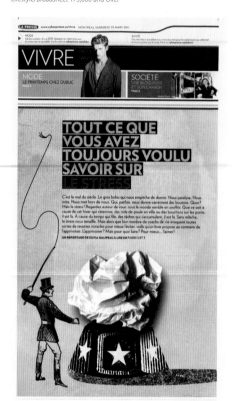

THE WASHINGTON POST
Washington, D.C.
Tim Ball, Art Director; **Paul Blow**, Illustrator; **Christopher Meighan**,
Deputy Design Director/Features; **Janet Michaud**, Design Director
AWARD OF EXCELLENCE
Feature Design Page(s)
Lifestyle/Broadsheet 175,000 and Over

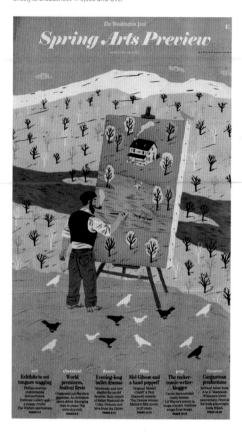

A TARDE
Salvador, Brazil
Pierre Themotheo, Art Editor-in-Chief; **Iansã Negrão**, Art Editor;
Mila Cordeiro, Photographer; **Silvia Rodrigues**, Designer
AWARD OF EXCELLENCE
Feature Design Page(s)
Lifestyle/Broadsheet 49,999 and Under

DAGENS NYHETER
Stockholm, Sweden
Lotta Ek, Art Director; **Klas Ernflog** Illustrator; **Maciej Zaremba**, Reporter
AWARD OF EXCELLENCE
Feature Design Page(s)
Opinion/Compact 175,000 and Over

TIMES OF OMAN
Muscat, Oman
Essa Al Zedjali, Chairman; **Ahmed Essa Al Zedjali**, CEO;
Adonis Durado, Design Director; **Waleed Rabin**, Designer
AWARD OF EXCELLENCE
Feature Design Page(s)
Lifestyle/Broadsheet 49,999 and Under

TIMES OF OMAN
Muscat, Oman
Essa Mohammed Al Zedjali, Chairman; **Ahmed Essa Al Zedjali**, CEO;
Adonis Durado, Design Director; **Gregory Fernandez**, Designer
AWARD OF EXCELLENCE
Feature Design Page(s)
Lifestyle/Broadsheet 49,999 and Under

TODAY'S ZAMAN
Istanbul, Turkey
Adnan Sarikabak, Designer; **Şemsi Açıkgöz**, Art Director;
Selim Şimşiroğlu, Art Director; **Fevzi Yazici**, Design Director;
Pinar Vurucu, Editor; **Bülent Keneş**, Editor-in-Chief
AWARD OF EXCELLENCE
Feature Design Page(s)
Lifestyle/Broadsheet 49,999 and Under

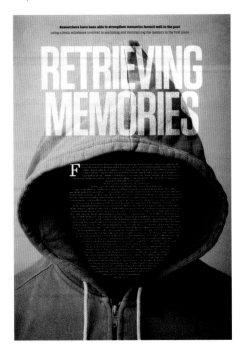
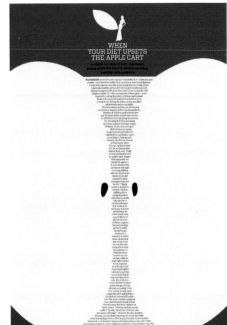
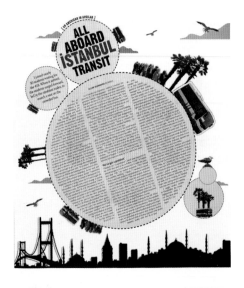
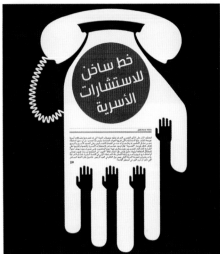

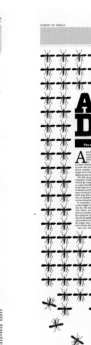
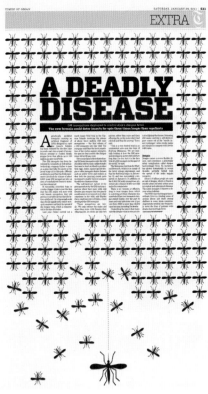
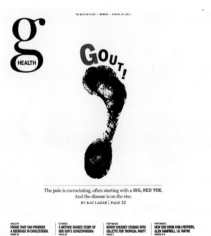

AL SHABIBA
Muscat, Oman
Essa Mohammed Al Zedjali, Chairman; **Ahmed Essa Al Zedjali**, Editor-in-Chief;
Adonis Durado, Design Director; **Osama Aljawish**, Designer
AWARD OF EXCELLENCE
Feature Design Page(s)
Lifestyle/Broadsheet 49,999 and Under

TIMES OF OMAN
Muscat, Oman
Essa Al Zedjali, Chairman; **Ahmed Essa Al Zedjali**, CEO;
Adonis Durado, Design Director; **Waleed Rabin**, Designer
AWARD OF EXCELLENCE
Feature Design Page(s)
Lifestyle/Broadsheet 49,999 and Under

TIMES OF OMAN
Muscat, Oman
Essa Mohammed Al Zedjali, Chairman; **Ahmed Essa Al Zedjali**, CEO; **Adonis Durado**,
Design Director; **Gregory Fernandez**, Designer
AWARD OF EXCELLENCE
Feature Design Page(s)
Lifestyle/Broadsheet 49,999 and Under

THE BOSTON GLOBE
Boston, Mass.
Gus Wezerek, Design Co-op; **Dan Zedek**, A.M.E./Design
AWARD OF EXCELLENCE
Feature Design Page(s)
Other/Compact 175,000 and Over

WASHINGTON POST EXPRESS
Washington, D.C.
Adam Griffiths, Editorial Designer; **Scott McCarthy**, Creative Director; **Lori Kelley**, Art Director; **Kevin Cobb**, Editorial Designer; **Ernie Smith**, Editorial Designer; **The Heads of State**, Illustrators
AWARD OF EXCELLENCE
Feature Design Page(s)
Entertainment/Compact 175,000 and Over

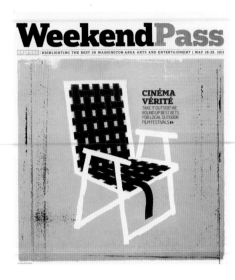

EL GRÁFICO
Antiquo Cuscatlán, El Salvador
Agustín Palacios, Editor de Diseño; **Alexander Rivera**, Coordinador de Diseño; **Francisco Ayala**, Illustrator; **Daniel Herrera**, Jefe de Redacción; **Marta Alvarenga**, Redactora
AWARD OF EXCELLENCE
Feature Design Page(s)
Entertainment/Compact 49,999 and Under

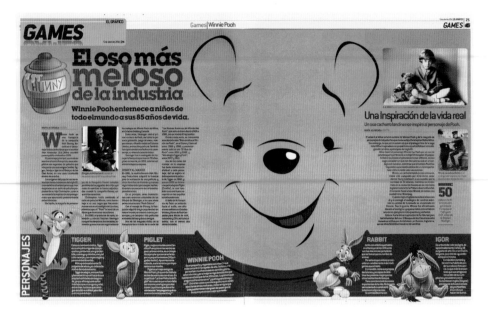

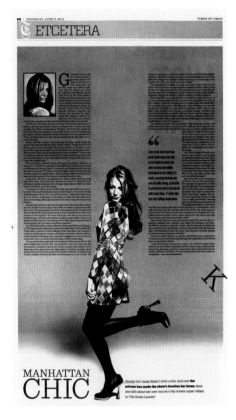

TIMES OF OMAN
Muscat, Oman
Essa Mohammed Al Zedjali, Chairman; **Ahmed Essa Al Zedjali**, CEO; **Adonis Durado**, Design Director; **Waleed Rabin**, Designer
AWARD OF EXCELLENCE
Feature Design Page(s)
Entertainment/Broadsheet 49,999 and Under

TIMES OF OMAN
Muscat, Oman
Essa Mohammed Al Zedjali, Chairman; **Ahmed Essa Al Zedjali**, CEO; **Adonis Durado**, Design Director; **Waleed Rabin**, Designer
AWARD OF EXCELLENCE
Feature Design Page(s)
Food/Broadsheet 49,999 and Under

THE BOSTON GLOBE
Boston, Mass.
Greg Klee, Art Director; **Dan Zedek**, A.M.E./Design
AWARD OF EXCELLENCE
Feature Design Page(s)
Food/Compact 175,000 and Over

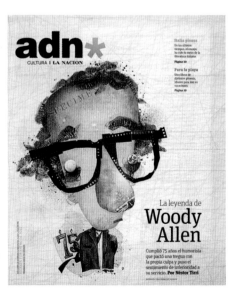

LA (ARGENTINA) NACIÓN
Buenos Aires, Argentina
Ana Gueller, Art Director; **Silvana Segú**, Art Editor; **Maria Paula Pilijos**, Graphic Designer; **Sebastián Menéndez**, Graphic Designer; **Andrea Knight**, Photo Editor; **Pablo Bernasconi**, Illustrator
AWARD OF EXCELLENCE
Feature Design Page(s)
Other/Compact 175,000 and Over

TIMES OF OMAN
Muscat, Oman
Essa Al Zedjali, Chairman; **Ahmed Essa Al Zedjali**, CEO;
Adonis Durado, Design Director; **Waleed Rabin**, Designer
AWARD OF EXCELLENCE
Feature Design Page(s)
Lifestyle/Broadsheet 49,999 and Under

TIMES OF OMAN
Muscat, Oman
Essa Mohammed Al Zedjali, Chairman; **Ahmed Essa Al Zedjali**, CEO;
Adonis Durado, Design Director; **Gregory Fernandez**, Designer
AWARD OF EXCELLENCE
Feature Design Page(s)
Lifestyle/Broadsheet 49,999 and Under

TODAY'S ZAMAN
Istanbul, Turkey
Adnan Sarikabak, Designer; **Şemsi Açıkgöz**, Art Director;
Selim Şimşiroğlu, Art Director; **Fevzi Yazici**, Design Director;
Pinar Vurucu, Editor; **Bülent Keneş**, Editor-in-Chief
AWARD OF EXCELLENCE
Feature Design Page(s)
Lifestyle/Broadsheet 49,999 and Under

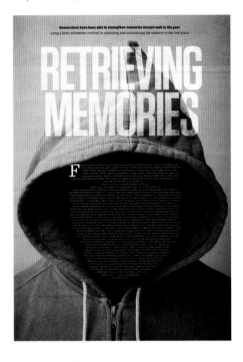

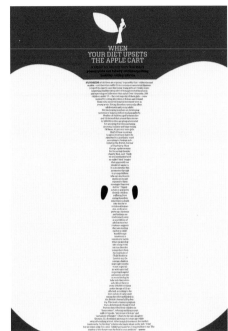

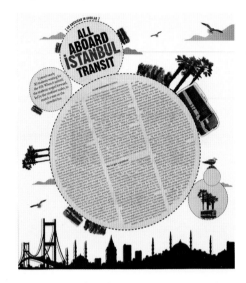

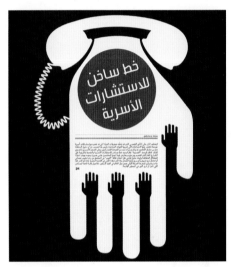

AL SHABIBA
Muscat, Oman
Essa Mohammed Al Zedjali, Chairman; **Ahmed Essa Al Zedjali**, Editor-in-Chief;
Adonis Durado, Design Director; **Osama Aljawish**, Designer
AWARD OF EXCELLENCE
Feature Design Page(s)
Lifestyle/Broadsheet 49,999 and Under

TIMES OF OMAN
Muscat, Oman
Essa Al Zedjali, Chairman; **Ahmed Essa Al Zedjali**, CEO;
Adonis Durado, Design Director; **Waleed Rabin**, Designer
AWARD OF EXCELLENCE
Feature Design Page(s)
Lifestyle/Broadsheet 49,999 and Under

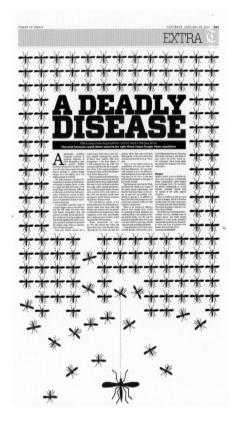

TIMES OF OMAN
Muscat, Oman
Essa Mohammed Al Zedjali, Chairman; **Ahmed Essa Al Zedjali**, CEO; **Adonis Durado**,
Design Director; **Gregory Fernandez**, Designer
AWARD OF EXCELLENCE
Feature Design Page(s)
Lifestyle/Broadsheet 49,999 and Under

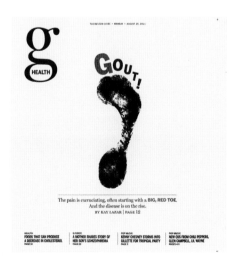

THE BOSTON GLOBE
Boston, Mass.
Gus Wezerek, Design Co-op; **Dan Zedek**, A.M.E./Design
AWARD OF EXCELLENCE
Feature Design Page(s)
Other/Compact 175,000 and Over

FOLHA DE SÃO PAULO
São Paulo, Brazil
Fabio Marra, Art Editor; **Mario Kanna**, Deputy Art Editor;
Marcela Souza, Page Designer; **Rafael Campos Rocha**, Illustrator
AWARD OF EXCELLENCE
Feature Design Page(s)
Entertainment/Broadsheet 175,000 and Over

DAGENS NYHETER
Stockholm, Sweden
Lotta Ek, Art Director; **Rickard Frank**, Art Director;
Mattias Hermansson, Editorial Development
AWARD OF EXCELLENCE
Feature Design Sections
Other 175,000 and Over

LA (COSTA RICA) NACIÓN
San José, Costa Rica
William Sánchez, Diseñador; **Guiselle González**, Diseñador;
Manuel Canales, Editor de Arte; **Luis Roberto Rojas**, Director de Arte
AWARD OF EXCELLENCE
Feature Design Page(s)
Lifestyle/Compact 50,000-174,999

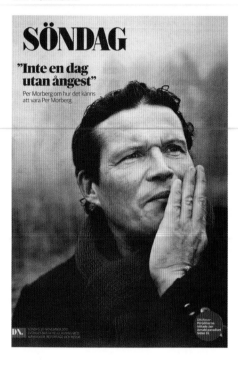

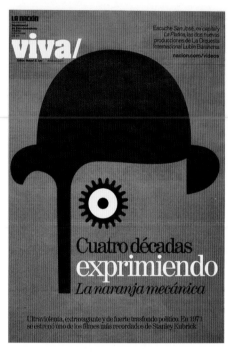

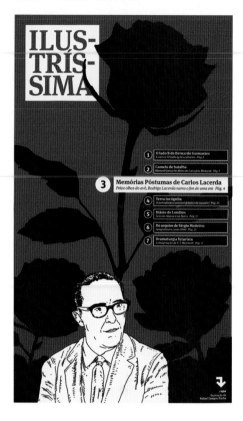

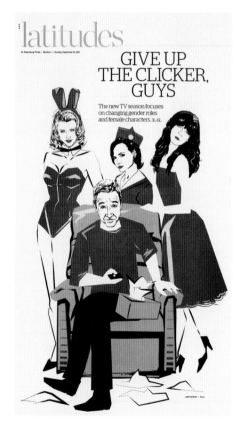

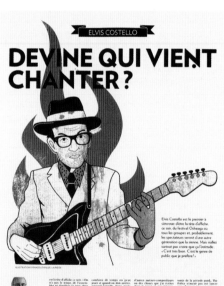

TAMPA BAY TIMES
St. Petersburg, Fla.
Jade Pilgrom, Illustrator; **Chris Kozlowski**, Design Director
AWARD OF EXCELLENCE
Feature Design Page(s)
Entertainment/Broadsheet 175,000 and Over

LA PRESSE
Montréal, Qué., Canada
Francis Léveillée, Designer/Illustrator; **André Rivest**, Deputy Art Director; **Hélène de Guise**, A.M.E./Art Director
AWARD OF EXCELLENCE
Feature Design Page(s)
Entertainment/Broadsheet 175,000 and Over

THE NATIONAL
Abu Dhabi, United Arab Emirates
Sara Baumberger, Designer
AWARD OF EXCELLENCE
Feature Design Page(s)
Entertainment/Broadsheet 50,000-174,999

THE NEW YORK TIMES MAGAZINE
New York, N.Y.
Arem Duplessis, Design Director; **Gail Bichler,** Art Director; **Tim Enthoven,** Illustrator
AWARD OF EXCELLENCE
Magazines
Cover Design

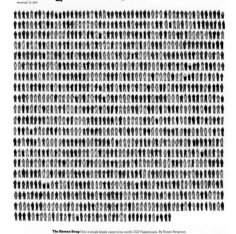

THE NATIONAL
Abu Dhabi, United Arab Emirates
Sara Baumberger, Designer
AWARD OF EXCELLENCE
Feature Design Page(s)
Entertainment/Broadsheet 50,000-174,999

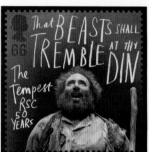

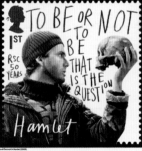

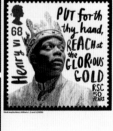

TIMES OF OMAN
Muscat, Oman
Essa Mohammed Al Zedjali, Chairman; **Ahmed Essa Al Zedjali,** CEO;
Adonis Durado, Design Director; **Gregory Fernandez,** Designer
AWARD OF EXCELLENCE
Feature Design Page(s)
Entertainment/Broadsheet 49,999 and Under

WASHINGTON POST EXPRESS
Washington, D.C.
Adam Griffiths, Editorial Designer; **Scott McCarthy**, Creative Director;
Lori Kelley, Art Director; **Kevin Cobb**, Editorial Designer; **Ernie Smith**,
Editorial Designer; **The Heads of State**, Illustrators
AWARD OF EXCELLENCE
Feature Design Page(s)
Entertainment/Compact 175,000 and Over

EL GRÁFICO
Antiguo Cuscatlán, El Salvador
Agustín Palacios, Editor de Diseño; **Alexander Rivera**, Coordinator de Diseño;
Francisco Ayala, Illustrator; **Daniel Herrera**, Jefe de Redacción; **Marta Alvarenga**, Redactora
AWARD OF EXCELLENCE
Feature Design Page(s)
Entertainment/Compact 49,999 and Under

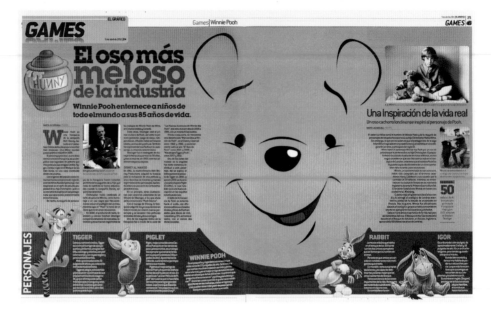

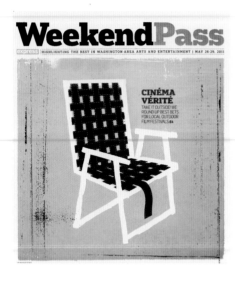

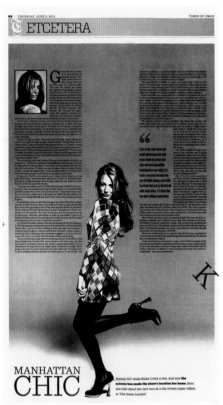

TIMES OF OMAN
Muscat, Oman
Essa Mohammed Al Zedjali, Chairman; **Ahmed Essa Al Zedjali**, CEO;
Adonis Durado, Design Director; **Waleed Rabin**, Designer
AWARD OF EXCELLENCE
Feature Design Page(s)
Entertainment/Broadsheet 49,999 and Under

TIMES OF OMAN
Muscat, Oman
Essa Mohammed Al Zedjali, Chairman; **Ahmed Essa Al Zedjali**, CEO;
Adonis Durado, Design Director; **Waleed Rabin**, Designer
AWARD OF EXCELLENCE
Feature Design Page(s)
Food/Broadsheet 49,999 and Under

THE BOSTON GLOBE
Boston, Mass.
Greg Klee, Art Director; **Dan Zedek**, A.M.E./Design
AWARD OF EXCELLENCE
Feature Design Page(s)
Food/Compact 175,000 and Over

LA (ARGENTINA) NACIÓN
Buenos Aires, Argentina
Ana Gueller, Art Director; **Silvana Segú**, Art Editor; **Maria Paula Pilijos**, Graphic Designer;
Sebastián Menéndez, Graphic Designer; **Andrea Knight**, Photo Editor; **Pablo Bernasconi**, Illustrator
AWARD OF EXCELLENCE
Feature Design Page(s)
Other/Compact 175,000 and Over

TIMES OF OMAN
Muscat, Oman
Essa Mohammed Al Zedjali, Chairman; **Ahmed Essa Al Zedjali**, CEO;
Adonis Durado, Design Director; **Gregory Fernandez**, Designer
AWARD OF EXCELLENCE
Feature Design Page(s)
Food/Broadsheet 49,999 and Under

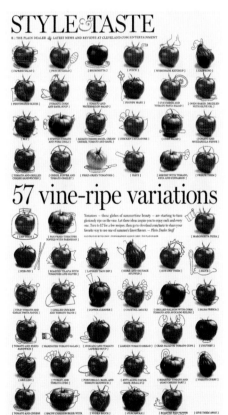

THE PLAIN DEALER
Cleveland, Ohio
Amanda Petkiewicz, Art Director; **Emmet Smith**, Deputy Design Director/News; **Ted Crow**, Illustrator; **Allison Carey**, Photographer; **Sharon Yemich**, Features Design Director;
Emily Hamlin Smith, Deputy Editor/Features; **Michael Tribble**, Design & Graphics Director;
David Kordalski, A.M.E./Visuals; **Debbie Van Tassel**, Features Editor
AWARD OF EXCELLENCE
Feature Design Page(s)
Food/Broadsheet 175,000 and Over

SAN FRANCISCO CHRONICLE
San Francisco, Calif.
Frank Mina, A.M.E./Presentation; **Matt Petty**, Art Director
AWARD OF EXCELLENCE
Feature Design Page(s)
Fashion/Broadsheet 175,000 and Over

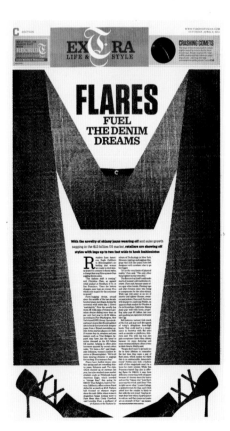

TIMES OF OMAN
Muscat, Oman
Essa Mohammed Al Zedjali, Chairman; **Ahmed Essa Al Zedjali**, CEO;
Adonis Durado, Design Director; **Waleed Rabin**, Designer
AWARD OF EXCELLENCE
Feature Design Page(s)
Fashion/Broadsheet 49,999 and Under

NATIONAL POST
Toronto, Ont., Canada
Antony Hare, Illustrator; **Nathalie Atkinson**, Style Editor; **Becky Guthrie**,
Associate Features Design Editor; **Benjamin Errett**, M.E./Features; **Stephen Meurice**,
Editor-in-Chief; **Gayle Grin**, M.E./Design & Graphics
AWARD OF EXCELLENCE
Feature Design Page(s)
Fashion/Broadsheet 50,000-174,999

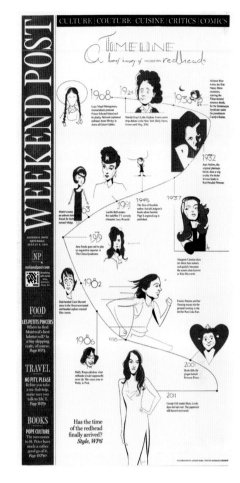

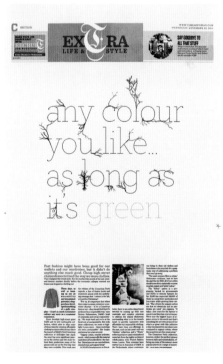

TIMES OF OMAN
Muscat, Oman
Essa Mohammed Al Zedjali, Chairman; **Ahmed Essa Al Zedjali**, CEO;
Adonis Durado, Design Director; **Waleed Rabin**, Designer
AWARD OF EXCELLENCE
Feature Design Page(s)
Fashion/Broadsheet 49,999 and Under

NATIONAL POST
Toronto, Ont., Canada
Becky Guthrie, Associate Features Design Editor; **Benjamin Errett,** M.E./Features;
Geneviève Biloski, Features Design Editor; **Rachel Ann Lindsay,** Illustrator; **Shari Kulha,**
Post Home Editor; **Stephen Meurice,** Editor-in-Chief; **Gayle Grin,** M.E./Design & Graphics
AWARD OF EXCELLENCE
Feature Design Page(s)
Home/Real Estate–Broadsheet 50,000-174,999

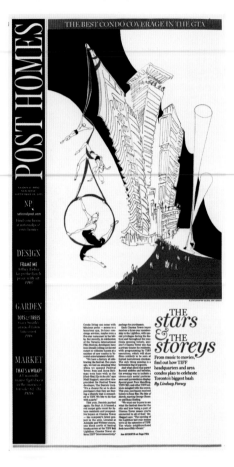

THE NATIONAL
Abu Dhabi, United Arab Emirates
Nathan Estep, Deputy Art Director
AWARD OF EXCELLENCE
Feature Design Page(s)
Travel/Broadsheet 50,000-174,999

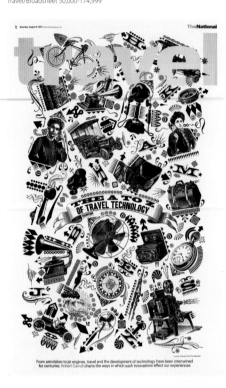

**FRANKFURTER ALLGEMEINE
SONNTAGSZEITUNG**
Frankfurt am Main, Germany
Peter Breul, Art Director; **Andreas Kuther,** Picture Editor; **Jörg Albrecht,** Editor;
Ulf von Rauchhaupt, Editor; **Valentine Edelmann,** Illustrator
AWARD OF EXCELLENCE
Feature Design Page(s)
Science/Technology–Broadsheet 175,000 and Over

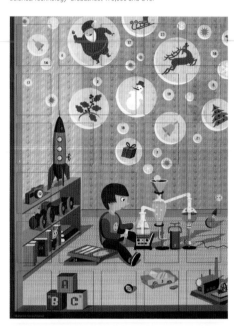

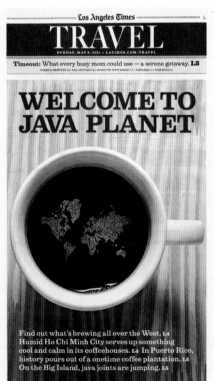

THE WALL STREET JOURNAL EUROPE (LONDON)
London, England
Elisabeth Limber, Art Director; **Carlos Tovar,** Graphics Director; **Viktor Koen,** Illustrator
AWARD OF EXCELLENCE
Feature Design Page(s)
Fashion/Compact 50,000-174,999

LOS ANGELES TIMES
Los Angeles, Calif.
Helayne Perry, Design Editor; **Michael Whitley,** A.M.E.;
Paul Gonzales, Deputy Design Director
AWARD OF EXCELLENCE
Feature Design Page(s)
Travel/Broadsheet 175,000 and Over

TIMES OF OMAN
Muscat, Oman
Essa Al Zedjali, Chairman; **Ahmed Essa Al Zedjali**, CEO;
Adonis Durado, Design Director; **Waleed Rabin**, Designer
AWARD OF EXCELLENCE
Feature Design Page(s)
Science/Technology–Broadsheet 49,999 and Under

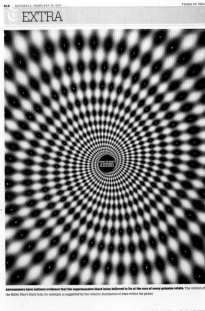

THE NATIONAL
Abu Dhabi, United Arab Emirates
Nathan Estep, Deputy Art Director
AWARD OF EXCELLENCE
Feature Design Page(s)
Home/Real Estate–Broadsheet 50,000–174,999

WELT GRUPPE/DIE WELT
Berlin, Germany
Barbara Krämer, Art Director; **Melanie Petersen**, Art Director;
Martin Steinröder, Infographics Artist; **Norbert Lossau**, Staff Editor
AWARD OF EXCELLENCE
Feature Design Page(s)
Science/Technology–Broadsheet 175,000 and Over

FRANKFURTER ALLGEMEINE SONNTAGSZEITUNG
Frankfurt am Main, Germany
Peter Breul, Art Director; **Andreas Kuther**, Picture Editor; **Jörg Albrecht**, Editor; **Ulf von Rauchhaupt**, Editor
AWARD OF EXCELLENCE
Feature Design Page(s)
Science/Technology–Broadsheet 175,000 and Over

TAMPA BAY TIMES
St. Petersburg, Fla.
Don Morris, Illustrator; **Jennifer DeCamp**, Features Designer
AWARD OF EXCELLENCE
Feature Design Page(s)
Travel/Broadsheet 175,000 and Over

SÍNTESIS
Puebla, Mexico
Ismael Espinoza, Diseñador; **Luis Estrada**, Editor; **Jesús Peña**, Gerente de Edición; **Omar Sánchez**, Director de Arte; **Erick Becerra**, Director Editorial; **Oscar Tendero**, Director General; **Armando Prida Noriega**, Vice Presidente; **Armando Prida Huerta**, Presidente
AWARD OF EXCELLENCE
Feature Design Page(s)
Inside Page/Broadsheet 49,999 and Under

THE NATIONAL
Abu Dhabi, United Arab Emirates
Nathan Estep, Deputy Art Director
AWARD OF EXCELLENCE
Feature Design Page(s)
Other/Broadsheet 50,000-174,999

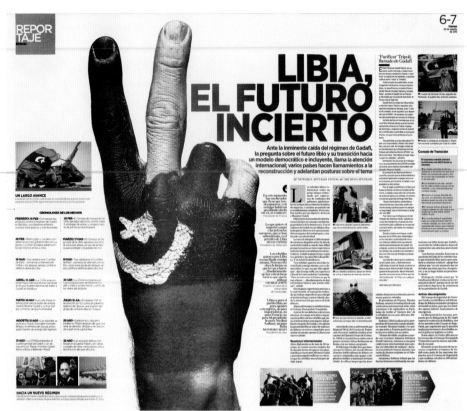

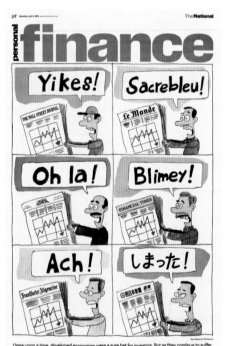

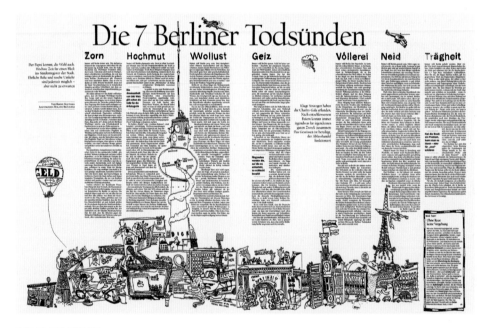

THE NATIONAL
Abu Dhabi, United Arab Emirates
Nathan Estep, Deputy Art Director
AWARD OF EXCELLENCE
Feature Design Page(s)
Other/Broadsheet 50,000-174,999

DER TAGESSPIEGEL
Berlin, Germany
Ursula Dahmen, Art Director; **Bettina Seuffert**, Art Director; **Roland Brückner**, Illustrator; **Lorenz Maroldt**, Editor-in-Chief; **Jan Oberländer**, Editor; **Bernd Matthies**, Editor
AWARD OF EXCELLENCE
Feature Design Page(s)
Inside Page/Broadsheet 50,000-174,999

TIMES OF OMAN
Muscat, Oman
Essa Al Zedjali, Chairman; **Ahmed Essa Al Zedjali**, CEO;
Adonis Durado, Design Director; **Waleed Rabin**, Designer
AWARD OF EXCELLENCE
Feature Design Page(s)
Science/Technology–Broadsheet 49,999 and Under

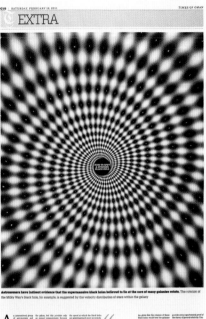

THE NATIONAL
Abu Dhabi, United Arab Emirates
Nathan Estep, Deputy Art Director
AWARD OF EXCELLENCE
Feature Design Page(s)
Home/Real Estate–Broadsheet 50,000-174,999

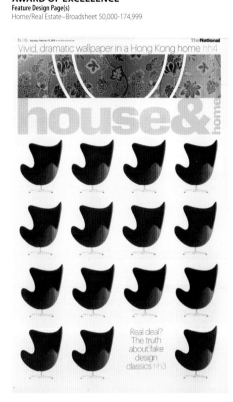

WELT GRUPPE/DIE WELT
Berlin, Germany
Barbara Krämer, Art Director; **Melanie Petersen**, Art Director;
Martin Steinröder, Infographics Artist; **Norbert Lossau**, Staff Editor
AWARD OF EXCELLENCE
Feature Design Page(s)
Science/Technology–Broadsheet 175,000 and Over

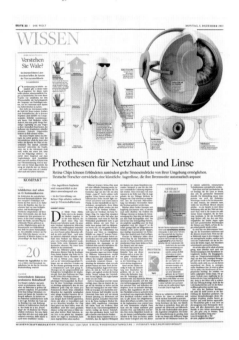

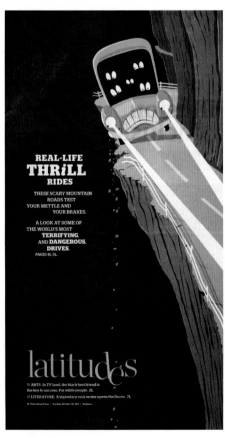

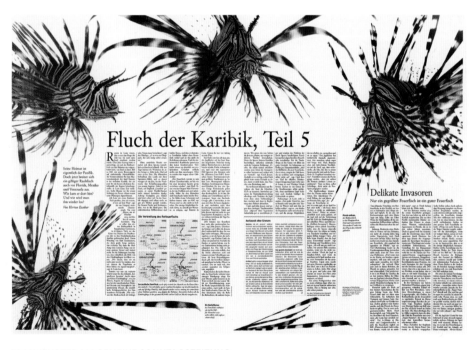

FRANKFURTER ALLGEMEINE SONNTAGSZEITUNG
Frankfurt am Main, Germany
Peter Breul, Art Director; **Andreas Kuther**, Picture Editor; **Jörg Albrecht**, Editor; **Ulf von Rauchhaupt**, Editor
AWARD OF EXCELLENCE
Feature Design Page(s)
Science/Technology–Broadsheet 175,000 and Over

TAMPA BAY TIMES
St. Petersburg, Fla.
Don Morris, Illustrator; **Jennifer DeCamp**, Features Designer
AWARD OF EXCELLENCE
Feature Design Page(s)
Travel/Broadsheet 175,000 and Over

THE NATIONAL
Abu Dhabi, United Arab Emirates
Nathan Estep, Deputy Art Director
AWARD OF EXCELLENCE
Feature Design Page(s)
Other/Broadsheet 50,000-174,999

SÍNTESIS
Puebla, Mexico
Ismael Espinoza, Diseñador; **Luis Estrada**, Editor; **Jesús Peña**, Gerente de Edición; **Omar Sánchez**, Director de Arte; **Erick Becerra**, Director Editorial; **Oscar Tendero**, Director General; **Armando Prida Noriega**, Vice Presidente; **Armando Prida Huerta**, Presidente
AWARD OF EXCELLENCE
Feature Design Page(s)
Inside Page/Broadsheet 49,999 and Under

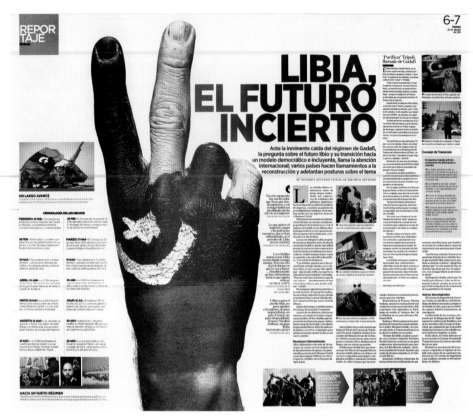

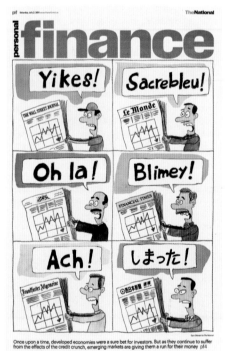

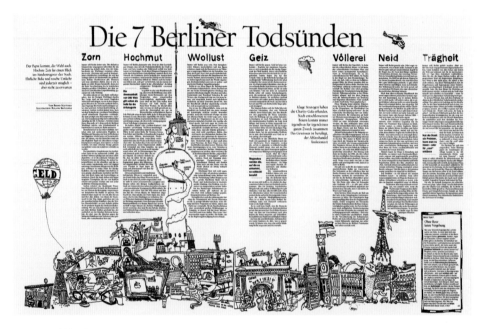

THE NATIONAL
Abu Dhabi, United Arab Emirates
Nathan Estep, Deputy Art Director
AWARD OF EXCELLENCE
Feature Design Page(s)
Other/Broadsheet 50,000-174,999

DER TAGESSPIEGEL
Berlin, Germany
Ursula Dahmen, Art Director; **Bettina Seuffert**, Art Director; **Roland Brückner**, Illustrator; **Lorenz Maroldt**, Editor-in-Chief; **Jan Oberländer**, Editor; **Bernd Matthies**, Editor
AWARD OF EXCELLENCE
Feature Design Page(s)
Inside Page/Broadsheet 50,000-174,999

CAPE COD TIMES
Hyannis, Mass.
Larry Rowe, Designer
AWARD OF EXCELLENCE
Feature Design Page(s)
Other/Broadsheet 49,999 and Under

SÍNTESIS
Puebla, Mexico
Israel Díaz, Diseñador; **Luis Estrada**, Editor; **Jesús Peña**, Gerente de Edición; **Omar Sánchez**, Director de Arte; **Erick Becerra**, Director Editorial; **Oscar Tendero**, Director General; **Armando Prida Noriega**, Vice Presidente; **Armando Prida Huerta**, Presidente
AWARD OF EXCELLENCE
Feature Design Page(s)
Inside Page/Broadsheet 49,999 and Under

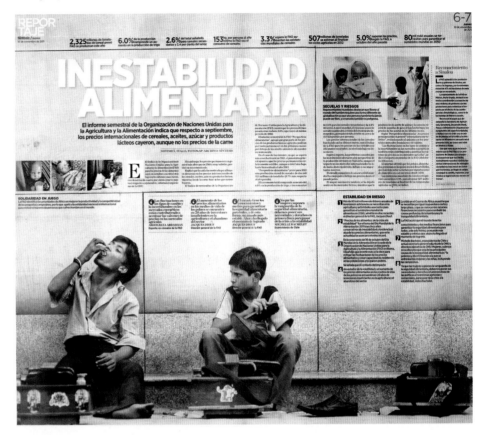

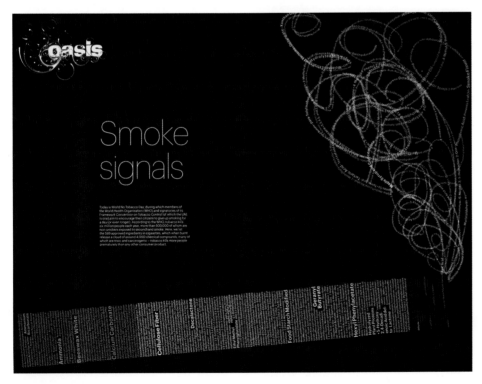

MAGNES - DZIENNIK POLSKI
Krakow, Poland
Tomasz Bocheński, Art Director
AWARD OF EXCELLENCE
Magazines
Cover Design

THE NATIONAL
Abu Dhabi, United Arab Emirates
Sara Baumberger, Designer
AWARD OF EXCELLENCE
Feature Design Page(s)
Inside Page/Broadsheet 50,000-174,999

LA RAZÓN DE MÉXICO
Mexico City, Mexico
Pablo Hiriart Le Bert, Director General; **Rubén Cortés Fernández**, Sub-Director General;
Adrian Castillo de los Cobos, Sub-Director Editorial; **Juan Carlos Ramírez González**,
Coordinador Arte y Diseño; **Ángel Salinas Cortés**, Editor;
Engelbert Chavarria Cruz, Infografía
AWARD OF EXCELLENCE
Feature Design Page(s)
Inside Page/Compact 49,999 and Under

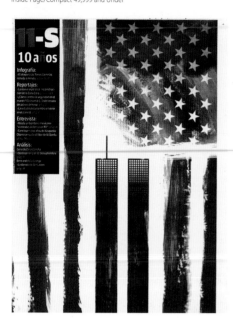

BERGENS TIDENDE
Bergen, Norway
Walter Jensen, Chief of Presentation; **Bente Ljones**, Chief of Graphics;
Anneli Solberg, Designer; **Marthe Vannebo**, Photographer
AWARD OF EXCELLENCE
Feature Design Page(s)
Inside Page/Compact 50,000-174,999

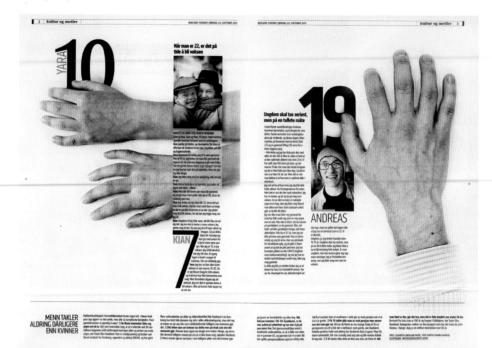

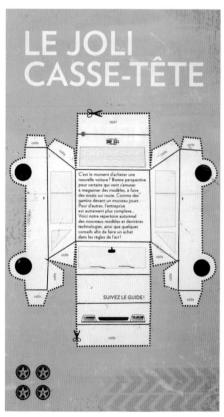

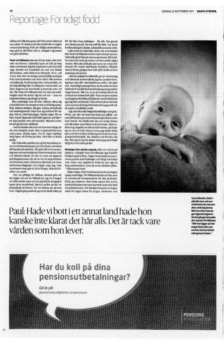

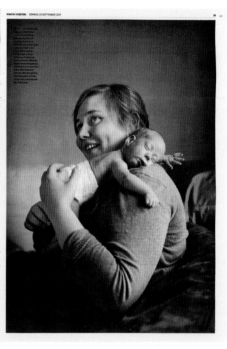

DAGENS NYHETER
Stockholm, Sweden
Lotta Ek, Art Director; **Ann Marie Höglund**, Page Designer; **Britt-Marie Schrammel**, Photo Editor; **Paul Hansen**, Text & Photo Editor
AWARD OF EXCELLENCE
Feature Design Page(s)
Inside Page/Compact 175,000 and Over

LA PRESSE
Montréal, Qué., Canada
Julie Grimard, Designer/Illustrator; **France Dupont**, Deputy Art Director;
Hélène de Guise, A.M.E./Art Director
AWARD OF EXCELLENCE
Feature Design Page(s)
Other/Broadsheet 175,000 and Over

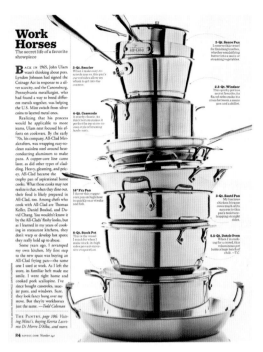

SAVEUR
New York, N.Y.
Marne Setton, Assistant Editor
AWARD OF EXCELLENCE
Magazines
Overall Design

BLOOMBERG BUSINESSWEEK
New York, N.Y.
Richard Turley, Creative Director; **David Carths**, Director of Photography; **Cynthia Hoffman**, Design Director; **Robert Vargas**, Art Director; **Jennifer Daniel**, Graphics Director; **Chandra Illick**, Designer; **Shawn Hasto**, Designer; **Maayan Pearl**, Designer; **Lee Wilson**, Designer; **Evan Applegate**, Graphic Artist
AWARD OF EXCELLENCE
Magazines
Overall Design

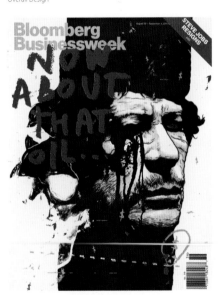

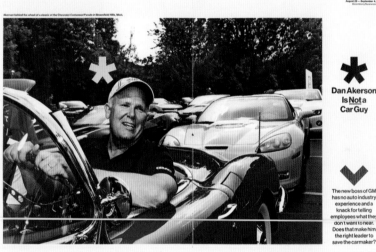

BERGENS TIDENDE
Bergen, Norway
Walter Jensen, Chief of Presentation;
Bente Ljones, Chief of Graphics; **Rune Saevig**,
Photographer; **Ingunn Roren**
AWARD OF EXCELLENCE
Magazines
Features/Cover Story Design

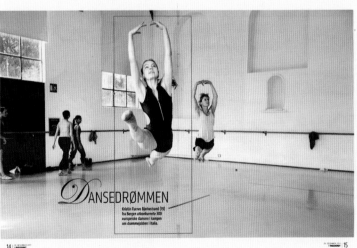

LOS ANGELES TIMES
Los Angeles, Calif.
Rip Georges, Creative Director; **Hansen Smith**, Art Director; **Cary Georges**, Designer; **Hannah Harte**, Photo Editor
AWARD OF EXCELLENCE
Magazines
Overall Design

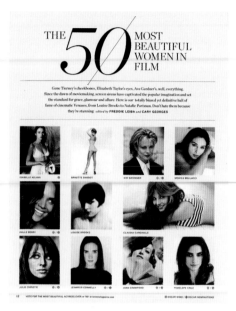

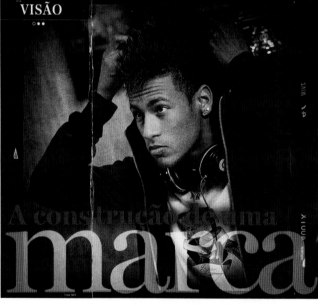

ÉPOCA NEGÓCIOS MAGAZINE
São Paulo, Brazil
Rodrigo Buldrini, Art Director; **Samir Hassan Ayoub**, Art Editor; **Idamázio Pereira Machado**, Producer Art; **Flávio Pessoa**, Designer; **Vitor Milito**, Designer; **Gabriel Gianordoli**, Infographic Artist; **Andrea Petkevicius**, Designer; **José Pequeno**, Creative Director
AWARD OF EXCELLENCE
Magazines
Overall Design

SÁBADO
Lisbon, Portugal
Fernando Barata, Art Director;
Miguel Pinheiro, Editor-in-Chief;
Gonçalo Pinheiro, Deputy Editor-in-Chief;
Daniel Neves, Designer
AWARD OF EXCELLENCE
Magazines
Features/Inside Page Design

SAN FRANCISCO CHRONICLE
San Francisco, Calif.
Frank Mina, A.M.E./Presentation;
Matt Petty, Art Director
AWARD OF EXCELLENCE
Magazines
Cover Design

BERGENS TIDENDE
Bergen, Norway
Walter Jensen, Chief of Presentation; **Bente Ljones**, Chief of Graphics; **Anneli Solberg**, Designer; **Anita Askeland**, Designer; **Rune Saevig**, Photographer; **Petter Larsen**, Copy Editor
AWARD OF EXCELLENCE
Magazines
Overall Design

Ojo-jo, ojo-jo-jo ...

Ikke røyker han, ikke drikker han, ikke løper han etter damene. Superhelten Kim Ojo er ikke som andre superhelter.

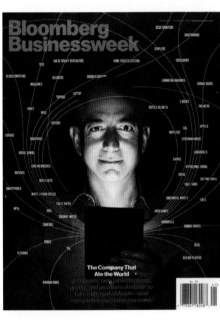

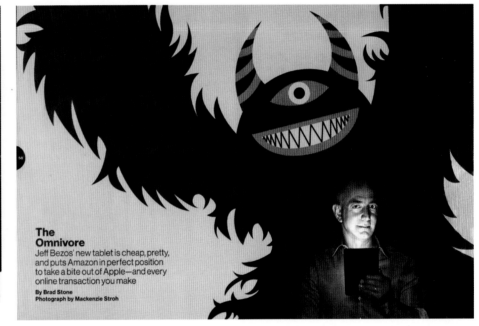

The Omnivore
Jeff Bezos' new tablet is cheap, pretty, and puts Amazon in perfect position to take a bite out of Apple—and every online transaction you make
By Brad Stone
Photograph by Mackenzie Stroh

BERGENS TIDENDE
Bergen, Norway
Walter Jensen, Chief of Presentation; **Bente Ljones**, Chief of Graphics;
Anneli Solberg, Designer; **Anita Askeland**, Designer;
Rune Saevig, Photographer; **Petter Larsen**, Copy Editor
AWARD OF EXCELLENCE
Magazines
Overall Design

DE VOLKSKRANT
Amsterdam, The Netherlands
Philippe Remarque, Editor-in-Chief; **Theo Audenaerd**, Picture Editor; **Hein van Putten**, Art Director; **Aleid Bos**, Designer; **Bart Koetsenruiter**, Editorial Manager; **Theo Stielstra**, Editor
AWARD OF EXCELLENCE
Magazines
Special Sections

GOGAMECOCKS
Columbia, S.C.
Meredith Sheffer, Designer/Art Director; **Gerry Melendez**, Photographer; **Rick Millians**, Editor; **Tom Peyton**, Photo Editor
AWARD OF EXCELLENCE
Magazines
Special Sections

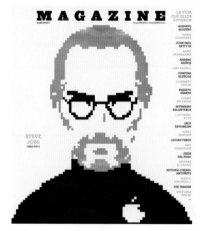

EL MUNDO MAGAZINE
Madrid, Spain
Rodrigo Sánchez, Design Director; **María González**, Art Director; **Javier Sanz**, Designer; **Francisco Alarcos**, Designer; **Adriana Rodriguez**, Designer
AWARD OF EXCELLENCE
Magazines
Special Sections

INGRAPHICS
Berlin, Germany
Ingraphics Staff
AWARD OF EXCELLENCE
Magazines
Special Sections

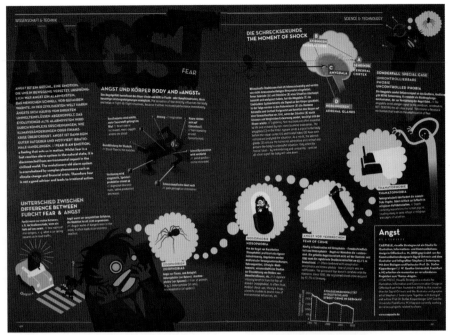

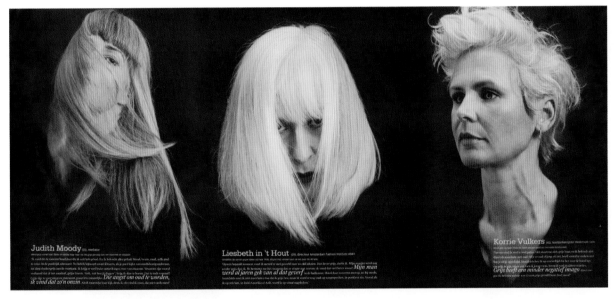

DE VOLKSKRANT
Amsterdam,
The Netherlands
Wendelien Daan, Photographer;
Philippe Remarque, Editor-in-Chief;
Theo Audenaerd, Picture Editor;
Hein van Putten, Art Director;
Aleid Bos, Designer;
Bart Koetsenruiter, Editor;
Theo Stielstra, Editor;
José Rozenbroek, Editorial Manager
**AWARD OF
EXCELLENCE**
Magazines
Features/Inside Page Design

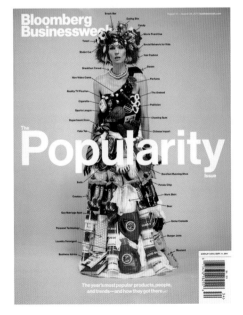

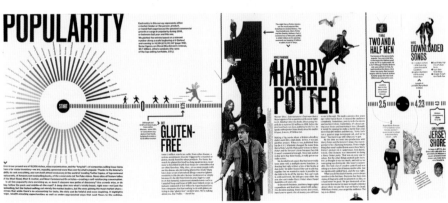

BLOOMBERG BUSINESSWEEK
New York, N.Y.
Richard Turley, Creative Director; **David Carths**, Director of Photography; **Cynthia Hoffman**, Design Director; **Robert Vargas**, Art Director; **Jennifer Daniel**, Graphics Director;
Chandra Illick, Designer; **Shawn Hasto**, Designer; **Maayan Pearl**, Designer; **Lee Wilson**, Designer; **Evan Applegate**, Graphic Artist
AWARD OF EXCELLENCE
Magazines
Features/Cover Story Design

REVISTA SHOCK
Bogotá, Colombia
Davio Favero, Art Director; **Pablo Barreto**, Assistant Art Director; **Christian Shrader**, Designer; **Nicolas Vallego**, Editor; **Manargela Rubbiui**, Director
AWARD OF EXCELLENCE
Magazines
Special Sections

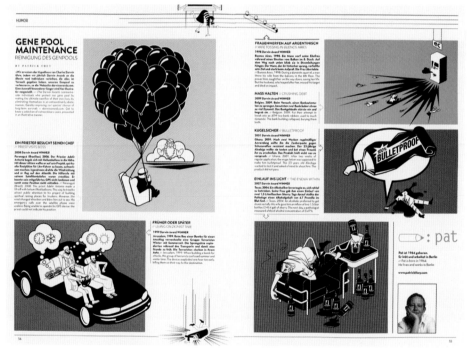

INGRAPHICS
Berlin, Germany
Ingraphics Staff
AWARD OF EXCELLENCE
Magazines
Special Sections

EL MUNDO MAGAZINE
Madrid, Spain
Rodrigo Sánchez, Design Director; **María González**, Art Director; **Javier Sanz**, Designer;
Francisco Alarcos, Designer; **Adriana Rodríguez**, Designer
AWARD OF EXCELLENCE
Magazines
Special Sections

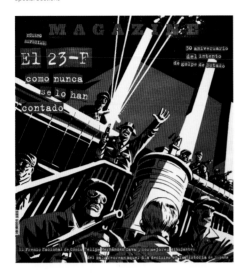

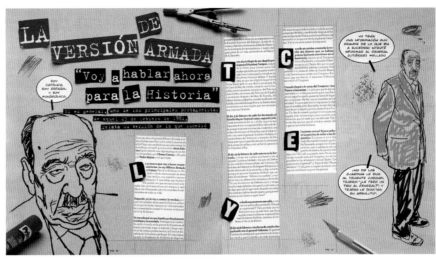

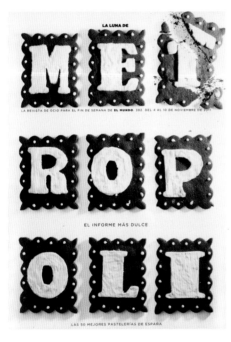

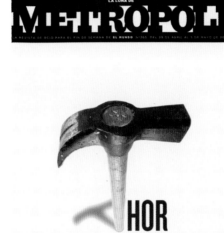

METROPOLI
Madrid, Spain
Rodrigo Sánchez, Art Director/Designer; **Ángel Becerril**, Photographer
AWARD OF EXCELLENCE
Magazines
Cover Design

METROPOLI
Madrid, Spain
Rodrigo Sánchez, Art Director/Designer; **Ángel Becerril**, Photographer
AWARD OF EXCELLENCE
Magazines
Cover Design

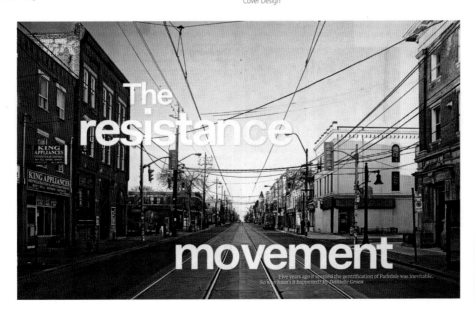

THE SAN DIEGO UNION-TRIBUNE
San Diego, Calif.
Peter Nguyen, Design Director; **Gloria Orbegozo**, Page Designer; **Cristina Martinez Byvik**, Illustrator
AWARD OF EXCELLENCE
Feature Design Page(s)
Other/Broadsheet 175,000 and Over

THE GRID
Toronto, Ont., Canada
Vanessa Wyse, Creative Director;
Shelbie Vermette, Photo Editor;
Jeremy Kohm, Photographer
AWARD OF EXCELLENCE
Magazines
Features/Cover Story Design

SUPERINTERESSANTE
São Paulo, Brazil
Renata Steffen, Art Editor; **Bruno Garattoni**, Text Editor; **Cia de Foto**, Photographer
AWARD OF EXCELLENCE
Magazines
Features/Inside Page Design

THE NEW YORK TIMES MAGAZINE
New York, N.Y.
Arem Duplessis, Design Director; **Gail Bichler**, Art Director;
Hilary Greenbaum, Designer; **Kathy Ryan**, Director of Photography;
Stacey Baker, Photo Editor; **Tom Sandberg**, Photographer
AWARD OF EXCELLENCE
Magazines
Cover Design

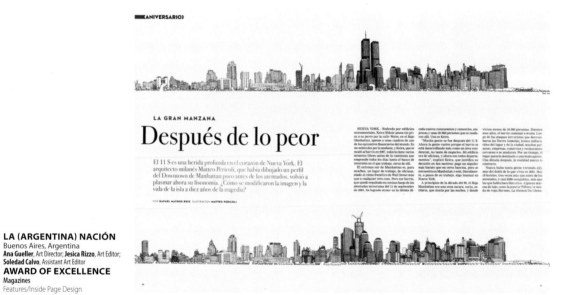

LA (ARGENTINA) NACIÓN
Buenos Aires, Argentina
Ana Gueller, Art Director; **Jesica Rizzo**, Art Editor;
Soledad Calvo, Assistant Art Editor
AWARD OF EXCELLENCE
Magazines
Features/Inside Page Design

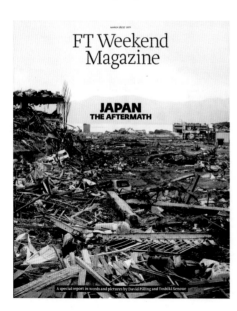

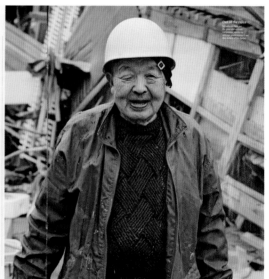

(LONDON) FINANCIAL TIMES
London, England
Mark Leeds, Design Consultant; **Paul Tansley**, Art Director; **Emma Bowkett**, Picture Editor; **Shannon Gibson**, Art Editor; **Toshiki Senolle**, Photographer
AWARD OF EXCELLENCE
Magazines
News/Cover story design

LOS ANGELES TIMES
Los Angeles, Calif.
Rip Georges, Creative Director; **Ann Field**, Illustrator
AWARD OF EXCELLENCE
Magazines
Features/Inside Page Design

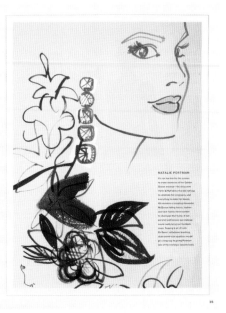

Crossroads
A bike crash sends the rider on an unexpected course.

[BY BELLA ENGLISH]

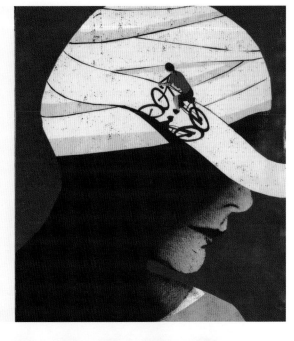

THE BOSTON GLOBE MAGAZINE
Boston, Mass.
Josue Evilla, Art Director; **Brian Stauffer**, Illustrator; **Dan Zedek**, A.M.E./Design
AWARD OF EXCELLENCE
Magazines
Features/Inside Page Design

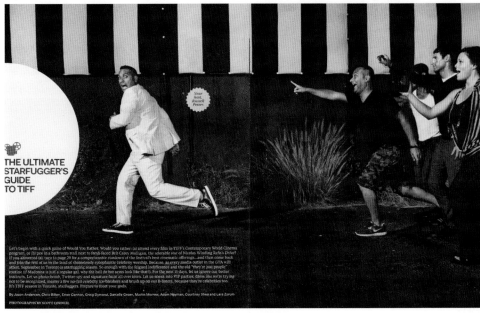

THE ULTIMATE STARFUGGER'S GUIDE TO TIFF

THE GRID
Toronto, Ont., Canada
Vanessa Wyse, Creative Director; **Shelbie Vermette**, Photo Editor; **Scott Council**, Photographer; **Angela Lewis**, Photographer
AWARD OF EXCELLENCE
Magazines
Features/Cover Story Design

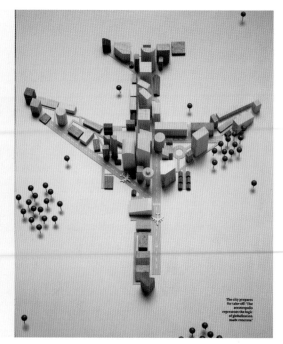

Once, airports were built to service cities. Now, the rise of the 'aerotropolis' is reversing that trend, as countries from China to Dubai build vast cities to service their airports. *Greg Lindsay* reports on how our urban future is less a society than a departure lounge to the global village. Photography *Beate Sonnenberg* Model set *Kyle Bean*

The city prepares for take-off! The aerotropolis represents the logic of globalisation made concrete

(LONDON) FINANCIAL TIMES
London, England
Mark Leeds, Design Consultant; **Paul Tansley**, Art Director;
Emma Bowkett, Picture Editor; **Shannon Gibson**, Art Editor
AWARD OF EXCELLENCE
Magazines
Features/Inside Page Design

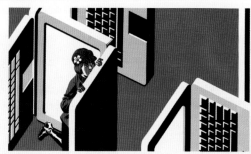

LISON MITCHELL spends a lot of time at the playground, a place of social opportunity – and uncertainty – for herself as well as her kids. A gregarious mother of two daughters, Mitchell sees her fellow Somerville parents as potential friends and says the best icebreaker often isn't the obvious commonalities, like bulky diaper bags or the line at the swings. Instead, it's the preexisting relationship she has with other playgroundgoers, thanks to the Internet. A former political press secretary who is now home full time with her kids, Mitchell has spent the last three years coordinating a 1,600-member e-mail list known locally as "Somerville Moms." The list – some version of which exists in dozens of Massachusetts communities – is an online forum for sharing pediatrician recommendations and debating hot-button topics like the chickenpox vaccine.

Members (I am one) use their real names and share the names and ages of their children in every post. So when Mitchell hears a stranger call out that Henry and Ava need to get off the seesaw right now, she often knows quite a bit about Henry and Ava – and sometimes she also knows intimate details about their mom.

"That happens a lot: You're at the playground and you hear the kids' names and then realize, 'Oh, you're the one with the ear infection,'" says Mitchell, 36, with a laugh. She's made friends with several women she met using the list and thinks it's a great resource for building real community, not just the cyber kind. But there's a downside: Looking for advice and support, members sometimes share details with a 1,600-person message list that they might not declare in front of a 1,600-person crowd, which can make for some awkward real-world encounters. If you meet another mom at the grocery store and realize she's the list member dealing with, say, a painful clogged

Clicking

Turning online friends into real-world ones
is not as simple as it might seem. BY ALISON LOBRON
ILLUSTRATION BY MICHAEL CHO

38 THE BOSTON GLOBE MAGAZINE MARCH 13, 2011

MARCH 13, 2011 THE BOSTON GLOBE MAGAZINE 37

THE BOSTON GLOBE MAGAZINE
Boston, Mass.
Greg Klee, Art Director; **Michael Cho**, Illustrator;
Dan Zedek, A.M.E./Design
AWARD OF EXCELLENCE
Magazines
Features/Inside Page Design

High and Mighty

The new bridge over the river Colorado wasn't designed as a work of art, but necessity became the mother to grandeur *by* MICHAEL HILTZIK / *photographs by* JAMEY STILLINGS

The Hoover Dam was situated precisely where it was—wedged into the inhospitable desert landscape of the Colorado River's Black Canyon—to control floods and provide water for both farmers and city dwellers in the West. But the dam wound up becoming a victim of its own success. With the population of the Southwest having surged by 40 million since the 1930s—much of that spawned by the promise of abundant water and power—the strip of blacktop upon the dam's crest evolved from a remote desert crossing to a bottleneck on a major regional thoroughfare for up to 14,000 vehicles a day. Throw in the increased security and safety concerns, and the need for a bypass became manifest.

So a new bridge was conceived to traverse the very same canyon. Construction of the main span 500 yards downstream began in 2005, and on October 19, 2010, the Mike O'Callaghan-Pat Tillman Memorial Bridge was opened to traffic. Jamey Stillings happened upon the project in 2009, when he took a

LOS ANGELES TIMES
Los Angeles, Calif.
Rip Georges, Creative Director; **Jamey Stillings**, Photographer
AWARD OF EXCELLENCE
Magazines
Features/Inside Page Design

54

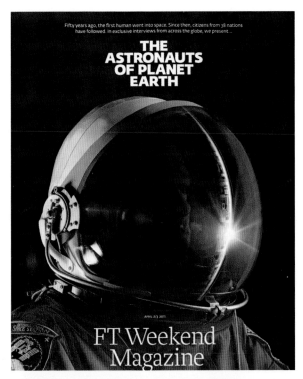

(LONDON) FINANCIAL TIMES
London, England
Mark Leeds, Design Consultant; **Paul Tansley**, Art Director;
Emma Bowkett, Picture Editor; **Shannon Gibson**, Art Editor
AWARD OF EXCELLENCE
Magazines
Features/Cover Story Design

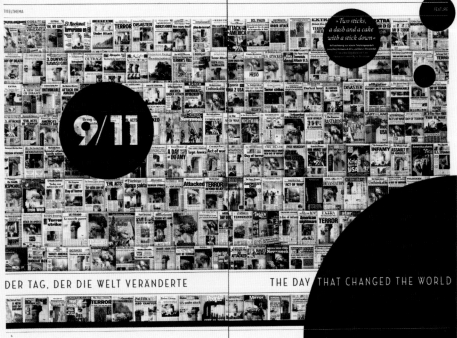

INGRAPHICS
Berlin, Germany
Jan Schwochow, CEO/Creative Director; **Katharina Stipp**, Graphic Editor;
Thomas Richter, Graphic Editor (Intern)
AWARD OF EXCELLENCE
Magazines
Features/Cover Story Design

THE BOSTON GLOBE
Boston, Mass.
Greg Klee, Art Director/Illustrator; **Dan Zedek**, A.M.E./Design
AWARD OF EXCELLENCE
Feature Design Page(s)
Opinion/Broadsheet 175,000 and Over

THE GLOBE AND MAIL
Toronto, Ont., Canada
Adrian Norris, M.E./Design; **David Pratt**, Design Editor/Folio; **Craig Offman**, Folio
Editor; **Roger Hallett**, Photo Editor
AWARD OF EXCELLENCE
Feature Design Page(s)
Opinion/Broadsheet 175,000 and Over

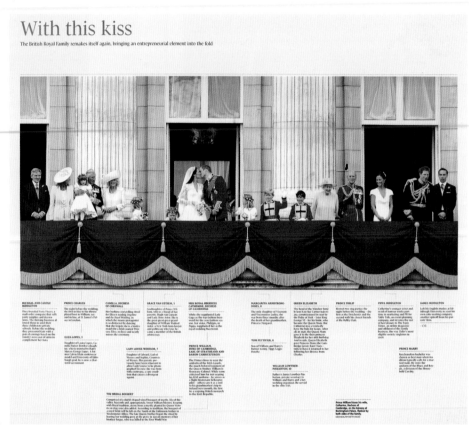

SAVEUR
New York, N.Y.
Marne Setton, Assistant Editor
AWARD OF EXCELLENCE
Magazines
Features/Cover Story Design

EL MUNDO MAGAZINE
Madrid, Spain
Rodrigo Sánchez, Art Director; **Maria González**, Designer; **Javier Sanz**, Designer;
Francisco Alarcos, Designer; **Adriana Rodriguez**, Designer; **Álvaro Villarrubia**,
Photographer
AWARD OF EXCELLENCE
Magazines
Cover Design

AGSZE HO
SIOR VOLKSKR
GARTER ZEITUNG ST
DESIGN
LL STREET JOUR
MES MEXICO NEW
SWERVE MAG
SSWEEK MAGNES-DZIENNIK
E MERCURY NEWS RE
PAULO CANADA H
E BEST OF NEWS DES
SND
33
RIBUNE THE NATIO
SEATTLE TIMES NA
TARDE OMAHA WORLD-H
LER FINANCIAL T
EGAS REVIEW-JOURNAL ORE
DAGENS NYHE
LAS VEGAS SUN NOROESTE MA
NUESTRO DIARIO RA
S EXPRESSO MET
LINE
CATARINA HOSPODÁ
ZETA WEEKLY STAR TRI
TERC RA SE

VISUALS

elementos visuals

THE DALLAS MORNING NEWS
Dallas, Texas
Gary Taxali, Illustrator; **Michael Hogue**, Art Director
AWARD OF EXCELLENCE
Illustration
Single Lead Color

THE DALLAS MORNING NEWS
Dallas, Texas
Dave Plunkert, Illustrator; **Michael Hogue**, Art Director
AWARD OF EXCELLENCE
Illustration
Single Lead Color

ZETA WEEKLY
Tijuana, Baja California, Mexico
Ariel Freaner, Creative & Art Director
AWARD OF EXCELLENCE
Illustration
Single Lead Color

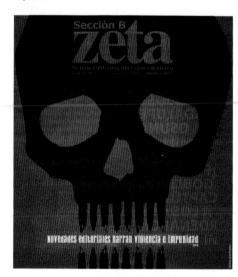

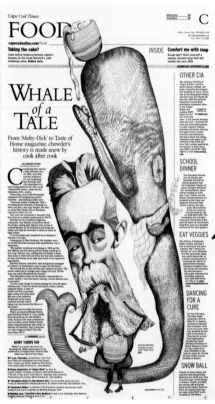

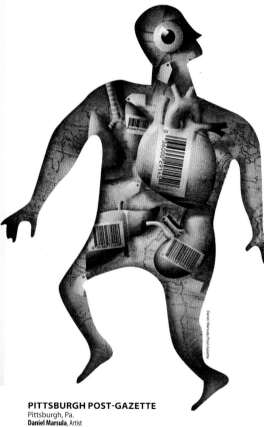

TAMPA BAY TIMES
St. Petersburg, Fla.
Brittany Volk, Illustrator
AWARD OF EXCELLENCE
Illustration
Single Lead Color

CAPE COD TIMES
Hyannis, Mass.
James Warren, Illustrator
AWARD OF EXCELLENCE
Illustration
Single Lead Color

PITTSBURGH POST-GAZETTE
Pittsburgh, Pa.
Daniel Marsula, Artist
AWARD OF EXCELLENCE
Illustration
Single Lead Color

THE NEW YORK TIMES
New York, N.Y.
Jason Hollery, Illustrator; **Peter Morance**, Art Director; **Tom Bodkin**, Design Director
AWARD OF EXCELLENCE
Illustration
Single Lead Color

THE BOSTON GLOBE
Boston, Mass.
David Plunkert, Illustrator; **Lesley Becker**, Art Director; **Dan Zedek**, A.M.E./Design
AWARD OF EXCELLENCE
Illustration
Single Lead Color

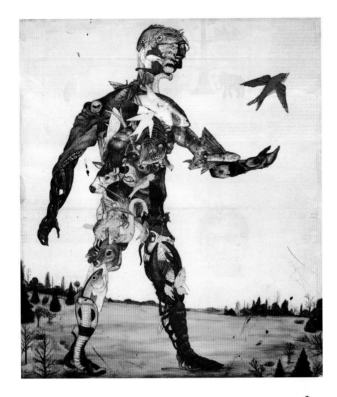

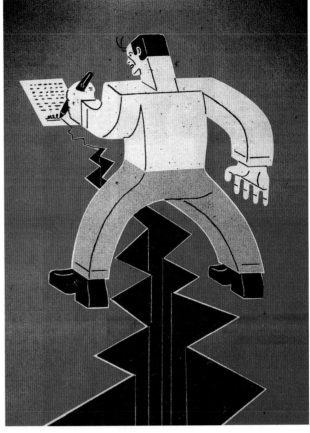

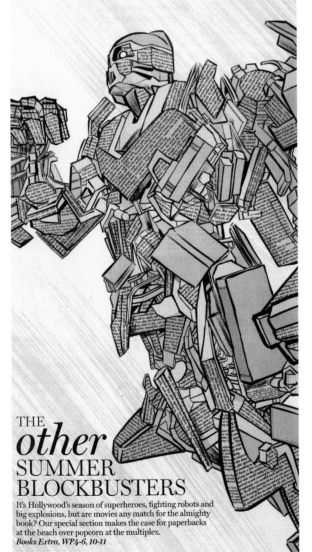

THE
other
SUMMER
BLOCKBUSTERS

It's Hollywood's season of superheroes, fighting robots and big explosions, but are movies any match for the almighty book? Our special section makes the case for paperbacks at the beach over popcorn at the multiplex.
Books Extra, WP4-6, 10-11

TIMES OF OMAN
Muscat, Oman
Essa Mohammed Al Zedjali, Chairman;
Ahmed Essa Al Zedjali, CEO;
Adonis Durado, Illustrator
AWARD OF EXCELLENCE
Illustration
Single Lead Color

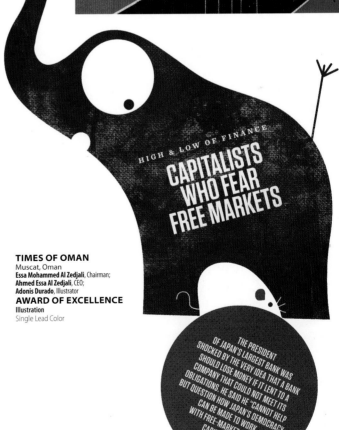

HIGH & LOW OF FINANCE
CAPITALISTS WHO FEAR FREE MARKETS

THE PRESIDENT OF JAPAN'S LARGEST BANK WAS SHOCKED BY THE VERY IDEA THAT A BANK SHOULD LOSE MONEY IF IT LENT TO A COMPANY THAT COULD NOT MEET ITS OBLIGATIONS. HE SAID HE "CANNOT HELP BUT QUESTION HOW JAPAN'S DEMOCRACY CAN BE MADE TO WORK WITH FREE-MARKET-BASED CAPITALISM"

NATIONAL POST
Toronto, Ont., Canada
Kagan McLeod, Illustrator; **Becky Guthrie**, Associate Features Design Editor; **Benjamin Errett**, M.E./Features; **Maryam Siddiqi**, D.M.E./Features; **Barry Hertz**, Arts & Life Editor; **Stephen Meurice**, Editor-in-Chief; **Gayle Grin**, M.E./Design & Graphics
AWARD OF EXCELLENCE
Illustration
Single Lead Color

THE NEW YORK TIMES
New York, N.Y.
Brendan Monroe, Illustrator; **Aviva Mikhaelov**, Art Director; **Tom Bodkin**, Design Director
AWARD OF EXCELLENCE
Illustration
Single Lead Color

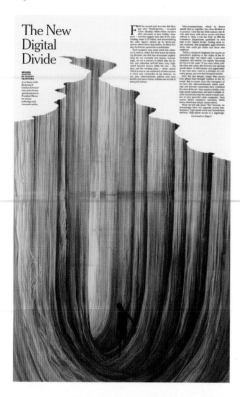

SOUTH CHINA MORNING POST
Hong Kong, China
Brian Wang, Graphic Designer
AWARD OF EXCELLENCE
Illustration
Single Lead Black-and-White

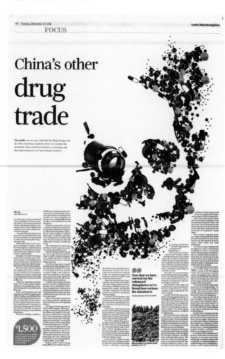

THE (NEW YORK) WALL STREET JOURNAL
New York, N.Y.
Tomaso Capuano, Creative Director; **Manny Velez**, Art Director;
Jon Krause, Illustrator
AWARD OF EXCELLENCE
Illustration
Single Spot Color

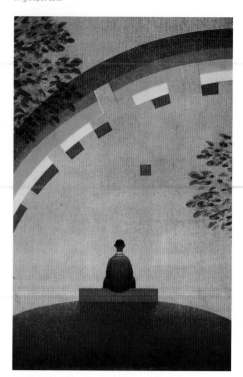

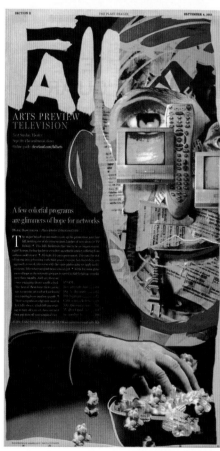

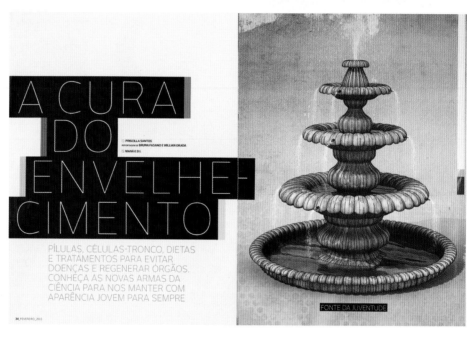

GALILEU
São Paulo, Brazil
Gerson Mora, Maná e.d.i.; **Anna Luiza Aragão**, Maná e.d.i.
AWARD OF EXCELLENCE
Illustration
Multiple

THE PLAIN DEALER
Cleveland, Ohio
Andrea Levy, Photographer/Illustrator
AWARD OF EXCELLENCE
Photography/Single Photos
Illustration

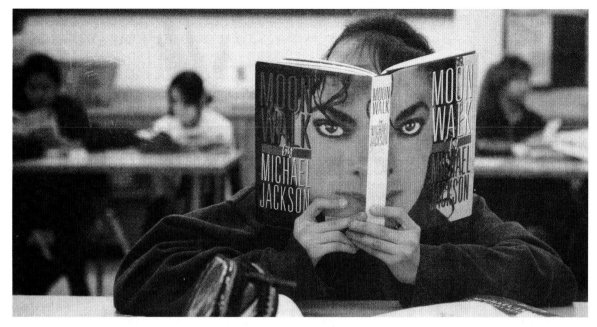

NATIONAL POST
Toronto, Ont., Canada
Tyler Anderson, Photographer;
Laura Morrison, News Presentation Editor;
Paolo Zinatelli, Senior Designer;
Jeff Wasserman, Photo & Multimedia Editor;
Ron Wadden, Toronto Editor;
Stephen Meurice, Editor-in-Chief;
Gayle Grin, M.E./Design & Graphics
AWARD OF EXCELLENCE
Photography/Single Photos
General News (Planned)

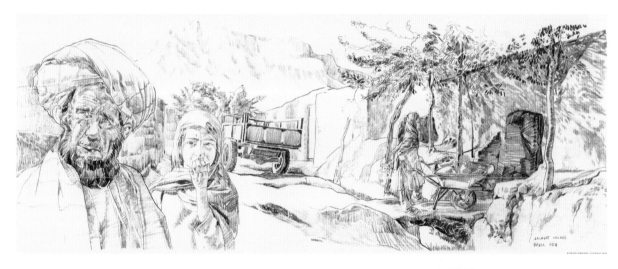

NATIONAL POST
Toronto, Ont., Canada
Richard Johnson, Illustrator/
Graphics Editor; **Laura Morrison**,
News Presentation Editor;
Paolo Zinatelli, Senior Designer;
Anne Marie Owens, M.E./News;
Michael Higgins, Foreign Editor;
Stephen Meurice, Editor-in-Chief;
Gayle Grin, M.E./Design & Graphics
**AWARD OF
EXCELLENCE**
Illustration
Multiple

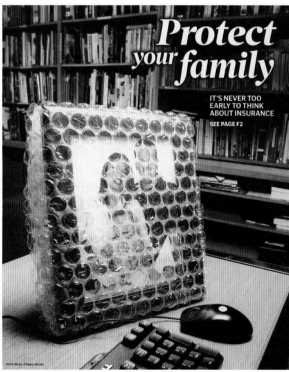

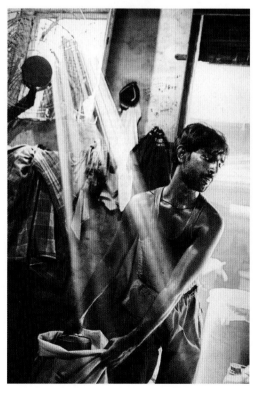

THE NEW YORK TIMES
New York, N.Y.
Adam Ferguson, Photographer; **Michele McNally**,
Photo Editor; **Tom Bodkin**, Design Director
AWARD OF EXCELLENCE
Photography/Single Photos
General News (Planned)

CALGARY HERALD
Calgary, Alb., Canada
Grant Black, Photographer; **Janet Matiisen**, Assistant News Editor/Design;
Brent Morrison, News Designer; **Steve Jenkinson**, Money Editor; **Tom Babin**, Sunday Editor
AWARD OF EXCELLENCE
Photography/Single Photos
Illustration

LOS ANGELES TIMES
Los Angeles, Calif.
Brian Van der Brug, Photographer; **Robert St. John**, Photo Editor; **Kelli Sullivan**, Deputy Design Director; **Michael Whitley**, A.M.E.
AWARD OF EXCELLENCE
Photography/Multiple Photos
Project Page or Spread

SAN JOSE MERCURY NEWS
San Jose, Calif.
Dai Sugano, Staff Photographer/Senior Multimedia Editor
AWARD OF EXCELLENCE
Photography/Single Photos
General News (Planned)

CARE AND ATONEMENT

A PASTORAL CARE WORKER comforts a dying inmate at the California Medical Facility in Vacaville. It was inside these walls that John Paul Madrona forged a bond with Freddy Garcia, who was serving nine years for robbery and who had terminal cancer.

Trying to make things right

Tending to ill and dying inmates in a prison hospice helped John Paul Madrona do penance for a terrible deed in his youth. But perhaps the work was not enough.

Kurt Streeter
FIRST OF TWO PARTS

MADRONA, A CONVICTED killer who is trying to turn his life around, is pensive during eulogies for recently deceased inmates.

THE SEATTLE TIMES
Seattle, Wash.
John Lok, Photographer
AWARD OF EXCELLENCE
Photography/Single Photos
General News (Planned)

THE NEW YORK TIMES
New York, N.Y.
Jonathan Corum, Graphics Editor
AWARD OF EXCELLENCE
Information Graphics
News/Non-Deadline 175,000 and Over

THE NEW YORK TIMES
New York, N.Y.
Damon Winters, Photographer; **John Macleod,**
Art Director; **Michele McNally,** Photo Editor;
Tom Bodkin, Design Director
AWARD OF EXCELLENCE
Photography/Single Photos
General News (Planned)

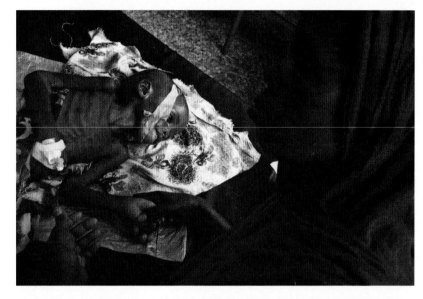

TORONTO STAR
Toronto, Ont., Canada
Randy Risling, Photographer
**AWARD OF
EXCELLENCE**
Photography/Single Photos
General News (Planned)

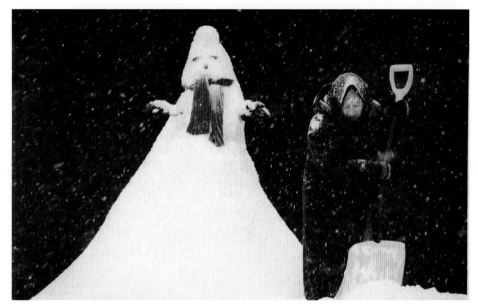

NATIONAL POST
Toronto, Ont., Canada
Tyler Anderson, Photographer; **Jeff Wasserman,** Photo & Multimedia Editor; **Ron Wadden,** Toronto Editor;
Laura Morrison, News Presentation Editor; **Stephen Meurice,** Editor-in-Chief; **Gayle Grin,** M.E./Design & Graphics
AWARD OF EXCELLENCE
Photography/Single Photos
General News (Planned)

NATIONAL POST
Toronto, Ont., Canada
Geneviève Biloski, Features Design Editor; **Benjamin Errett,** M.E./Features;
Barry Hertz, Arts & Life Editor; **Stephen Meurice,** Editor-in-Chief;
Gayle Grin, M.E./Design & Graphics
AWARD OF EXCELLENCE
Photography/Multiple Photos
Page Design

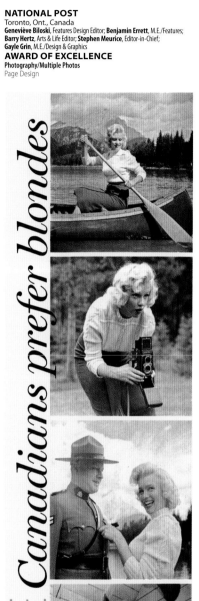

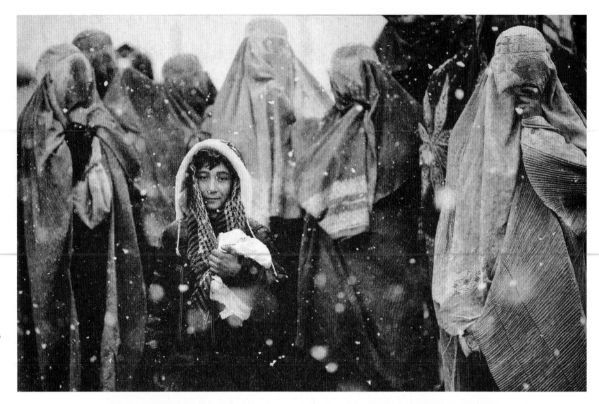

OMAHA WORLD-HERALD
Omaha, Neb.
Jeff Bundy, Director of Photography;
Alyssa Schukar, Photographer
AWARD OF EXCELLENCE
Photography/Single Photos
Spot News

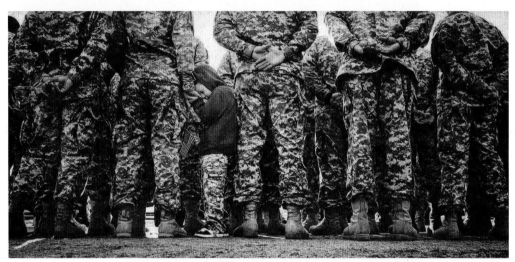

THE STATE
Columbia, S.C.
Tim Dominick, Photographer
AWARD OF EXCELLENCE
Photography/Single Photos
General News (Planned)

The Attraction
Is Truly
Skin Deep

THE NEW YORK TIMES
New York, N.Y.
Tony Cenicola, Photographer; **Fred Norgaard**, Art Director; **Tom Bodkin**, Design Director
AWARD OF EXCELLENCE
Photography/Single Photos
Features

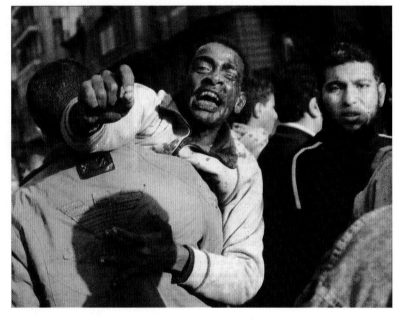

LOS ANGELES TIMES
Los Angeles, Calif.
Michael Robinson Chavez, Photographer; **Steve Stroud**, Photo Editor; **Gerard Babb**, Designer
AWARD OF EXCELLENCE
Photography/Single Photos
Spot News

TIMES OF OMAN
Muscat, Oman
Essa Al Zedjali, Chairman; **Ahmed Essa Al Zedjali**, CEO; **Adonis Durado**, Design Director; **AR Rajkumar**, Photographer
AWARD OF EXCELLENCE
Photography/Single Photos
Spot News

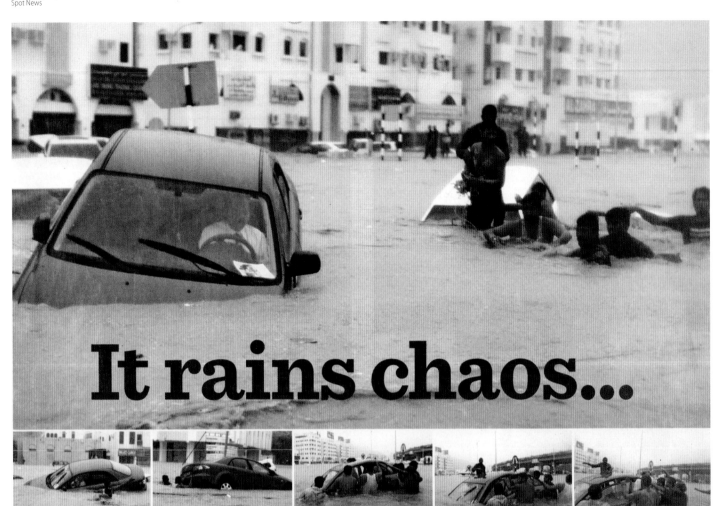

It rains chaos...

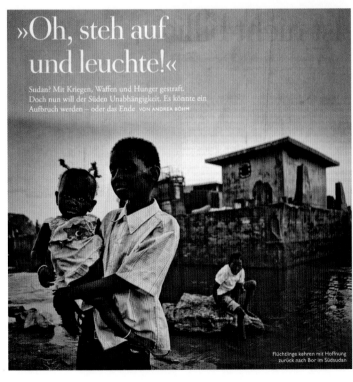

»Oh, steh auf
und leuchte!«

Sudan? Mit Kriegen, Waffen und Hunger gestraft.
Doch nun will der Süden Unabhängigkeit. Es könnte ein
Aufbruch werden – oder das Ende VON ANDREA BÖHM

Flüchtlinge kehren mit Hoffnung
zurück nach Bor im Südsudan

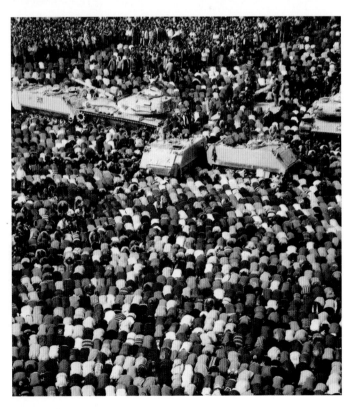

DIE ZEIT
Hamburg, Germany
Haika Hinze, Art Director; **Ellen Dietrich**, Director/Photography; **Klaus-D. Sieling**, Deputy Art Director; **Mirko Bosse**,
Layout Editor; **Martin Burgdorff**, Layout Editor; **Mechthild Fortmann**, Layout Editor; **Tim Freccia**, Photographer
AWARD OF EXCELLENCE
Photography/Single Photos
General News (Planned)

LOS ANGELES TIMES
Los Angeles, Calif.
Rick Loomis, Photographer; **Steve Stroud**, Photo Editor; **Gerard Babb**, Designer
AWARD OF EXCELLENCE
Photography/Single Photos
Spot News

THE NEW YORK TIMES
New York, N.Y.
Joe Burgess, Graphics Editor; **Haeyoun Park**, Graphics Editor; **Sergio Pecanha**, Graphics Editor; **Aya Sakamoto**, Graphics Editor; **Archie Tse**, Graphics Editor
AWARD OF EXCELLENCE
Information Graphics
News/Non-Deadline 175,000 and Over

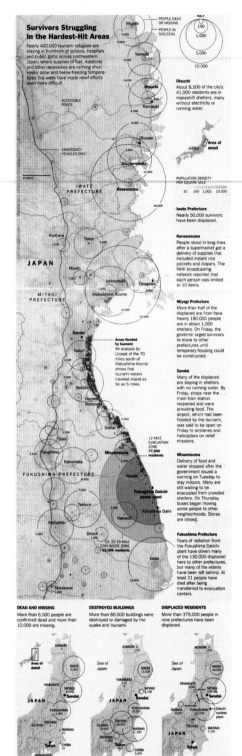

Survivors Struggling In the Hardest-Hit Areas
Nearly 400,000 tsunami refugees are staying in hundreds of schools, hospitals and public gyms across northeastern Japan, where supplies of fuel, medicine and other necessities are running short. Heavy snow and below-freezing temperatures this week have made relief efforts even more difficult.

Otsuchi
About 8,500 of the city's 41,000 residents are in makeshift shelters, many without electricity or running water.

Iwate Prefecture
Nearly 50,000 survivors have been displaced.

Kensennuma
People stood in long lines after a supermarket got a delivery of supplies that included instant rice packets and diapers. The NHK broadcasting network reported that each person was limited to 10 items.

Miyagi Prefecture
More than half of the displaced are from here. Nearly 180,000 people are in about 1,000 shelters. On Friday, the governor urged other prefectures to move to other temporary housing could be constructed.

Sendai
Many of the displaced are staying in shelters with no running water. By Friday, shops near the main train station reopened and were providing food. The airport, which had been flooded by the tsunami, was said to be open on Friday to airplanes and helicopters on relief missions.

Minamisoma
Delivery of food and water stopped after the government issued a warning on Tuesday to stay indoors. Many are still waiting to be evacuated from crowded shelters. On Thursday, buses began moving some people to other neighborhoods. Stores are closed.

Fukushima Prefecture
Fears of radiation from the Fukushima Daiichi plant have driven many of the 130,000 displaced here to other prefectures, but many of the elderly have been left behind. At least 21 people have died after being transferred to evacuation centers.

DEAD AND MISSING
More than 6,500 people are confirmed dead and more than 10,000 are missing.

DESTROYED BUILDINGS
More than 80,000 buildings were destroyed or damaged by the quake and tsunami.

DISPLACED RESIDENTS
More than 375,000 people in nine prefectures have been displaced.

THE VIRGINIAN-PILOT
Norfolk, Va.
Ross Taylor, Staff Photographer; **The Pham**, Advance Planning Photo Editor; **Randall Greenwell**, Director of Photography; **Sam Hundley**, Designer
AWARD OF EXCELLENCE
Photography/Multiple Photos
Series/Project or Story

TORONTO STAR
Toronto, Ont., Canada
Lucas Oleniuk, Photographer
AWARD OF EXCELLENCE
Photography/Single Photos
Spot News

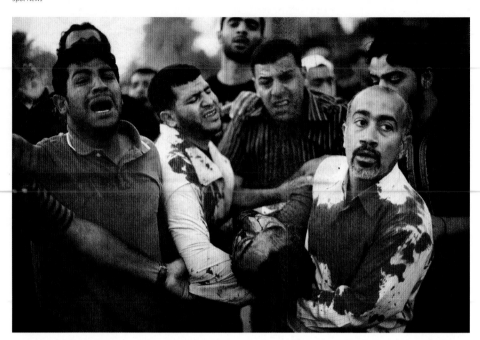

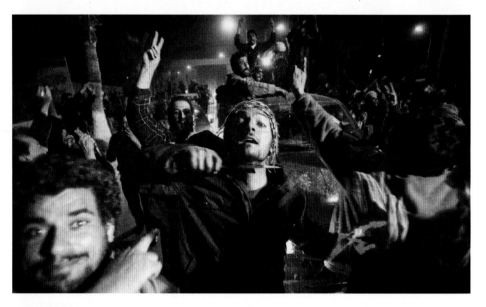

TORONTO STAR
Toronto, Ont., Canada
Rick Madonik, Photographer
AWARD OF EXCELLENCE
Photography/Single Photos
Spot News

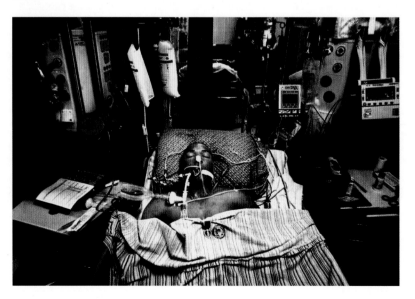

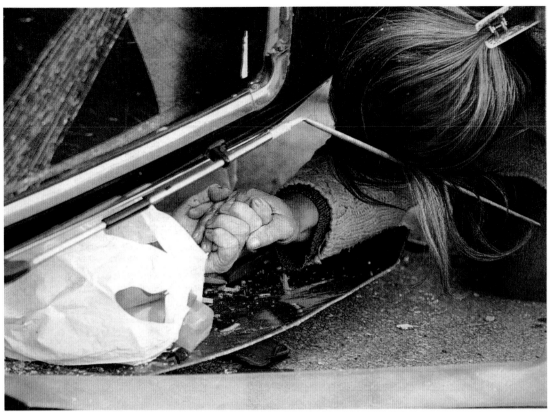

JORNAL DE SANTA CATARINA
Blumenau, Santa Catarina, Brazil
Artur Moser, Photojournalist
AWARD OF EXCELLENCE
Photography/Single Photos
Spot News

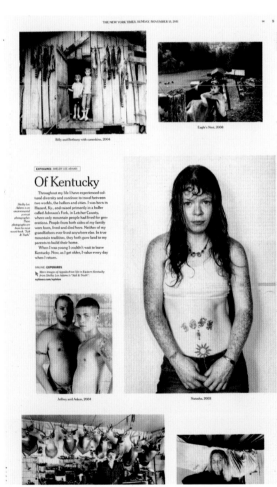

THE NEW YORK TIMES
New York, N.Y.
Jeffrey Scales, Photo Editor; **Shelby Lee Adams**, Photographer;
Tom Bodkin, Design Director
AWARD OF EXCELLENCE
Photography/Multiple Photos
Project Page or Spread

LOS ANGELES TIMES
Los Angeles, Calif.
Carolyn Cole, Photographer; **Steve Stroud**, Photo Editor;
Kelli Sullivan, Deputy Design Director
AWARD OF EXCELLENCE
Photography/Single Photos
Spot News

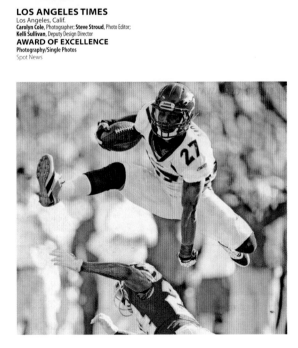

THE DENVER POST
Denver, Colo.
John Leyba, Photographer
AWARD OF EXCELLENCE
Photography/Single Photos
Sports

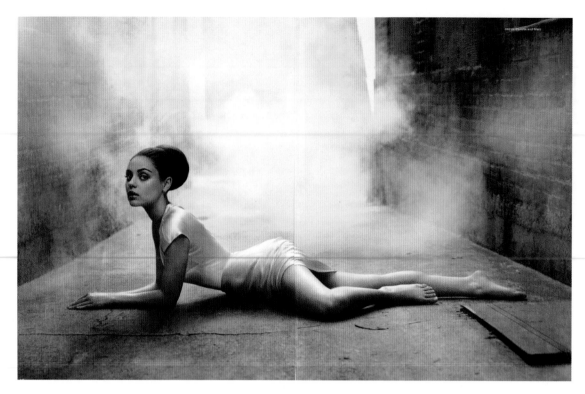

LOS ANGELES TIMES
Los Angeles, Calif.
Rip Georges, Creative Director; **Ruven Afanador**, Photographer; **Kim Pollock**, Producer
AWARD OF EXCELLENCE
Photography/Multiple Photos
Project Page or Spread

CLARÍN
Buenos Aires, Argentina
Pablo Loscri, Graphic Editor;
Alejandro Tumas, Graphic Editor;
Clarisa Mateo, Artist;
Andrea Carballo, Researcher;
Romina Ferreyra, Researcher
AWARD OF EXCELLENCE
Information Graphics
News/Non-Deadline
175,000 and Over

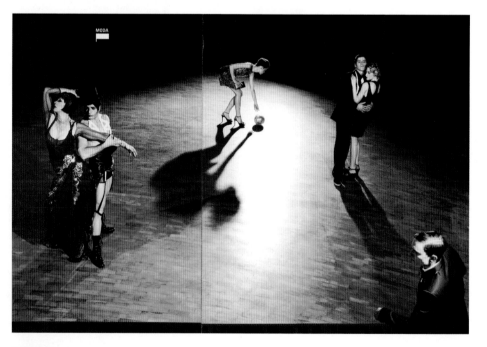

SWERVE MAGAZINE
Calgary, Alb., Canada
Todd Korol, Photographer
AWARD OF EXCELLENCE
Photography/Single Photos
Features

SERAFINA
São Paulo, Brazil
Teté Ribeiro, Editor-in-Chief; **Luciano Schmitz**, Art Director; **Cassiana der Haroutiounian**, Photography Editor;
Anderson Rodrigues, Stylist; **Vivian Whiteman**, Journalist; **Rafael Pinho**, Photographer; **Daniel Raad**, Stylist;
Junior Guarnieri, Props Producer; **Simone Pokropp**, Props Producer
AWARD OF EXCELLENCE
Photography/Multiple Photos
Project Page or Spread

SERAFINA
São Paulo, Brazil
Teté Ribeiro, Editor-in-Chief; **Luciano Schmitz**, Art Director; **Cassiana der Haroutiounian**, Photography Editor; **Adriana Komura**, Designer;
Fabrício Corsaletti, Journalist; **Vavá Ribeiro**, Photographer; **Ivan Finotti**, Assistant Editor; **Adriana Küchler**, Assistant Editor
AWARD OF EXCELLENCE
Photography/Multiple Photos
Project Page or Spread

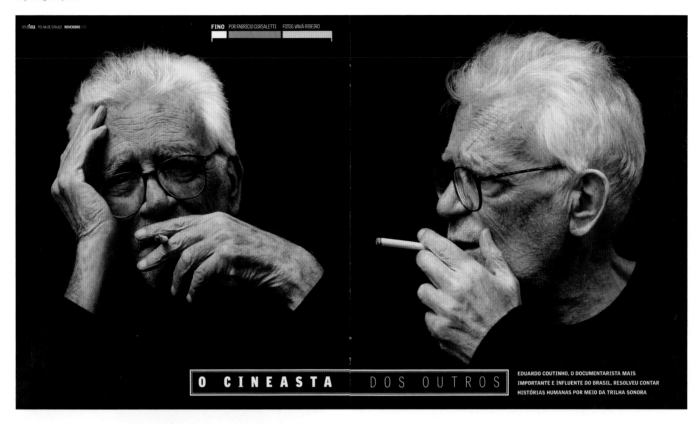

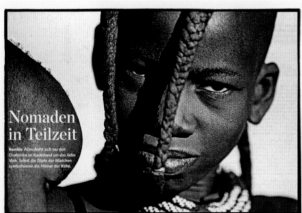

STUTTGARTER ZEITUNG
Stuttgart, Germany
Steffen Honzera, Photographer; **Christoph Link**, Editor; **Sabastian Klöpfer**, Page Designer;
Uta Glauß, Page Designer; **Dirk Steininger**, Art Director; **Joachim Dorfs**, Editor-in-Chief
AWARD OF EXCELLENCE
Photography/Multiple Photos
Project Page or Spread

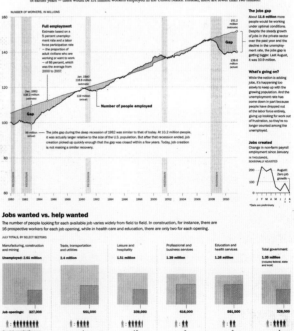

THE WASHINGTON POST
Washington, D.C.
Todd Lindeman, Graphics Artist; **Neil Irwin**, Reporter
AWARD OF EXCELLENCE
Information Graphics
News/Non-Deadline 175,000 and Over

(CHICAGO) HOY
Chicago, Ill.
Nuccio Dinuzzo, Photographer; **Lorena González**, Designer; **Jacqueline Marrero**, Designer;
Rodolfo Jiménez, Art Director; **Octavío López**, Editor; **Fernando Díaz**, M.E.; **John Trainor**, General Manager
AWARD OF EXCELLENCE
Photography/Single Photos
Sports

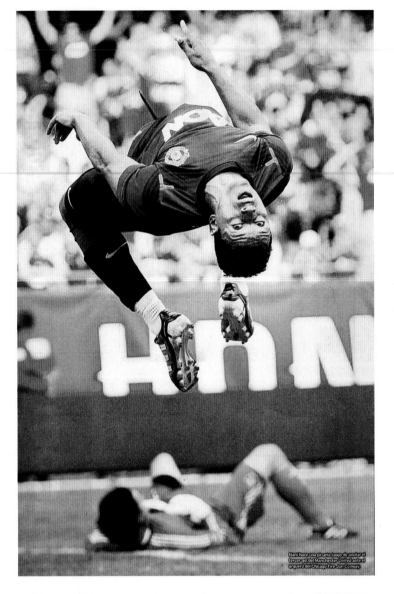

Nani hace una pirueta luego de anotar el tercer gol del Manchester United ante el arquero del Chicago Fire Jon Conway

MINNEAPOLIS STAR TRIBUNE
Minneapolis, Minn.
Carlos Gonzalez, Staff Photographer
AWARD OF EXCELLENCE
Photography/Single Photos
Sports

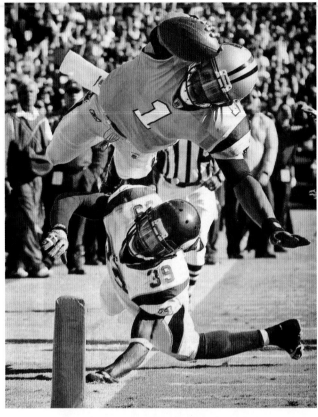

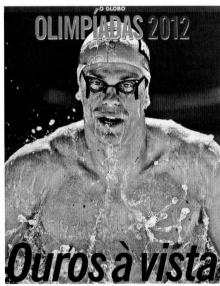

O GLOBO
Rio de Janeiro, Brazil
Ivo Gonzalez, Photographer
AWARD OF EXCELLENCE
Photography/Single Photos
Sports

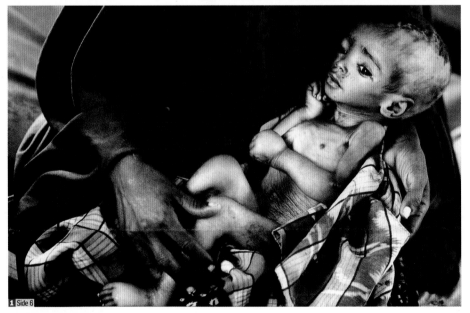

POLITIKEN
Copenhagen, Denmark
Peter Hove Olesen, Photographer
AWARD OF EXCELLENCE
Photography/Single Photos
Spot News

**MILWAUKEE
JOURNAL SENTINEL**
Milwaukee, Wis.
Tom Lynn, Staff Photographer;
Ed Brud, Page Designer;
Angela Peterson, Picture Editor
AWARD OF EXCELLENCE
Photography/Single Photos
Sports

(CHICAGO) HOY
Chicago, Ill.
Nancy Stone, Photographer; **Lorena González**,
Designer; **Jacqueline Marrero**, Designer;
Rodolfo Jiménez, Art Director;
José Luis Sánchez Pando, Sports Editor;
Octavio López, Editor; **Fernando Díaz**, M.E.;
John Trainor, General Manager
AWARD OF EXCELLENCE
Photography/Single Photos
Sports

(CHICAGO) HOY
Chicago, Ill.
Chris Sweda, Photographer; **Lorena González**,
Designer; **Jacqueline Marrero**, Designer;
Rodolfo Jiménez, Art Director;
José Luis Sánchez Pando, Sports Editor;
Octavio López, Editor; **Fernando Díaz**, M.E.;
John Trainor, General Manager
AWARD OF EXCELLENCE
Photography/Single Photos
Sports

LAS VEGAS SUN
Henderson, Nev.
Steve Marcus, Photographer
AWARD OF EXCELLENCE
Photography/Single Photos
Sports

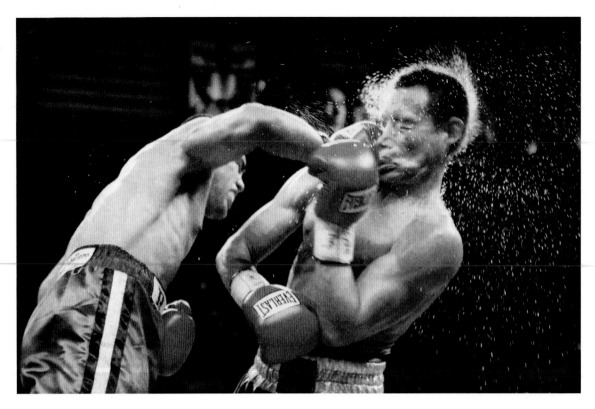

WYOMING TRIBUNE EAGLE
Cheyenne, Wyo.
Angela St. Clair, A.M.E./Presentation;
Michael Smith, Photographer
AWARD OF EXCELLENCE
Photography/Single Photos
Sports

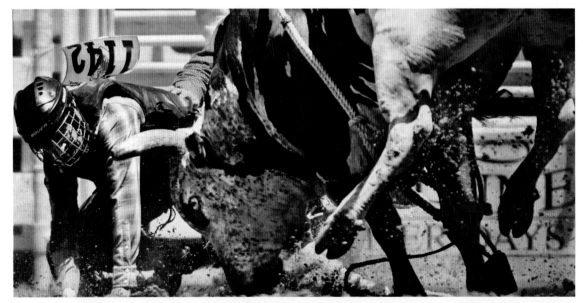

THE DENVER POST
Denver, Colo.
Joe Amon, Photographer
AWARD OF EXCELLENCE
Photography/Single Photos
Features

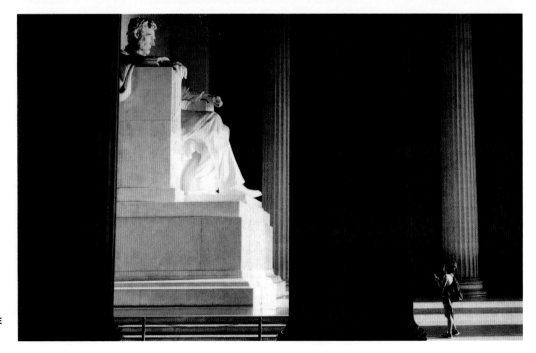

PITTSBURGH POST-GAZETTE
Pittsburgh, Pa.
Peter Diana, Staff Photographer
AWARD OF EXCELLENCE
Photography/Single Photos
Sports

THE CHRONICLE OF HIGHER EDUCATION
Washington, D.C.
Rose Engelland, Photo Editor
AWARD OF EXCELLENCE
Photography/Single Photos
Features

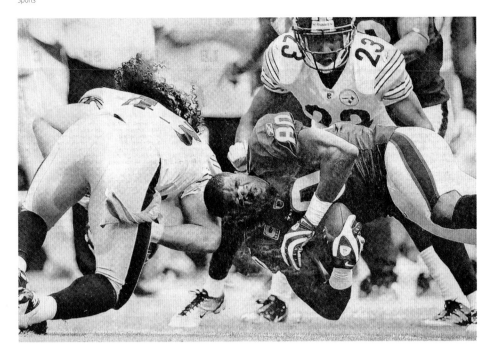

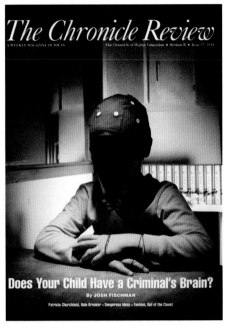

MINNEAPOLIS STAR TRIBUNE
Minneapolis, Minn.
Janet Reeves, A.M.E./Photo/Multimedia; **Tom Sweeney**,
Features Photo Editor; **Colleen Kelly**, Features Designer;
Leah Millis, Photographer
AWARD OF EXCELLENCE
Photography/Single Photos
Features

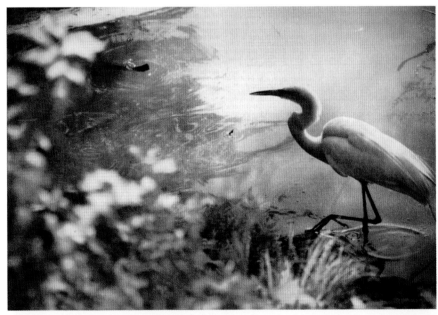

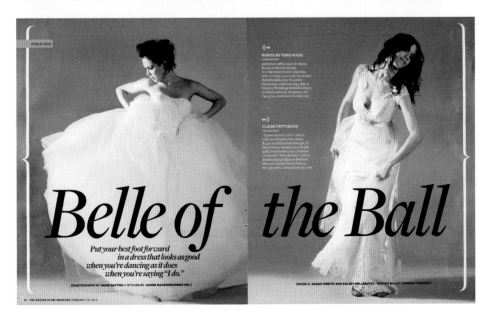

THE BOSTON GLOBE
Boston, Mass.
Josue Evilla, Art Director; **Sadie Dayton**, Photographer; **Dan Zedek**, A.M.E./Design
AWARD OF EXCELLENCE
Photography/Multiple Photos
Project Page or Spread

LOS ANGELES TIMES
Los Angeles, Calif.
Barbara Davidson, Photographer; **Mary Cooney**, Deputy Photo Editor; **Colin Crawford**, D.M.E.; **Kelli Sullivan**, Deputy Design Director
AWARD OF EXCELLENCE
Photography/Single Photos
Features

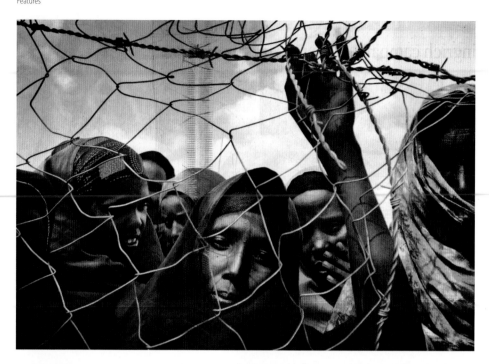

POLITIKEN
Copenhagen, Denmark
Per Folkver, Photographer
AWARD OF EXCELLENCE
Photography/Single Photos
Portrait

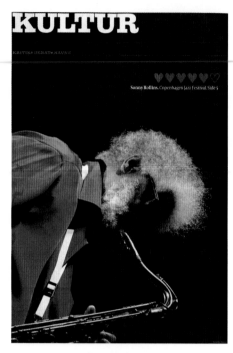

LOS ANGELES TIMES
Los Angeles, Calif.
Brian Van der Brug, Photographer; **Robert St. John**, Photo Editor; **Kelli Sullivan**, Deputy Design Director
AWARD OF EXCELLENCE
Photography/Single Photos
Features

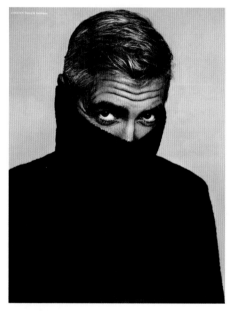

LOS ANGELES TIMES
Los Angeles, Calif.
Rip Georges, Creative Director; **Ruven Afanador**, Photographer;
Hannah Harte, Photo Editor
AWARD OF EXCELLENCE
Photography/Single Photos
Portrait

LOS ANGELES TIMES
Los Angeles, Calif.
Brian Van der Brug, Photographer; **Robert St. John**, Photo Editor;
Kelli Sullivan, Deputy Design Director
AWARD OF EXCELLENCE
Photography/Single Photos
Features

THE SAN DIEGO UNION-TRIBUNE
San Diego, Calif.
Christina Martinez Byvik, Illustrator; **Peter Nguyen**, Design Director
AWARD OF EXCELLENCE
Illustration
Single Lead Color

EXPRESIÓN

NOROESTE MAZATLÁN
Mazatián, Mexico
Luis Brito, Photographer; **Alexander Probst**, Art Director; **Rodolfo Díaz**, Editorial Director;
Guillermina García, Editorial Sub-Director; **Adriana Castro**, Editor; **Martha Rivera**, Graphic Editor
AWARD OF EXCELLENCE
Photography/Single Photos
Portrait

THE SAN DIEGO UNION-TRIBUNE
San Diego, Calif.
Nelvin C. Cepeda, Staff Photographer
AWARD OF EXCELLENCE
Photography/Single Photos
General News (Planned)

THE OREGONIAN
Portland, Ore.
Benjamin Brink, Photographer
AWARD OF EXCELLENCE
Photography/Single Photos
Features

THE DENVER POST
Denver, Colo.
AAron Ontiveroz, Photographer
AWARD OF EXCELLENCE
Photography/Single Photos
Portrait

EMERGING TALENT

AL BAYAN
Dubai, United Arab Emirates
Luis Chumpitaz, Information Graphic Director; **Liz Ramos Prado**, Information Graphic Editor; **German Fernandez**, Information Graphic Editor; **Karina Aricoche**, Information Graphic Researcher; **Asma Ali**, Translator
AWARD OF EXCELLENCE
Information Graphics
Features 50,000-174,999

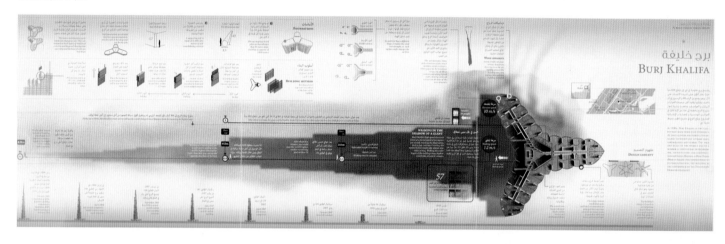

TORONTO STAR
Toronto, Ont., Canada
Aaron Harris, Photographer
AWARD OF EXCELLENCE
Photography/Single Photos
Portrait

THE CHARLOTTE OBSERVER
Charlotte, N.C.
David T. Foster III, Staff Photographer; **Bert Fox**, Director of Photography
AWARD OF EXCELLENCE
Photography/Single Photos
Sports

RAY VILLAFANE at his home studio in Surprise, Ariz.

THE (NEW YORK) WALL STREET JOURNAL
New York, N.Y.
Jeff Newton, Photographer; **Rebecca Horne**, Photo Editor; **Lucy Gilmour**, Deputy Photo Director; **Jack Van Antwerp**, Director of Photography; **Kelly Peck**, Art Director; **Keith Webb**, Art Director
AWARD OF EXCELLENCE
Photography/Single Photos
Portrait

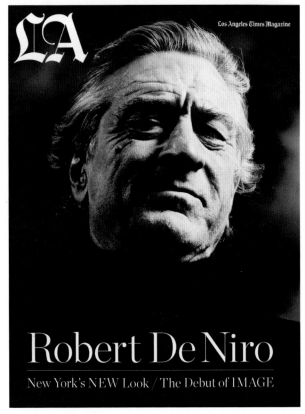

THE (NEW YORK) WALL STREET JOURNAL
New York, N.Y.
Sam Comen, Photographer; **Rebecca Horne**, Photo Editor; **Lucy Gilmour**, Deputy Photo Director; **Jack Van Antwerp**, Director of Photography; **Kelly Peck**, Art Director; **Keith Webb**, Art Director
AWARD OF EXCELLENCE
Photography/Single Photos
Portrait

LOS ANGELES TIMES
Los Angeles, Calif.
Rip Georges, Creative Director; **Hedi Slmane**, Photographer; **Kim Pollock**, Producer
AWARD OF EXCELLENCE
Photography/Single Photos
Portrait

INGRAPHICS
Berlin, Germany
Jan Schwochow, CEO/Creative Director; **Katharina Stipp**, Graphic Editor;
Frederic Brodbeck, Graphic Editor
AWARD OF EXCELLENCE
Information Graphics
Features 49,999 and Under

EL SEMANAL
Santiago, Chile
Tomás Munita, Photographer
AWARD OF EXCELLENCE
Photography/Multiple Photos
Project Page or Spread

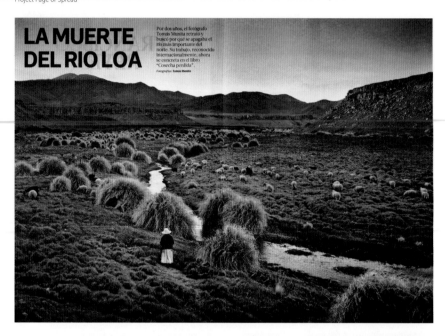

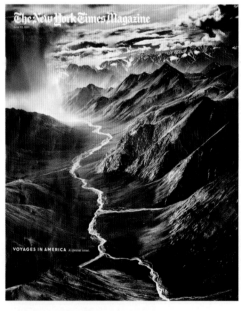

THE NEW YORK TIMES MAGAZINE
New York, N.Y.
Arem Duplessis, Design Director; **Gail Bichler**, Art Director; **Sebastião Salgado**,
Photographer; **Kathy Ryan**, Director of Photography; **Joanna Milter**, Deputy Photo Editor
AWARD OF EXCELLENCE
Photography/Multiple Photos
Series/Project or Story

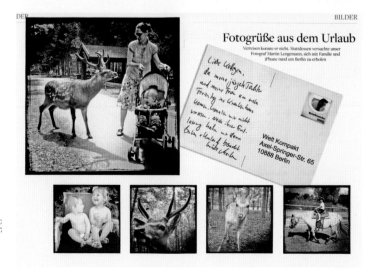

WELT GRUPPE
Berlin, Germany
Ronny Wahliss, Page Designer; **Amin Akhtar**, Photographer; **Massimo Rodari**, Photographer;
Christian Hahn, Photographer; **Reto Klar**, Photographer; **Martin Lengemann**, Photographer;
Marion Hunger, Photographer; **Joerg Krauthoefer**, Photographer
AWARD OF EXCELLENCE
Photography/Multiple Photos
Series/Project or Story

SWERVE MAGAZINE
Calgary, Alb., Canada
Leah Hennel, Photographer
AWARD OF EXCELLENCE
Photography/Multiple Photos
Series/Project or Story

CRUEL SHOES

For about a thousand years, ending in the early 1900s, foot binding was practised in China. The process is pretty much self-explanatory, but the end result pretty much defies description. Tightly wrapping the feet of young girls led to broken arches (after about two years) and the toes curling underneath the feet. The ideal female foot was no more than nine centimetres long. It is hard to imagine that as the standard of female beauty, but then, stilettos can't be a treat to walk around in, either.

TWENTY-FOUR

BRIDGES
Saskatoon, SK, Canada
Andrew Spearin, Photographer; **Jeff Losie**, Page Designer; **Heather Persson**, Editor; **Rob McLaughlin**, Editor-in-Chief
AWARD OF EXCELLENCE
Photography/Single Photos
Portrait

HOT YOGI

HOW RYAN LEIER OF SASKATOON BECAME ARCADE FIRE'S GO-TO GURU P. 8

FREE

THESTARPHOENIX.COM/BRIDGES

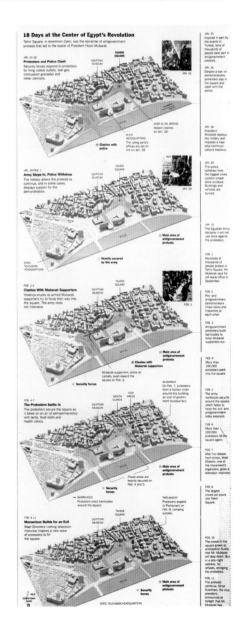

18 Days at the Center of Egypt's Revolution

THE NEW YORK TIMES MAGAZINE
New York, N.Y.
Arem Duplessis, Design Director; **Gail Bichler**, Art Director; **Alex Prager**, Photographer; **Kathy Ryan**, Director of Photography; **Joanna Milter**, Deputy Photo Editor; **Hilary Greenbaum**, Designer
AWARD OF EXCELLENCE
Photography/Multiple Photos
Series/Project or Story

THE NEW YORK TIMES
New York, N.Y.
Stephen Farrell, Reporter; **Sergio Pecanha**, Graphics Editor; **Graham Roberts**, Graphics Editor; **Archie Tse**, Graphics Editor
AWARD OF EXCELLENCE
Information Graphics/Portfolios
Breaking news/Extended Coverage (Staff)
175,000 and Over

SOUTH CHINA MORNING POST
Hong Kong, China
Yves Sieur, Photo Editor
AWARD OF EXCELLENCE
Photography/Multiple Photos
Page Design

SOUTH CHINA MORNING POST
Hong Kong, China
Yves Sieur, Photo Editor; **Troy Dunkley**, Designer
AWARD OF EXCELLENCE
Photography/Multiple Photos
Page Design

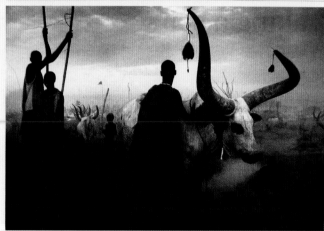

BACK PAGE

Humanity laid bare

BACK PAGE

I spy with my eye …

Our photographers Sam Tsang, Martin Chan, Simon Song and Robert Ng catch a glimpse of Hong Kong life through their smartphone lenses.

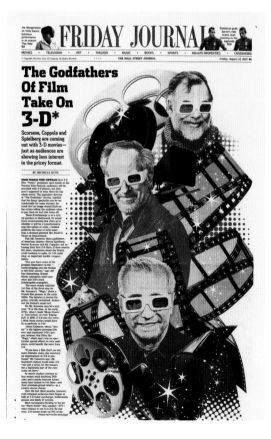

FRIDAY JOURNAL

The Godfathers Of Film Take On 3-D*

Scorsese, Coppola and Spielberg are coming out with 3-D movies — just as audiences are showing less interest in the pricey format.

BY MICHELLE KUNG

THE (NEW YORK) WALL STREET JOURNAL
New York, N.Y.
Tomaso Capuano, Creative Director; **Manny Velez**, Art Director; **Sean McCabe**, Illustrator
AWARD OF EXCELLENCE
Photography/Single Photos
Illustration

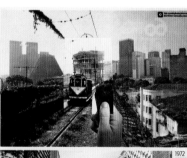

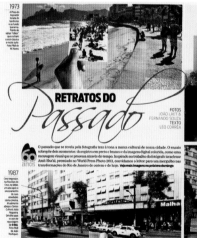

RETRATOS DO Passado

FOTOS
JOÃO LAET &
FERNANDO SOUZA
TEXTO
LEO CORRÊA

O DIA
Rio de Janeiro, Brazil
André Hippertt, Art Director; **Leo Corrêa**, Photo Editor;
Jo Laet, Photographer; **Fernando Souza**, Photographer;
Renata Maneschy, Designer
AWARD OF EXCELLENCE
Photography/Multiple Photos
Series/Project or Story

THE INDIANAPOLIS STAR
Indianapolis, Ind.
Stephen Beard, Graphic Artist; **Jennifer Imes**, Graphics Editor; **Scott Goldman**, Director/Digital & Visuals
AWARD OF EXCELLENCE
Information Graphics
News/Non-Deadline 175,000 and Over

NATIONAL POST
Toronto, Ont., Canada
Louie Palu, Photographer; **Laura Morrison**, News Presentation Editor; **Paolo Zinatelli**, Senior Designer; **Richard Johnson**, Graphics Editor; **Jeff Wasserman**, Photo & Multimedia Editor; **Joe Hood**, Page One Editor; **Michael Higgins**, Foreign Editor; **Stephen Meurice**, Editor-in-Chief; **Gayle Grin**, M.E./Design & Graphics
AWARD OF EXCELLENCE
Photography/Multiple Photos
Page Design

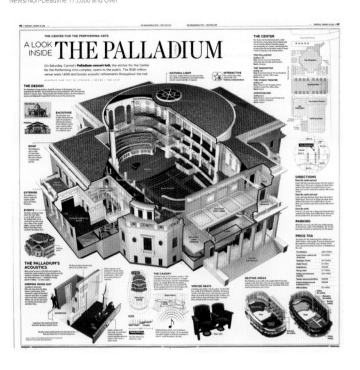

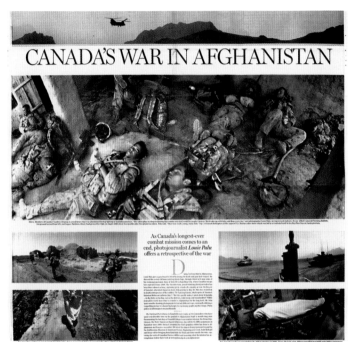

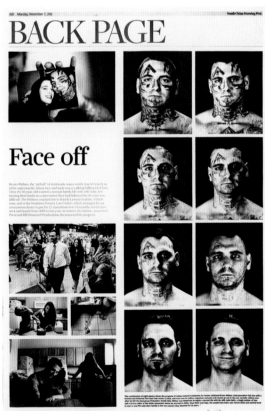

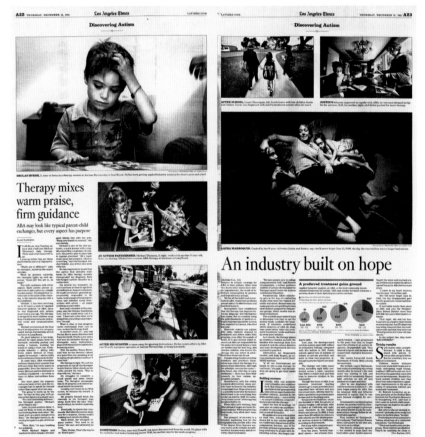

SOUTH CHINA MORNING POST
Hong Kong, China
Yves Sieur, Photo Editor; **Jody Megson**, Photo Editor
AWARD OF EXCELLENCE
Photography/Multiple Photos
Page Design

LOS ANGELES TIMES
Los Angeles, Calif.
Francine Orr, Photographer; **Mary Vignoles**, Photo Editor; **Kelli Sullivan**, Deputy Design Director; **Michael Whitley**, A.M.E.
AWARD OF EXCELLENCE
Photography/Multiple Photos
Series/Project or Story

DAGENS NYHETER
Stockholm, Sweden
Stefan Rothmaier, Infographics Artist

AWARD OF EXCELLENCE
Information Graphics
News/Non-Deadline 175,000 and Over

O ESTADO DE S. PAULO
São Paulo, Brazil
Fabio Sales, Art Director; **Regina Silva**, Infographics Director; **Eduardo Asta**, Infographic Assistant Editor; **Rubens Paiva**, Infographic Assistant Editor; **William Mariotto**, Infographic Assistant Editor; **Glauco Lara**, Infographic Assistant Editor

AWARD OF EXCELLENCE
Information Graphics
News/Non-Deadline 175,000 and Over

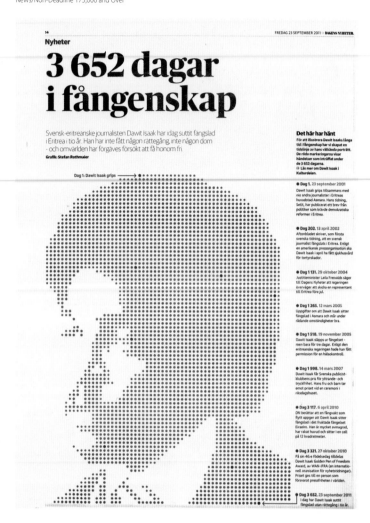

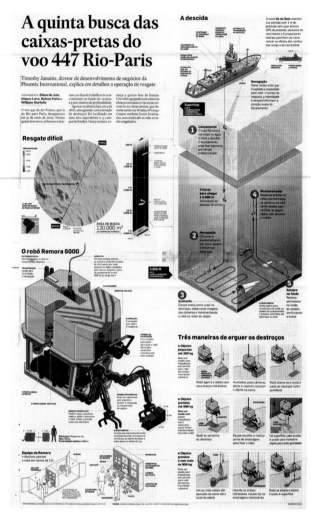

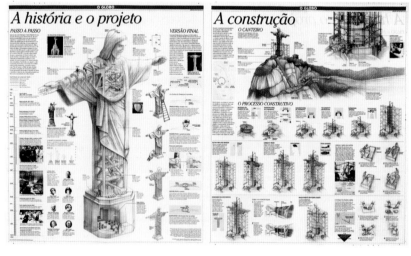

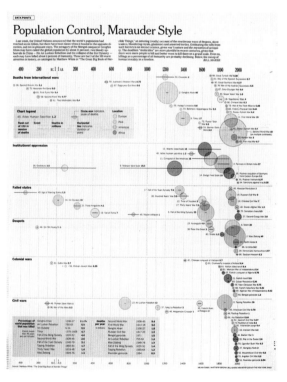

O GLOBO
Rio de Janeiro, Brazil
Alessandro Alvim, Art Assistant Editor/Infographist; **Renato Carvalho**, Infographist; **Michelle Rodrigues**, Trainee Infographist; **Kamilla Pavão**, Trainee Infographist

AWARD OF EXCELLENCE
Information Graphics
News/Non-Deadline 175,000 and Over

THE NEW YORK TIMES
New York, N.Y.
Micah Cohen, Graphics Editor; **Matthew Ericson**, Graphics Editor; **Bill Marsh**, Graphics Editor; **Kevin Quealy**, Graphics Editor

AWARD OF EXCELLENCE
Information Graphics
Features 175,000 and Over

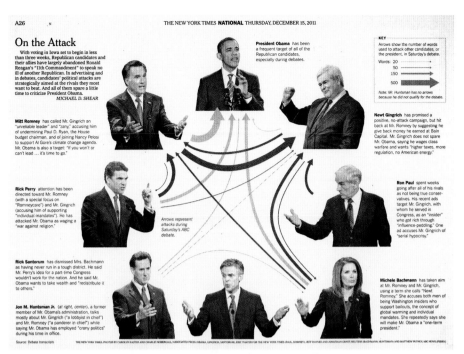

On the Attack

With voting in Iowa set to begin in less than three weeks, Republican candidates and their allies have largely abandoned Ronald Reagan's "11th Commandment" to speak no ill of other Republican. In advertising and in debates, candidates' political attacks are strategically aimed at the rivals they most want to beat. And all of them spare a little time to criticize President Obama.
MICHAEL D. SHEAR

President Obama has been a frequent target of all of the Republican candidates, especially during debates.

KEY
Arrows show the number of words used to attack other candidates, or the president, in Saturday's debate.
Words: 20
50
150
500

Note: Mr. Huntsman has no arrows because he did not qualify for the debate.

Mitt Romney has called Mr. Gingrich an "unreliable leader" and "zany," accusing him of undermining Paul D. Ryan, the House budget chairman, and of joining Nancy Pelosi to support Al Gore's climate change agenda. Mr. Obama is also a target: "If you won't or can't lead ... it's time to go."

Newt Gingrich has promised a positive, no-attack campaign, but hit back at Mr. Romney by suggesting he give back money he earned at Bain Capital. Mr. Gingrich does not spare Mr. Obama, saying he wages class warfare and wants "higher taxes, more regulation, no American energy."

Rick Perry attention has been directed toward Mr. Romney (with a special focus on "Romneycare") and Mr. Gingrich (accusing him of supporting "individual mandates"). He has attacked Mr. Obama as waging a "war against religion."

Ron Paul spent weeks going after all of his rivals as not being true conservatives. His recent ads target Mr. Gingrich, with whom he served in Congress, as an "insider" who got rich through "influence-peddling." One ad accuses Mr. Gingrich of "serial hypocrisy."

Arrows represent attacks during Saturday's ABC debate.

Rick Santorum has dismissed Mrs. Bachmann as having never run in a tough district. He said Mr. Perry's idea for a part-time Congress wouldn't work for the nation. And he said Mr. Obama wants to take wealth and "redistribute it to others."

Jon M. Huntsman Jr. (at right, center), a former member of Mr. Obama's administration, talks mostly about Mr. Gingrich ("a lobbyist in chief") and Mr. Romney ("a panderer in chief") while saying Mr. Obama has employed "crony politics" during his time in office.

Michele Bachmann has taken aim at Mr. Romney and Mr. Gingrich, using a term she calls "Newt Romney." She accuses both men of being Washington insiders who support bailouts, the concept of global warming and individual mandates. She repeatedly says she will make Mr. Obama a "one-term president."

Source: Debate transcripts

THE NEW YORK TIMES
New York, N.Y.
Jonathan Corum, Graphics Editor; **Alicia Parlapiano**, Graphics Editor; **Michael D. Shear**, Reporter
AWARD OF EXCELLENCE
Information Graphics
News/Non-Deadline 175,000 and Over

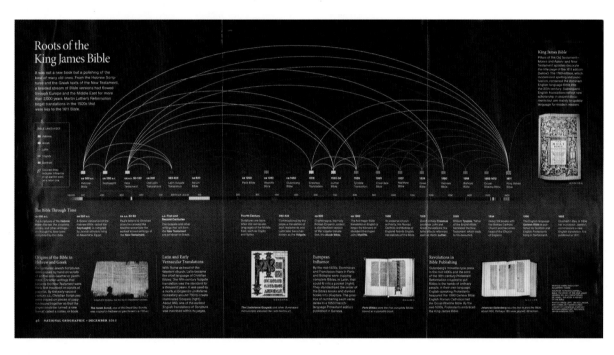

Roots of the King James Bible

It was not a new book but a polishing of the best of many old ones. From the Hebrew Scriptures and the Greek texts of the New Testament, a braided stream of Bible versions had flowed through Europe and the Middle East for more than 2,000 years. Martin Luther's Reformation begat translations in the 1500s that were key to the 1611 Bible.

NATIONAL GEOGRAPHIC MAGAZINE
Washington, D.C.
Amanda Hobbs, Research Editor; **Alejandro Tumas**, Artist
AWARD OF EXCELLENCE
Information Graphics
Features 175,000 and Over

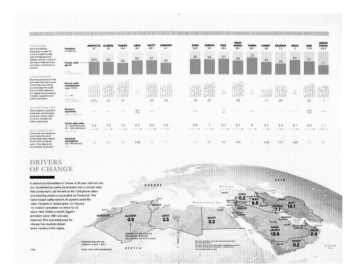

DRIVERS OF CHANGE

NATIONAL GEOGRAPHIC MAGAZINE
Washington, D.C.
William McNulty, Maps Director; **Lawson Parker**, Graphic Editor; **Sean McNaughton**, Senior Graphics Editor; **Juan Velasco**, Art Director; **Kovas Boguta**, Artist
AWARD OF EXCELLENCE
Information Graphics
News/Non-Deadline 175,000 and Over

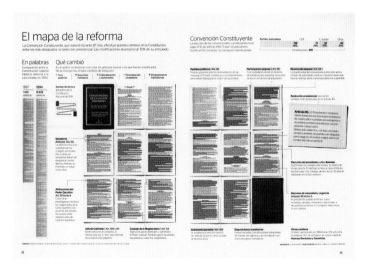

El mapa de la reforma

CLARÍN
Buenos Aires, Argentina
Pablo Loscri, Graphic Editor; **Alejandro Tumas**, Graphic Editor; **Clarisa Mateo**, Artist; **Andrea Carballo**, Researcher; **Romina Ferreyra**, Researcher
AWARD OF EXCELLENCE
Information Graphics
News/Non-Deadline 175,000 and Over

INGRAPHICS
Berlin, Germany
Jan Schwochow, CEO/Creative Director; **Paul Blickle,** Art Director; **Katharina Stipp,** Graphic Editor; **Lukas Engelhardt,** Graphic Editor (Intern)
AWARD OF EXCELLENCE
Information Graphics
News/Non-Deadline 49,999 and Under

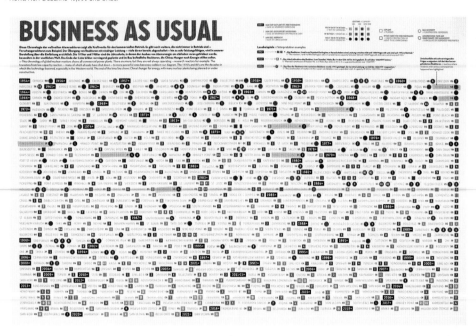

BUSINESS AS USUAL

NATIONAL POST
Toronto, Ont., Canada
Richard Johnson, Graphics Editor; **Anne Marie Owens,** M.E./News; **Michael Higgins,**
Foreign Editor; **Stephen Meurice,** Editor-in-Chief; **Gayle Grin,** M.E./Design & Graphics
AWARD OF EXCELLENCE
Information Graphics
News/Non-Deadline 50,000-174,999

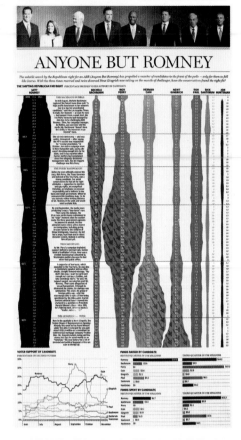

ANYONE BUT ROMNEY

BERLINER MORGENPOST
Berlin, Germany
Martin Steinroeder, Infographic Artist;
Isabell Bischoff, Infographic Artist;
Stefan Frommann, Editor
AWARD OF EXCELLENCE
Information Graphics
News/Non-Deadline 50,000-174,999

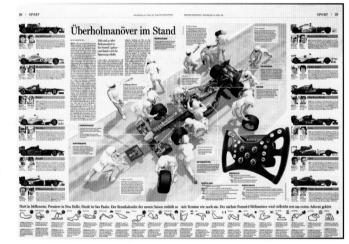

Überholmanöver im Stand

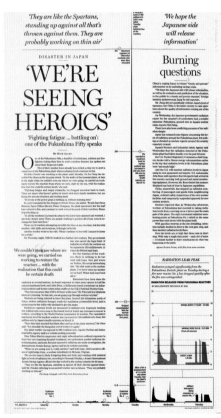

'They are like the Spartans, standing up against all that's thrown against them. They are probably working on thin air'

'We hope the Japanese side will release information'

DISASTER IN JAPAN

'WE'RE SEEING HEROICS'

'Fighting fatigue ... battling on': one of the Fukushima Fifty speaks

Burning questions

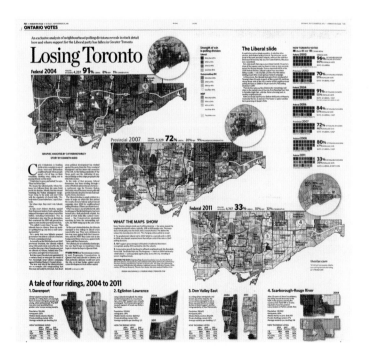

TORONTO STAR
Toronto, Ont., Canada
Catherine Farley, Information Designer;
Kenneth Kidd, Reporter;
Alison Uncles, Sunday Editor
AWARD OF EXCELLENCE
Information Graphics
Features 175,000 and Over

Losing Toronto

NATIONAL POST
Toronto, Ont., Canada
Richard Johnson, Graphics Editor; **Andrew Barr,** Graphic Artist;
Kagan McLeod, Graphic Artist; **Mike Faille,** Graphic Artist; **Jonathon Rivait,** Graphic Artist;
Anne Marie Owens, M.E./News; **Michael Higgins,** Foreign Editor;
Stephen Meurice, Editor-in-Chief; **Gayle Grin,** M.E./Design & Graphics
AWARD OF EXCELLENCE
Information Graphics
News/Non-Deadline 50,000-174,999

CLARÍN
Buenos Aires, Argentina
Pablo Loscri, Graphic Editor; **Alejandro Tumas**, Graphic Editor; **Clarín Staff**
AWARD OF EXCELLENCE
Information Graphics
News/On Deadline 175,000 and Over

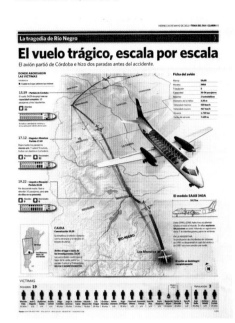

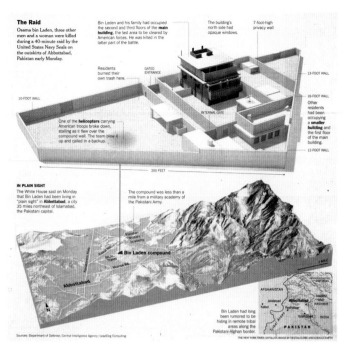

THE NEW YORK TIMES
New York, N.Y.
New York Times Graphics Staff
AWARD OF EXCELLENCE
Information Graphics
News/On Deadline 175,000 and Over

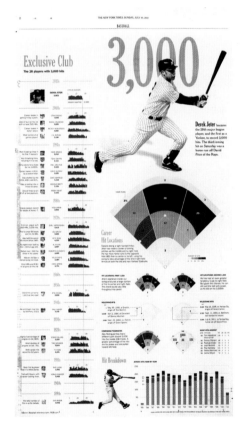

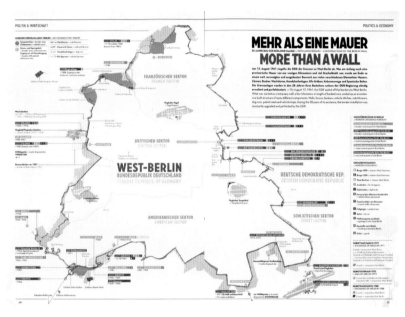

INGRAPHICS
Berlin, Germany
Jan Schwochow, CEO/Creative Director; **Jan Torzinski**, Graphic Editor (Intern)
AWARD OF EXCELLENCE
Information Graphics
News/Non-Deadline 49,999 and Under

THE NEW YORK TIMES
New York, N.Y.
Shan Carter, Graphics Editor; **Joe Ward**, Graphics Editor
AWARD OF EXCELLENCE
Information Graphics
Features 175,000 and Over

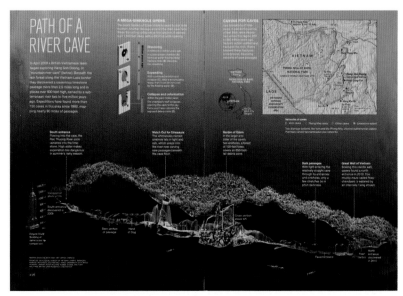

NATIONAL GEOGRAPHIC MAGAZINE
Washington, D.C.
Martin Gamache, Senior Graphics Editor; **Bryan Christie**, Artist
AWARD OF EXCELLENCE
Information Graphics
Features 175,000 and Over

NATIONAL GEOGRAPHIC MAGAZINE
Washington, D.C.
Juan Velasco, Art Director; **Aldo Chiappe**, Artist; **Jane Vessels**, Text Editor; **Shelley Sperry**, Researcher; **Gary Hincks**, Artist
AWARD OF EXCELLENCE
Information Graphics
Features 175,000 and Over

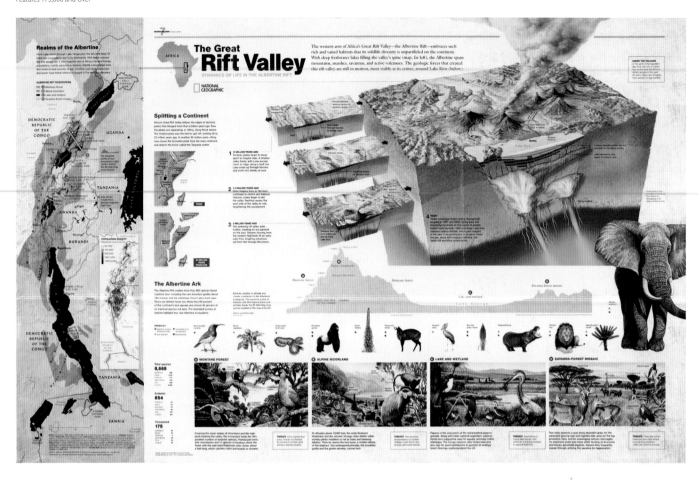

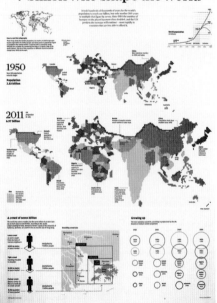

SOUTH CHINA MORNING POST
Hong Kong, China
Simon Scarr, Infographics Director
AWARD OF EXCELLENCE
Information Graphics
Features 50,000-174,999

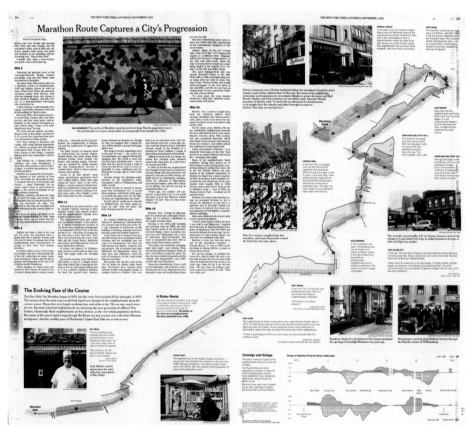

THE NEW YORK TIMES
New York, N.Y.
Alan McLean, Graphics Editor; **Archie Tse**, Graphics Editor; **Lisa Waananen**, Graphics Editor; **Timothy Wallace**, Graphics Editor; **Joe Ward**, Graphics Editor
AWARD OF EXCELLENCE
Information Graphics
Features 175,000 and Over

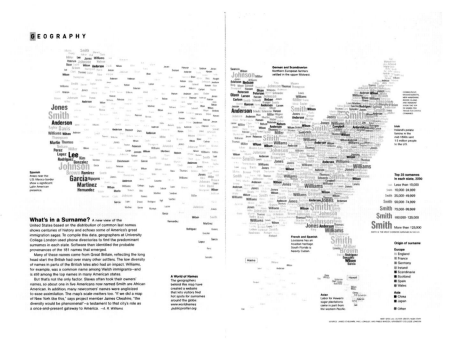

What's in a Surname?

A new view of the United States based on the distribution of common last names shows centuries of history and echoes some of America's great immigration sagas. To compile this data, geographers at University College London used phone directories to find the predominant surnames in each state. Software then identified the probable provenances of the 181 names that emerged.

Many of these names came from Great Britain, reflecting the long head start the British had over many other settlers. The low diversity of names in parts of the British Isles also had an impact. Williams, for example, was a common name among Welsh immigrants—and is still among the top names in many American states.

But that's not the only factor. Slaves often took their owners' names, so about one in five Americans now named Smith are African American. In addition, many newcomers' names were anglicized to ease assimilation. The map's scale matters too. "If we did a map of New York like this," says project member James Cheshire, "the diversity would be phenomenal"—a testament to that city's role as a once-and-present gateway to America. —A. R. Williams

NATIONAL GEOGRAPHIC MAGAZINE
Washington, D.C.
Oliver Uberti, Design Editor; Mina Liu, Intern
AWARD OF EXCELLENCE
Information Graphics
Features 175,000 and Over

AL BAYAN
Dubai, United Arab Emirates
Luis Chumpitaz, Information Graphic Director; Liz Ramos Prado, Information Graphic Editor; German Fernandez, Information Graphic Editor; Karina Aricoche, Information Graphic Researcher; Asma Ali, Translator
AWARD OF EXCELLENCE
Information Graphics
Features 50,000-174,999

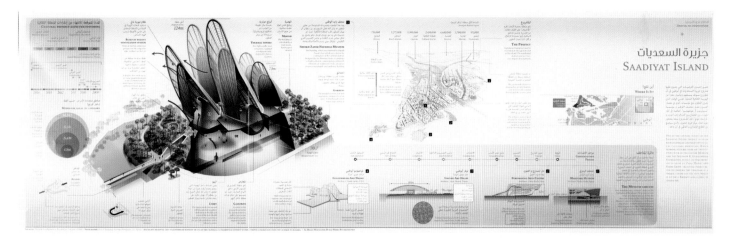

جزيرة السعديات
SAADIYAT ISLAND

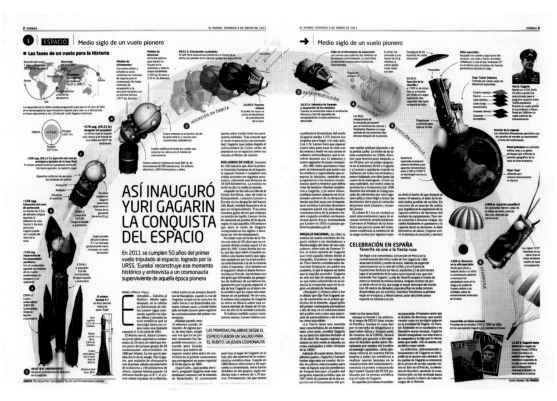

ASÍ INAUGURÓ YURI GAGARIN LA CONQUISTA DEL ESPACIO

En 2011 se cumplen 50 años del primer vuelo tripulado al espacio, logrado por la URSS. 'Eureka' reconstruye ese momento histórico y entrevista a un cosmonauta superviviente de aquella época pionera

EL MUNDO
Madrid, Spain
Emilio Amade, Graphic Editor
AWARD OF EXCELLENCE
Information Graphics
Features 175,000 and Over

AL BAYAN
Dubai, United Arab Emirates
Luis Chumpitaz, Information Graphic Director; **Liz Ramos Prado**, Information Graphic Editor; **German Fernandez**,
Information Graphic Editor; **Karina Aricoche**, Information Graphic Researcher; **Asma Ali**, Translator
AWARD OF EXCELLENCE
Information Graphics
Features 50,000-174,999

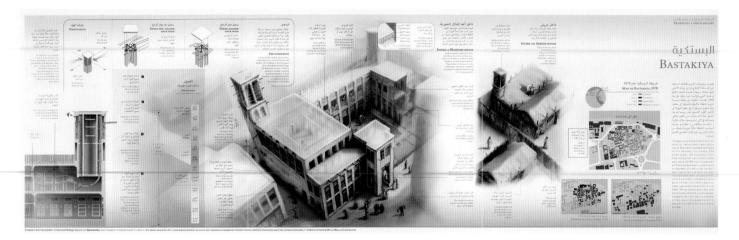

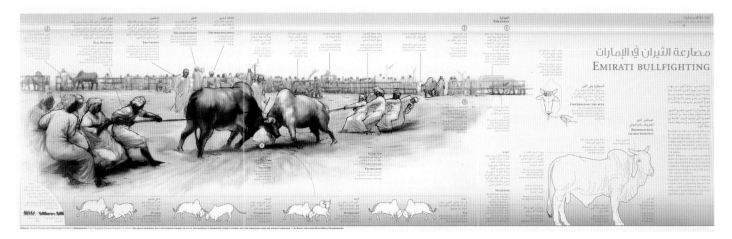

AL BAYAN
Dubai, United Arab Emirates
Luis Chumpitaz, Information Graphic Director; **Liz Ramos Prado**, Information Graphic Editor; **German Fernandez**, Information Graphic Editor; **Karina Aricoche**, Information Graphic Researcher; **Asma Ali**, Translator
AWARD OF EXCELLENCE
Information Graphics
Features 50,000-174,999

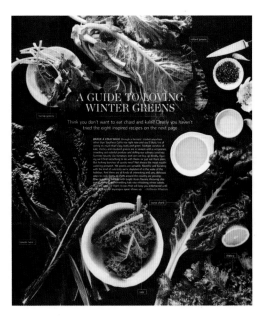

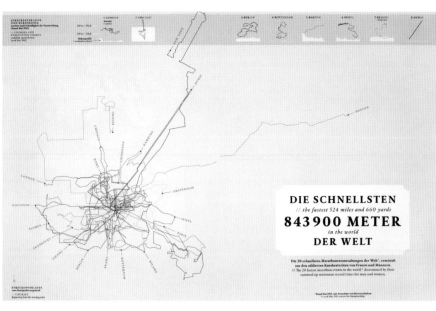

THE (NEW YORK) WALL STREET JOURNAL
New York, N.Y.
David Prince, Photographer; **Brett Kurzweil**, Food Stylist; **Daniel Murphy**,
Photo Editor; **Lucy Gilmour**, Deputy Photo Director; **Jack Van Antwerp**,
Director of Photography; **Bryan Erickson**, Senior Art Director
AWARD OF EXCELLENCE
Photography/Single Photos
Features

INGRAPHICS
Berlin, Germany
Jan Schwochow, CEO/Creative Director; **Katja Günther**, Graphic Editor
AWARD OF EXCELLENCE
Information Graphics
Features 49,999 and Under

THE NEW YORK TIMES
New York, N.Y.
Bill Marsh, Graphics Editor
AWARD OF EXCELLENCE
Information Graphics/Portfolios
Non-Breaking or Feature (Individual) 175,000 and Over

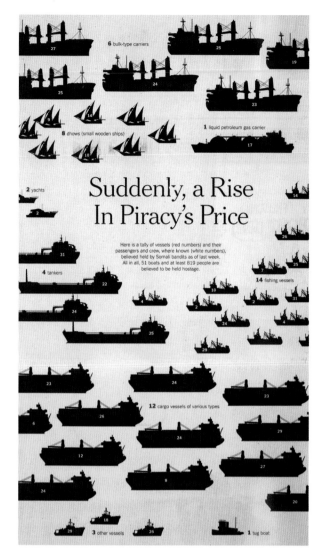

GULF NEWS
Dubai, United Arab Emirates
Dwynn Ronald Trazo, Senior Infographic Artist; **Miguel Angel Gomez**, Design Director;
Mohammed AlMezel, M.E.; **Abdul Hamid Ahmad**, Editor-in-Chief
AWARD OF EXCELLENCE
Information Graphics
News/Non-Deadline 50,000-174,999

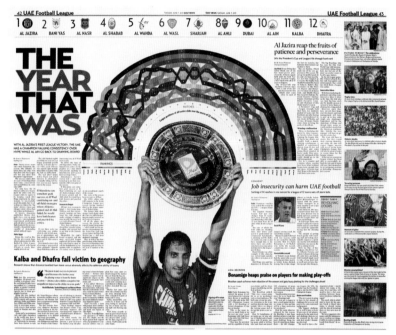

THE BOSTON GLOBE
Boston, Mass.
Josue Evilla, Art Director; **C.J. Burton**, Photographer; **Dan Zedek**, A.M.E./Design
AWARD OF EXCELLENCE
Photography/Single Photos
Features

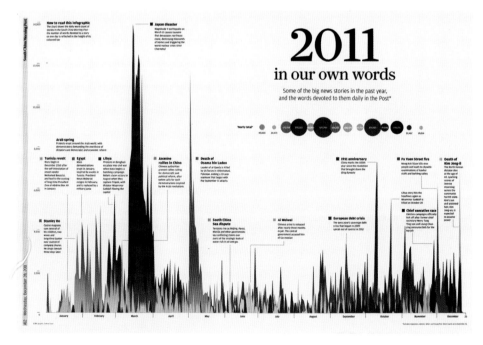

SOUTH CHINA MORNING POST
Hong Kong, China
Simon Scarr, Infographics Director
AWARD OF EXCELLENCE
Information Graphics
Features 50,000-174,999

THE VIRGINIAN-PILOT
Norfolk, Va.
Hyunsoo Leo Kim, Staff Photographer; **Martin Smith-Rodden**, Daily Sections Photo Editor; **Bill Kelley**, Advance Planning Photo Editor; **Randall Greeenwell**, Director of Photography; **Sam Hundley**, Designer
AWARD OF EXCELLENCE
Photography/Multiple Photos
Series/Project or Story

magazine
The Sunday Break

Of life and love
WHAT I LEARNED FROM ERIC MIDDLETON'S LAST DAYS

THE BOSTON GLOBE
Boston, Mass.
Josue Evilla, Art Director; **Sadie Dayton**, Photographer; **Dan Zedek**, A.M.E./Design
AWARD OF EXCELLENCE
Photography/Single Photos
Features

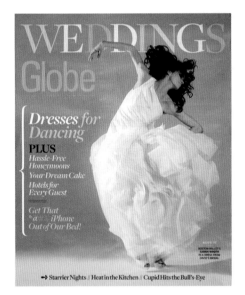

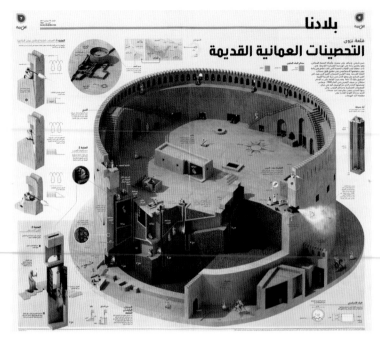

AL SHABIBA
Muscat, Oman
Essa Mohammed Al Zedjali, Chairman; **Ahmed Essa Al Zedjali**, Editor-in-Chief; **Adonis Durado**, Design Director; **Antonio Farach**, Infographics Editor; **Lucille Umali**, Illustrator
AWARD OF EXCELLENCE
Information Graphics
Features 49,999 and Under

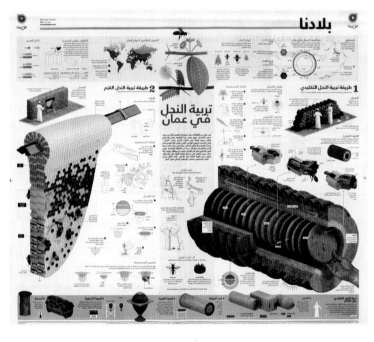

AL SHABIBA
Muscat, Oman
Essa Mohammed Al Zedjali, Chairman; **Ahmed Essa Al Zedjali**, Editor-in-Chief; **Adonis Durado**, Design Director; **Antonio Farach**, Infographics Editor; **Winie Ariany**, Illustrator; **Sreemanikandan Satheendranathan**, Illustrator
AWARD OF EXCELLENCE
Information Graphics
Features 49,999 and Under

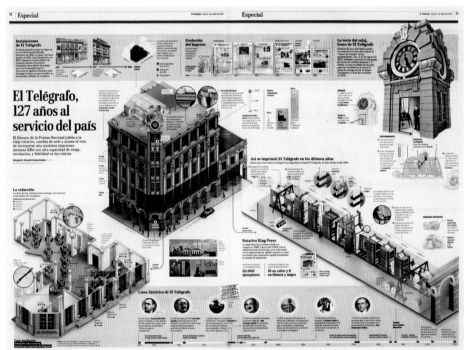

El Telégrafo, 127 años al servicio del país

EL TELÉGRAFO
Guayaquil, Ecuador
Manuel Cabrera Patiño, Infografista
AWARD OF EXCELLENCE
Information Graphics
Features 49,999 and Under

LOS ANGELES TIMES
Los Angeles, Calif.
Rip Georges, Creative Director; **Martin Schoeller**, Photographer; **Hannah Harte**, Photo Editor
AWARD OF EXCELLENCE
Photography/Single Photos
Portrait

THE (NEW YORK) WALL STREET JOURNAL
New York, N.Y.
Shannon Taggart, Photographer; **Rebecca Horne**, Photo Editor; **Lucy Gilmour**, Deputy Photo Director; **Jack Van Antwerp**, Director of Photography; **Kelly Peck**, Art Director; **Keith Webb**, Art Director
AWARD OF EXCELLENCE
Photography/Single Photos
Portrait

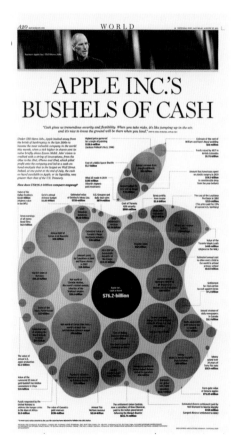

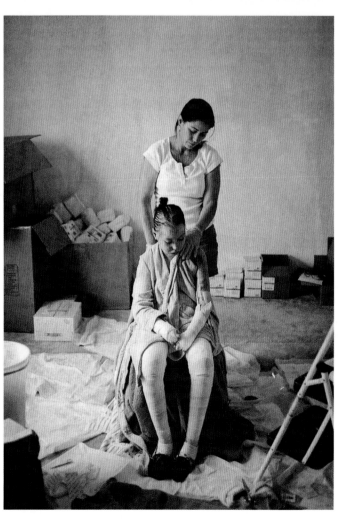

NATIONAL POST
Toronto, Ont., Canada
Richard Johnson, Graphics Editor; **Andrew Barr**, Graphic Artist; **Kagan McLeod**, Graphic Artist; **Mike Faille**, Graphic Artist; **Jonathon Rivait**, Graphic Artist; **Dean Tweed**, Graphic Artist; **Anne Marie Owens**, M.E./News; **Michael Higgins**, Foreign Editor; **Stephen Meurice**, Editor-in-Chief; **Gayle Grin**, M.E./Design & Graphics
AWARD OF EXCELLENCE
Information Graphics/Portfolios
Non-Breaking or Feature (Staff) 50,000-174,999

TAMPA BAY TIMES
St. Petersburg, Fla.
Bryan Thomas, Photographer
AWARD OF EXCELLENCE
Photography/Single Photos
Features

LA (COSTA RICA) NACIÓN
San José, Costa Rica
Manuel Canales, Infographics Editor; **William Sánchez**, Infographic Artist;
Daniel Solano, 3-D Modeler/Infographic Artist; **Michelle Soto**, Investigator;
Alejandra Vargas, Investigator; **Pablo Fonseca**, Investigator; **Andrea Solano**,
Investigator; **Irene Rodríguez**, Investigator
AWARD OF EXCELLENCE
Information Graphics/Portfolios
Planned News/Extended Coverage (Staff) 50,000-174,999

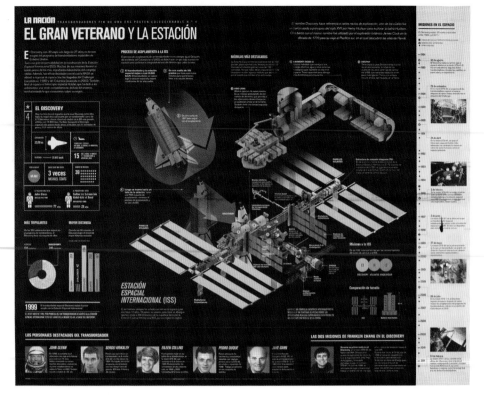

AL BAYAN
Dubai, United Arab Emirates
Luis Chumpitaz, Information Graphic Director;
Liz Ramos Prado, Information Graphic Editor;
German Fernandez, Information Graphic Editor;
Karina Aricoche, Information Graphic Researcher;
Asma Ali, Translator
AWARD OF EXCELLENCE
Information Graphics/Portfolios
Non-Breaking or Feature
(Staff) 50,000-174,999

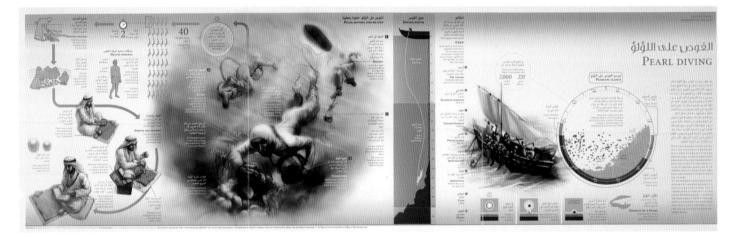

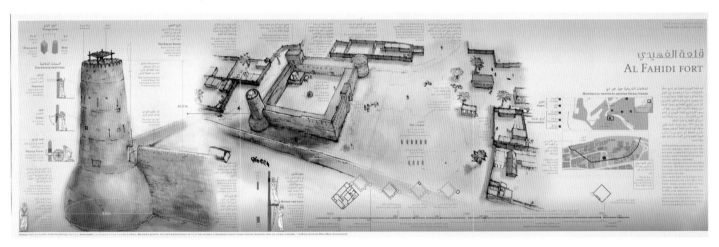

AL BAYAN
Dubai, United Arab Emirates
Luis Chumpitaz, Information Graphic Director; **Liz Ramos Prado**, Information Graphic Editor; **German Fernandez**, Information Graphic Editor; **Karina Aricoche**, Information Graphic Researcher; **Asma Ali**, Translator
AWARD OF EXCELLENCE
Information Graphics/Portfolios
Non-Breaking or Feature (Staff) 50,000-174,999

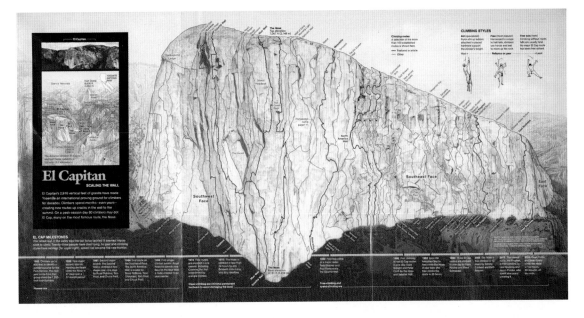

NATIONAL GEOGRAPHIC MAGAZINE
Washington, D.C.
Martin Gamache, Senior Graphics Editor
AWARD OF EXCELLENCE
Information Graphics/Portfolios
Non-Breaking or Feature (Individual) 175,000
and Over

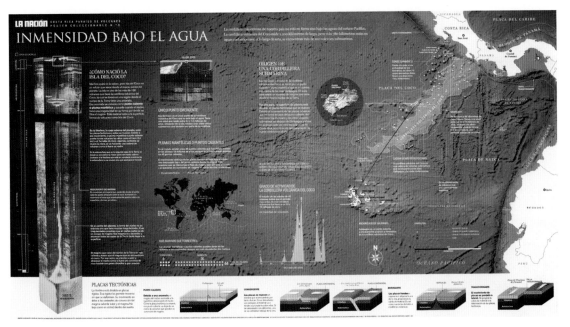

LA (COSTA RICA) NACIÓN
San José, Costa Rica
Manuel Canales, Infographics Editor;
William Sánchez, Infographic Artist;
Ronald Paniagua, 3-D Modeler; **Daniel Solano**,
3-D Modeler; **Michelle Soto**, Investigator;
Alejandra Vargas, Investigator
AWARD OF EXCELLENCE
Information Graphics/Portfolios
Planned News/Extended Coverage (Staff)
50,000-174,999

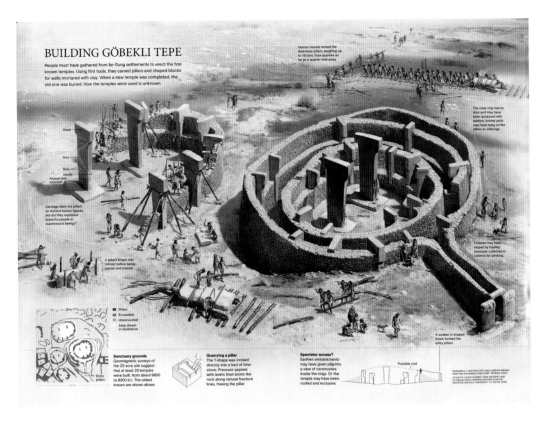

NATIONAL GEOGRAPHIC MAGAZINE
Washington, D.C.
Fernando G. Baptista, Senior Graphics Editor
AWARD OF EXCELLENCE
Information Graphics/Portfolios
Non-Breaking or Feature (Individual) 175,000 and Over

SOUTH CHINA MORNING POST
Hong Kong, China
Simon Scarr, Infographics Director
AWARD OF EXCELLENCE
Information Graphics/Portfolios
Combination (Individual) 50,000-174,999

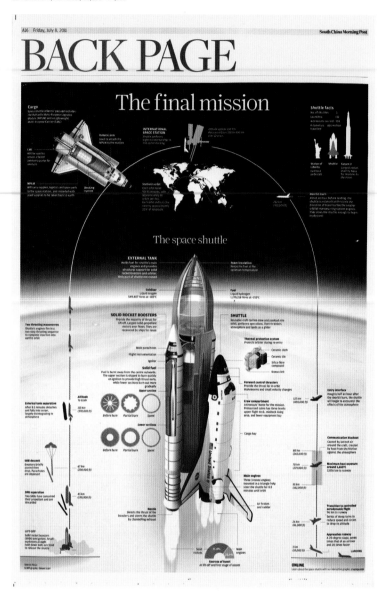

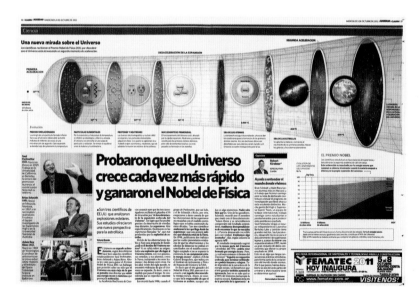

CLARÍN
Buenos Aires, Argentina
Pablo Loscri, Graphic Editor; **Alejandro Tumas**, Graphic Editor; **Clarín Graphics Staff**
AWARD OF EXCELLENCE
Information Graphics/Portfolios
Combination (Staff) 175,000 and Over

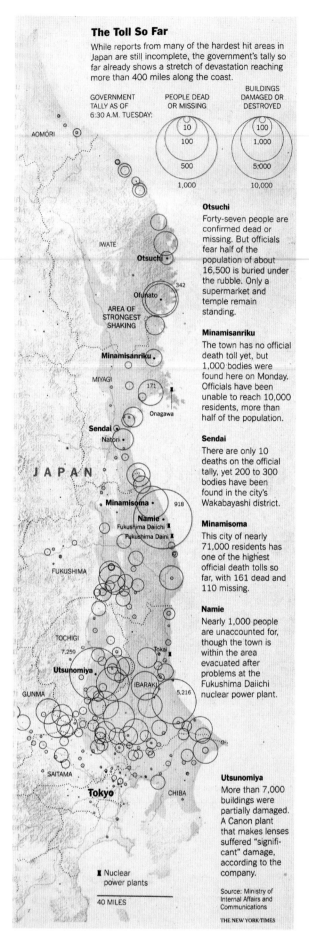

The Toll So Far

While reports from many of the hardest hit areas in Japan are still incomplete, the government's tally so far already shows a stretch of devastation reaching more than 400 miles along the coast.

Otsuchi
Forty-seven people are confirmed dead or missing. But officials fear half of the population of about 16,500 is buried under the rubble. Only a supermarket and temple remain standing.

Minamisanriku
The town has no official death toll yet, but 1,000 bodies were found here on Monday. Officials have been unable to reach 10,000 residents, more than half of the population.

Sendai
There are only 10 deaths on the official tally, yet 200 to 300 bodies have been found in the city's Wakabayashi district.

Minamisoma
This city of nearly 71,000 residents has one of the highest official death tolls so far, with 161 dead and 110 missing.

Namie
Nearly 1,000 people are unaccounted for, though the town is within the area evacuated after problems at the Fukushima Daiichi nuclear power plant.

Utsunomiya
More than 7,000 buildings were partially damaged. A Canon plant that makes lenses suffered "significant" damage, according to the company.

Source: Ministry of Internal Affairs and Communications

THE NEW YORK TIMES

THE NEW YORK TIMES
New York, N.Y.
Joe Burgess, Graphics Editor; **Haeyoun Park**, Graphics Editor; **Sergio Pecanha**, Graphics Editor;
Aya Sakamoto, Graphics Editor; **Archie Tse**, Graphics Editor
AWARD OF EXCELLENCE
Information Graphics/Portfolios
Breaking news/Extended Coverage (Staff) 175,000 and Over

NATIONAL GEOGRAPHIC MAGAZINE
Washington, D.C.
Lawson Parker, Graphics Editor; **Kaitlin Yarnall**, Deputy Creative Director
AWARD OF EXCELLENCE
Information Graphics
Features 175,000 and Over

DIE ZEIT
Hamburg, Germany
Haika Hinze, Art Director; **Ellen Dietrich**, Director/Photography; **Klaus-D Sieling**,
Deputy Art Director; **Sina Giesecke**, Layout Editor; **Katrin Guddat**, Layout Editor;
Philipp Schultz, Layout Editor; **Delia Wilms**, Layout Editor; **Anne Gerdes**, Illustrator
AWARD OF EXCELLENCE
Information Graphics
Features 175,000 and Over

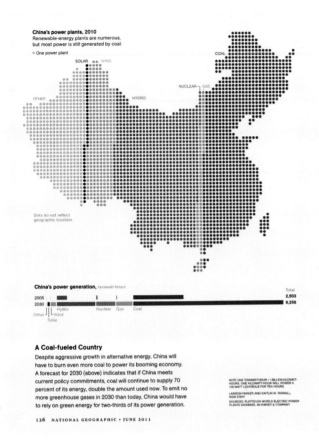

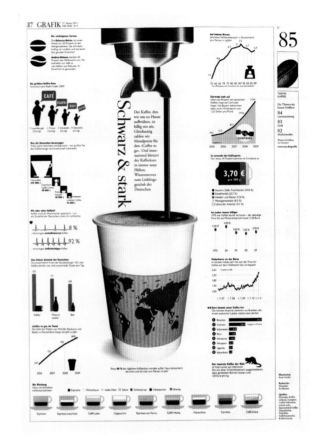

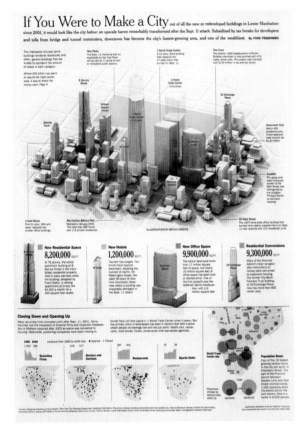

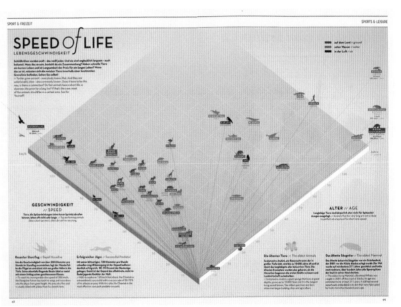

INGRAPHICS
Berlin, Germany
Jan Schwochow, CEO/Creative Director; **Julia Kontor**,
Graphic Editor (Intern); **Philipp Dettmer**, Graphic Editor (Intern)
AWARD OF EXCELLENCE
Information Graphics
Features 49,999 and Under

ORIENTAL MORNING POST
Shanghai, China
Jiafeng Zhao, Art Director; **Yuan Li**, Designer
AWARD OF EXCELLENCE
Illustration
Single Lead Color

LOS ANGELES TIMES
Los Angeles, Calif.
Steve Stroud, Deputy Photo Editor; **Carolyn Cole**, Photographer; **Rick Loomis**, Photographer;
Michael Robinson Chavez, Photographer; **Robert St. John**, Photo Editor; **Colin Crawford**,
D.M.E.; **Kelli Sullivan**, Deputy Design Director; **Michael Whitley**, A.M.E.
AWARD OF EXCELLENCE
Photography/Multiple Photos
Series/Project or Story

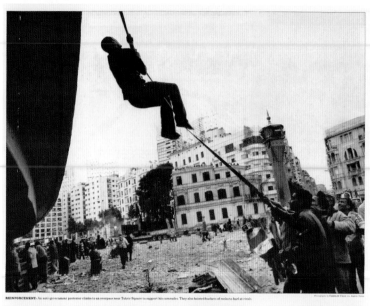

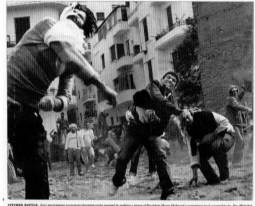

REINFORCEMENT: An anti-government protester climbs to an overpass near Tahrir Square to support his comrades. They also hoisted buckets of rocks to hurl at rivals.

PITCHED BATTLE: Anti-government protesters throwing rocks succeed in pushing a group of President Hosni Mubarak's supporters back several blocks. Pro-Mubarak forces reacted fresly through many Cairo neighborhoods, especially in the business district. Some harassed human rights workers and roughed up foreign journalists.

FIELD HOSPITAL: A man gets treatment at a makeshift clinic set up by protesters. He had been detained as a suspected infiltrator.

UNBEARABLE LOSS: A protester mourns the death of his brother on the front lines. The spot is still marked by bloodstains.

LOS ANGELES TIMES
Los Angeles, Calif.
Rip Georges, Creative Director; **Ruven Afanador**, Photographer; **Kim Pollock**, Producer
AWARD OF EXCELLENCE
Photography/Single Photos
Portrait

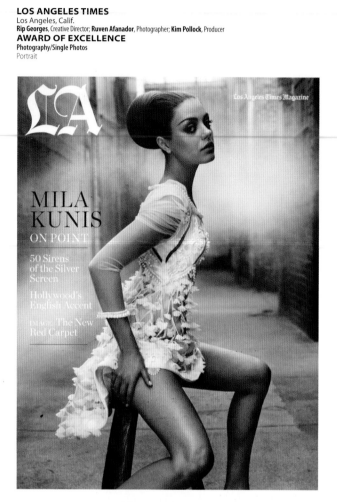

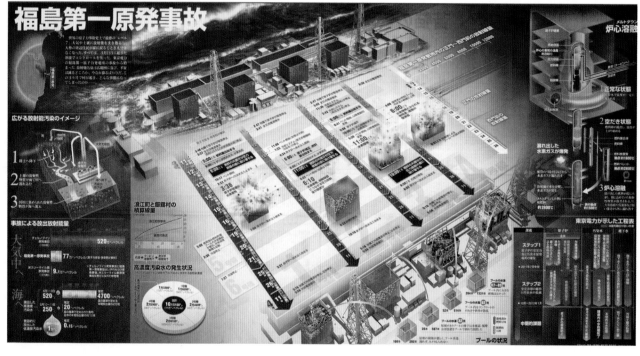

福島第一原発事故

THE ASAHI SHIMBUN
Tokyo, Japan
Guo Yi, Graphic Designer; **Akinori Yonezawa**, Graphic Designer; **Shinya Uemura**, Graphic Designer
AWARD OF EXCELLENCE
Information Graphics
News/Non-Deadline 175,000 and Over

THE NEW YORK TIMES
New York, N.Y.
Karl Russell, Graphics Editor; **Bill Marsh**, Graphics Editor
AWARD OF EXCELLENCE
Information Graphics
Features 175,000 and Over

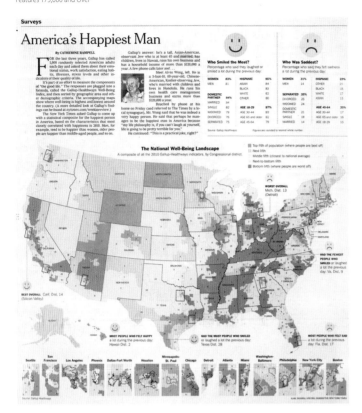

THE NEW YORK TIMES
New York, N.Y.
SHOUT, Illustrator; **Rodrigo Honeywell**, Art Director; **Tom Bodkin**, Design Director
AWARD OF EXCELLENCE
Illustration
Single Lead Color

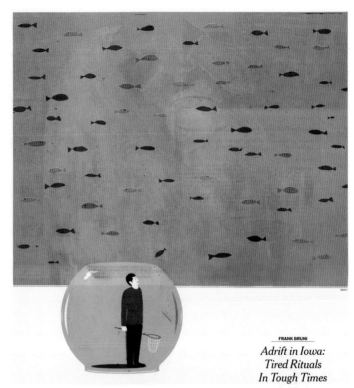

*Adrift in Iowa:
Tired Rituals
In Tough Times*

FRANK BRUNI

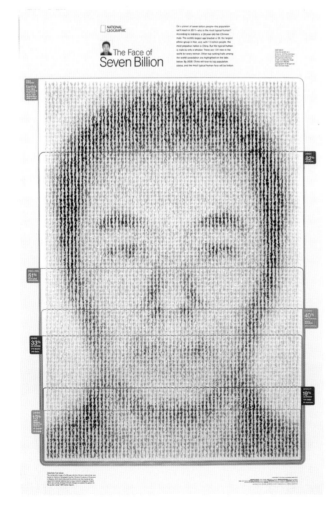

NATIONAL GEOGRAPHIC MAGAZINE
Washington, D.C.
John Tomanio, Senior Graphics Editor; **Bryan Christie**, Artist; **Jane Vessels**, Text Editor;
Kaitlin Yarnall, Deputy Creative Director; **Juan Velasco**, Art Director
AWARD OF EXCELLENCE
Information Graphics
Features 175,000 and Over

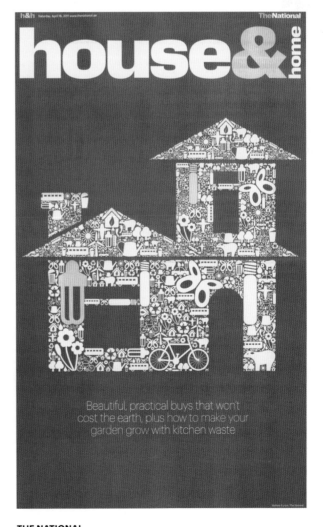

THE NATIONAL
Abu Dhabi, United Arab Emirates
Mathew Kurian, Designer
AWARD OF EXCELLENCE
Illustration
Multiple

UPSALA NYA TIDNING
Uppsala, Finland
Sven-Olof Ahlgren, Photographer; **Staffan Ulfstrand**, Reporter
AWARD OF EXCELLENCE
Photography/Single Photos
Features

THE SPOKESMAN-REVIEW
Spokane, Wash.
Dan Pelle, Photographer
AWARD OF EXCELLENCE
Photography/Single Photos
Features

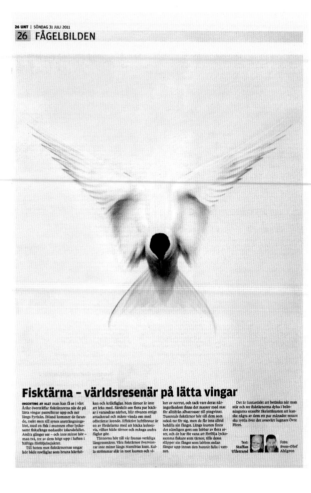

Fisktärna – världsresenär på lätta vingar

INGENTING AV ALLT man kan få se i vårt Årike överträffar fisktärnorna när de på lätta vingar patrullerar upp och ner längs Fyrisån. Ibland kommer de farande, raskt men till synes ansträngningslöst, med en fisk i munnen efter lyckosamt fiskafänge nedanför Islandsfallet. Andra gånger ser – och inte minst hör – man två, tre av dem högt upp i luften i häftiga förföljelsejakter.

Till hoten mot fisktärnornas ungar hör både rovfåglar som bruna kärrhökar och kråkfåglar. Men tärnor är inte att leka med. Särskilt om flera par häckar i varandras närhet, blir rövaren otligt attackerad och måste vända om med oförrättat ärende. Effektivt luftförsvar är en av fördelarna med att häcka koloni-vis, vilket både tärnor och många andra fåglar gör.

Tärnorna hör till vår faunas verkliga långsresenärer. Våra fisktärnor övervintrar inte minst längs Namibias kust. Kalla strömmar slår in mot kusten och vi-

ker av norrut, och tack vare deras näringsrikedom finns det massor med mat för allsköns albatrosser till pingviner. Tusentals fisktärnor hör till dem som också tar för sig, men de får inte alltid behålla sin fångst. Längs kusten finns där nämligen gott om labbar av flera arter, och de har för vana att förfölja lyckosamma fiskare som tärnor, tills dessa slipper sin fångst som labben sedan fångar upp innan den hunnit falla i vattnet.

Det är fantastiskt att betänka när man står och ser fisktärnorna dyka i bräningarna utanför Skelettkusten att kanske några av dem ett par månader senare ska rytta över den avsevärt lugnare Övre Fyret.

Text: **Staffan Ulfstrand** Foto: **Sven-Olof Ahlgren**

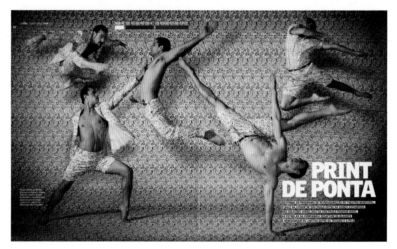

PRINT DE PONTA

SERAFINA
São Paulo, Brazil
Teté Ribeiro, Editor-in-Chief; **Luciano Schmitz**, Art Director; **Iara Crepaldi**, Photography Editor; **Adriana Komura**, Designer; **Vivan Whiteman**, Journalist; **Rogério Cavalcanti**, Photographer; **Marcos Costa**, Beauty Artist; **Junior Guarnieri**, Scenography; **Simone Pokropp**, Stylist
AWARD OF EXCELLENCE
Photography/Single Photos
Features

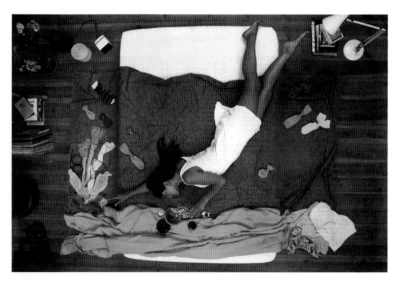

DIE ZEIT
Hamburg, Germany
Haika Hinze, Art Director; **Ellen Dietrich**, Director/Photography; **Klaus-D. Sieling**, Deputy Art Director; **Sina Giesecke**, Layout Editor; **Katrin Guddat**, Layout Editor; **Philipp Schultz**, Layout Editor; **Delia Wilms**, Layout Editor; **Jan von Holleben**, Photographer
AWARD OF EXCELLENCE
Photography/Single Photos
Features

SPECIAL COVERAGE

cobertura especial

THE VIRGINIAN-PILOT
Norfolk, Va.
Sam Hundley, Designer; **Steve Earley**, Photographer
AWARD OF EXCELLENCE
Special Coverage/Single Subject
News

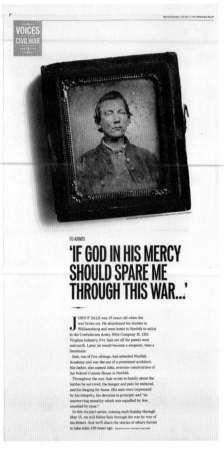

VOICES CIVIL WAR

TO ARMS!

'IF GOD IN HIS MERCY SHOULD SPARE ME THROUGH THIS WAR...'

JOHN F. SALE was 19 years old when the war broke out. He abandoned his studies in Williamsburg and went home to Norfolk to enlist in the Confederate Army. With Company H, 12th Virginia Infantry, Pvt. Sale set off for points west and north. Later, he would become a sergeant, then a lieutenant.

Sale, one of five siblings, had attended Norfolk Academy and was the son of a prominent architect. His father, also named John, oversaw construction of the federal Custom House in Norfolk.

Throughout the war, Sale wrote to family about the battles he survived, the hunger and pain he endured, and his longing for home. His men were impressed by his integrity, his devotion to principle and "an unswerving morality which was equalled by few, excelled by none."

In this six-part series, coming each Sunday through May 15, we will follow Sale through the war by way of his letters. And we'll share the stories of others forced to take sides 150 years ago.

THE ARIZONA REPUBLIC
Phoenix, Ariz.
Arizona Republic Staff
AWARD OF EXCELLENCE
Special Coverage/Single Subject
News

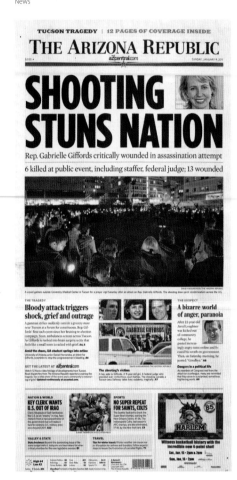

TUCSON TRAGEDY | 12 PAGES OF COVERAGE INSIDE

THE ARIZONA REPUBLIC
azcentral.com

SUNDAY, JANUARY 9, 2011

SHOOTING STUNS NATION

Rep. Gabrielle Giffords critically wounded in assassination attempt
6 killed at public event, including staffer, federal judge; 13 wounded

THE TRAGEDY
Bloody attack triggers shock, grief and outrage

THE SUSPECT
A bizarre world of anger, paranoia

GET THE LATEST AT azcentral.com

NATION & WORLD
KEY CLERK WANTS U.S. OUT OF IRAQ

SPORTS
NO SUPER REPEAT FOR SAINTS, COLTS

VALLEY & STATE

TRAVEL

THE PLAIN DEALER
Cleveland, Ohio
Emmet Smith, Deputy Design Director/News; **Plain Dealer Photography Staff**; **Bill Gugliotta**, Director of Photography; **Dale Omori**, Deputy Director of Photography; **Wendy McManamon**, Copy Editor; **Ellen Stein Burbach**, Series Editor; **Michael Tribble**, Design & Graphics Director; **David Kordalski**, A.M.E./Visuals; **Thom Fladung**, M.E.; **Debra Adams Simmons**, Editor
AWARD OF EXCELLENCE
Special Coverage/Single Subject
News

FRIDAY, NOVEMBER 18, 2011
TALES FROM THE HEART
Inside the Cleveland Clinic heart center

The test of time

BRIE ZELTNER, AMANDA GARRETT and DIANE SUCHETKA | Plain Dealer Reporters

One exercise physiologist wraps a blood pressure cuff around Gus George's right arm. Another one pinches Gus' nose closed with a plastic clip and helps him put in a mouthpiece that will measure how well his heart and lung function while he's on the treadmill. ¶ "You're going to hear four beeps, and then the treadmill's going to start," the exercise physiologist, or EP, tells 18-year-old Gus. "Go ahead and step on." ¶ In 2009, Gus' 19-year-old brother, Samuel, died on a basketball court of the same heart malady Gus has, hypertrophic cardiomyopathy, or HCM. Life hasn't been the same since, says his father. ¶ Austin George sits in the waiting room outside the testing area, too worried to watch. He fears what happened to his older son could happen to Gus. ¶ Gus isn't as concerned. His Cleveland Clinic cardiologist, Dr. Milind Desai, hovers nearby. HCM is his specialty at the Miller Family Heart & Vascular Institute. ¶ Gus starts walking slowly. ¶ Desai looks over the shoulders of the EPs. "No blood pressure drop, right?" he asks.

[PART SIX OF EIGHT]

CONTINUED ON THE FOLLOWING PAGE

THE PLAIN DEALER

ORIENTAL MORNING POST
Shanghai, China
Minqi Yang, Director; **Yanli Tang**, Designer; **Yong Jiang**, Designer
AWARD OF EXCELLENCE
Special Coverage/Single Section
News/No Ads

The Washington Post

9 11 11
A SPECIAL REPORT SECTION AA

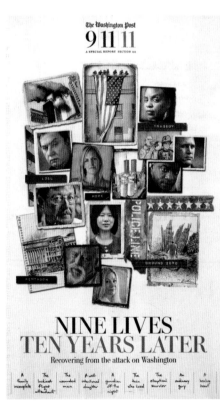

NINE LIVES
TEN YEARS LATER
Recovering from the attack on Washington

THE WASHINGTON POST
Washington, D.C.
Janet Michaud, Design Director; **Tim Ball**, Designer; **Jon Wile**, Senior News Designer; **Greg Manifold**, Deputy Design Director/News; **Bonnie Jo Mount**, Photographer; **Michel du Cille**, A.M.E./Photo; **David Griffin**, Visuals Editor; **Marilyn Thompson**, Editor
AWARD OF EXCELLENCE
Special Coverage/Single Section
News/With Ads

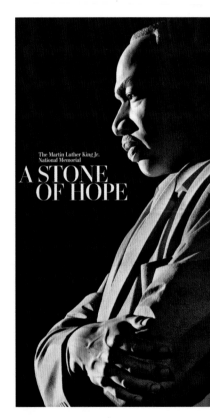

The Martin Luther King Jr.
National Memorial

A STONE OF HOPE

THE WASHINGTON POST
Washington, D.C.
Christopher Meighan, Deputy Design Director/Features; **Nikki Kahn**, Photographer; **Anne Farrar**, Photo Editor; **Michel du Cille**, Director of Photography; **Diamond James**, Designer; **Janet Michaud**, Design Director
AWARD OF EXCELLENCE
Special Coverage/Sections
News/Cover Only

THE DENVER POST
Denver, Colo.
J. Damon Cain, M.E./Presentation & Design
AWARD OF EXCELLENCE
Special Coverage/Section Pages
News/Inside Page or Spread

BEIJING TIMES
Beijing, China
Li Na Liu, Art Inspector-General; **Jia Ning Yang**, Art Editor/Director;
Xiao Yan Liu, Art Editor/Director
AWARD OF EXCELLENCE
Special Coverage/Single Section
News/With Ads

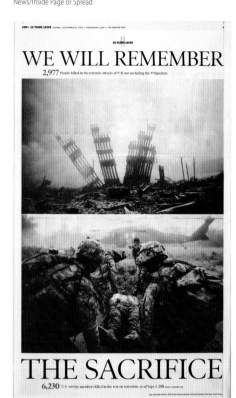

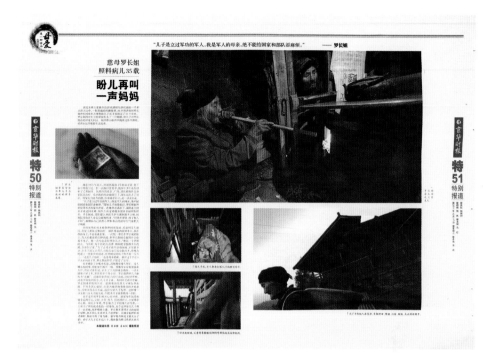

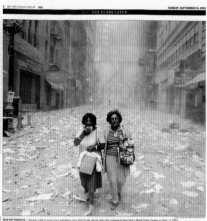

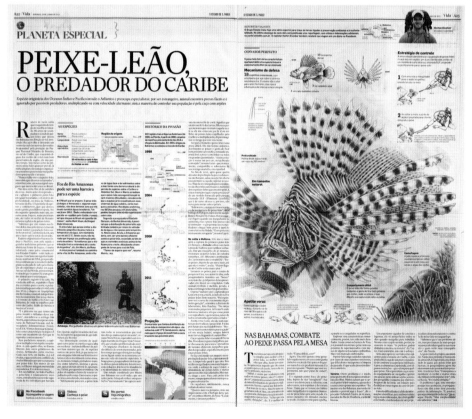

SAN JOSE MERCURY NEWS
San Jose, Calif.
Tiffany Grandstaff, Design Director; **Alex K. Fong**, Deputy Design Director; **Jami Smith**,
Picture Editor; **Ron Kitagawa**, M.E./Production; **Margaret Bethel**, Copy Chief;
Tim O'Rourke, Copy Chief; **John Swartley**, Copy Editor; **Dai Sugano**,
Senior Multimedia Editor/Photographer
AWARD OF EXCELLENCE
Special Coverage/Single Section
News/No Ads

O ESTADO DE S. PAULO
São Paulo, Brazil
Fabio Sales, Art Director; **Regina Silva**, Infographics Director; **Rubens Paiva**, Infographic Assistant Editor; **William Mariotto**,
Infographic Assistant Editor; **Glauco Lara**, Infographic Assistant Editor; **Eduardo Asta**, Infographic Assistant Editor; **Edmilson Silva**,
Infographic Designer; **Filipe Campoi**, Infographic Designer; **Rodrigo Fortes**, Infographic Designer; **Leandro Sanches**, Illustrator
AWARD OF EXCELLENCE
Special Coverage/Single Subject
News

THE BUFFALO NEWS
Buffalo, N.Y.
Terry Lew, Assistant Design Editor; **Vincent Chiaramonte**, Design Director;
Mark Mulville, Photographer
AWARD OF EXCELLENCE
Special Coverage/Single Subject
Sports

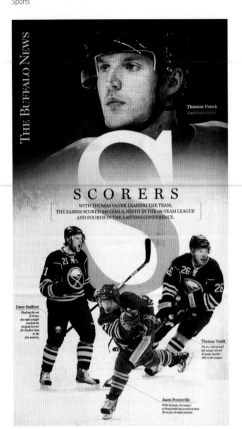

BEIJING NEWS AGENCY
Beijing, China
Yu Jia, Designer/Illustrator; **Wang Xuan**, Designer
AWARD OF EXCELLENCE
Special Coverage/Single Subject
Features

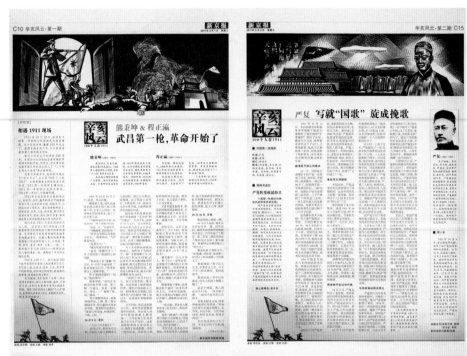

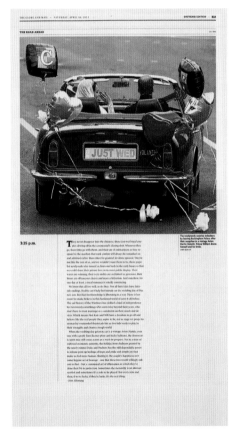

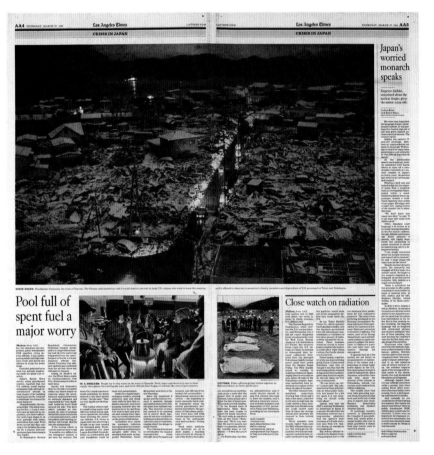

THE GLOBE AND MAIL
Toronto, Ont., Canada
Adrian Norris, M.E./Design; **Devin Slater**, Assistant Art Director;
Tonia Cowan, Graphics Editor; **Dennis Owen**, Photo Editor;
Roger Hallett, Assistant Photo Editor
AWARD OF EXCELLENCE
Special Coverage/Single Section
News/With Ads

LOS ANGELES TIMES
Los Angeles, Calif.
Kelli Sullivan, Deputy Design Director; **Michael Whitley**, A.M.E.; **Dan Santos**, Designer;
Mark Yemma, Designer; **Gerard Babb**, Designer; **Lorraine Wang**, Designer;
Rick Collins, Designer; **Steve Stroud**, Photo Editor; **Robert St. John**, Photo Editor;
Mary Vignoles, Photo Editor
AWARD OF EXCELLENCE
Special Coverage/Single Subject
News

ORLANDO SENTINEL
Orlando, Fla.
Bonita Burton, Visuals Editor; **Todd Stewart**, Design & Graphics Editor; **Wes Meltzer**, Information Design Editor; **Tom Burton**, Photo Editor; **Red Huber**, Photographer

AWARD OF EXCELLENCE
Special Coverage/Section Pages
News/Inside Page or Spread

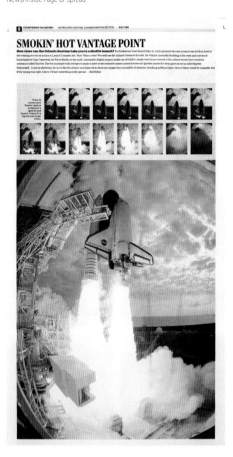

LA PRESSE
Montréal, Qué., Canada
Rachel Hotte, Designer/Illustrator; **Jacques-Olivier Bras**, Designer; **Marc Séguin**, Illustrator; **Martin Tremblay**, Photo Director; **France Dupont**, Deputy Art Director; **Hélène de Guise**, A.M.E./Art Director; **Marco Campanozzi**, Photographer; **André Pichette**, Photographer; **François Roy**, Photographer; **Presse Photography Staff**

AWARD OF EXCELLENCE
Special Coverage/Single Section
News/No Ads

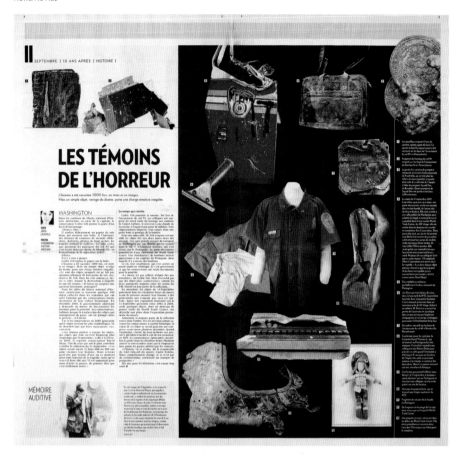

THE DALLAS MORNING NEWS
Dallas, Texas
Michael Hogue, Graphic Artist

AWARD OF EXCELLENCE
Miscellaneous

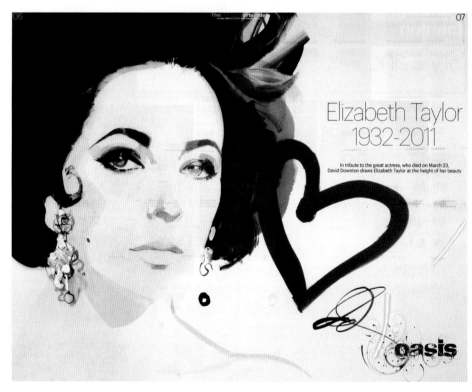

THE NATIONAL
Abu Dhabi, United Arab Emirates
Laura Koot, Art Director; **Gemma Champ**, Features Writer; **Sara Baumberger**, Designer; **David Downton**, Illustrator

AWARD OF EXCELLENCE
Special Coverage/Single Subject
Features

AL BAYAN
Dubai, United Arab Emirates
Luis Chumpitaz, Information Graphic Director; **Liz Ramos Prado**, Information Graphic Editor; **German Fernandez**, Information Graphic Editor;
Karina Aricoche, Information Graphic Researcher; **Asma Ali**, Translator
AWARD OF EXCELLENCE
Special Coverage/Single Section
Sports/No Ads

HOSPODÁŘSKÉ NOVINY
Prague, Czech Republic
Petr Vabata, Editor-in-Chief; **Lucie Tvarulková**, Deputy Editor; **Jan Vyhnánek**, Art Director;
Ctirad Vappel, Sub-Editor; **Ldenek Mihalco**, Sub-Editor
AWARD OF EXCELLENCE
Special Coverage/Multiple Sections
News/With Ads

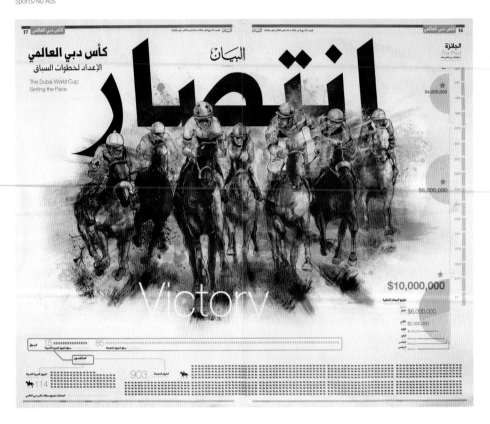

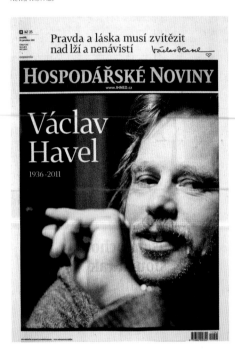

NEWSDAY
Melville, N.Y.
Newsday Staff
AWARD OF EXCELLENCE
Special Coverage/Single Section
News/No Ads

THE PLAIN DEALER
Cleveland, Ohio
Emmet Smith, Deputy Design Director/News; **Plain Dealer Photography Staff;**
Bill Gugliotta, Director of Photography; **Dale Omori**, Deputy Director of Photography;
Wendy McManamon, Copy Editor; **Ellen Stein Burbach**, Series Editor; **Michael Tribble**,
Design & Graphics Director; **David Kordalski**, A.M.E./Visuals; **Thom Fladung**, M.E.;
Debra Adams Simmons, Editor
AWARD OF EXCELLENCE
Special Coverage/Multiple Sections
News/No Ads

THE SEATTLE TIMES
Seattle, Wash.
Rich Boudet, Designer; **Don Shelton**, Sports Editor; **Bill Reader**, Section Editor;
Jon Fisch, Assistant Sports Editor/Presentation
AWARD OF EXCELLENCE
Special Coverage/Section Pages
Sports/Cover Only

THE WASHINGTON POST
Washington, D.C.
Tim Ball, Designer/Art Director; **Desmond Bieler**, Designer; **Brian Gross**, Senior Art Director/Sports; **Leonard Bernstein**,
Assistant Sports Editor; **Greg Manifold**, Deputy Design Director/News; **Janet Michaud**, Design Director
AWARD OF EXCELLENCE
Special Coverage/Single Section
Sports/With Ads

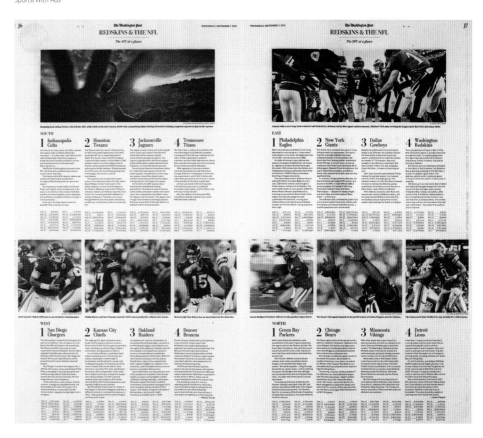

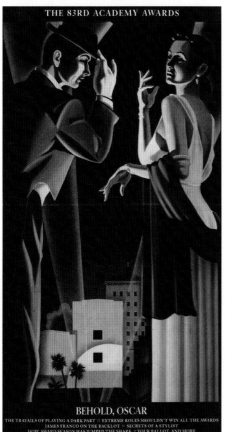

LOS ANGELES TIMES
Los Angeles, Calif.
Paul Gonzales, Deputy Design Director; **Michael Whitley**, A.M.E.; **Kenton Nelson**, Illustrator
AWARD OF EXCELLENCE
Special Coverage/Section Pages
Features/Cover Only

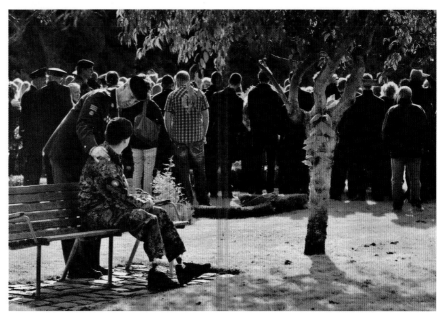

POLITIKEN
Copenhagen, Denmark
Politiken Design Staff
AWARD OF EXCELLENCE
Special Coverage/Single Section
News/No Ads

POLITIKEN
Copenhagen, Denmark
Søren Nyeland, Design Editor; **Henriette Lind**, Editor; **Liv Ajse Olsen**, Page Designer;
Tomas Borberg, Photo Editor; **Annelise Fibæk**, Photoresearcher; **Rune Pedersen**, Photoshopper
AWARD OF EXCELLENCE
Special Coverage/Single Section
Features/With Ads

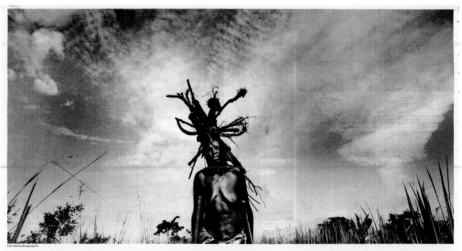

" Her går jeg. Jeg bærer brænde hjem, men det ser ud, som om brændet på mit hoved er en slags vinger, så jeg kan flyve i himlen

Hun hedder **Filda Adoch**. Bor i Uganda. Først mistede hun sin mand. Så sin søn. Så sin anden mand. Og så sit ene ben. Hun er 53 år og er smittet med hiv. Men det er ikke historien om Filda. Fotografen **Martina Bacigalupo** boede sammen med hende i en måned. Hver dag viste hun Filda de billeder, hun havde taget af hende - og bad hende fortælle, hvad hun så. **Og Filda fortalte. En helt anden historie**: Om at være stærk. Smuk. Få lys fra stjernerne. Være tæt på sin datter. Og kunne klare alt. ▶▶▶

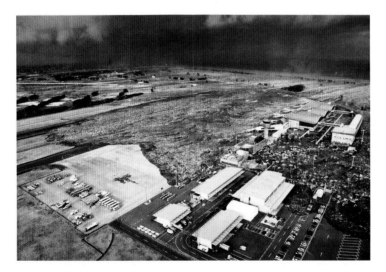

DE VOLKSKRANT
Amsterdam, The Netherlands
Philippe Remarque, Editor-in-Chief; **Rigtje Hehenkamp**, Art Director; **Frank Schallmaier**, Photo Editor
AWARD OF EXCELLENCE
Special Coverage/Single Section
Features/With Ads

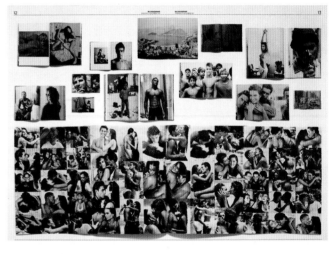

DE VOLKSKRANT
Amsterdam, The Netherlands
Philippe Remarque, Editor-in-Chief; **Sandra Zuijderduin**, Designer; **Gerrit-Jan van Ek**, Photo Editor;
Frank Schallmaier, Photo Editor; **Hans Worrel**, Image Editor
AWARD OF EXCELLENCE
Special Coverage/Single Section
Features/With Ads

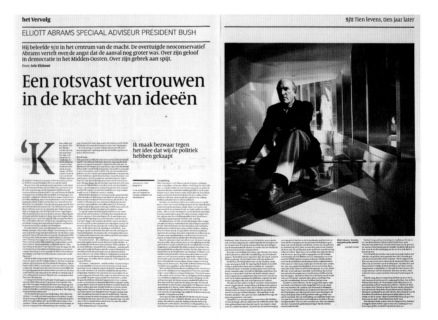

DE VOLKSKRANT
Amsterdam, The Netherlands
Philippe Remarque, Editor-in-Chief; **Rigtje Hehenkamp**, Art Director;
Paul Brill, Compiler; **Frank Schallmaier**, Photo Editor
AWARD OF EXCELLENCE
Special Coverage/Single Section
Features/No Ads

JORNAL DE SANTA CATARINA
Blumenau, Sta. Catarina, Brazil
Maiara Santos, Designer; **Cleisi Soares**, Editor; **Rafaela Martins**, Photojournalist; **Daiane Santos**, Journalist
AWARD OF EXCELLENCE
Special Coverage/Multiple Sections
Features/No Ads

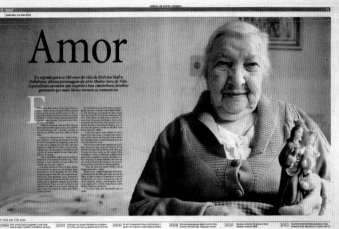

VITA.MN
Minneapolis, Minn.
Leslie Plesser, Art Director; **London Nelson**, Designer; **Marci Schmitt**, Designer
AWARD OF EXCELLENCE
Miscellaneous

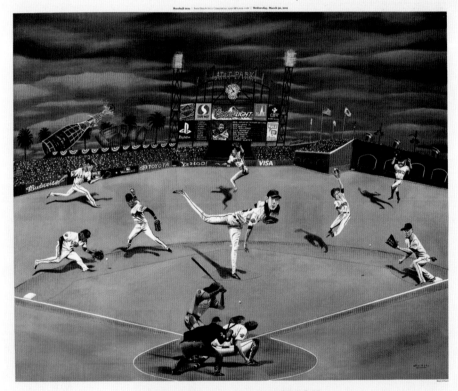

THE ART OF A CHAMPION

SAN FRANCISCO CHRONICLE
San Francisco, Calif.
Frank Mina, A.M.E./Presentation; **Matt Petty**, Art Director; **Mark Ulriksen**, Illustrator
AWARD OF EXCELLENCE
Special Coverage/Section Pages
Sports/Inside Page or Spread

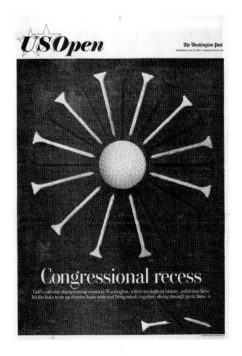

THE WASHINGTON POST
Washington, D.C.
Tim Ball, Art Director; **Heads of State**, Illustration; **Brian Gross**, Senior Art Director/Sports; **Greg Manifold**,
Deputy Design Director/News; **Lindsay Applebaum**, Assistant Sports Editor; **Janet Michaud**, Design Director
AWARD OF EXCELLENCE
Special Coverage/Section Pages
Sports/Cover Only

NATIONAL POST
Toronto, Ont., Canada
Steve Murray, Illustrator; **Geneviève Biloski**, Features Design Editor; **Becky Guthrie**, Associate Features Design Editor; **Benjamin Errett**, M.E./Features; **Barry Hertz**, Arts & Life Editor; **Stephen Meurice**, Editor-in-Chief; **Gayle Grin**, M.E./Design & Graphics
AWARD OF EXCELLENCE
Miscellaneous

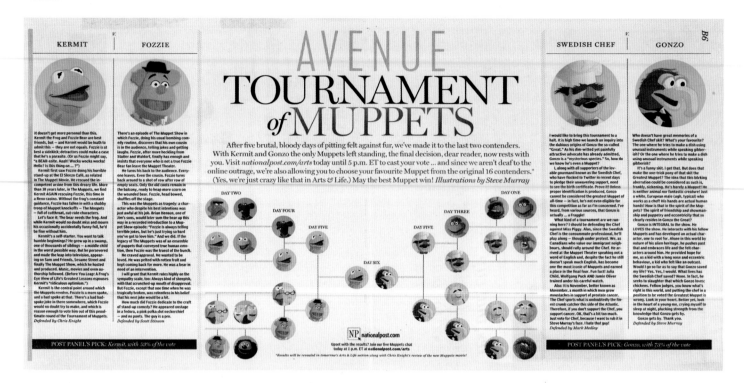

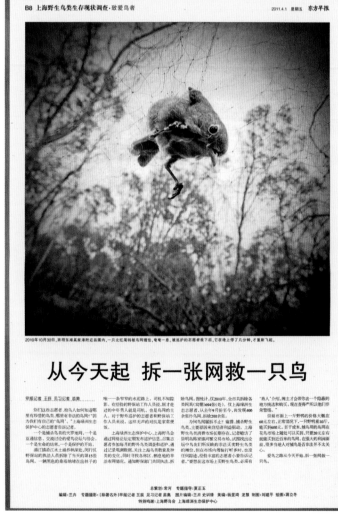

ORIENTAL MORNING POST
Shanghai, China
Minqi Yang, Director; **Hui Long**, Designer
AWARD OF EXCELLENCE
Special Coverage/Multiple Sections
News/With Ads

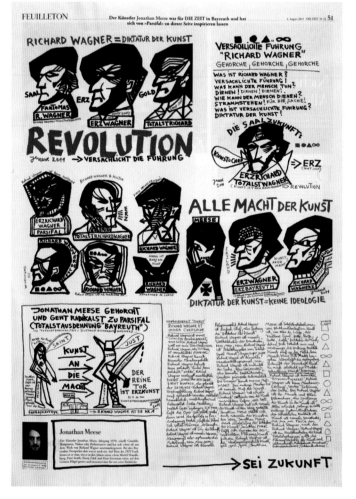

DIE ZEIT
Hamburg, Germany
Hinze Haika, Art Director; **Ellen Dietrich**, Director/Photography; **Klaus-D. Sieling**, Deputy Art Director; **Mirko Bosse**, Layout Editor; **Martin Burgdorff**, Layout Editor; **Mechthild Fortmann**, Layout Editor; **Jonathan Meese**, Artist
AWARD OF EXCELLENCE
Miscellaneous

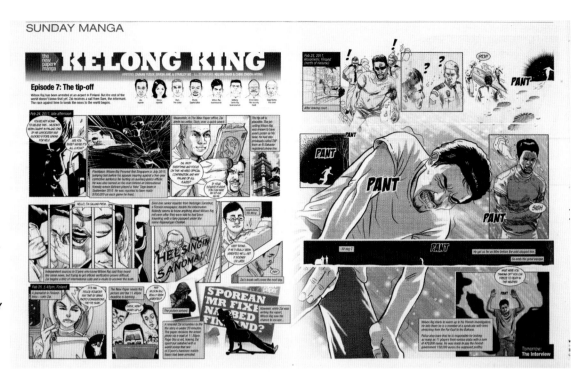

THE NEW PAPER ON SUNDAY
Singapore
Zaihan Yusof, Correspondent; **Simon Ang**,
Executive Artist; **Kelvin Chan**, Executive Artist;
Choon Hiong Chang, Artist; **Stanley Ho**,
Executive Sub-Editor
AWARD OF EXCELLENCE
Miscellaneous

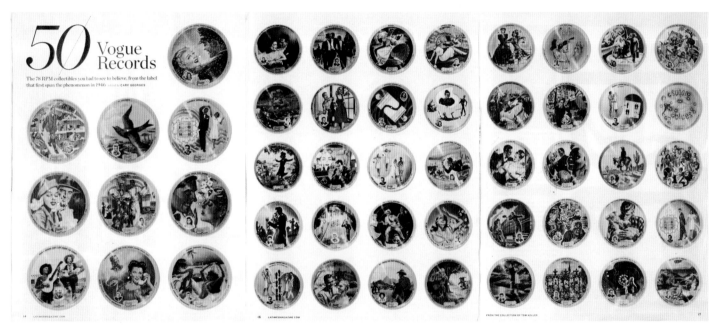

LOS ANGELES TIMES
Los Angeles, Calif.
Cary Georges, Art Director/Designer
AWARD OF EXCELLENCE
Miscellaneous

THE BUFFALO NEWS
Buffalo, N.Y.
Terry Lew, Assistant Design Editor; **Vincent Chiaramonte**, Design Director; **Lisa Wilson**, Executive Sports Editor
AWARD OF EXCELLENCE
Miscellaneous

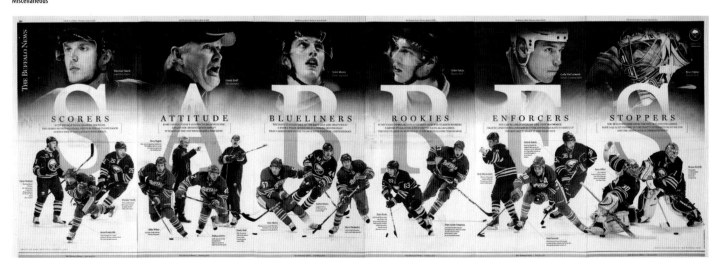

THE BUFFALO NEWS
Buffalo, N.Y.
Vincent Chiaramonte, Design Director; **Lisa Wilson**, Executive Sports Editor
AWARD OF EXCELLENCE
Special Coverage/Section Pages
Sports/Cover Only

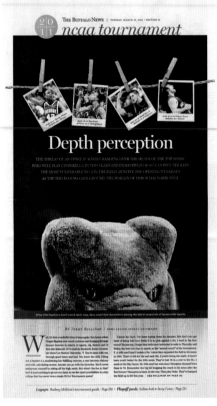

TAMPA BAY TIMES
St. Petersburg, Fla.
Terry Chapman, Designer; **John Pendygraft**, Photographer; **Bruce Moyer**, Photo Editor
AWARD OF EXCELLENCE
Special Coverage/Single Section
Features/No Ads

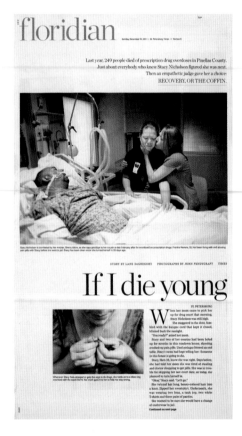

LOS ANGELES TIMES
Los Angeles, Calif.
Kelli Sullivan, Deputy Design Director; **Michael Whitley**, A.M.E.;
Mark Boster, Photographer; **Kathy Pyon**, Photo Editor;
Alan Hagman, Photo Editor; **Calvin Hom**, Deputy Photo Editor
AWARD OF EXCELLENCE
Miscellaneous

KRISTIANSTADSBLADET
Kristianstad, Sweden
Rickard Frank, Designer/Consultant; **Maria Nilson**, Design Editor
AWARD OF EXCELLENCE
Special Coverage/Multiple Sections
News/With Ads

NATIONAL POST
Toronto, Ont., Canada
Geneviève Biloski, Features Design Editor; **Becky Guthrie**,
Associate Features Design Editor; **Benjamin Errett**, M.E./Features;
Daniel De Souza, Acting Features Design Editor; **Barry Hertz**, Arts & Life Editor;
Stephen Meurice, Editor-in-Chief; **Gayle Grin**, M.E./Design & Graphics
AWARD OF EXCELLENCE
Miscellaneous

THE PLAIN DEALER
Cleveland, Ohio
Emmet Smith, Deputy Design Director/News; **Chris Morris**, Art Director/Illustrator;
Michael Tribble, Design & Graphics Director; **David Kordalski**, A.M.E./Visuals
AWARD OF EXCELLENCE
Special Coverage/Section Pages
Sports/Cover Only

THE SAN DIEGO UNION-TRIBUNE
San Diego, Calif.
Gloria Orbegozo, Page Designer
AWARD OF EXCELLENCE
Portfolio/Page Designer
Features 175,000 and Over

THE BOSTON GLOBE
Boston, Mass.
Greg Klee, Art Director
AWARD OF EXCELLENCE
Portfolio/Page Designer
News 175,000 and Over

THE BOSTON GLOBE
Boston, Mass.
Luke Knox, Sports Designer
AWARD OF EXCELLENCE
Portfolio/Page Designer
Sports 175,000 and Over

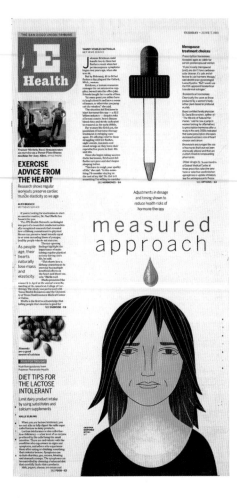

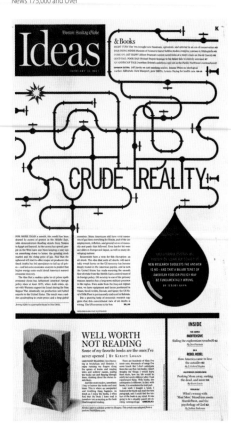

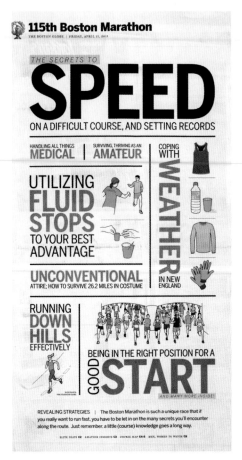

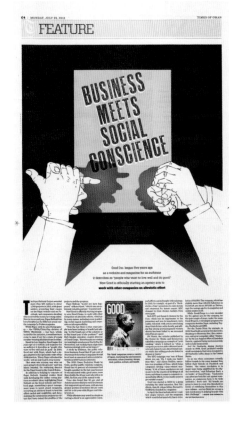

TIMES OF OMAN
Muscat, Oman
Adonis Durado, Designer
AWARD OF EXCELLENCE
Portfolio/Page Designer
News 49,999 and Under

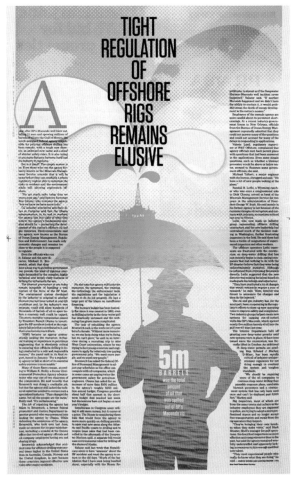

TIMES OF OMAN
Muscat, Oman
Adonis Durado, Designer
AWARD OF EXCELLENCE
Portfolio/Page Designer
News 49,999 and Under

TIMES OF OMAN
Muscat, Oman
Sahir KM, Designer
AWARD OF EXCELLENCE
Portfolio/Page Designer
News 49,999 and Under

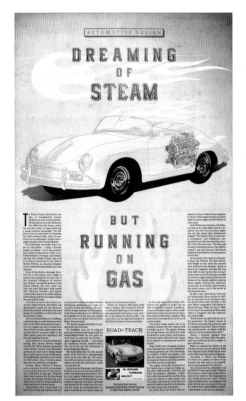

AUTOMOTIVE DESIGN

DREAMING OF STEAM

BUT RUNNING ON GAS

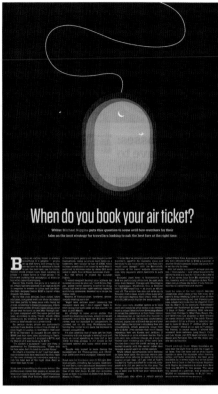

When do you book your air ticket?

OFF THE SHELF

POST MOVIES

SO WHAT EXACTLY DOES MICHAEL FASSBENDER GET UP TO IN THE DARK SEX-ADDICTION DRAMA SHAME? WELL, FIRST HE ███ OUT HIS ███ IN THE OFFICE BATHROOM BEFORE ███ AND THEN ███. THERE'S A SERIES OF ENCOUNTERS WITH ███ AT HIS AUSTERE CONDO, WHERE HE ███ THEM WITH HIS ███ BEFORE ███ AND THEN ███ AFTER, IT'S OFF TO A CHIC MEAT-PACKING DISTRICT HOTEL FOR SOME ███ WITH NUBILE ███ WHERE THEIR FLESH IS ███ BEFORE BEING ███. STILL CRAVING MORE, OUR ███ HEADS TO AN ███ FILLED WITH ███ SMELLING OF LEATHER AND ███ AND YES, EVEN ███! THERE, A ███ GOES ███ BEFORE ███. IN BETWEEN, THERE'S TIME TO SURF FOR ███ AT ███ BEFORE ███ ONCE MORE, FAST AND FURIOUSLY AND ███ UNTIL HE FINALLY, HE STUMBLES UPON A MASSIVE ███ FILLED WITH ███ AND A COUPLE OF HER ███ WHERE THEY ALL VENTURE TO A SEEDY, SWEATY ███, ███ BEFORE TURNING ███ AND GETTING LOST IN ███ AND ███ AND SO MANY ███ IT'S HARD TO COUNT. FOR NATHALIE ATKINSON'S ███ REVIEW, TURN TO PAGE B3. AND THEN ███ GET US A ███ CIGARETTE, PLEASE.

NATIONAL POST
Toronto, Ont., Canada
Geneviève Biloski, Features Design Editor
AWARD OF EXCELLENCE
Portfolio/Page Designer
Features 50,000-174,999

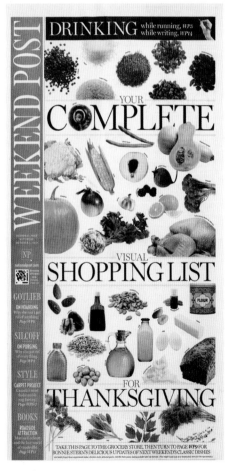

WEEKEND POST

DRINKING while running, WP15 while writing, WP14

YOUR COMPLETE

VISUAL SHOPPING LIST

FOR THANKSGIVING

TAKE THIS PAGE TO THE GROCERY STORE, THEN TURN TO PAGE WP9 FOR BONNIE STERN'S DELICIOUS UPDATES OF NEXT WEEKEND'S CLASSIC DISHES

FEATURE

IT'S 2026, AND THE DEBT IS DUE

DE VOLKSKRANT
Amsterdam, The Netherlands
Lucas van Esch, Art Director
AWARD OF EXCELLENCE
Portfolio/Page Designer
Features 175,000 and Over

THE BUFFALO NEWS
Buffalo, N.Y.
Vincent Chiaramonte, Design Director
AWARD OF EXCELLENCE
Portfolio/Page Designer
Sports 175,000 and Over

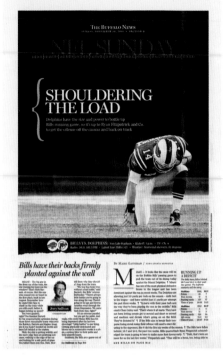

SHOULDERING THE LOAD

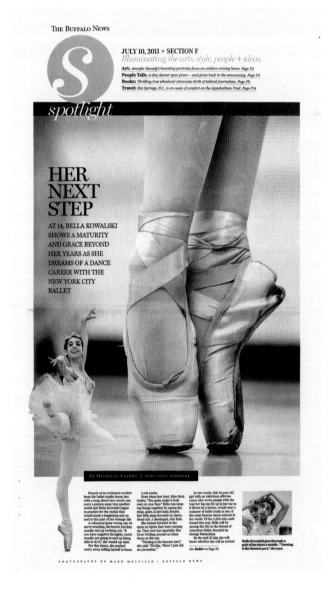

HER NEXT STEP

AT 14, BELLA KOWALSKI SHOWS A MATURITY AND GRACE BEYOND HER YEARS AS SHE DREAMS OF A DANCE CAREER WITH THE NEW YORK CITY BALLET

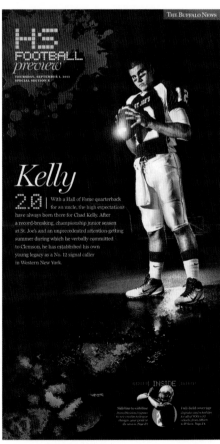

Kelly 2.0

With a Hall of Fame quarterback for an uncle, the high expectations have always been there for Chad Kelly. After a record-breaking, championship junior season at St. Joe's and an unprecedented attention-getting summer during which he verbally committed to Clemson, he has established his own young legacy as a No. 12 signal caller in Western New York.

THE BUFFALO NEWS
Buffalo, N.Y.
Vincent Chiaramonte, Design Director
AWARD OF EXCELLENCE
Portfolio/Page Designer
Features 50,000-174,999

THE BUFFALO NEWS
Buffalo, N.Y.
Vincent Chiaramonte, Design Director
AWARD OF EXCELLENCE
Portfolio/Page Designer
Sports 175,000 and Over

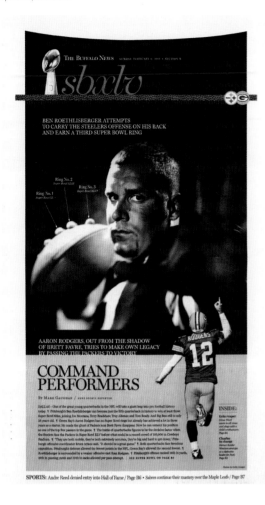

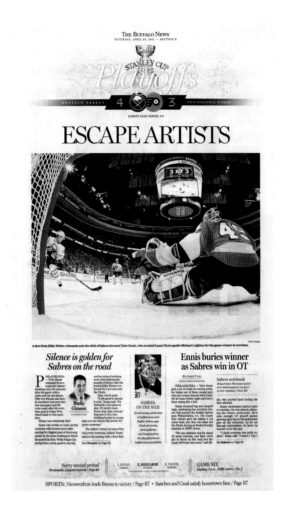

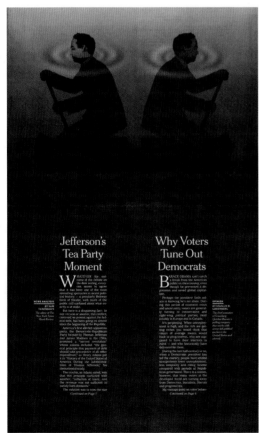

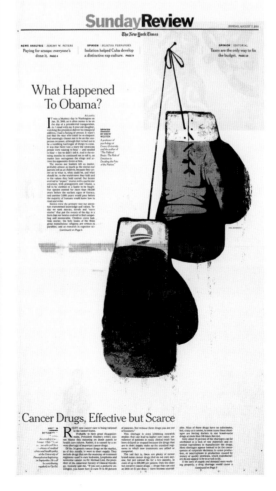

THE NEW YORK TIMES
New York, N.Y.
Rodrigo Honeywell, Art Director
AWARD OF EXCELLENCE
Portfolio/Page Designer
Features 175,000 and Over

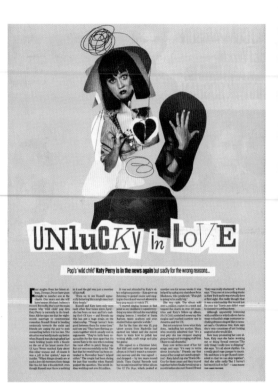

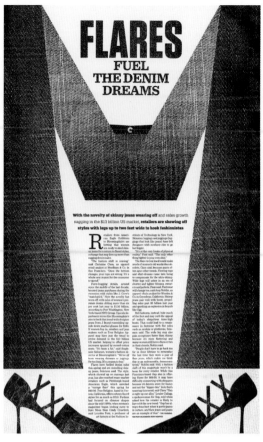

TIMES OF OMAN
Muscat, Oman
Essa Mohammed Al Zedjali, Chairman;
Ahmed Essa Al Zedjali, CEO; **Adonis Durado**,
Designer; **Waleed Rabin**, Designer;
Gregory Fernandez, Designer
AWARD OF EXCELLENCE
Portfolio/Staff
Combination 49,999 and Under

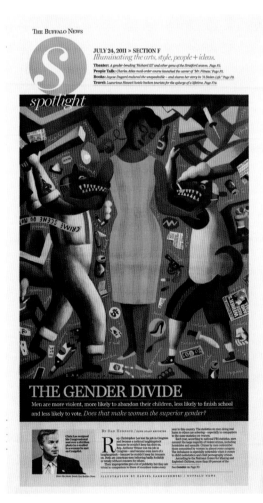

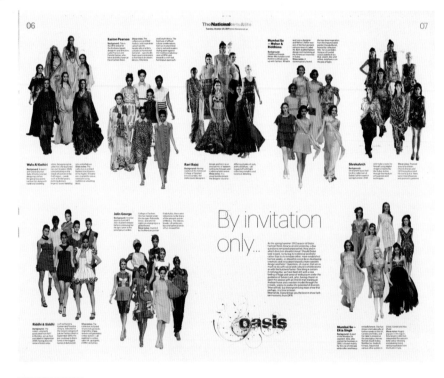

THE NATIONAL
Abu Dhabi, United Arab Emirates
Sara Baumberger, Designer
AWARD OF EXCELLENCE
Portfolio/Page Designer
Features 50,000-174,999

THE BUFFALO NEWS
Buffalo, N.Y.
Vincent Chiaramonte, Design Director; **Leah Samol**, Designer
AWARD OF EXCELLENCE
Portfolio/Staff
Combination 175,000 and Over

THE STATE
Columbia, S.C.
Meredith Sheffer, Page Designer
AWARD OF EXCELLENCE
Portfolio/Page Designer
Magazine 49,999 and Under

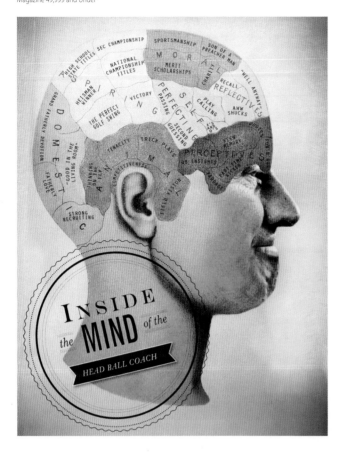

INSIDE the MIND of the

HEAD BALL COACH

STEVE SPURRIER HAS A *PHOTOGRAPHIC MEMORY* FOR ALL THINGS FOOTBALL, BUT WHEN IT COMES TO REMEMBERING HIS ANNIVERSARY, FORGET ABOUT IT.

STORY BY JOSH KENDALL

LA PRESSE
Montréal, Qué., Canada
Johan Batier, Designer
AWARD OF EXCELLENCE
Portfolio/Page Designer
Combination 175,000 and Over

THE HERALD/SUNDAY HERALD
Glasgow, Scotland
Roxanne Sorooshian, Assistant Group Production Editor
AWARD OF EXCELLENCE
Portfolio/Page Designer
Combination 49,999 and Under

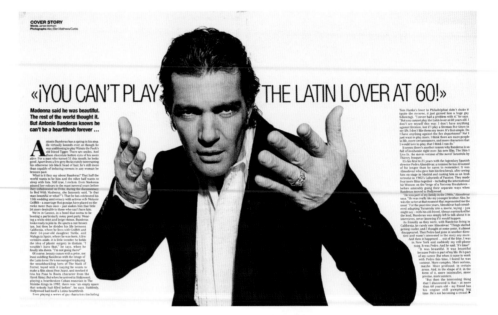

COVER STORY
Words James Mottram
Photographs Mary Ellen Matthews/Corbis

«¡YOU CAN'T PLAY THE LATIN LOVER «AT 60!»

Madonna said he was beautiful. The rest of the world thought he was. But Antonio Banderas knows he can't be a heartthrob forever …

THE BUFFALO NEWS
Buffalo, N.Y.
Vincent Chiaramonte, Design Director; **Terry Lew**, Assistant Design Editor;
Christina Wilemski, Designer
AWARD OF EXCELLENCE
Portfolio/Staff
Sports 175,000 and Over

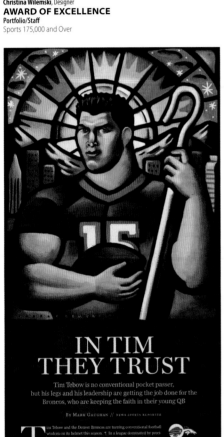

IN TIM THEY TRUST

Tim Tebow is no conventional pocket passer,
but his legs and his leadership are getting the job done for the
Broncos, who are keeping the faith in their young QB

BY MARK GAUGHAN // NEWS SPORTS REPORTER

GOING DUTCH

MANY OF US DREAM OF A NEW LIFE ABROAD.
CATRIONA BLACK NEVER DID. SHE WANTED TO RAISE
HER CHILDREN IN SCOTLAND. THEN HER HUSBAND
GOT A JOB IN THE NETHERLANDS AND THE FAMILY
HAD TO UPROOT. HERE'S HOW THEY GOT ON

POLITIKEN
Copenhagen, Denmark
Philip Ytournel, Artist
AWARD OF EXCELLENCE
Illustration
Portfolio/Individual

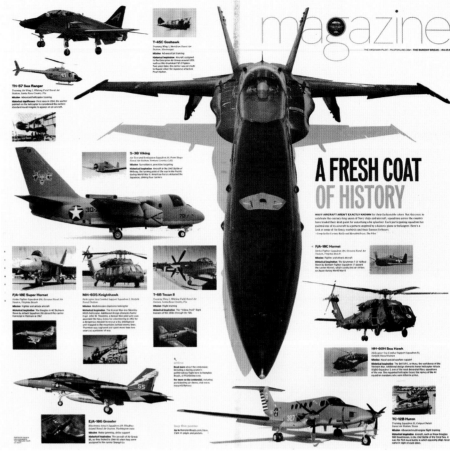

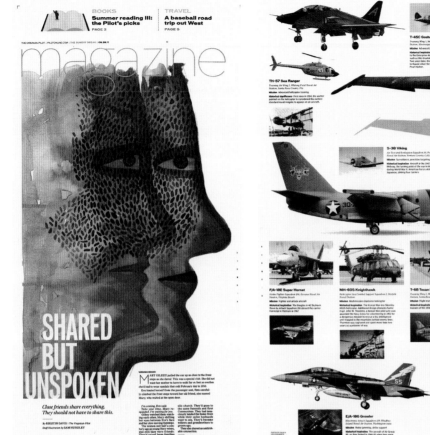

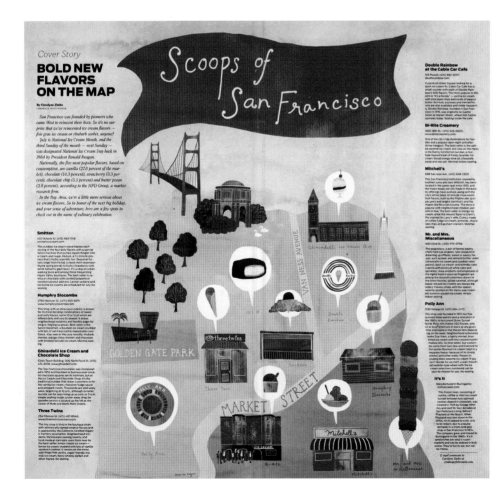

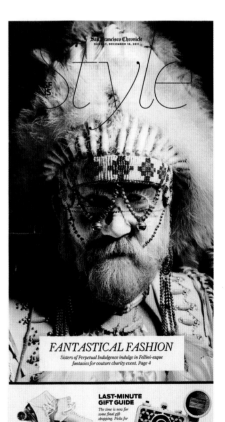

THE OREGONIAN
Portland, Ore.
Oregonian Photography Staff
AWARD OF EXCELLENCE
Photography/Multiple Photos
Portfolio/Team or Staff

GÖTEBORGS-POSTEN
Göteborg, Sweden
Malin Ankarhem, Page Designer; **Albert Rosander**, Page Designer;
Karin Teghammar Arell, Page Designer; **Gunilla Wernhamn**, Page Designer
AWARD OF EXCELLENCE
Portfolio/Staff
Features 175,000 and Over

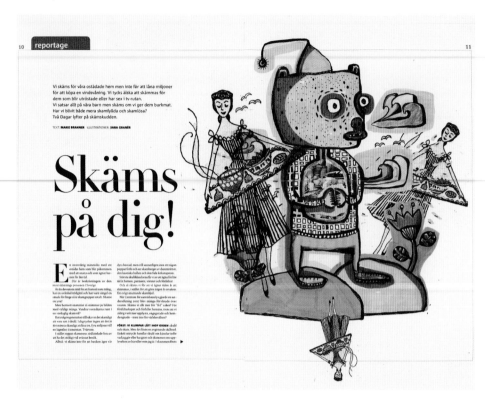

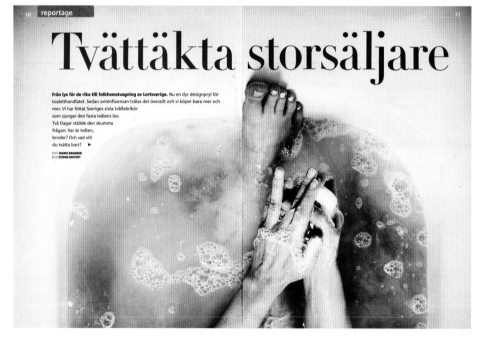

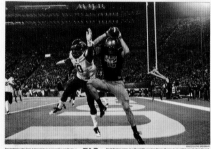

THE NATIONAL
Abu Dhabi, United Arab Emirates
Laura Koot, Art Director; **Nathan Estep**, Deputy Art Director
AWARD OF EXCELLENCE
Illustration
Portfolio/Art Direction/Staff

THE PLAIN DEALER
Cleveland, Ohio
Chris Morris, Art Director/Illustrator;
Amanda Petkiewicz, Art Director; **Emmet Smith**,
Deputy Design Director/News; **Andrea Levy**,
Photographer/Illustrator; **Scott Sheldon**,
Graphics Editor; **Sharon Yemich**,
Features Design Director; **Michael Tribble**,
Design & Graphics Director; **David Kordalski**,
A.M.E./Visuals
AWARD OF EXCELLENCE
Illustration
Portfolio/Art Direction/Staff

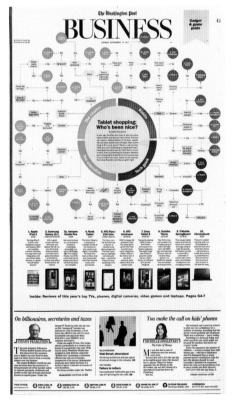

REDEYE
Chicago, Ill.
Rex Chekal, Designer
AWARD OF EXCELLENCE
Portfolio/Page Designer
News 175,000 and Over

THE WASHINGTON POST
Washington, D.C.
Marianne Seregi, Designer
AWARD OF EXCELLENCE
Portfolio/Page Designer
News 175,000 and Over

THE BUFFALO NEWS
Buffalo, N.Y.
Daniel Zakroczemski, Illustrator; **Vincent Chiaramonte**, Design Director;
Leah Samol, Art Director; **Terry Lew**, Art Director
AWARD OF EXCELLENCE
Illustration
Portfolio/Art Direction/Staff

Flirting with femininity

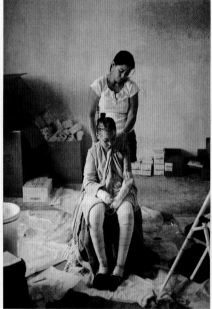

floridian

Just another girl

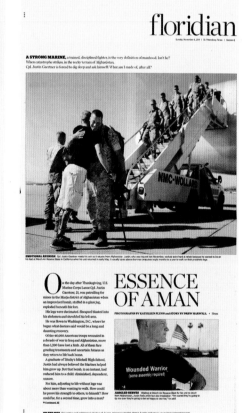

ESSENCE OF A MAN

TAMPA BAY TIMES
St. Petersburg, Fla.
Tampa Bay Times Photography Staff
AWARD OF EXCELLENCE
Photography/Multiple Photos
Portfolio/Team or Staff

TAMPA BAY TIMES
St. Petersburg, Fla.
John Pendygraft, Photographer
AWARD OF EXCELLENCE
Photography/Multiple Photos
Portfolio/Individual

TAMPA BAY TIMES
St. Petersburg, Fla.
Kathleen Flynn, Photographer
AWARD OF EXCELLENCE
Photography/Multiple Photos
Portfolio/Individual

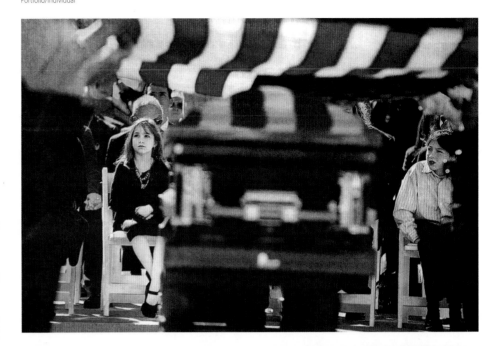

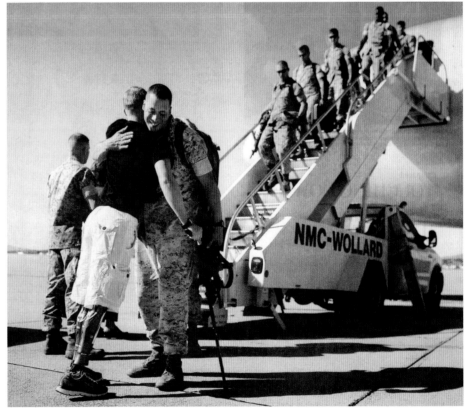

floridian

Letter from Tennessee

On rainy midway, a father shines

Still standing

STORIES AND PHOTOGRAPHS BY JOHN PENDYGRAFT • OF THE TIMES

Small business

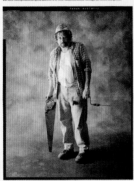

Discipline, sacrifice and unyielding passion

Building and rebuilding

More inside

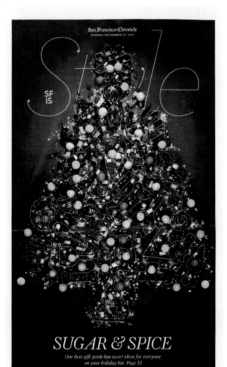

SUGAR & SPICE

Our luxe gift guide has sweet ideas for everyone on your holiday list. Page 13

INSIDE

SAN FRANCISCO CHRONICLE
San Francisco, Calif.
Matt Petty, Art Director
AWARD OF EXCELLENCE
Portfolio/Page Designer
Features 175,000 and Over

ORIENTAL MORNING POST
Shanghai, China
Yuan Li, Designer
AWARD OF EXCELLENCE
Illustration
Portfolio/Individual

THE NEW YORK TIMES
New York, N.Y.
Nicolas Blechman, Art Director; **New York Times Illustrators**; **Tom Bodkin**, Design Director
AWARD OF EXCELLENCE
Illustration
Portfolio/Art Direction/Staff

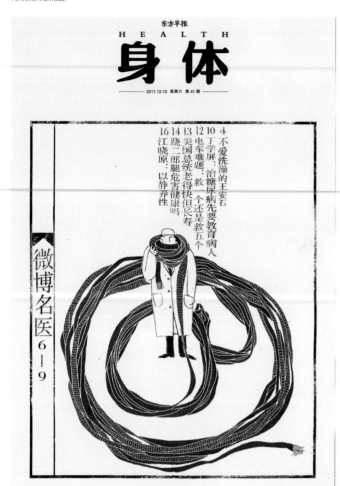

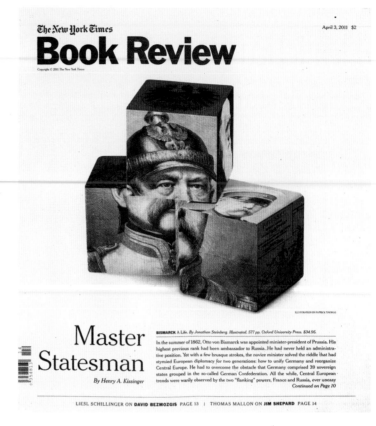

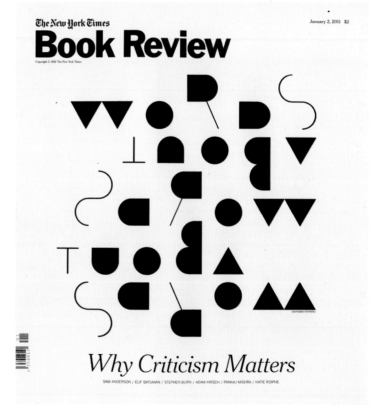

EL DIARIO DE HOY
San Salvador, El Salvador
Sebastián Suárez, Photographer; **Edgardo Mendoza**, Design Editor;
Norma Ramírez Campos, Art Director
AWARD OF EXCELLENCE
Photography/Multiple Photos
Portfolio/Individual

Bejuquilla en cautiverio

Foto y texto: Sebastián Suárez
comunidades@eldiariodehoy.com

Definitivamente impresiona ver una serpiente, aún cuando esté en cautiverio. Este ejemplar es parte de la colección de Reptilandia, exposición de diferentes reptiles que funciona en Juayúa, Sonsonate.

Es una bejuquilla, especie que habita en México y Centro América. Llegan a medir más de dos metros y son ligeramente venenosas.

Pero su mordedura no es mortal para los seres humanos, aunque llega a causar inflamación en el área afectada, dolores considerables e incluso parálisis por periodos prolongados de tiempo.

Generalmente estas víboras permanecen en los árboles y se alimentan de pequeñas aves, lagartijas y roedores.

Hay dos tipos de bejuquillas, la verde, como la de la foto, que puede alcanzar hasta tres metros de largo, y la parda, que muchos consideran la verdadera bejuquilla, es extremadamente larga y delgada. Llega a medir hasta dos metros de largo, pero en su parte más gruesa no es de más de 15 centímetros de diámetro.

Comunidades	34
Tendencias	46
Escena&Arte	83
Deportes	96

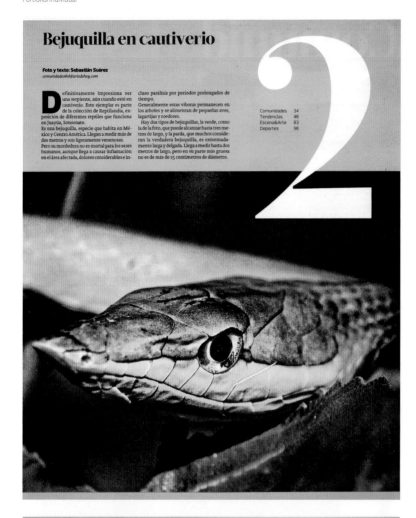

OMAHA WORLD-HERALD
Omaha, Neb.
Jay St. Pierre, Lead Sports Designer; **Tim Parks**, Deputy News & Presentation Editor;
Quentin Lueninghoener, Designer
AWARD OF EXCELLENCE
Portfolio/Staff
Sports 50,000-174,999

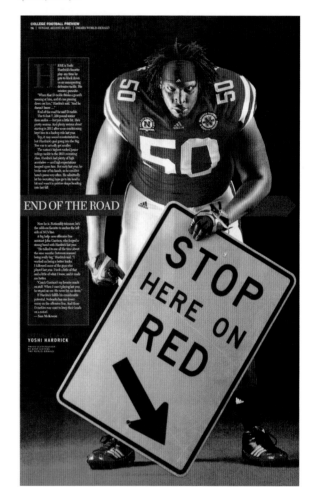

Un vuelo y luego un chapuzón

Foto y texto: Sebastián Suárez
comunidades@eldiariodehoy.com

Volar a baja altura sobre el mar es una estrategia común para muchas especies de aves que buscan así peces para alimentarse.

Al descubrir a sus futuras presas, los siguen atentamente para apreciar el momento en que se sumergen en el agua, abalanzándose sobre el pez y convertirlo en su banquete.

La serenidad de estas aves, la elegancia de su vuelo y la agilidad con que se desplazan forman un agradable espectáculo para cualquier persona que visite cualquiera de las zonas costeras del país.

Comunidades	56
Tendencias	65
Escena&Arte	92
Deportes	114

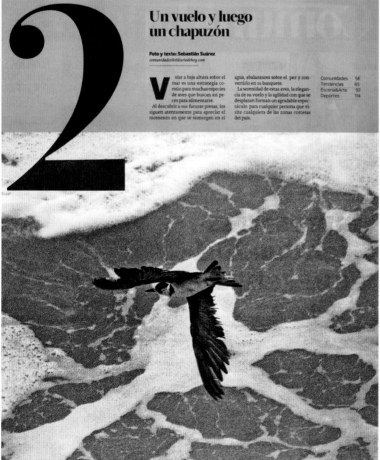

THE PLAIN DEALER
Cleveland, Ohio
Emmet Smith, Deputy Design Director/News
AWARD OF EXCELLENCE
Portfolio/Page Designer
Sports 175,000 and Over

OMAHA WORLD-HERALD
Omaha, Neb.
Tim Parks, Deputy News & Presentation Editor
AWARD OF EXCELLENCE
Portfolio/Page Designer
Sports 50,000-174,999

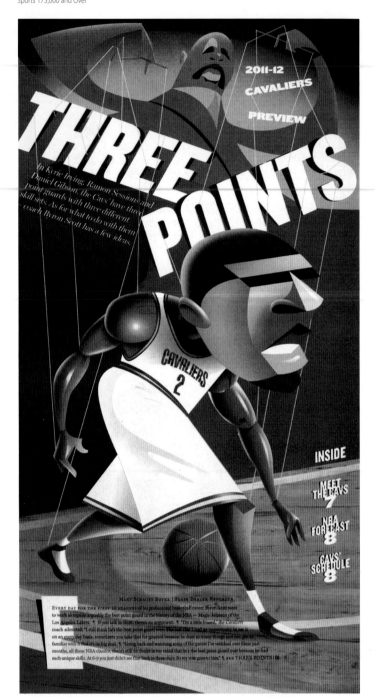

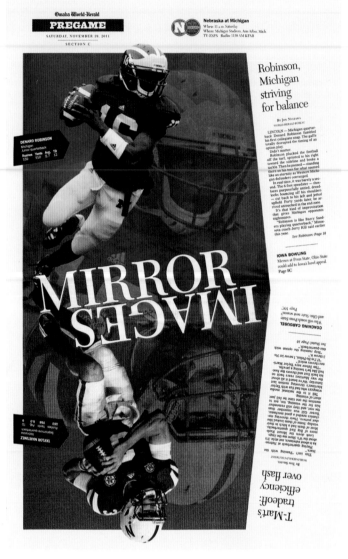

G ZE TU

SIOR VOLKSKR

GARTER ZEITUNG STA

DESIGN

LL STREET JOUR

MES MEXICO NEW

SWERVE MAGA

SSWEEK MAGNES-DZIENNIK

E MERCURY NEWS REC

PAULO CANADA H

E BEST OF NEWS DES

SND

33

RIBUNE THE NATIO

SEATTLE TIMES NA

TARDE OMAHA WORLD-H

LER FINANCIAL TI

EGAS REVIEW-JOURNAL OREG

DAGENS NYHET

LAS VEGAS SUN NOROESTE MAZ

NUESTRO DIARIO RA

S EXPRESSO METR

LINE

REDESIGNS

rediseños

CATARINA HOSPODÁS

ZETA WEEKLY STAR TRIB

ERCERA

FRIDAY MAGAZINE/GULF NEWS
Dubai, United Arab Emirates
Melany Reyes, Designer; **Sue-Mae Easton**, Senior Designer;
Sara Sherlock-Thomas, Design Editor; **Miguel Angel Gomez**,
Design Director; **Adrian Pickstock**, Publishing Director;
Abdul Hamid Ahmad, Executive Director/Publications;
Malavika Kamaraju, Editor; **Victoria Etherington**, Chief Sub-Editor
AWARD OF EXCELLENCE
Redesigns
Overall Magazine

AFTER

BEFORE

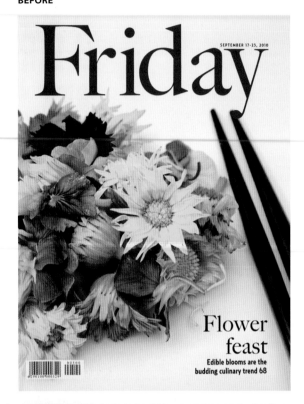

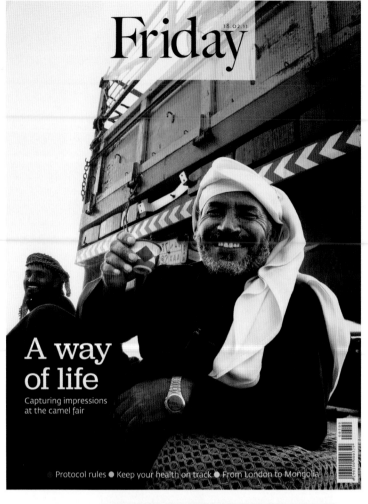

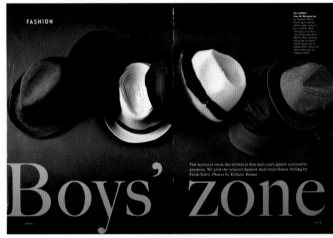

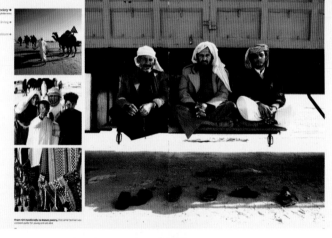

AFTER

AFTER

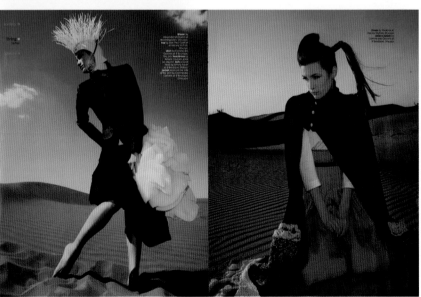

AFTER

ALPHA.MAGAZINE
Dubai, United Arab Emirates
Sooraj Raveendran, Senior Designer; **Nitin Nair**, Editor; **Sara Sherlock-Thomas**,
Design Editor; **Victoria Etherington**, Chief Sub-Editor; **Miguel Angel Gomez**,
Design Director; **Adrian Pickstock**, Publishing Director;
Abdul Hamid Ahmad, Editor-in-Chief
AWARD OF EXCELLENCE
Redesigns
Overall Magazine

BEFORE

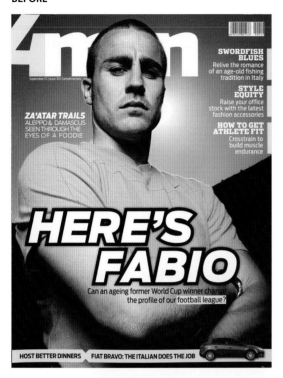

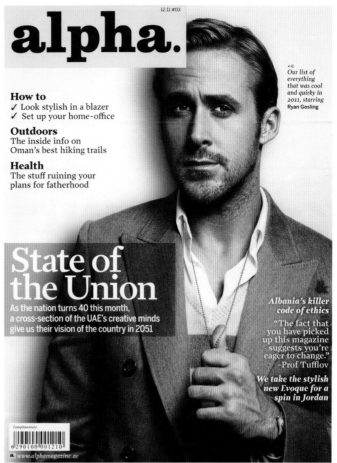

AFTER

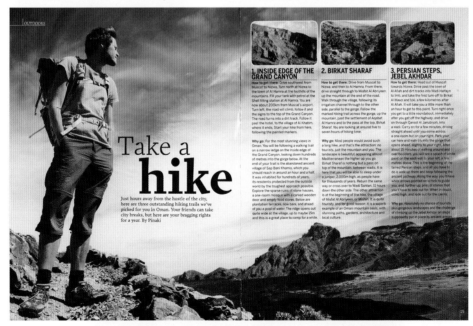

AFTER

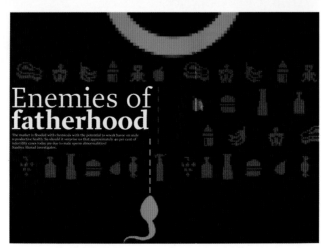

AFTER

TORONTO STAR
Toronto, ON, Canada
Nuri Ducassi, A.M.E./Presentation; **Lynn McAuley**, Associate Editor;
Tim Fryer, Designer; **Glenn Colbourn**, Team Leader; **Catherine Farley**, Graphic Artist;
Brian Hughes, Graphic Artist; **Anne Hewitt**, Editor
AWARD OF EXCELLENCE
Redesigns
Section

LA REPUBLICA AFFARI & FINANZA
Rome, Italy
Giovanni Mascolo, Art Director; **Paolo Feligioni**, Chief Graphic Designer; **Enrico Lucatelli**, Chief Graphic Designer;
Paola Bergami, Graphic Designer; **Rossella Bergonzoni**, Graphic Designer; **Vladimiro De Vito**, Graphic Designer
AWARD OF EXCELLENCE
Redesigns
Overall Newspaper

BEFORE

BEFORE

AFTER

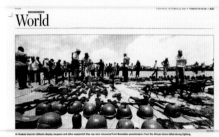

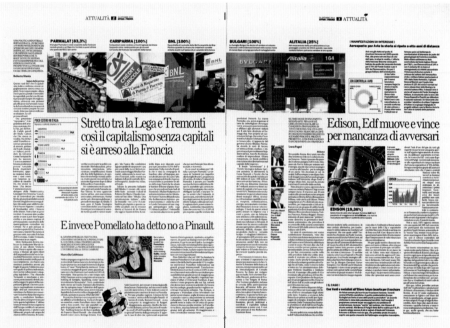

AFTER

AFTER

GAZETA WYBORCZA
Warsaw, Poland
Maciej Kałkus, Art Director; **Graphic Design Studio**
AWARD OF EXCELLENCE
Redesigns
Overall Newspaper

BEFORE

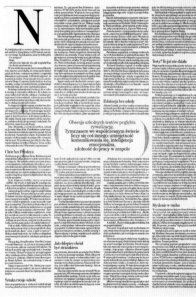

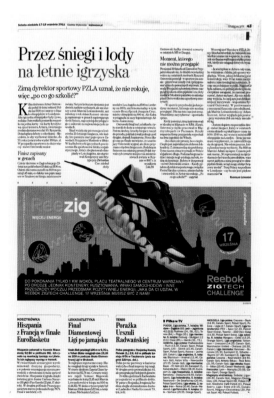

AFTER

AFTER

AFTER

POLITIKEN
Copenhagen, Denmark
Politiken Design Staff
AWARD OF EXCELLENCE
Redesigns
Overall Newspaper

BEFORE

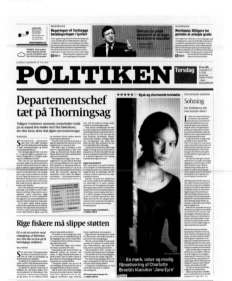

AFTER

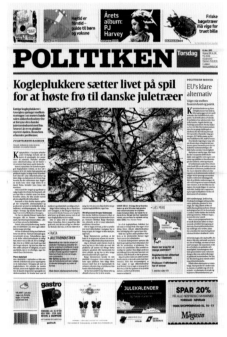

AFTER

BEFORE

AFTER

AFTER

DAGENS NYHETER
Stockholm, Sweden
Rickard Frank, Head of Design; **Lotta Ek**, Art Director; **Javier Errea**, Consultant; **Johan Andersson**, Infographic Artist; **Lotta Härdelin**, Project Manager; **Mattias Hermansson**, Editorial Development; **Per Boström**, Consultant; **Gunilla Herlitz**, Editor-in-Chief; **Dagens Nyheter Staff**
AWARD OF EXCELLENCE
Redesigns
Overall Newspaper

DAGBLAD DE PERS
Amsterdam, The Netherlands
Koos Jeremiasse, Art Director
AWARD OF EXCELLENCE
Redesigns
Overall Newspaper

BEFORE

AFTER

AFTER

AFTER

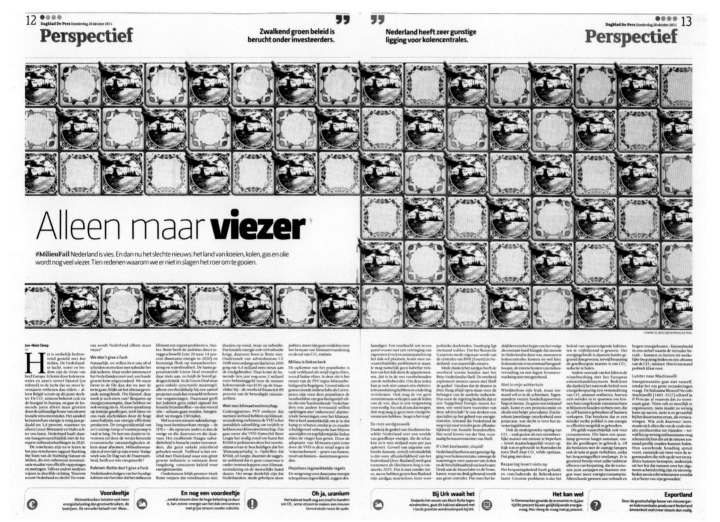

MÁS POR MÁS
Mexico City, Mexico
Gustavo Guzmán Favela, CEO; **Abraham Urbina Granados**, General Sub Director; **Octavio Cárdenas Váldez**, Editorial Director; **Sergio Fraire Monreal**, Art Director;
Danilo Black USA, Design Consulting; **Eduardo Danilo Ruíz**, Creative Director; **Victror Sánchez**, Art Director; **Gustavo Belman**, Associate Art Director; **Ana Lucía Ramos**, Senior Designer
AWARD OF EXCELLENCE
Redesigns
Overall Newspaper

BEFORE

AFTER

AFTER

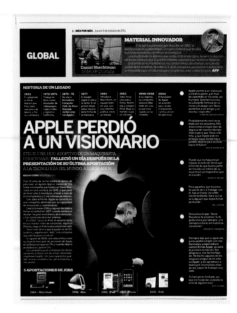

CLARÍN
Buenos Aires, Argentina
Gustavo Lo Valvo, Art Director; **Carlos Vazquez**, Design Editor;
Estívaliz Las Heras, Design Editor; **Zerman Mariana**, Designer;
Segal Adrian, Designer
AWARD OF EXCELLENCE
Redesigns
Section

BEFORE

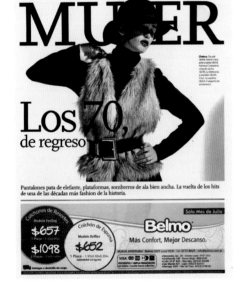

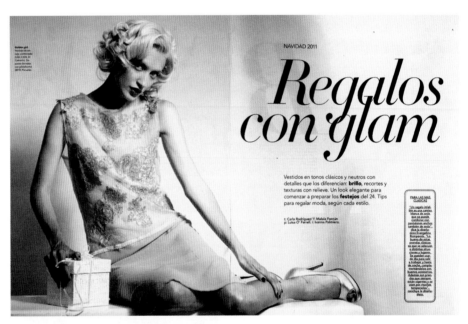

AFTER

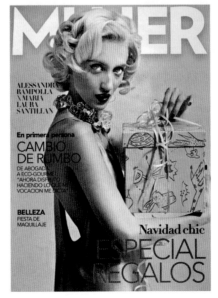

AFTER

DAGENS NYHETER
Stockholm, Sweden
Lotta Ek, Art Director; **Rickard Frank**, Art Director; **Mattias Hermansson**, Editorial Development
AWARD OF EXCELLENCE
Redesigns
Section

AFTER

BEFORE

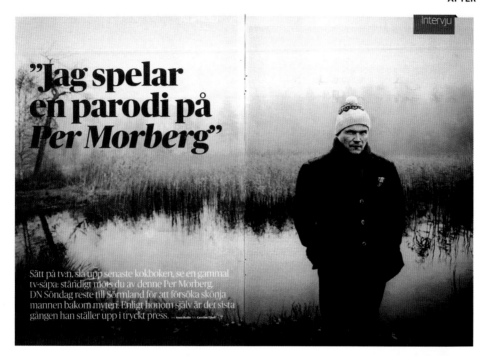

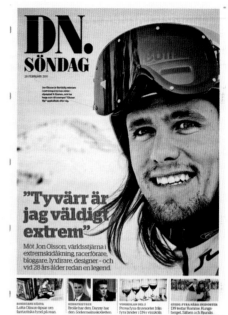

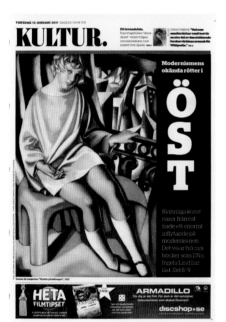

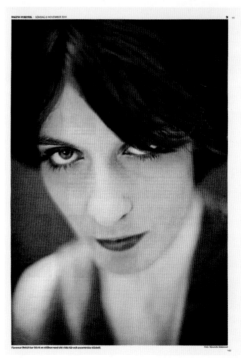

BEFORE

DAGENS NYHETER
Stockholm, Sweden
Lotta Ek, Art Director; **Rickard Frank**, Art Director; **Mattias Hermansson**, Editorial Development; **Harald Bergius**, Editorial Development
AWARD OF EXCELLENCE
Redesigns
Section

AFTER

THE BUFFALO NEWS
Buffalo, N.Y.
Vincent Chiaramonte, Design Director; **Melinda Miller**, Features Editor; **Daniel Zakroczemski**, Illustrator; **Brian Connolly**, M.E.
AWARD OF EXCELLENCE
Redesigns
Pages/Newspaper

BEFORE

AFTER

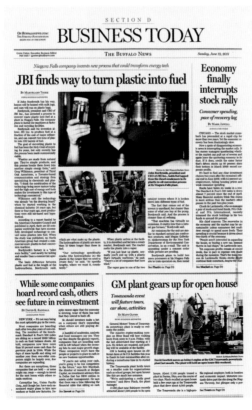

THE BUFFALO NEWS
Buffalo, N.Y.
Leah Samol, Designer; **Vincent Chiaramonte**, Design Director;
Grove Potter, Business Editor
AWARD OF EXCELLENCE
Redesigns
Pages/Newspaper

BEFORE

AFTER

Judges/Facilitators for Digital Competition

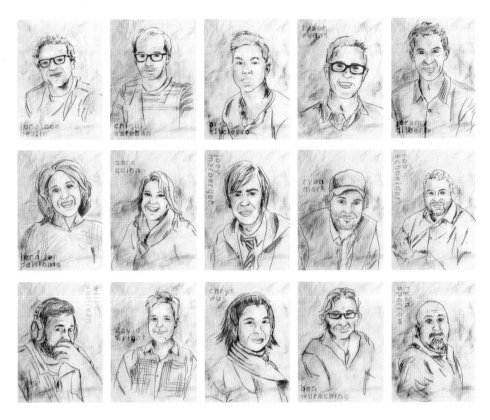

JONATHON BERLIN, SND PRESIDENT AND GRAPHICS EDITOR, THE CHICAGO TRIBUNE

CHIQUI ESTEBAN, DIGITAL NARRATIVE DIRECTOR, LAINFORMACION.COM

BRIAN ELLCIERTO, LEAD DESIGNER FOR ALL DIGITAL PRODUCTS FOR THE GLOBE AND MAIL

TYSON EVANS, DEPUTY EDITOR FOR INTERACTIVE NEWS, THE NEW YORK TIMES

JEREMY GILBERT, ASSOCIATE PROFESSOR OF MEDIA PRODUCT DESIGN, NORTHWESTERN

JENNIFER GEORGE-PALILONIS, GEORGE AND FRANCES BALL DISTINGUISHED PROFESSOR OF MULTIMEDIA, BALL STATE UNIVERSITY

SARA QUINN, VISUAL JOURNALISM FACULTY, THE POYNTER INSTITUTE FOR MEDIA STUDIES

JOEY MARBURGER, MOBILE DESIGNER, THE WASHINGTON POST

RYAN MARK, NEWS APPLICATIONS DEVELOPER, THE CHICAGO TRIBUNE

ROB SCHNEIDER, PRESENTATION DIRECTOR, THE DALLAS MORNING NEWS

WILL SULLIVAN, DIRECTOR OF MOBILE NEWS, ST. LOUIS POST-DISPATCH

DAVID WRIGHT, LEAD INTERACTIVE DESIGNER, NPR

CHRYS WU, USER ENGAGEMENT STRATEGIST, MATCHSTRIKE

BEN WUERSCHING, DESIGN EDITOR FOR THE DIGITAL AND MOBILE SECTOR, THE GUARDIAN

RYAN SPARROW, DIGITAL COMPETITION COORDINATOR, INSTRUCTOR OF JOURNALISM, BALL STATE UNIVERSITY

KYLE ELLIS, CNN, FACILITATOR, BLOGGER

BALL STATE STUDENTS: STEPHANIE STAMM, CHELSEA KARDOKUS, TIFFANY REUSSER, VALERIE CARNEVALE, STEPHANIE MEREDITH, LIZ SPANGLER, EVAN BACKSTROM

NORTHWESTERN STUDENTS: EMILY CHOW, REBECCA LAI, HILARY FUNG

DIGITAL

Judges' overall statement:
Stories carefully crafted with ambition, precision and user needs

INTERACTION DESIGN IS MATURING RAPIDLY. As the craft evolves, news designers are not being left behind. The best of the work has challenged long-standing industry conventions by making better use of data, employing responsive techniques and overcoming the limitations of content management systems.

OUR PRIORITY, STORYTELLING

Designs that focus on storytelling — stressing form over function and making the most of limited resources — were rewarded. Winning work had to be more than just beautiful, it needed to be journalistically sound, with great storytelling and editing. Many of the best entries took known narrative tools and stretched their capabilities, resulting in richer, more compelling stories. Other entries created new ways of telling stories that will be useful, not just in a single moment, but going forward.

FOR WEB ENTRIES

Web-based design seems to be maturing. Designers are finding ways to make experiences richer and more inviting, but the news apps viewed in the contest did not always measure up to these web experiences. The range of tools and techniques in the market today is impressive, even overwhelming. It is not surprising that the largest news organizations most often struck the right balance between exploring new storytelling possibilities and polished presentations. But the news-viewing public is blind to circulation traffic and staff size. Small and medium organizations showed exciting new ideas, yet often fell short in execution.

FOR MOBILE ENTRIES

Although there were many intriguing mobile and tablet entries, these apps did not seem to universally embrace the touch-medium. More needs to be done to make news apps the polished equivalent of the web-based entries. Touch-based news apps should take special care with multimedia elements. These apps should better fulfill their different places in the lives of users and address specific needs, not just replicate print or web-based experiences. There must be additional focus on load times, intuitive interfaces, touch interaction and crash-resistance if innovative news tools are to more adequately serve the user. More experimentation is needed from the companies that produce the news, and they must always be aware of the user.

OUR AMBITIONS

The entries receiving the highest awards in this competition needed not only to be innovative, but nearly peerless. For an entry to achieve a gold medal or the honor of World's Best Designed, it must combine a rare blend of vision and execution. Many entries were strong in one area, but not both.

The news designer in 2012 is a sophisticated storyteller with a world of tools at his disposal. The work we saw was inspiring and we are eager for the innovations that await. All designers must continue to strive to keep the users at the center of our work and provide them with clean, precise ways to understand the news.

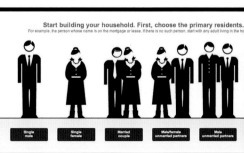

Declaración general de los jueces:
Artículos creados con ambición y precisión, y dirigidos a los lectores

El diseño interactivo está madurando con rapidez. A medida que evoluciona, los diseñadores de noticias no se han quedado atrás. Las mejores piezas desafiaron arraigadas convenciones de los medios al sacarle mejor partido a los datos, emplear técnicas de respuesta y superar las limitaciones de los sistemas de administración de contenidos.

NUESTRA PRIORIDAD, LA NARRACIÓN DE HISTORIAS

Los diseños enfocados en la narración de historias, que privilegian la forma sobre la función y que le sacan jugo a los limitados recursos, fueron los ganadores. Era preciso que los trabajos premiados fueran más allá de la simple belleza; debían ser profundos en términos periodísticos y tener un alto nivel de narración y edición. Muchas de las mejores piezas aprovecharon herramientas narrativas conocidas y ampliaron sus posibilidades, lo que produjo relatos más convincentes. Otras piezas generaron nuevas formas de contar historias que serán útiles no solo en un momento determinado sino que de ahí en adelante.

PIEZAS DE LA WEB EN COMPETENCIA

Parece ser que el diseño basado en la web está madurando. Los diseñadores están encontrando formas de hacer que las experiencias sean más ricas y más atractivas, aunque las aplicaciones de noticias examinadas en la competencia no siempre estuvieran a la altura de esas experiencias en la web. El rango de herramientas y técnicas disponibles hoy en día es impresionante, a veces incluso abrumador. Por eso, no es sorprendente que la mayoría de las veces los medios periodísticos más grandes hayan logrado el justo equilibrio entre la exploración de nuevas posibilidades de narración y las presentaciones bien terminadas. Sin embargo, la audiencia de noticias en la web es ciega tanto para la circulación y el tráfico, como para el tamaño de la planta laboral. Los medios pequeños y medianos también mostraron ideas nuevas y apasionantes, aunque a menudo quedaron cortas en su materialización.

PIEZAS PARA MÓVILES

Aunque hubo muchas piezas fascinantes para móviles y tabletas, no pareció que el medio táctil fuera adoptado universalmente por estas aplicaciones. Se debe hacer más para lograr que las aplicaciones de noticias sean equivalentes a las piezas de web. Estas aplicaciones táctiles deberían tratar con especial esmero los elementos multimediales, y deberían, por un lado, cumplir de mejor forma los diversos roles que juegan en las vidas de los usuarios, y, por otro, atender las necesidades específicas, y no simplemente replicar las experiencias web o impresas. El foco en el usuario, la atención en los tiempos de descarga, las interfaces intuitivas y la interacción táctil, y la resistencia a la caída de las herramientas noticiosas innovadoras, todo eso supera con creces lo que la mayoría de los propios medios está haciendo. Las compañías que producen las noticias deben entregar una mayor experimentación y más conciencia del usuario.

NUESTRAS AMBICIONES

Las piezas que recibieron los mayores premios en esta competencia no solo debieron ser innovadoras, sino prácticamente incomparables. Para que alguna lograra la medalla de oro o el honor de ser "La mejor diseñada del mundo", debía tener una inusual mezcla de visión y materialización. Muchas piezas eran fuertes en un área, pero no en ambas.

Los diseñadores del 2012 son narradores sofisticados y cuentan con todo un mundo de herramientas a su disposición. Las piezas que examinamos fueron inspiradoras, y esperamos con ilusión las innovaciones que nos esperan. Todos los diseñadores deben seguir esforzándose por mantener al usuario en el centro de su trabajo y proveerles de formas limpias y precisas para entender las noticias

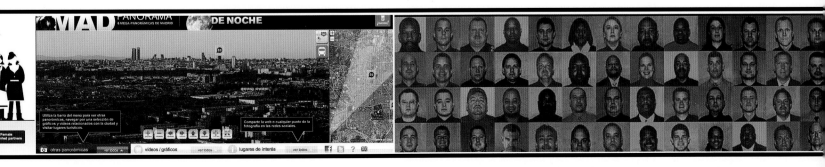

THE LAUNCH OF BOSTONGLOBE.COM DECISIVELY RAISED THE BAR FOR DIGITAL NEWS DESIGN. The Globe's intrepid embrace of responsive design rewrote the equation of our industry's expectations and ambitions and defined state-of-the-art across the web. The site embraces the increasingly chaotic ecosystem of devices without sacrificing thoughtfulness or splintering user experience.

Much of the past 17 years of news design on the web has been spent mapping analog conventions to digital experiences, sometimes quite crudely. The Globe site is a refreshing shift away from crafting news design as a single artifact and toward news design as an organism that responds to context, to device and to the user.

The designer Wilson Miner recently described responsive design as "one of those little shifts in thinking that cracks open a whole new set of questions and possibilities." And this is certainly true for The Globe, which is aggressively rebalancing the signal-to-noise ratio of storytelling, and even rethinking the shape and behavior of advertising.

Working with a team of external developers and designers at The Filament Group, Upstatement and Ethan Marcotte, one of the thought leaders and authors of the book on responsive web design, the Boston Globe staff created a remarkably beautiful design that allows content to sing with typography and grids, also while functioning across all platforms — from mobile to full desktop — and even adapt to a 13-year-old Apple Newton MessagePad.

It's no small feat. The Globe's responsive design is remarkable and deserves to be noted as one of the key moments in media design history, akin to USA Today's embrace of color and graphics. Its impact will affect a generation of digital journalists and is an example of what's possible when smart design and rich content are balanced with a focus on being standards-compliant and future-friendly across all platforms.

EL LANZAMIENTO DE BOSTONGLOBE.COM CIERTAMENTE ALZÓ LA VARA DEL DISEÑO DE NOTICIAS DIGITALES. La intrépida adopción por parte de The Globe de un diseño receptivo reescribió la ecuación de las expectativas y ambiciones de los medios, y definió la vanguardia de toda la web. Lo más importante es que el sitio web adopta el ecosistema de aparatos cada vez más caótico sin sacrificar la consideración por la experiencia de los usuarios ni de escindirla.

Buena parte de los últimos 17 años de diseño de noticias en la web se ha destinado a trazar el mapa de convenciones análogas en experiencias digitales, a veces de forma bastante rudimentaria. El sitio web de The Globe es un viraje refrescante desde la confección del diseño de noticias como un único artefacto hacia el diseño como un organismo que responde al contexto, al aparato y al usuario.

El diseñador Wilson Miner recientemente describió el diseño receptivo así: "Una de esas pequeñas modificaciones en el pensamiento que abre en dos toda una gama de preguntas y posibilidades". Esto es muy cierto en el caso de The Globe, el cual está reequilibrando con empuje y dinamismo la razón señal-ruido de la narración, e incluso está repensando la forma y el comportamiento que toma la publicidad.

En conjunto con un equipo de desarrolladores y diseñadores externos de The Filament Group, Upstatement y Ethan Marcotte, unos de los líderes del pensamiento y autores de libros sobre diseño web receptivo, la planta laboral de The Boston Globe creó un diseño extraordinariamente hermoso que permite que el contenido cante al unísono con la tipografía

y las retículas o grillas, a la vez que funciona a través de todas las plataformas –desde la móvil a la del computador estacionario–, e incluso se adapta al MessagePad Newton, de Apple, que ya tiene 13 años.

No es una proeza menor. El diseño receptivo de The Globe se destaca y merece ser reconocido como uno de los hitos en la historia del diseño medial, semejante a la adopción de parte de USA Today del color y los infográficos. Va a tener impacto en toda una generación de periodistas digitales y es un ejemplo de lo que es posible cuando el diseño inteligente y el contenido valioso se equilibran con el objetivo de cumplir con estándares y son amables con el futuro a través de todas las plataformas.

TELLING GREAT STORIES and designing successful experiences are never easy. Whether the team or the organization is small, limited resources can limit, but they can also inspire great creativity. Several small teams and organizations stood out in this year's competition. The Roanoke Times is emblematic of the challenges of a smaller community and team. Roanoke's coverage may not be as broad as national or international news organizations, but it is deep within its community. The multimedia storytelling explores highly personal issues and forces viewers to confront issues that rarely surface in their daily lives. Another organization, the National Post, translated its humor and whimsy to its audience's digital experience. Whether it was Muppets facing off in fan voting or an interactive gallery of 40 faces of Harrison Ford, the Post's voice is clear and engaging. La Información consistently challenges conventional thinking about informational graphics viewed on digital platforms. The visual storytelling is bold, the illustrations vivid. The Dallas Morning News may not have much time to allocate for interactive projects, yet somehow it still manages to explore many different storytelling directions, including sports-related games, tracking local food trucks or voting for a favorite Maverick's cheerleader. These were not the only small organizations that showed great promise, and not all the storytelling was equally or evenly polished, but the intent and the passion are clear. There is great promise and storytelling in these smaller organizations.

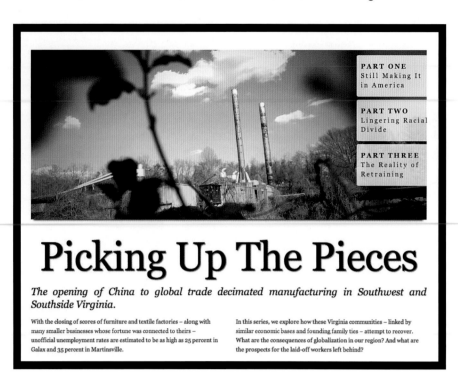

NUNCA ES FÁCIL CONTAR GRANDES HISTORIAS y diseñar experiencias exitosas. Cuando el equipo o el medio es pequeño, los escasos recursos pueden ser limitantes, pero también pueden inspirar una gran creatividad. Varios pequeños equipos y medios se destacaron en la competición de este año. The Roanoke Times es emblemático de los desafíos de una comunidad menor y un equipo pequeño. Es posible que la cobertura del Roanoke pueda no ser tan amplia como la de medios noticiosos nacionales o internacionales, pero es profunda dentro de su comunidad. La narración multimedial explora asuntos sumamente personales y fuerza a la audiencia a enfrentar temas que rara vez ocurren en sus vidas rutinarias. Otro medio, The National Post, tradujo su humor y banalidad a la experiencia digital de su público. Se tratara de los Muppets enfrentando la votación de sus seguidores o una galería interactiva de las 40 caras del actor Harrison Ford, la voz del Post era clara y comprometida. La Información consistentemente desafió el pensamiento convencional sobre las infografías tal como se ven en plataformas digitales. La narración visual es atrevida y las ilustraciones son vivaces. Es posible que The Dallas Morning News no contara con mucho tiempo para distribuir proyectos interactivos, pero de alguna forma sigue logrando explorar variadas orientaciones narrativas, incluyendo los juegos relativos al deporte, siguiendo la pista de camiones que transportan comida local o votando por su porrista favorita del equipo local de básquetbol Mavericks. No se trató solo de medios pequeños que demuestran un gran potencial, y no toda la narración fue pulida por igual o de forma pareja, pero la intención y la pasión fueron evidentes. Estos medios pequeños son muy prometedores y cuentan grandes relatos.

JSR for Reductive, Adaptive Design: Chicago Now

THE CHICAGO NOW REDESIGN is a reductive refresh that rejects the conventions of a traditional newspaper-driven layout. The designers ruthlessly eliminated cruft and elevated the importance of content. At the story level, content is king, sharing space with a sensible branding system and little else. Above all, it solves all of these problems within the context of an adaptive design. This redesign is an impressive upgrade and an example of thoughtful, forward progress in digital news presentation.

EL REDISEÑO DE CHICAGO NOW es una renovación reduccionista que rechaza las convenciones del diseño guiado por un periódico tradicional. Los diseñadores eliminaron implacablemente los desechos indeseables y elevaron la importancia del contenido. A nivel del artículo, el contenido es rey, y comparte el espacio con un sistema de branding (marcas) sensato y nada más. Por sobre todo, resuelve todos estos problemas en el contexto de un diseño adaptativo. Este rediseño es un admirable ascenso de categoría y un ejemplo de progreso considerado en el diseño de noticias digitales.

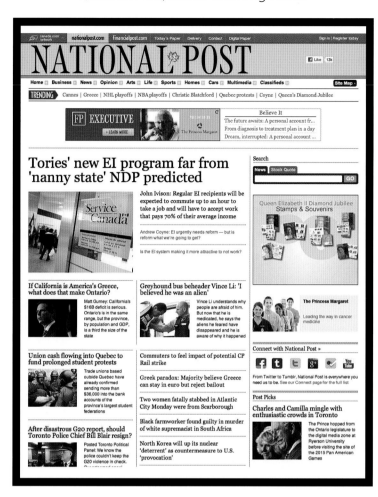

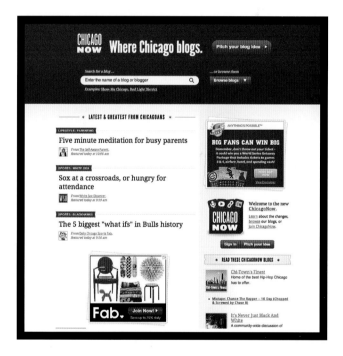

The New York Times — Gold

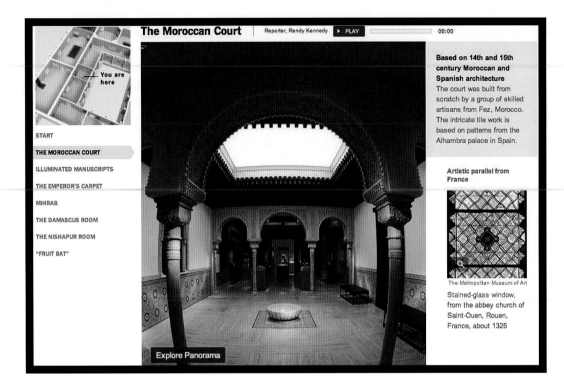

The New York Times — Gold

The New York Times — Silver

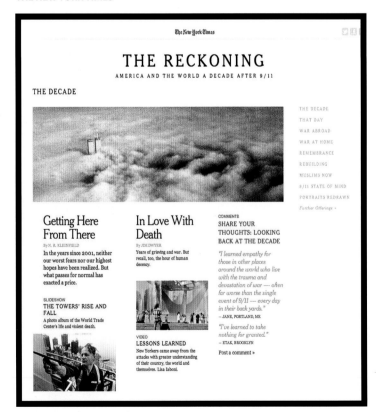

The New York Times — Silver

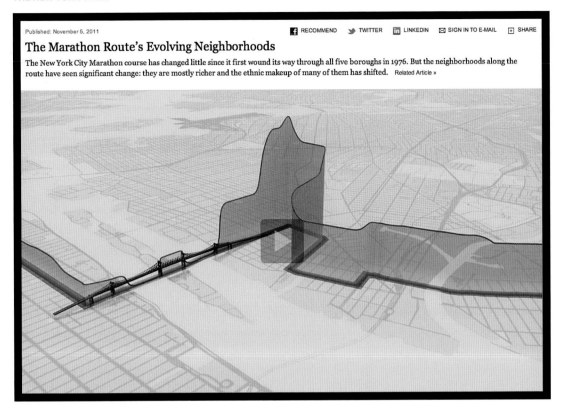

The Boston Globe — Silver

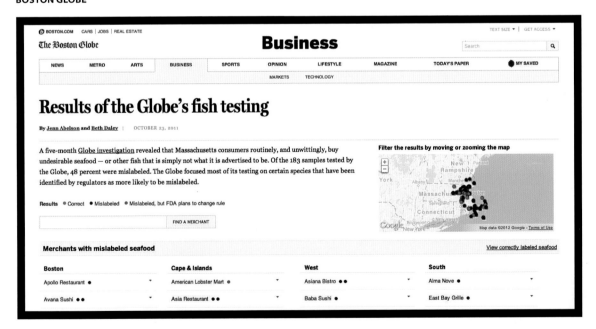

The New York Times — Silver NPR — Silver

THE OSCARS
THE NEW YORK TIMES

VISUALIZING HOW A POPULATION GROWS TO 7 BILLION
NPR

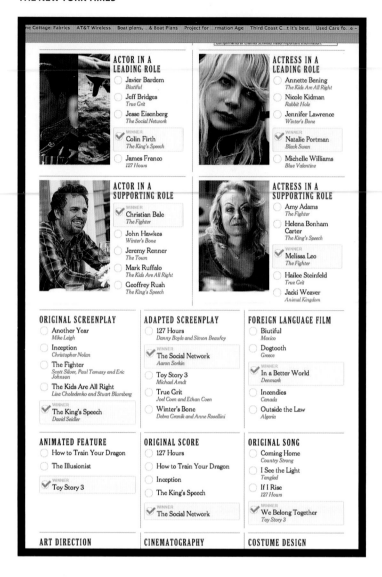

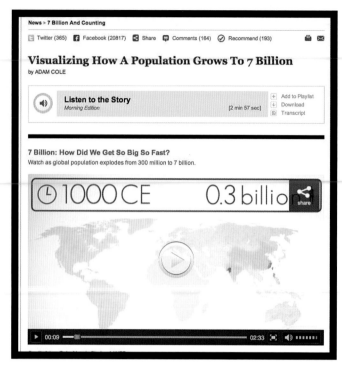

University of North Carolina, Chapel Hill — Silver

COAL: A LOVE STORY
UNIVERSITY OF NORTH CAROLINA, CHAPEL HILL

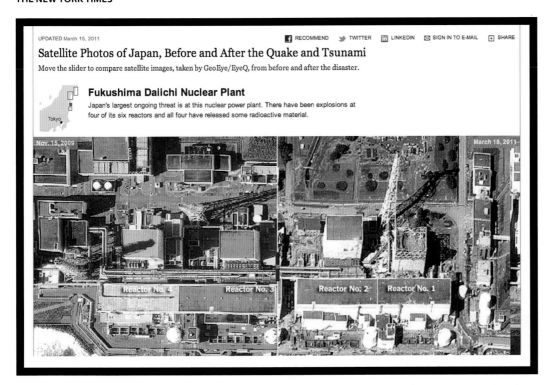

UPDATED March 15, 2011

RECOMMEND TWITTER LINKEDIN SIGN IN TO E-MAIL SHARE

Satellite Photos of Japan, Before and After the Quake and Tsunami

Move the slider to compare satellite images, taken by GeoEye/EyeQ, from before and after the disaster.

Fukushima Daiichi Nuclear Plant

Japan's largest ongoing threat is at this nuclear power plant. There have been explosions at four of its six reactors and all four have released some radioactive material.

Tokyo

Nov. 15, 2009 March 18, 2011

Reactor No. 4 Reactor No. 3 Reactor No. 2 Reactor No. 1

The New York Times 9/11 : The Reckoning

The World Trade Center Towers As They Were

Philippe Petit: The Art | Henry J. Guthard: The Architecture | Leslie E. Robertson: The Engineering

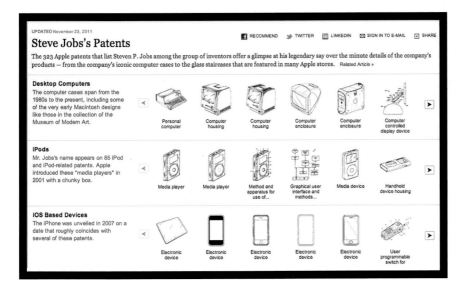

UPDATED November 23, 2011

RECOMMEND TWITTER LINKEDIN SIGN IN TO E-MAIL SHARE

Steve Jobs's Patents

The 323 Apple patents that list Steven P. Jobs among the group of inventors offer a glimpse at his legendary say over the minute details of the company's products — from the company's iconic computer cases to the glass staircases that are featured in many Apple stores. Related Article »

Desktop Computers
The computer cases span from the 1980s to the present, including some of the very early Macintosh designs like those in the collection of the Museum of Modern Art.

Personal computer Computer housing Computer housing Computer enclosure Computer enclosure Computer controlled display device

iPods
Mr. Jobs's name appears on 85 iPod and iPod-related patents. Apple introduced these "media players" in 2001 with a chunky box.

Media player Media player Method and apparatus for use of... Graphical user interface and methods... Media device Handheld device housing

iOS Based Devices
The iPhone was unveiled in 2007 on a date that roughly coincides with several of these patents.

Electronic device Electronic device Electronic device Electronic device Electronic device User programmable switch for

PORTFOLIO: INDIVIDUAL
TOM GIRATIKANON, BOSTON GLOBE

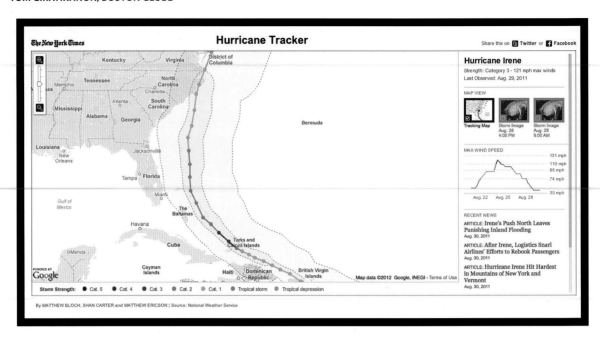

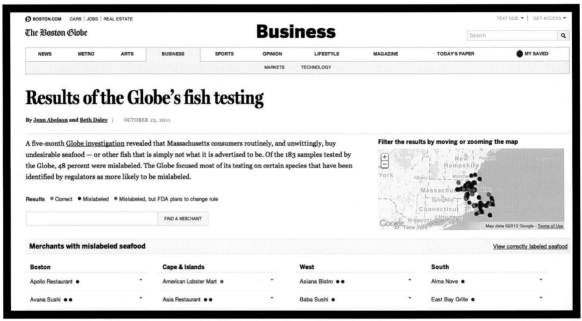

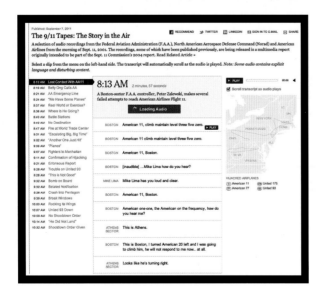

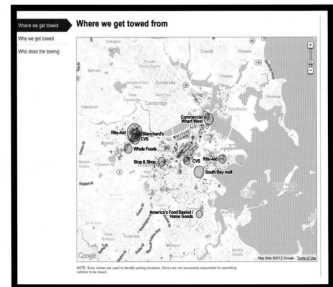

MADRID TO BARCELONA
LA INFORMACION

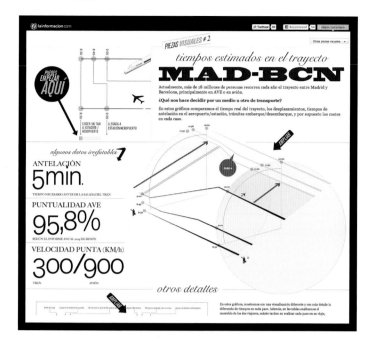

STUDENT VETERANS
VOX MAGAZINE, COLUMBIA MISSOURIAN

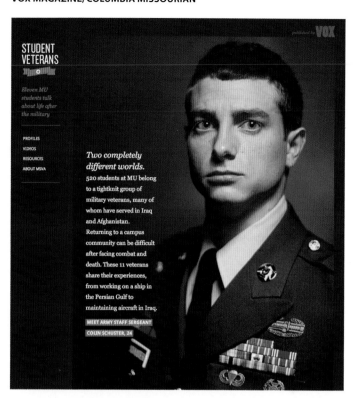

TRIAL EXCERPTS: GETTING TO 'NOT GUILTY'
BOSTON GLOBE

CRISIS GUIDE: IRAN
COUNCIL ON FOREIGN RELATIONS

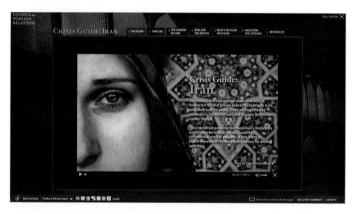

EL NUEVO NORMAL
2011 SYRACUSE NEWS21, SYRACUSE UNIVERSITY

30-S INSUBORDINACION POLICIAL
EL COMERCIO, QUITO, ECAUDOR

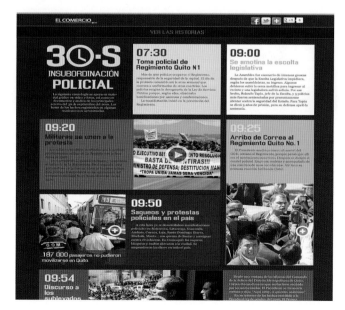

GROUND ZERO NOW
THE NEW YORK TIMES

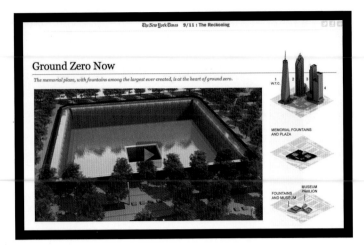

SPEED AND SPIN: NADAL'S LETHAL FOREHAND
THE NEW YORK TIMES

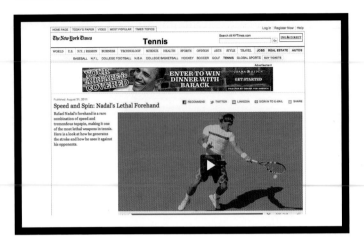

JAPAN AND HAITI: PICTURING THE UNIMAGINABLE
NPR

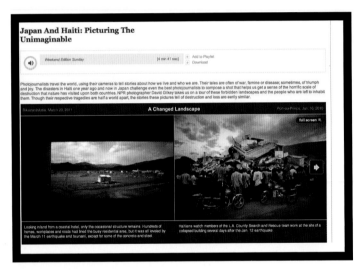

UNDER SUSPICION: VOICES ABOUT MUSLIMS IN AMERICA
THE WASHINGTON POST

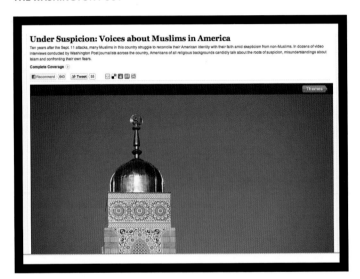

COMING OUT
THE NEW YORK TIMES

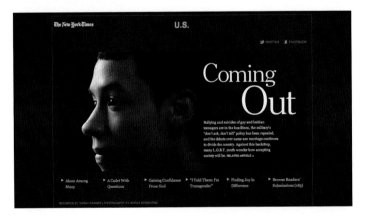

SWEET SOUNDS OF SCIENCE
THE NEW YORK TIMES

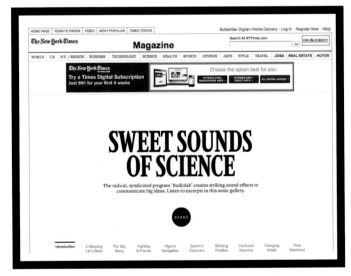

Award of Excellence Winners — Section or topic: less than 50 million

GRAPHIC NEWS
LA INFORMACION.COM

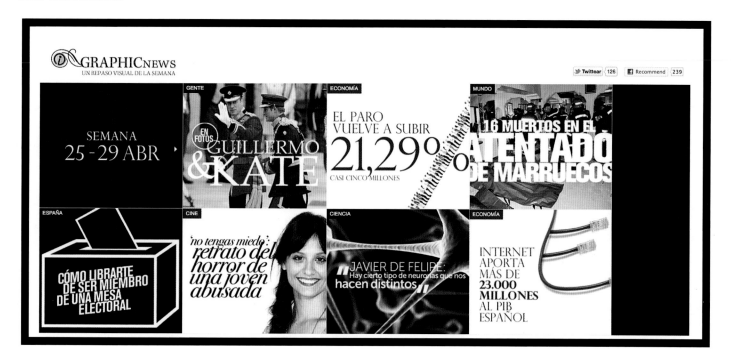

Award of Excellence Winners — Section or topic: more than 50 million

DEBATE DASHBOARD
THE NEW YORK TIMES

SCHOOLBOOK
THE NEW YORK TIMES

NPR MUSIC
NPR

INFINITE PLAYER
NPR

Award of Excellence Winners — Breaking news: less than 50 million

THE KOLSKAYA DRILLING RIG ACCIDENT IN THE SEA OF OKHOTSK
RIA NOVOSTI

Award of Excellence Winners — Breaking news: 50 million or more

HOW OSAMA BIN LADEN WAS LOCATED AND KILLED
THE NEW YORK TIMES

PANORAMAS OF JOPLIN BEFORE AND AFTER THE TORNADO
THE NEW YORK TIMES

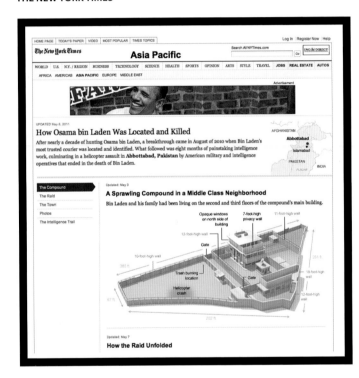

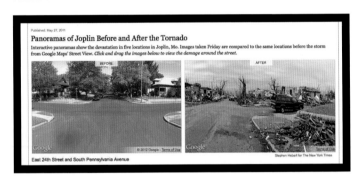

THE DEATH OF A TERRORIST: A TURNING POINT?
THE NEW YORK TIMES

HURRICANE IRENE: FLOODING, POWER FAILURES, RAINFALL AND DAMAGE FROM HURRICANE IRENE
THE NEW YORK TIMES

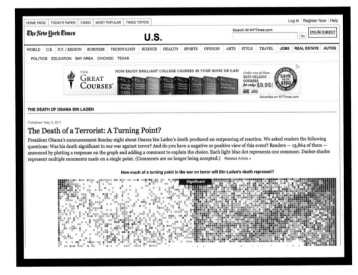

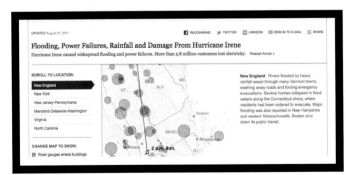

Award of Excellence Winners — Data-driven project: less than 50 million

BOBBY VALENTINE'S RED SOX ERA BEGINS WITH OPTIMISM
BOSTON GLOBE

WHERE DOES YOUR FRESHMAN CLASS COME FROM?
THE CHRONICLE OF HIGHER EDUCATION

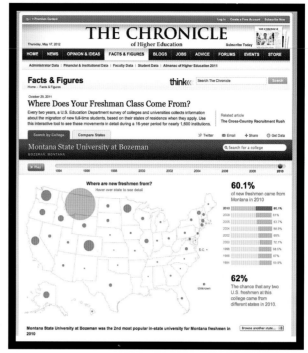

LABIORAL SCHEDULE
LAINFORMACION.COM

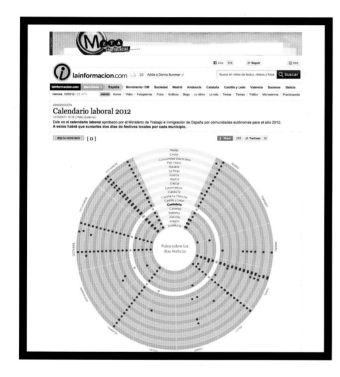

THE OPPORTUNITY GAP
PROPUBLICA

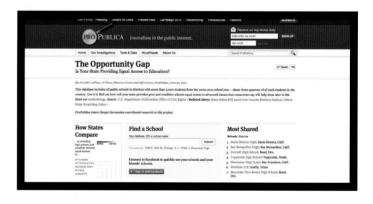

EMPTY CRADLES
MILWAUKEE JOURNAL SENTINEL

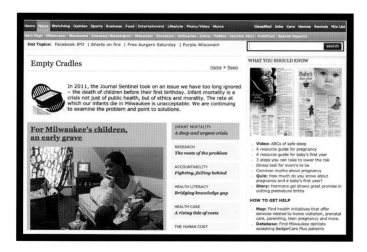

TWO LOCALITIES ARE WORLDS APART
BOSTON GLOBE

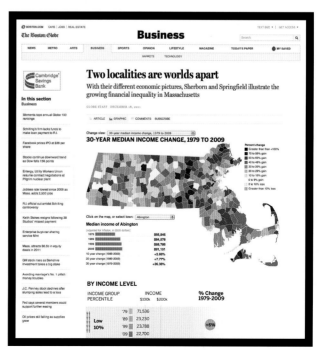

Award of Excellence Winners — Data-driven project: less than 50 million

CURBWISE.COM
OMAHA WORLD-HERALD

EXECUTIVE COMPENSATION AT PRIVATE COLLEGES
THE CHRONICLE OF HIGHER EDUCATION

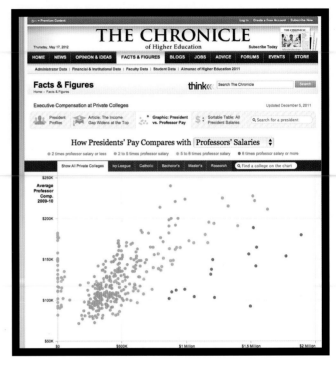

BOTH SIDES OF THE LAW
MILWAUKEE JOURNAL SENTINEL

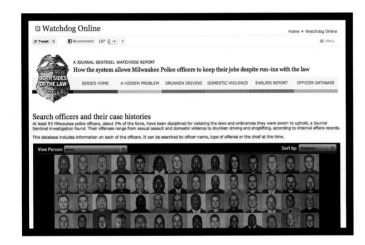

Award of Excellence Winners — Data-driven project: more than 50 million

STEVE JOBS'S PATENTS
THE NEW YORK TIMES

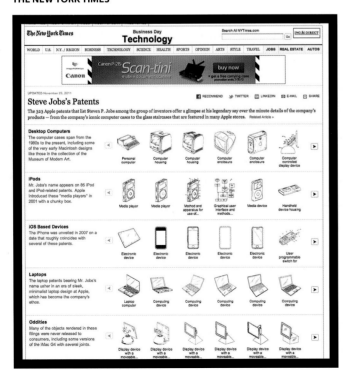

IT'S ALL CONNECTED: AN OVERVIEW OF THE EURO CRISIS
THE NEW YORK TIMES

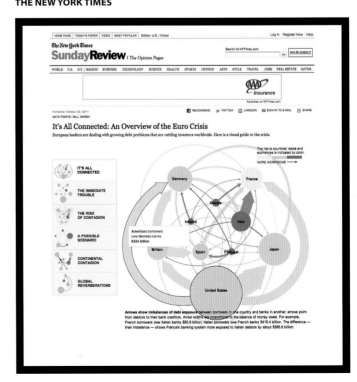

Award of Excellence Winners — Data-driven project: less than 50 million

BOBBY VALENTINE'S RED SOX ERA BEGINS WITH OPTIMISM
BOBBY VALENTINE'S RED SOX ERA BEGINS WITH OPTIMISM
BOSTON GLOBE

LABIORAL SCHEDULE
LAINFORMACION.COM

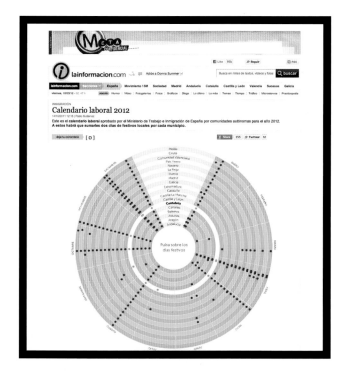

EMPTY CRADLES
MILWAUKEE JOURNAL SENTINEL

WHERE DOES YOUR FRESHMAN CLASS COME FROM?
THE CHRONICLE OF HIGHER EDUCATION

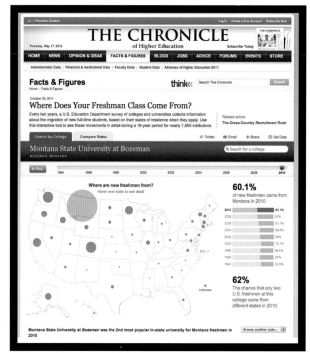

THE OPPORTUNITY GAP
PROPUBLICA

TWO LOCALITIES ARE WORLDS APART
BOSTON GLOBE

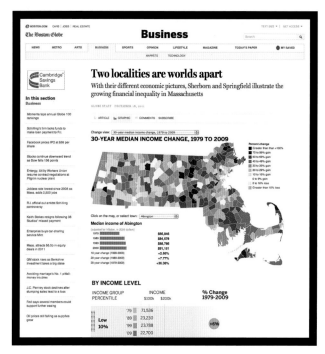

Award of Excellence Winners — Data-driven project: less than 50 million

OMAHA WORLD-HERALD

THE CHRONICLE OF HIGHER EDUCATION

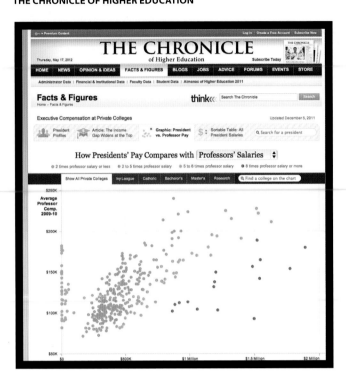

MILWAUKEE JOURNAL SENTINEL

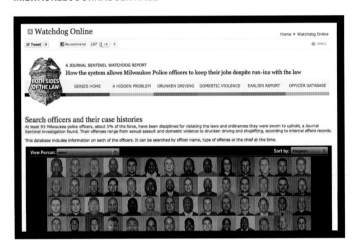

Award of Excellence Winners — Data-driven project: more than 50 million

THE NEW YORK TIMES

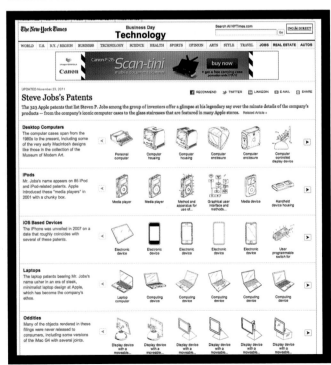

THE NEW YORK TIMES

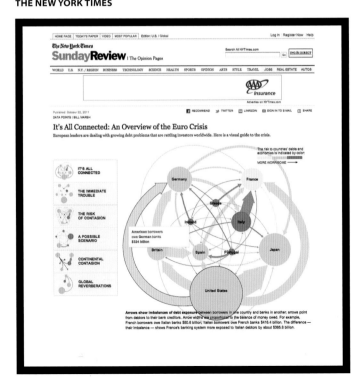

A HISTORY OF THE DETAINEE POPULATION
THE NEW YORK TIMES

MAPPING THE NATION'S WELL-BEING
THE NEW YORK TIMES

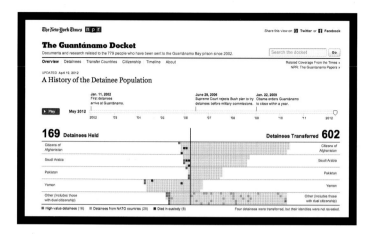

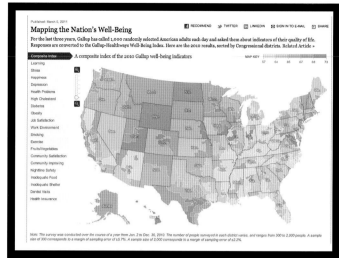

IF SOMEONE MADE A CITY
THE NEW YORK TIMES

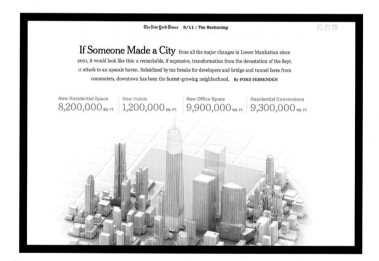

MAP OF DAMAGE FROM THE JAPANESE EARTHQUAKE
THE NEW YORK TIMES

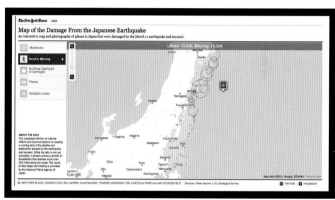

HOW MANY HOUSEHOLDS ARE LIKE YOURS?
THE NEW YORK TIMES

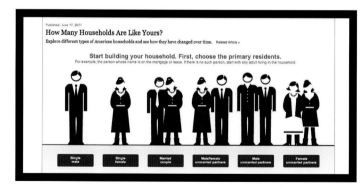

WHAT'S YOUR ECONOMIC OUTLOOK?
THE NEW YORK TIMES

Award of Excellence Winners — Data-driven project: 50 million or more

2011 U.S. OPEN: HOW THE COURSE HAS PLAYED
THE WASHINGTON POST

BROWSE: WHERE WERE YOU ON 9/11
THE NEW YORK TIMES

THE VAN DUSENS THROUGH HISTORY
THE NEW YORK TIMES

ROCK-PAPER-SCISSORS: YOU V. THE COMPUTER
THE NEW YORK TIMES

A GLOBAL LOOK AT CARDIAC RISK FACTORS
THE WASHINGTON POST

SCHOOLBOOK
THE NEW YORK TIMES

MAPPING THE 2010 U.S. CENSUS
THE NEW YORK TIMES

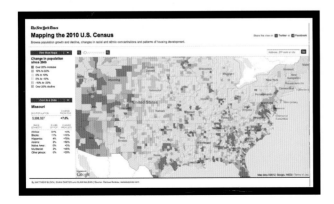

Award of Excellence Winners — Student work

Award of Excellence Winners — Series or event: less than 50 million

LESS THAN 50 MILLION
FORTY FORDS

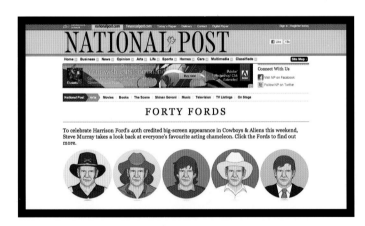

SPANISH PRESIDENTIAL ELECTIONS
LA INFORMACION.COM

THE LONG ROAD
NATIONAL POST

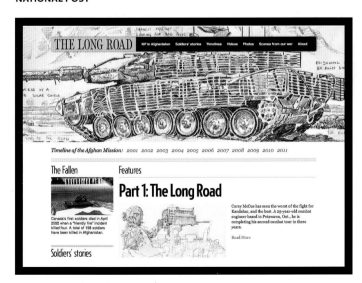

PANORAMAS
LA INFORMACION.COM

SPREADING REVOLUTION
THE NEW YORK TIMES

2011 U.S. OPEN: HOW CONGRESSIONAL HAS PLAYED
THE WASHINGTON POST

GETTING IN: NAVIGATING BOSTON'S SCHOOL ASSIGNMENT MAZE
THE BOSTON GLOBE

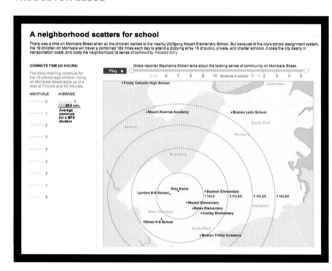

2011 U.S. OPEN: HOLE-BY-HOLE
THE WASHINGTON POST

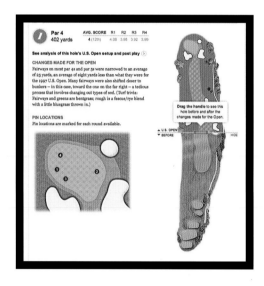

THANKSGIVING HELP LINE
THE NEW YORK TIMES

PUNCHED OUT
THE NEW YORK TIMES

Award of Excellence Winners — Portfolio individual: 50 million or more

CHIQUI ESTEBAN
LA INFORMACION.COM

Award of Excellence Winners — Tablet experience

50 GREATEST PHOTOGRAPHS OF NATIONAL GEOGRAPHIC
NATIONAL GEOGRAPHIC

SVD INSIKT
SVENSKA DAGBLADET

FLUD

GUARDIAN IPAD EDITION
THE GUARDIAN

Award of Excellence Winners — Mobile experience

PROPUBLICA MOBILE EXPERIENCE
PROPUBLICA

THE WASHINGTON POST FOR ANDROID APP
THE WASHINGTON POST

DC Going Out Guide
THE WASHINGTON POST

REDEYE MOBILE APPLICATION
REDEYE

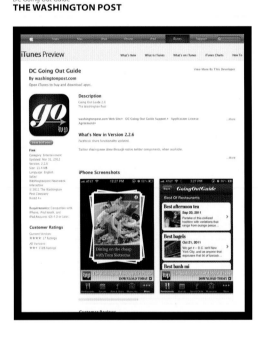

ASAHI SHIMBUN DIGITAL
THE ASAHI SHIMBUN

FLUD

Index: people

Índice: nombres

Index: people

Index: publications

LANCE JOHNSON, Editor, *The Best of News Design™*

The following people contributed to the production of the 33rd edition of The Best of News Design™:

Marshall Matlock, Stephen Komives, Shamus Walker, Josh Crutchmer, Cristóbal Edwards, Susan Santoro, Ryan Sparrow, Jennifer Johnson, Gregory Feit and Clara Montesi.